THE WAY WEST

THE WAY

ART OF FRONTIER AMERICA

PETER HASSRICK
Director, Buffalo Bill Historical Center, Cody, Wyoming

WEST

ABRADALE PRESS/HARRY N. ABRAMS, INC. NEW YORK

To Philip and Charles

Editor: Joanne Greenspun
Designer: Wei-Wen Chang

Library of Congress Cataloging in Publication Data

Hassrick, Peter H.
 The way West.

 Includes bibliographical references and index.
 1. West (U.S.) in art. 2. Art, Modern—19th century
—United States. 3. Art, Modern—20th century—United
States. I. Title.
N8214.5.U6H3 1983 704.9′49978 83–7142
ISBN 0–8109–8053–3

This 1983 edition is published by Harry N. Abrams, Inc., New York.

Printed and bound in Japan

Contents

Introduction

For all of our two hundred years, Americans have sought an answer to the question, What is unique about us? Where have we been distinguished historically from the rest of the world, and how and why? These have each been fundamental considerations, which, in their introspection, have fused the essence of our self-understanding.

Our nation was not yet a decade old when St. John de Crèvecoeur asked the question—"What . . . is the American?"[1] He was either a direct emigrant from some European country or a descendant of a European family. The resulting amalgamation proved distinctive to De Crèvecoeur for he saw in America a "strange mixture of blood, which you will find in no other country."[2] By the middle of the next century, however, historians had generally concluded that it was not so much how bloodlines merged that counted, but where the mixing took place. The American environment, they contended, with the unique problems and promises it posed for the Europeans who came to this continent, had caused Americans to pattern their lives and thoughts in a manner quite distinct from their European counterparts.

This change of historical thought evolved in part through the gradual realization that America's frontier, and particularly the West, played a significant role in determining pervasive American institutions. Alexis de Tocqueville suggested a frontier influence when, in 1863, he observed that in America, "nature herself favors the cause of the people."[3] Two years later, Edwin L. Godkin, editor of the influential American magazine *The Nation*, expanded that theory. "If we inquire what are those phenomena of American society which it is generally agreed distinguish it from that of older countries, we shall find . . . that by far the larger number of them may be attributed . . . to what, for want of a better name, we shall call 'the frontier life' led by a large proportion of the inhabitants."[4]

Through the remaining years of the nineteenth century and in fact up to our own day, this idea of frontier dominance in the American experience has been expatiated and refined, renounced and redefined. By now, the "frontier hypothesis," as dubbed in the pronouncements of Wisconsin historian Frederick Jackson Turner, has become a fundamental school of American historical thought.

Equally consuming as the quest for a homegrown explanation of this country's historical novelty has been America's newly awakened interest in her own art. There has always been a lag between the recognition of our social, political, and economic institutions and our arts. In the humanities, Americans have from the beginning signaled new directions for the world; in the arts we have suffered the onus of eclecticism. We were thought of as patterning our aesthetics after European lessons rather than forging new models from either the unique environment or our rich cultural mixture seasoned with people from all parts of the world. This is why Jay B. Hubbell has contended that our literature "has always been less American than our history."[5] This is why, until twenty-five years ago, American painting and sculpture were virtually ignored at home and abroad. And, it is a reflection of why critic Arthur Hoeber would write in 1908 an article entitled "Concerning Our Ignorance of American Art." Here he lamented the substantial class of art patrons "who have made their wealth directly through the patronage of their fellow-countrymen, from products taken from the soil of America, who have bought freely of pictures by Europeans living and dead, but who have no use for the American painter on any terms whatever."[6]

American art no longer suffers the neglect of past years. Since World War II the public as well as academia have lavished devout attention on the subject. American art is now firmly established as an expression of our national identity and as such has become a recognized discipline in itself. The past generation has produced a cadre of zealous and energetic art historians who set to the task of rediscovering and reevaluating their nation's artistic past.

As in the appraisal of the American historical experience, primary consideration has come to focus on a determination of uniqueness. What is American about American art? is a question which has received almost as much attention in recent years as the individual artists or schools of art being rediscovered. In 1936 Samuel Isham emphasized in the first sentence of his book, *The History of*

[1] J. Hector St. John de Crèvecoeur, *Letters from an American Farmer* (New York, 1957), p. 39.

[2] Ibid.

[3] Alexis de Tocqueville, *Democracy in America* (Cambridge, Eng., 1863), p. 372.

[4] Edwin L. Godkin, "Aristocratic Opinions of Democracy," *North American Review*, 206 (January, 1865), 209.

[5] Jay B. Hubbell, "The Frontier" in Norman Foerster, ed., *The Reinterpretation of American Literature* (New York, [1928]), p. 43.

[6] Arthur Hoeber, "Concerning Our Ignorance of American Art," *Forum*, 39 (January–March, 1908), 353.

American Painting, that "the fundamental and mastering fact about American painting is that it is in no way native to America, but is European painting imported, or rather transplanted, to America."[7] Twenty-six years later, art historian James Flexner refuted Isham's premise by publishing a definitive work on what he referred to specifically as America's "Native School" of painting. Although Flexner cautioned that "the ultimate question concerning a work of art is not whether it is national or cosmopolitan, but whether it has beauty and power,"[8] other observers have continued to herald specific aesthetic and technical tenets identifiable as purely American. Barbara Novak, for example, points to "the conceptual nature of the American vision" as one of "the most distinguishing qualities of American art. This," she adds, "is accompanied by a strong feeling for the linear, for the wholeness of objects that must not rationally be allowed to lose their tactile identity—to be lost or obscured by the flickering lights and shadows of the European painterly tradition."[9]

One idea which illogically has not sprung from all the newborn interest in American art and the persistence of the frontier hypothesis in contemporary historiography is a notion that the frontier effected the determination of American art forms. There has never been a cultural history of the American West, perhaps because the frontier in the American mind was not merely "a boundary between civilization and savagery, but between an inferior state of civilization and its total absence."[10] By its disparate nature, humanity on the Western frontier had no chance to evolve a cultural integrity of its own. So dynamic were the forces which drove Americans west and dictated their activities that no room for cultural appurtenance in the matter of survival existed. This does not mean that there were no cultural attitudes, but that they were so adaptive, polyglot, and ever-changing that no constancy is definable, at least in the same way one might find in New England, for example.[11]

[7] Samuel Isham and Royal Cortissoz, *The History of American Painting* (New York, 1936), p. 3.

[8] James Thomas Flexner, *That Wilder Image* (New York, 1962), p. xiii.

[9] Barbara Novak, *American Painting of the Nineteenth Century* (New York, 1969), p. 90.

[10] Roland Van Zandt, *The Catskill Mountain House* (New Brunswick, 1966), p. 7.

[11] See William H. Goetzmann, "The American West and the American Nation," *Journal of World History,* 10 (1967), 902.

However, numerous and obvious elements in the frontier West served diacritically for both American history and art. The land which beckoned beyond the Mississippi, the natives of the Plains and Rockies, the evolving frontiers from gold bonanzas to cattle kingdoms were subjects which fascinated all Americans and the world. As themes, these and countless more became pervasive elements in American literature and art. Though regionally lacking in culture itself, the Western frontier created iconic forms assimilable nationally as cultural pattern.

Art of the American West was first separated from the general corpus of American art in two pivotal exhibitions of the mid-1950s—*Westward the Way,* held at the St. Louis Art Museum and the Walker Art Center, and *Building the West* at the Denver Art Museum.[12] Both exhibitions set the pattern for a host of shows in subsequent years in which painting and sculpture were used as pictorial analogue to history. It became popular dictum. That segment of American art devoted to the pictorialization of the Western scene has earned the rather exclusive and sometimes confusing nomenclature of its own—"Western art."

As an entity, Western art has come to evidence certain qualities in the popular mind, ostensibly separating it from the broader field of American art. For many aficionados, Western art, by virtue of its theme, embodies those pragmatic and wholesome qualities purportedly synonymous with the American dream. For other, less passionate defenders of things Western, it is simply that junk stuff collected at outlandish prices by unimaginative collectors for uninspired museums. It is art for the fellow who falls back on the cliché, "I don't know anything about art, but I know what I like." Because of its inclusive regional focus there is no need to inquire what is Western about Western art. That is self-evident. Yet, in light of divergent opinion, it seems appropriate to ask, What is art about Western art?

The popular conception of what makes Western art distinctive incorporates many principles beyond the fact that a given work is Western in theme. Standards thought to be consistent with Western

[12] See Perry T. Rathbone, ed., *Westward the Way* (St. Louis, 1954), and Royal B. Hassrick, *Building the West* (Denver, 1955).

art may be summarized in *A Dash for the Timber* (plate 1), painted early in the career of Frederic Remington, an artist generally considered a paragon among Western artists. As a metaphor for Western art in general, the painting is first recognizable as a narrative one. It tells the story of frontier defense, cowboys on thundering horses careening at full tilt toward the trees with the hope of fending off an avenging host of Apaches at their rear. Overtly masculine in temper, the painting depicts man in contest with nature.

A Dash for the Timber presents a stirring frontier scene. Physical action is paramount. Horses and men in the fashion of a Jean Meissonier charge are keyed to the high point of drama. Every rifle and six-shooter discharge at the moment of the viewer's first glance. The horses seem to emerge from the canvas itself, the dust and the pounding of their hooves swirling with them.

Detail in the picture is accurately and laboriously recounted. In order to capture the authenticity of the scene, Remington depended on a variety of props collected by himself on the frontier. He even wrote an Arizona friend, Powhatan H. Clarke, to send him extra pairs of chaps so that each of his figures in the painting might be individually and authentically attired. "I have a big order for a cow-boy picture and I want a lot of 'chapperas' [*sic*]—say two or three pairs—and if you will buy them of some of the cow-boys there and ship them to me by express C.O.D. I will be your slave. I want *old ones*—and they should all be different in shape. . . . I have four pairs now and want some more and as soon as I can get them will begin the picture."[13]

Remington's painting wedded Romanticism and Realism. Anatomical detail was viewed with the exactitude and studied observation of a Thomas Eakins and an Eadweard Muybridge. The scene itself carried the feeling of factual, historical documentation and, if not an actual retelling of an incident, was at least history for what Remington saw it to be. It is romantic; Remington was in reality an artist after the fact. The painting symbolized the West, representing a nostalgic look over his shoulder into the past.

A Dash for the Timber was something of a technical *tour de force* as well. "The drawing is true and strong," wrote a reviewer for the *New York Herald* who saw the huge canvas at the Autumn Exhibition of the National Academy of Design in 1889. "The figures of men and horses are in fine action, tearing along at full gallop, the sunshine effect is realistic and the color is good."[14] The foreshortening of figures was accomplished. The colors he depicted, though criticized as "hot and often lurid,"[15] were bold in their candor and emphatically Western. Unlike the Eastern woodlands, color on the open prairies was not so much harmonious as prodigious.

That Remington consciously avoided any effort to please dilettante taste is perhaps apparent in the theme of the picture. This was not a painting fit to adorn a Victorian parlor. A few years later Remington would advise his friend Owen Wister to construct scenes in his stories around the thunder of horses's hoofs, the jammer of profane frontier jargon, and the flow of blood. Episodes, he cautioned, were never to occur in the dark.

If these then are qualities synonymous with the popular conception of Western art, it should come as something of a surprise to view in analytical fashion one of Remington's later works. Among the paintings completed by the artist in 1909 was an oil entitled *Sign of Friendship* (plate 2), which by its very name suggests the antithesis of *A Dash for the Timber*. Both paintings were conceived of as pieces for exhibition and sale rather than as illustrations. Both dealt with the subject of an Indian confrontation. And both rest today as examples of Remington's finest efforts. However, the fundamental qualities of the two paintings are diametrically opposed.

The narrative element in Remington's *Sign of Friendship* has not disappeared, to be sure. It is apparent that the mounted warriors are about to interact in some manner with an unknown party who approaches them. Yet, the picture transcends storytelling to become symbolic—the epitome of mystery and quiescence in Indian life.

Unlike *A Dash for the Timber*, Remington's *Sign of Friendship* is not aggressively masculine. No longer is man in conflict with man or with nature. Instead, harmony has rested on the Western scene, euphoric and gracious in full measure. In accord with this union, the painting itself even speaks a different language. The physical action which dominated *A Dash for the Timber* has been replaced by a concentration on visual dynamics. The figures

[13] Letter from Remington to Powhatan H. Clarke dated April 2, 1889, in the Missouri Historical Society, St. Louis.

[14] "The Autumn Exhibition, a Display of Much Interest," *New York Herald* (November 16, 1889).

[15] "Frederic Remington," *American Art News* (January, 1910), unpaged.

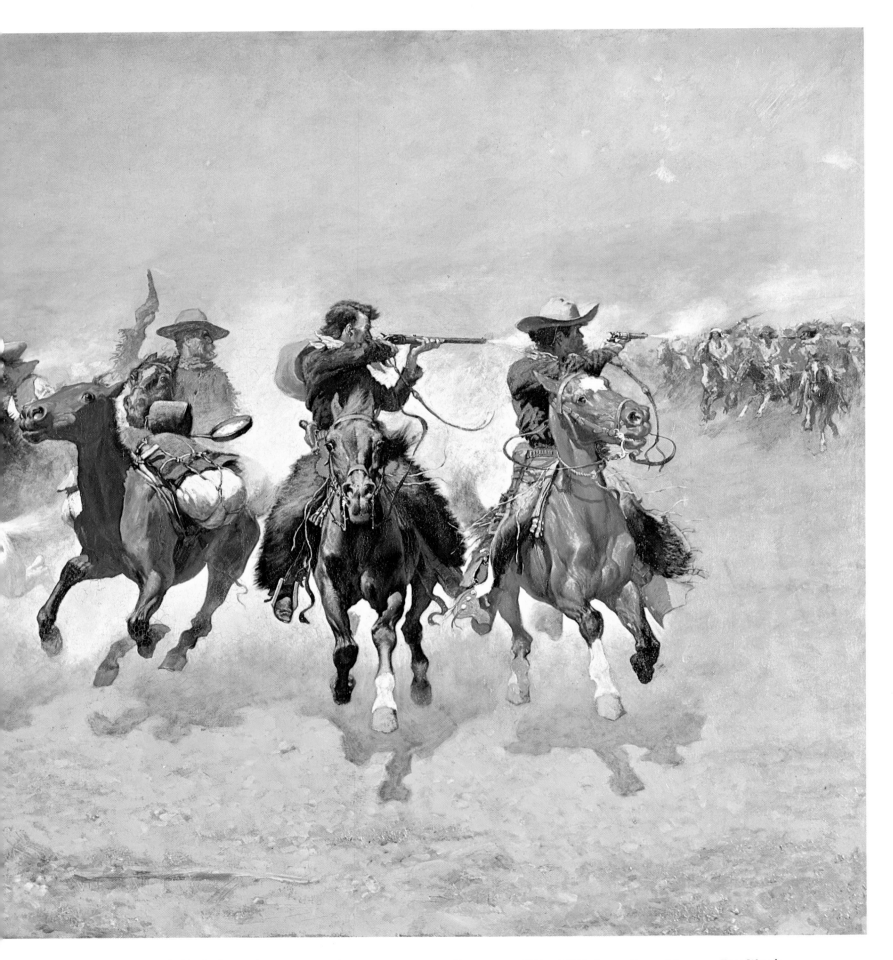

1. Frederic Remington. *A Dash for the Timber.* 1889. Oil on canvas, 48¼ x 84⅛". Amon Carter Museum, Fort Worth

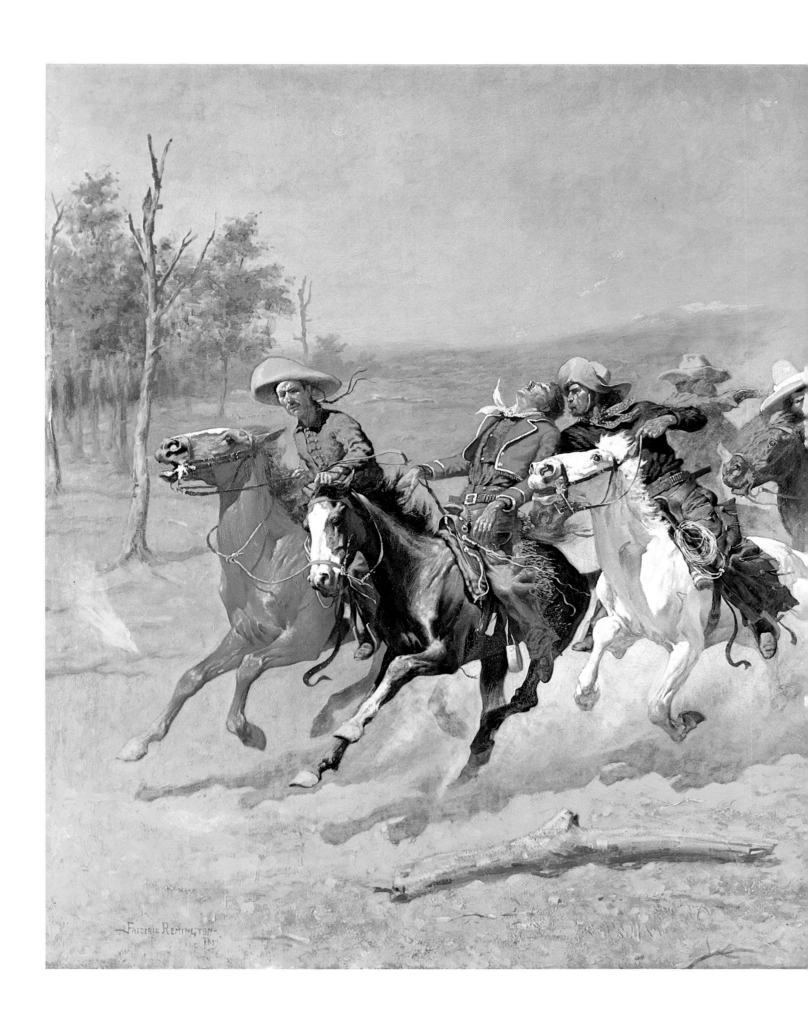

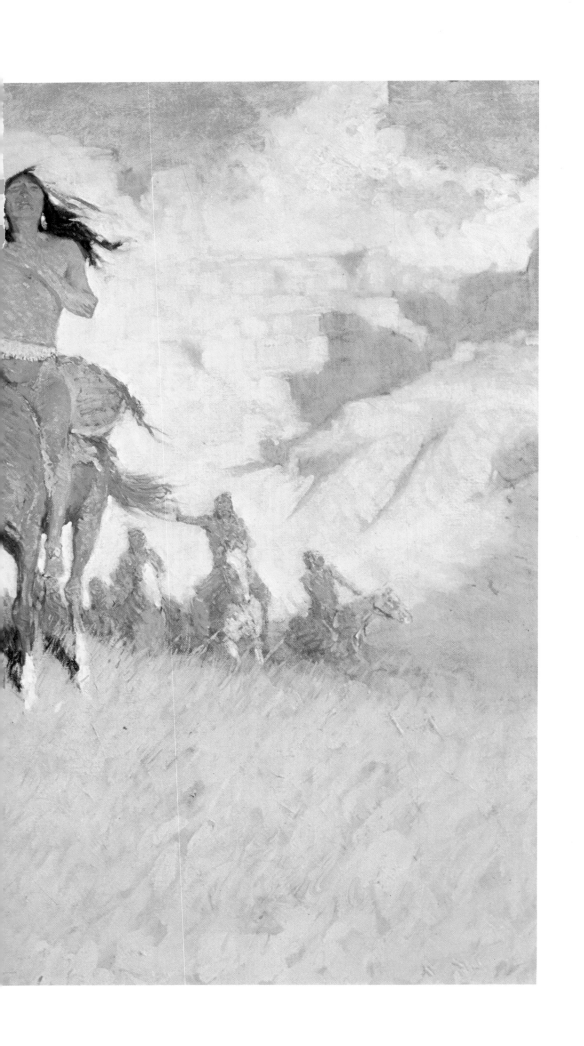

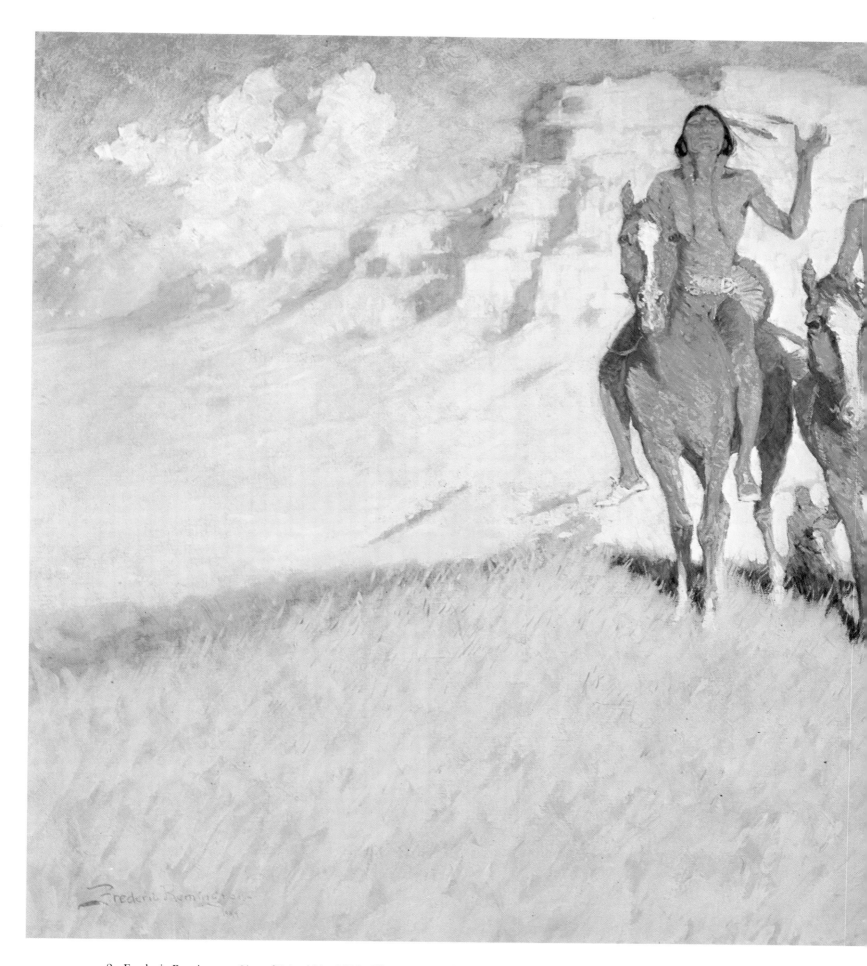

2. Frederic Remington. *Sign of Friendship.* 1909. Oil on canvas, 27 x 40″. The El Paso Museum of Art, El Paso, Texas

are firmly planted in the composition but the vital brushwork, the subtle interplay of shadow and light, and the greater attention to harmony of tone create a pictorial momentum and force.

The objective quality of Remington's realism, so important to the success of *A Dash for the Timber*, has given way in the *Sign of Friendship* to a personal style of Impressionism. No longer was Remington concerned with the depiction of life at face value, but rather he became devoted to pictorial analysis—to picture making. After 1900 he refused to travel west as he had done throughout his career to collect material for his paintings. He went only to capture the effects of light. Brick chimneys, bibbed overalls, and barbed wire had destroyed his illusions of what the West ought to be. Only the landscape and Western light remained constant. In 1895 Remington had described a vista in northern Mexico as "massive in its proportions and opalescent in color. There are torquois [*sic*] hills, dazzling yellow foregrounds—the palette of the 'rainbow school' is everywhere."[16] Now, in 1909, these observations assumed their true force. Western color in his paintings was still strong but the values were allied to create a relatively flat, decorative space in agreement with his Impressionist leanings.

Drama was still central to Remington's *Sign of Friendship*, as it had been in *A Dash for the Timber*. Yet in the later piece, the drama seems to have receded within the picture plane, producing a rather cerebral, inward evocation of myth as opposed to blatant theater on canvas. Even the themes have changed in the later picture. The scene does not require blood, profanity, and pounding action. Remington has created a stylized embodiment of what the Indian meant to him— riders in an open land, free, windblown, sunlit, and indomitable.

The differences in artistic qualities expressed in these two paintings make it clear that Western art cannot be considered as a genre separate from the mainstream of American art, even within the confines of one painter's work. The artists who created that corpus of work referred to as Western art were really part and parcel of the developing art of this nation. They were, in fact, much in accord with world art of their times, not proponents of a separate discipline.

If Western artists are not distinguishable on aesthetic terms, perhaps they have been tradition-

ally separated as a class, assuming they possessed certain characteristics common to the frontier types they documented. Were there typical frontier traits which, as observers exhorted, had "been created by causes and circumstances existing in the West alone?"[17] Robert Baird, in advice given to emigrants going west, enumerated three qualities considered peculiar to Western types: "*A spirit of adventurous enterprise* . . . *independence of thought and action* . . . [and] *an apparent roughness,* which some would deem *rudeness of manners.*"[18] And, would such innate qualities apply equally to the chroniclers as well as the chronicled?

It is doubtful that many of the nineteenth-century artists of the West would have fit the third criterion for membership in the fraternity of frontier characters—rudeness of manners. It is difficult to imagine Thomas Moran, Titian Peale, William Ranney, or many others mentioned in this book as evidencing "simplicity of manners, want of deference [or] want of reserve"[19] which Baird equated with frontier roughness. Equally improbable is the conjecture that independence of thought and action was any more prevalent among artists of the Western scene than elsewhere in America. One has only to read the biographies of James McNeill Whistler or Albert Pinkham Ryder to refute such thoughts. Was it then a spirit of adventurous enterprise which distinguished Western artists as a common group? Perhaps this, if any trait is separable, would fit the majority of artists who chose the West as their studio. The romance of adventure and the remunerative rewards of capturing unrecorded scenes in the untamed West were no doubt fundamental motivations for all artists who dared bridge the broad Mississippi with their easels, palettes, brushes, and paints. Perhaps an anonymous contributor to the *New York Tribune* of April 1, 1843, in describing the "true pioneer," also defined best the qualities of our early Western artists. "Fearlessness, hospitality and independent frankness, united with restless enterprise and unquenchable thirst for novelty and change are the peculiar characteristics of the Western pioneer."

Although a significant factor, restless enterprise was by no means the sole *raison d'être* for Western art. At least the earliest artists into the Far West carried with them a far more altruistic motive.

[16] Frederic Remington, *Pony Tracks* (New York, 1895), p. 157.

[17] Robert Baird, *View of the Valley of the Mississippi, or the Emigrant's and Traveller's Guide to the West* (Philadelphia, 1834), p. 100.

[18] Ibid., pp. 101–3.

[19] Ibid., p. 103.

They were imbued with a partly scientific, partly literary passion to record the world around them. These first artists beyond the Mississippi were furthering a cosmological tradition which had been sired by the Age of Enlightenment and brought to full expression in the nineteenth century by the German scientist Alexander von Humboldt. An orderable natural world, broken down into observable elements, was the only way in which man might reveal to his soul "the existence of laws that regulate the forces of the universe."[20] It was thus with a sense of universal inquiry that artist Rembrandt Peale advised his young half-brother Titian in 1818. "I suspect you will be the only Draughtsman," he wrote Titian, who was making preparations to accompany Major Steven Long's historic expedition to the Rockies. "I therefore recommend you to practice immediately sketching from nature. I know how well you draw when you have the object placed quietly before you, but if you practice sketching from human figures as well as animals and trees, hills, cataracts, etc., you will be able to present us with many a curious representation."[21] Peale returned in 1820 with 122 sketches. He had traveled several thousand miles from his Philadelphia home to the foot of the Rockies and as assistant naturalist to the expedition had gathered materials for a vital new chapter in the understanding of the cosmos. According to the English edition of the published journals, he had also been "active and industrious in the collection and preservation of such rare specimens of animals, &c. as come under . . . observation."[22] That Peale in later years took over the management of the Peale Museum in Philadelphia evidences his allegiance to art and science. The inscription on the ticket to that museum offers a clear picture of personal incentives as well as a capsule view of his age—"The Birds and Beasts will teach thee! Admit the Bearer to Peale's Museum, containing the Wonderful works of NATURE and Curious Works of ART."[23]

In much the same sense that Titian Peale sketched and collected specimens of the natural world, a Philadelphia watercolorist, Samuel Seymour, was employed to document the landscape. As official artist of the expedition, Seymour was also assigned to record likenesses of Indians and "exhibit groups of savages engaged in celebrating their festivals, or sitting in council."[24]

Peale and Seymour are generally considered the first artists to venture into the American West. They were not, but as artist-explorers they were the first major extension westward of a pattern begun with the awakening of intellectual life and the broadening of horizons which followed on the Renaissance. According to Washington Irving, this tradition had its roots in the New World with Columbus, who supposedly brought a painter with him on one of his voyages.[25] Spanish conquistadores are known to have supplemented their expeditions with artists, and throughout the sixteenth and seventeenth centuries English, French, and Dutch explorers either contracted for artists or were artists in their own right. Thus, the tradition of the artist-explorer had developed and was nurtured not only from the need to depict the natural world visually, but also from the very expansion of that natural world itself.

Artist-explorers first viewed the American West from the Pacific coast. John Webber, sailing on Captain Cook's third voyage, saw the Northwest shores in 1778. A Swiss landscape painter of considerable renown, Webber was not only hired as official artist but was responsible for supervising the preparation of his sketches into finished engravings which illuminated the offical journals. Such pictorial documentation became an integral part of the reports every major expedition was expected to compile.

Perhaps the most exemplary of such sketches in this early period in the West was executed by an English artist named John Sykes. A member of the crew on Captain George Vancouver's Pacific expedition between 1790 and 1795, Sykes produced a number of sketches which illustrated the final published report, *Voyage of Discovery to the North Pacific Ocean*. Captain Vancouver's statement at the beginning of his trip sheds some light on the importance of art to such ventures.

It was with infinite satisfaction that I saw amongst the officers and young gentlemen of the quarter-deck, some who, with little instruction,

[20] Alexander von Humboldt, *Cosmos: A Sketch of a Physical Description of the Universe* (New York, n.d.), I, p. 25.

[21] Quoted in Jessie Poesch, *Titian Ramsay Peale 1799–1885 and His Journals of the Wilkes Expedition* (Philadelphia, 1961), p. 3.

[22] Edwin James, *Account of an Expedition From Pittsburgh to the Rocky Mountains . . .* (London, 1823), III, p. 181.

[23] Charles C. Sellers, *The Artist of the Revolution: The Early Life of Charles Willson Peale* (Hebron, Conn., 1939), p. 270.

[24] James, op. cit., p. 3.

[25] Porter Butts, *Art in Wisconsin* (Madison, 1936), p. 22.

would soon be enabled to construct charts, take plans of bays and harbours, draw landscapes, and make faithful representations of several head-lands, coasts and countries, which we might discover; thus by the united efforts of our little community, the whole of our proceedings, and the information we might obtain in the course of the voyage, would be rendered profitable to those who might succeed us in transversing the remote parts of the globe that they were destined to explore, without the assistance of professional persons, as astronomers or draftsmen.[26]

The English were not alone in their search for knowledge about the American West. French, Russian, and Spanish interests were seen along the West Coast in the eighteenth and early nineteenth centuries. The Americans too wanted their share. At an early date, America's practical minds conceived of the economically strategic position of the West Coast. Learning from the published journals of the Cook expedition about the possibilities of the China trade, a group of enterprising Boston merchants sponsored Captain Robert Gray on a series of fact-finding missions.[27] As on the Vancouver voyage, there were no official artists, but George Davidson, ship painter on the 1791–92 journey, when not wielding his brush along the topsides, recorded scenes of the wondrous new places. Gray's search for the great Western waterway ended at the mouth of the broad flowing river which he named after his boat, the *Columbia.* Davidson captured the historic scene with his pencil.[28] And, although Davidson died somewhere in the Pacific in 1800, a few of his drawings were later reproduced and surely played a part in propagandizing the American side of the Oregon question.

Explorations were strategic in such political questions as Oregon, not only because of the discoveries but also because of the reports and illustrations which popularized their cause. Since two important factors, discovery and possession, were involved in claims of ownership in Oregon as well as in much of the West, publishing views of the area along with written eulogies helped influence America's destiny.

[26] Paul Mills, ed., *Early Paintings of California in the Robert B. Honeyman Jr. Collection* (Oakland, 1956), p. 15.

[27] Edward G. Porter, "The Ship Columbia and the Discovery of Oregon," *New England Magazine,* n.s. 6 (June, 1892), 480.

[28] John Taylor Forrest, "Capturing the American Scene," *El Palacio,* 68 (autumn, 1961), 173.

It was for other than political motivation that some artists moved into the Far West in the early 1800s. George Catlin, for one, came of his own accord, driven by a Darwin-like desire to record nature and the universe in unspoiled terms. With a passion to salvage a likeness of the native tribes before they suffered white influence and acculturation, Catlin in 1832 wandered two thousand miles up the wild Missouri River to the heart of the Northern Plains.

Catlin foresaw the destiny of the American nation, that it would someday spread from shore to shore, and he knew also that those who stood in her path must succumb to her civilizing gale. The Jackson administration's policy of Indian removal, initiated in 1830, signified a change as powerful as the influx of whites, for the Eastern tribes would soon be pushed to the prairie, and those who dwelled thereon would in due course be forced to further extremes of the continent. Americans viewed their dominion as limitless; Catlin knew that it was not. He wrote in 1844:

> . . . By the past policy of the Government, one hundred and twenty thousand of these poor people, (who had just got initiated into the mysteries and modes of civilized life, surrounded by examples of industry and agriculture which they were beginning to adopt), have been removed several hundred miles to the West, to meet a second siege of the whiskey-sellers and traders in the wilderness. . . . Where they have to . . . scuffle for a few years upon the plains, with the wild tribes, and with white men also, for the flesh and the skins of the last of the buffaloes; where their carnage, but not their *appetites,* must stop in a few years, and with the ghastliness of hunger and despair, they will find themselves gazing at each other upon a vacant waste.[29]

For the next eight years Catlin battled his cause, and when he was done he had completed over six hundred paintings of the American West. Assembled as the Catlin "Indian Gallery," the collection then toured American and European capitals for the next thirty years. *The Art-Union* proclaimed its approval. "The portraits of distinguished warriors, &c., the representations of religious ceremonies, war-dances, buffalo-hunts, &c., &c., are depicted

[29] George Catlin, *Letters and Notes on the Manners, Customs, and Condition of the North American Indians* (London, 1844), II, p. 249.

by Mr. Catlin himself, and that with a force and evident truth that bring the whole detail of Indian life in eloquent reality before the eyes of the spectator."[30] The *United States Gazette* proffered similar acclaim. "There can be no mistake or exaggeration in pronouncing the exhibition of these views of the scenery and natural history of the western country the most important and interesting object for public attention which has ever been offered to the eastern division of the United States."[31] And if America was impressed, imagine the revel of European audiences. Paris's great chronicle, *Le Charivari*, reported in 1845, "C'est le portrait aussi fidèle que possible."[32]

Catlin was not alone in this personal quest for documentation. John Mix Stanley, fifteen years after him, began an odyssey as extensive as that of his predecessor. He spent over a decade traversing the Plains and exploring the Rockies to assemble a cumulative portrait of Western tribes. One hundred and fifty-two paintings composed his fabulous gallery, which he proudly advertised as "Portraits of North American Indians." His collection comprised an accumulation of "portraits painted from life of forty-three different tribes of Indians, obtained at the cost, hazard, and inconvenience of a ten years' tour through the Southwestern Prairies, New Mexico, California, and Oregon." Stanley hoped in earnest that the paintings he gathered would "excite some desire that the memory, at least, of these tribes may not become extinct."[33]

In their day, Catlin and Stanley were frequently compared, primarily because they both cherished the idea that their Indian galleries would be acquired by the Federal Government as national treasures. The original Catlin Indian Gallery did not come to rest in the Smithsonian Institution until 1879, seven years after the artist's death. Stanley in a sense was even less fortunate. The 1864 *Annual Report* of the Smithsonian Institution announced that $20,000 was paid to the artist for compensation. "About two hundred portraits, nearly all of life size, painted and principally owned by Mr. J.M.

Stanley . . . which were on deposit in the institution"[34] were lost when the building burned in January of that year.

The comparative merits of these two collections are difficult to determine today, since only five of Stanley's canvases survived the conflagration.[35] Nonetheless, the consensus of the time favored Stanley's relatively formal presentations. An 1852 letter from artist Seth Eastman to Stanley indicates this persuasion.

Mr. Stanley,
DEAR SIR: Having been requested by you to express my opinions as to the comparative merits of yours and Mr. Catlin's Paintings of the Indians of this country, it affords me pleasure to say that I consider the artistic merits of yours far superior to Mr. Catlin's; and they give a better idea of the Indian than any works in Mr. Catlin's collection.
Very respectfully, your obedient servant,
S. EASTMAN
Captain United States Army[36]

By more recent standards, Karl Bodmer, a young painter from Zürich who accompanied Prince Alexander Philip Maximilian on his historic tour of the Far West in 1833–34, possessed the surest perception and greatest artistic ability of any of the early Western artists. Less dedicated perhaps than Catlin, he nonetheless had an eye so true to form and beauty that he stands apart from other chroniclers.

Some of Bodmer's precise delineation must be credited to his sponsor, Maximilian. It was the prince's persistent discipline which demanded the laborious exactitude evidenced in much of Bodmer's work. Upon reaching the American shore, for example, the artist and the explorer made thorough studies of already established collections of Western art. They visited at length with Titian Peale in Philadelphia, where they absorbed the work of both Peale and Seymour, who preceded them onto the Western frontier. In New York and Boston they scoured bookshops for elu-

[30] Quoted in George Catlin, *Catalogue of Catlin's Indian Gallery of Portraits, Landscapes, Manners . . .* (New York, 1838), p. 55.
[31] Ibid., p. 75.
[32] Ibid., p. 85.
[33] J.M. Stanley, "Portraits of North American Indians, With Sketches of Scenery, Etc., Painted by J.M. Stanley," in *Smithsonian Miscellaneous Collections* (Washington, D.C., 1862), II, p. 3.

[34] "Proceedings of the Board of Regents," in *Smithsonian Institution, Annual Report, 1864* (Washington, D.C., 1872), p. 119.
[35] See David I. Bushness, Jr., "John Mix Stanley, Artist-Explorer," in *Annual Report of the Smithsonian Institution for the Year Ending June 30, 1924* (Washington, D.C., 1925), pp. 506–19.
[36] Quoted in W. Vernon Kinietz, *John Mix Stanley and His Indian Paintings* (Ann Arbor, 1942), p. 17.

cidating Western material; in St. Louis, which they reached in March of 1833, they visited Major Benjamin O'Fallon to view his small but interesting collection of Catlin works and to discuss the trip ahead of them.

Swiss artist Rudolph Friederich Kurz, whose wanderlust had been fired by conversations with explorer-naturalist Alexander von Humboldt in 1839 and by studying Bodmer's watercolors, came to the West a decade later to see for himself. He praised his friend Bodmer's work but Catlin faired less well in his judgment. In his journals from the upper Missouri in 1851, Kurz wrote that Catlin "is regarded here as a humbug." His drawings "are for the most part in bad taste, and to a high degree inexact, especially the buffaloes."[37] Some years later, another artist interested in Indians and the West, Frederic Remington, wrote to Francis Parkman extolling the virtues of Bodmer's work. "Bodner [sic] drew much better than Catlin and in fact was able to render what he saw to a very good account. He was tredemendiously [sic] painstaking, and for refference [sic] and scientific purposes he is much better—even better than a modern man who would give you more of his heart than he did of his head."[38]

Despite these references, George Catlin was the first important artist to document in breadth the native cultures of the Far West. Because he was constantly on the move, the exigencies of time and space forced him to record the essence of early Western life and scenes. This he did with freshness and directness, leaving a spontaneous and vital pictorial record that in scope and number was unprecedented and unequaled.

If Catlin, Bodmer, and Stanley were essentially concerned with the image of America's Indian population, Alfred Jacob Miller was equally devoted to the first whites in the West. Traveling to the frontier wilderness in 1837 with Scotsman Sir William Drummond Stewart, Miller became the first artist to penetrate the Rocky Mountains and paint the fur-trapping rendezvous and the fur trade. This initial American enterprise in the West had already been recorded in literature, and Miller adroitly filled the pictorial void. Washington

Irving's *The Rocky Mountains,* published the same year as Miller's trip, incited even greater interest, and Miller's accounts found considerable demand.

Miller was more than the documentarian of this new era. His works view the West and its inhabitants in idyllic haze. While Karl Bodmer had been painting on the upper Missouri during 1833–34, Miller had been in Paris studying at the École des Beaux-Arts and copying old masters in the Louvre. When he came west three years later, Miller brought with him not the urgings of Alexander von Humboldt but the lessons of pre-Davidian French Romanticism. The Indian and mountain man were parallel nobilities in the innocent scheme of nature. The Indian was compared with the most esteemed *beau ideal* of the Greeks and the mountain man with the Rousseauian return to the wilderness. The concentration on ethnographic detail, seen in varying degree in the work of Catlin, Stanley, and Bodmer, became subservient to form and mood in Miller's paintings.

Miller, then, plays something of a transitional role between the artists motivated by a quasi-scientific dedication and those of more academic bent who wished to uncover the picturesque elements of the West. Miller's fame rested on this unique premise and spread almost as widely as that of his contemporaries. On May 25, 1839, the *New York Mirror* reported on "Miller's paintings of Oregon scenery," indicating the artist's attraction to anecdote over science.

The beautiful paintings by the American artist, Miller, executed for Sir William Stuart [sic], and illustrative of scenery and adventures in the Oregon territory, after having been exhibited two or three weeks at the Apollo Gallery, have been shipped to England. These paintings have excited much attention in this city, and will, doubtless, attract much more in Europe, from their novelty. A contemporary justly remarks, that the skill of the artist is chiefly shown in his spirited delineations of the wild sports of the Far West. The different buffalo hunts, the encounter with the grisly bear, the hunter's camp, and all the wild scenes of peril and adventure through which his pencil has followed his gallant friend, are depicted with a life-like force and reality that promise a rich renown as a painter.[39]

[37] J.N.B. Hewitt, ed., and Myrtis Jarrell, trans., "Journal of Rudolph Friederich Kurz," *Smithsonian Institution, Bureau of American Ethnology,* bulletin 115 (Washington, D.C., 1937), p. 130.

[38] Letter from Remington to Parkman dated January 9, 1892, quoted in Wilbur E. Jacobs, ed., *Letters of Francis Parkman* (Norman, Okla., 1960), II, p. 254.

[39] Quoted in Marvin C. Ross, *The West of Alfred Jacob Miller* (Norman, Okla., 1968), pp. xxiv–xxv.

Like Catlin before him, Miller called on fellow artists, painters, and sculptors alike to turn their eyes to the West for inspiration. "Sculptors travel thousands of miles to study Greek statues in the Vatican but here at the foot of the Rocky Mountains are as fine forms stalking about with a natural grace . . . as ever the Greeks dreamed of in their happiest conceptions."[40] Yet the West and its wonders were not always an acceptable subject. Even twenty years later, when genre painter Eastman Johnson decided on a Western trip, critics complained. "We regret to learn that Mr. Eastman Johnson intends going off on an extended tour of the North-west for the purpose of making sketches among the half-breeds and Indians who live beyond the confines of civilized life. We cannot but think that he might find better subjects for his pencil in the back slums of the Atlantic cities."[41]

Toward mid-century though, the West began to provide a rich anecdotal store from which narrative painters, both genre and historical, could draw unsparingly. The trapper and the emigrant, the gold seeker and the trader filled canvases for American dreamers who preferred to stay home. Because of the boldness of these themes, genre paintings of such Western subjects remained fairly close to nature and avoided the guise of sentimentality which infused American painting at this time. George Caleb Bingham portrayed the beauty and integrity of simple everyday frontier life. His poetic interpretations avoided drama as well as sentiment. Bingham was touched by and in turn touched his audience with plain storytelling in its most lyrical and enduring form.

For another genre painter, William Ranney, the momentary and dramatic facets of Western life rather than a timeless essence were significant. He, like Arthur Tait and Charles Deas, engendered a sense of peril in the Western image. Their straining, tense characters epitomized the dangers on the frontier.

If the 1840s and 1850s witnessed a surge of interest in themes of the evolving Western epic, the years directly following the Civil War saw an awakened appreciation for the land. Catlin and Bodmer had returned with sumptuous and exotic views of the landscape along the Missouri River. Miller's romantic eye had captured the grandeur and sublimity of the Rockies, and by the 1850s Albertis De Orient Browere and Thomas Ayres had returned to the East with entrancing views of the California mountains.

"See Yosemite and die!" rang the words of writer Albert D. Richardson, who visited that place in 1865.

I shall not attempt to describe it; the subject is too large and my capacity too small. Here might the author of the "Divine Comedy," whose troubled brow and yearning eyes appeal to us through the shadows of five centuries, despairingly repeat: "I may not paint them all in full, for the long theme so chases me that many times the word comes short of the reality."[42]

In the East, the Catskills, which had for years nurtured the "romantic adulation of the poet and artist," now began to yield to the "popular idealization of the tourist and vacationer."[43] The Rockies and Pacific coast ranges were still unspoiled and could still hold up their full beauty for the painter's gaze.

Albert Bierstadt's was the first in a parade of white umbrellas to come west in pursuit of grandeur. Contrary to the delicate English and French persuasion of his predecessor Miller, Bierstadt applied the lessons of the Düsseldorf Academy in full measure. Melodramatic and Wagnerian in impact, Bierstadt swelled the magnificence to near heavenly crescendo. Mankind, those Indians and frontiersmen who had dominated the works of earlier painters, was now subordinated to minutia in comparison with the awesome power of the landscape. No longer did the artist need to look for the fearful element; God was manifest in the earth itself. Its glory suggested the future course for America.

Its mines, forests and prairies await the capitalist. Its dusky races, earth-monuments and ancient cities importune the antiquarian. Its cataracts, canyons and crests woo the painter. Its mountains, minerals and stupendous vegetable productions challenge the naturalist. Its air invites the invalid, healing the system wounded by ruder climates. Its society welcomes the immigrant, offering high interest upon his investment of money, brains or skill; and if need be, generous obliviousness of errors past—a clean page to begin anew the record of his life.

[40] Quoted in Bernard DeVoto, *Across the Wide Missouri* (Cambridge, Mass., 1947), p. 317.
[41] *New York Daily Tribune* (March 31, 1860), p. 4.

[42] Albert D. Richardson, *Beyond the Mississippi* (Hartford, Conn., 1869), p. 420.
[43] Van Zandt, op. cit., p. 136.

The themes are fruitful. The Pacific Railroad hastens toward completion. We seem on the threshold of a destiny higher and better than any nation has yet fulfilled. And the great West is to rule us.[44]

Manifest Destiny pervaded American art as well as life. The painters watched and recorded the steps of the burgeoning nation as she strode to close the gap which separated her shores. Emanuel Leutze proclaimed the march of civilization in his monumental *Westward the Course of Empire Takes Its Way* (plate 88). Through the remaining nineteenth century artists followed in his path. By the 1860s, themes of Westward expansion invaded all levels of artistic expression. The astute academic painter Samuel Colman documented in grand fashion the trains of Conestoga wagons which wove across the prairies. For Currier & Ives, Fanny Palmer recorded the tide of settlement and the coming of the transcontinental railroad in her popular lithograph *Across the Continent* (plate 95). Even H. Schile, regarded by experts as the worst lithographer in America,[45] produced a version of America's empire in the making. His 1870 print, *Across the Continent: Passing the Humboldt River*, was distributed widely in Europe as well as America. It pictured docile Indians, public schools, a neat community, and prosperous settlers.

The promise of American progress involved her land as well as her people. Thomas Moran returned from Yellowstone after a summer's expedition with Ferdinand V. Hayden. The artist had seen enough there to stake his reputation on the results. "I have always held that the grandest, most beautiful or wonderful in nature, would . . . make the grandest, most beautiful or wonderful pictures," he wrote Hayden the next year. "All the above characteristics attach to the Yellowstone region, and if I fail to prove this, I fail to prove myself worthy of the name of painter."[46]

Admitting that Yellowstone's "beautiful tints were beyond the reach of human art,"[47] Moran nonetheless succeeded in his quest for equating the grand in art with the grand in nature. That Congress purchased his resulting painting, *The Grand Canyon of the Yellowstone* (plate 133), and pronounced the region America's first national park confirmed the public confidence in their newly mended republic and its inherent beauty. America's paean to her own natural splendor, which had been first sung in the 1820s, now reached its highest pitch in the works of artists whose studio became the Rocky Mountains, the canyons of the Colorado, and the Pacific shores as far north as Alaska.

Even so, the emerging American middle-class for whom such pictures were painted could not find full nourishment in the cerebral Thoreauian view of the West as an arm of the wilderness from which civilization might draw life. The material prosperity of the post–Civil War period demanded recognition as well. An observer in the 1850s had brought the point out cogently, that material progress was an embodiment of the Western faith. "I saw in the West, no signs of quiet enjoyment of life as it passes. . . . At present the inhabitants are hewing wood and drawing water—laying the foundations of a civilization which is yet to be, and such as has never been before. . . . Though men do not write books there, or paint pictures, there is no lack, in our western world, of mind. The genius of this new country is necessarily mechanical."[48]

Consciously or unconsciously the Far West underwent a dramatic series of brief yet incisive changes. Predicated on expansion and material progress, the West experienced an evolution as mercurial and rigorous as any before seen in American history. American artists found in each of the successive and overlapping frontiers elements both national and universal. The mining frontier brought humanity together in wild and unoccupied corners of the West. This polyglot monster with but one common motive, greed, advanced civilization across the continent, first stepping from east to west and then retracing itself in web-like fashion from west to east.

In support of the miners came the freighters—first wagons, then coaches, then the Pony Express, and finally rails. As the tracks spanned and crisscrossed the Western dominion, the American penchant for ordered material progress followed. Towns along the tracks, first known as "Hells on

[44] Richardson, op. cit., pp. i–ii.

[45] See Harry T. Peters, *America on Stone* (New York, 1931), pp. 358–59.

[46] Letter quoted in *19th-Century America, Paintings and Sculpture* (The Metropolitan Museum of Art, New York, 1970), no. 129.

[47] *Preliminary Report of the United States Geological Survey of Montana and Adjacent Territories* (1871), p. 84, quoted in Thurman Wilkins, *Thomas Moran: Artist of the Mountains* (Norman, Okla., 1966), p. 65.

[48] J. Milton Mackie, "Forty Days in a Western Hotel," *Putnam Magazine* (December, 1854), quoted in John A. Kouwenhoven, *The Arts in Modern American Civilization* (New York, 1967), p. 104.

Wheels," grew into settled communities. Many who had gone west to mine or work on the railroads remained to ranch or farm.

For whatever stood in the way of these peregrinations, the ebullience of progress or the parceling of sections, there was no solace. The prairies were broken open and the mountains overcome. The wild buffalo found replacement with a hardy domestic variety, and the native peoples, once eulogized as noble and free, saw the capriciousness of those words. Thanks to the artists of narrative persuasion there remain pictorial records of this metamorphosis. Chapter by chapter, from the promise of the forty-niner to the plague of reservation life, American artists recounted the joy and pathos of the evolving Western frontiers.

Painter Charles Christian Nahl had gone to California to join the gold rush in 1850. He remained there to capitalize not on gold dust but on a propensity to record life around him with glazed precision and mastery. Pointing to the brevity of the frontier evolution, it was only thirty years before Charles Russell and Frederic Remington arrived in Montana to pursue careers as ranchers. They stayed, one physically and the other spiritually, to document the final phase of frontier life which was already slipping from sight. Remington later recounted, in what is now a famous quote, his impressions of the West he found in 1881.

Evening overtook me one night in Montana, and I by good luck made the camp-fire of an old wagon freighter who shared his bacon and coffee with me. I was nineteen years of age and he was a very old man. Over the pipes he developed that he was born in Western New York and had gone West at an early age. His West was Iowa. Thence, during his long life he had followed the receding frontiers, always further and further West. "And, now," said he, "there is no more West. In a few years the railroad will come along the Yellowstone and a poor man can not make a living at all."

The old man had closed my very entrancing book almost at the first chapter. I knew the railroad was coming—I saw men already swarming into the land. I knew the derby hat, the smoking chimneys, the cord-binder, and the thirty day note were upon us in a restless surge. I knew the wild riders and the vacant land were about to vanish forever, and the more I considered the subject the bigger the Forever loomed.[49]

Remington, Russell, and their contemporaries stayed to see the closing of the frontier. Then, calling on the past, they gradually worked their way backward in time as pictorial historians. Such recapitulation required very different motivation and produced quite distinctive results from their predecessors. There evolved a realism synonymous with the variant nature of the Western subject. Raw at times and blatant, their art reflects the reality as well as the attendant myth of the romantic saga. Such bold expression won surprising favor in the long-stemmed Victorian view, and the artists were catapulted into the twentieth century on a wave of appreciative popular fervor. Remington and Russell became, as a consequence, summary creators as well as purveyors of the Western pageant.

In his career after 1900, Remington served also as a bridge between the tradition of narrative Western art and a new sensitivity toward the quiet passing of the frontier. With the adaptation of Impressionist doctrines, Remington opened a new perspective for Western vision. E. Irving Couse, one of several painters who took Taos, New Mexico, as his home and studio before 1915, also helped to uncover a new world in his art. The Indian as a motif, for example, became a decorative rather than a historic model. Scenes of Indian life were removed from action, transformed into studies of mood and character. Nostalgia replaced history; pattern and medley were gradually substituted for human drama.

The final chapter in the art of America's West was authored by proponents of two schools, one espousing advancing Modernism, the other retrospective Regionalism. The West, its history well closed by then, fell victim to antagonistic, aesthetic systems. By the 1930s diverse artists had elevated its vision while wringing the last drop of life from a once-boundless fount.

There is no question that the West has spurred and will continue to spur vital artistic expression. Though some recent artists have failed to keep abreast of their times, many others have transformed the spirit, style, and subject of past examples into evocative amalgamations of modern aesthetic and regional focus. They are, of course, tangential to this overview, but it is to these artists that the world will look to carry on the traditions and forces long established in the art of Western America.

[49] Frederic Remington, "A Few Words from Mr. Remington," *Collier's*, 34 (March 18, 1905), 16.

Exploring America's

New Dominion

Whenawarding accolades to artists of the Far West, credit for being first must go to two painters from Philadelphia, Samuel Seymour and Titian Ramsay Peale. They accompanied Major Steven Long to the Rocky Mountains in 1820 on what was erroneously called the "Yellowstone Expedition," the last phase of a three-part program directed by Secretary of War J.C. Calhoun to establish Western forts. The troop had initially intended to found a military post far up the Missouri River at the mouth of the Yellowstone River, a destination they never even neared.

The group shipped out of St. Louis in the spring of 1819 with a military force of one thousand men under General Henry Atkinson and a small scientific crew directed by Major Long. They wove their way up the Missouri in five poorly constructed steamboats for the militia and a slightly better built one, the *Western Engineer,* for the scientific contingent. As the latter vessel passed through St. Louis, a local newspaper observed on her bow the banner which was to be carried overland by the crew for the whole length of the trip. "She is well armed," it was reported of the little stern-wheeler, "but carries an elegant flag, painted by Mr. Peale, representing a white man and an Indian shaking hands, the calumet of Peace and a sword."[1]

During their winter encampment near present-day Omaha in 1819–20, Seymour, as official artist for the expedition, put his talents to work in recording a variety of Indian councils. In October Major Benjamin O'Fallon, agent for the Missouri tribes, met first with the Oto then with the Pawnee, who had raised havoc with the explorers earlier in the autumn. At the Pawnee council pictured, the chiefs promised to reprimand some of their fellow tribesmen who had stolen horses from a detachment of the expedition.

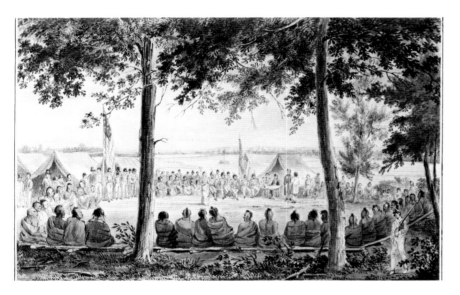

3. Samuel Seymour. *Pawnee Indian Council.* 1819. Watercolor, 5⅞ x 8⅛". Beinecke Rare Book and Manuscript Library, Yale University, New Haven, Conn.

As the explorers moved farther west toward the Rockies in the following year, both Peale and Seymour reveled in the scenes from Indian life that passed before them. Though technically employed in the role of naturalist to collect and draw specimens of flora and fauna, Peale was distracted by the drama of the buffalo hunt and the equestrian skill of the Plains Indians, evidenced in a group of sketches depicting Indians hunting from horseback.

The Long expedition reached the Rockies via the Platte River on the last day of June, 1820. They moved south from there along the grand outline of the front range to the Arkansas River, where the party split. About half the group, under Captain Bell and including Seymour, was assigned the reconnaissance of the Arkansas River. The remaining group struck out for the Red River, farther south.

Though referred to by some as "an unqualified failure,"[2] the Long expedition was responsible for bringing before the American people their first pictorial view of the Far West and the lifeways of its native people. Perhaps the most striking visual account of this initial interaction between East and West is told in Seymour's watercolor, *Detachment of the Long Expedition at the Encampment of Kiowa and Allied Indians on the Arkansas,* painted in July of 1820. Edwin James, botanist and geologist to the Long expedition, set the scene in the official report.

4. Titian Ramsay Peale. *Plains Indian Bowman on a Running Horse.* 1819–20. Pencil and watercolor, 5½ x 9¼". American Philosophical Society, Philadelphia

Late in the afternoon [of July 26] we saw, at a great distance before us, evident indications of the proximity of Indians, consisting of conic elevations, or skin lodges, on the edge of the skirting timber, partially concealed by the foliage of the trees. On our nearer approach we observed their horses peacefully grazing; but becoming suddenly frightened, probably by our scent, they all bounded off towards the camp, which was now full in view. Our attention was called off from the horses by the appearance of their masters, who were now seen run-

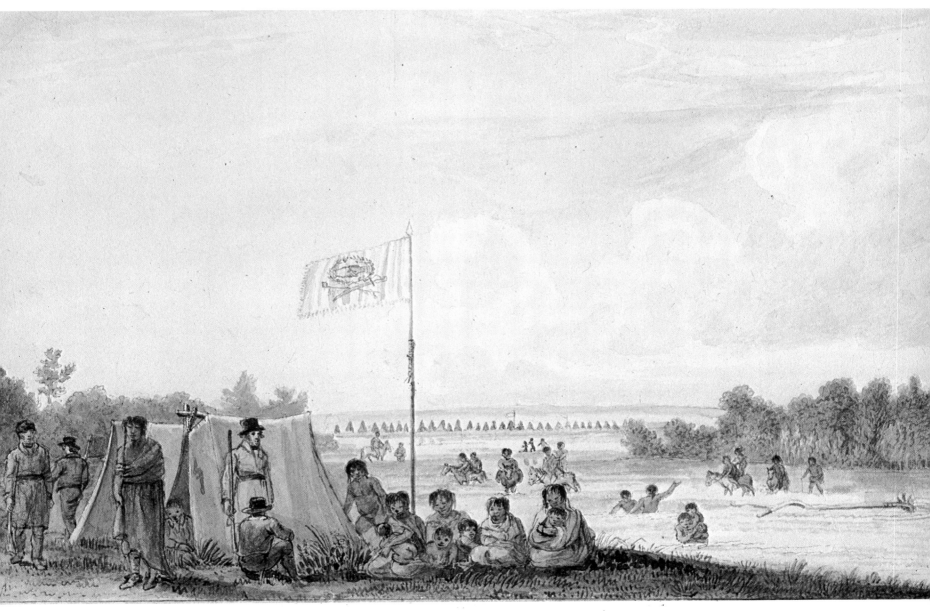

5. Samuel Seymour. *Detachment of the Long Expedition at the Encampment of Kiowa and Allied Indians on the Arkansas.*
1820. Watercolor, 5¾ x 8⅛". Beinecke Rare Book and Manuscript Library, Yale University, New Haven, Conn.

ning towards us with all their swiftness. A minute afterwards we were surrounded by them, and were happy to observe, in their features and gestures, a manifestation of the most pacific disposition; they shook us by the hand, assured us by signs that they rejoiced to see us, and invited us to partake of their hospitality. We, however, replied that we had brought our own lodges with us, and would encamp near them. We selected for this purpose a clear spot of ground on the bank of the river, intending to remain a day or two with this little known people, to observe their manners and way of life. We had scarcely pitched our tents, watered and staked our horses, before presents of jerked bison meat were brought to us by the squaws, . . . and in sufficient quan-

tity for the consumption of two or three days. . . . About sundown they all retired, and left us to our repose. The Indians were encamped on both sides of the river, but the great body of them was on the opposite bank, their skin lodges extending in a long single line, the extremities of which were concealed from our view . . . whilst about ten lodges only were erected on the side we occupied, and within a quarter of a mile of our camp.[3]

[1] *Missouri Gazette and Public Adviser* (May 26, 1819), p. 2.
[2] Hiram M. Chittenden, *A History of the American Fur Trade of the Far West* (Stanford, Calif., 1954), II, p. 570.
[3] Edwin James, *Account of an Expedition from Pittsburgh to the Rocky Mountains* (Philadelphia, 1823), II, pp. 174–75.

Not two years after Samuel Seymour had painted the bellicose Pawnee in council on the banks of the Platte River, Major O'Fallon brought a delegation of sixteen Indians to Washington. The visit was part of an elaborate government design to wile the Indians into acceptance of American expansion. Chiefs and subchiefs from the Oto, Kansa, Omaha, Missouri, and Pawnee made up the proud and beautifully bedecked contingent from the Far West. One of the most illustrious members of the group was the Pawnee, Petalesharo.

On February 4, 1822, members of this select group met with President Monroe at the White House. The president, assured of the superiority of his own way of life, welcomed the Indians with confidence to his home and to the new and secure mantle of civilization. In response, Sharitarish, brother of the Pawnee head chief, replied prophetically. "My Great Father, I have traveled a great distance to see you—I have seen you and my heart rejoices. I have heard your words . . . and I will carry them to my people as pure as they came from your mouth. . . . [I] have seen your people, your homes, your vessels on the big lake, and a great many wonderful things far beyond my comprehension." As impressed as he was, however, he concluded his speech with a plea that fell on deaf ears. "We have everything we want—we have plenty of land, if you will keep your people off it."[1]

Impressions of awe were felt on both sides. On New Year's Day, 1822, when Petalesharo and a group of his braves performed a war dance on the front lawn of the White House, six thousand spectators came to observe, Washington businesses closed their doors, and Congress adjourned its session.[2]

Petalesharo, known to his fellow Pawnees as the bravest of the brave, had won his laurels several years before by countering tribal tradition and rescuing from the sacrificial pyre a young Comanche girl whose life was about to be

6. George Catlin. *Wi-jun-jon (The Pigeon's Egg Head) On His Way Home from Washington.* 1852. Pen and ink, 13¾ x 10". Newberry Library, Chicago. Edward E. Ayer Collection

given to the morning star. On the last day of their visit to Washington, Petalesharo's encounter with another young girl was termed the "climax to the Pawnee's visit to Washington." Mary Rapine, a student at Miss White's Seminary for Select Young Ladies, "dressed in crisp crinoline, her pretty face ringed with curls and her young heart thumping in her chest like an imprisoned bird, held up the velvet ribbon from which hung a silver medal. The handsome Indian, his face streaked with red and black paint, bent down. The girl carefully placed the ribbon about his neck and recited her rehearsed speech. . . . Then Petalesharo (Generous Chief) with dignity thanked the schoolgirl for her kindness."[3]

Petalesharo returned to his people shortly after this ceremony. In later years he became head chief of the Pawnee, in part, no doubt, because of his connection with the whites. Other Indians who journeyed to see the Great White Father fared less well. Wi-jun-jon, an Assiniboin warrior, described by George Catlin as "young—proud—handsome — valiant, and graceful,"[4] was chosen to represent his tribe on a trip to Washington a decade later. When he returned to the mouth of the Yellowstone River the following spring, his people could not believe what they saw. "On his head was a high-crowned beaver hat, with a broad silver lace band, surmounted by a huge red feather, some two feet high; his coat collar stiff with lace, came higher up than his ears, and over it flowed, down towards his haunches—his long Indian locks, stuck up in rolls and plaits, with red paint. . . . On his hands he had drawn a pair of white kid gloves, and in them held, a blue umbrella in one, and a large fan in the other."[5] In this guise he strutted and whistled "Yankee Doodle" while telling his fellow Assiniboin of the wonders to the East. At first he was held in awe, then shunned as a liar, and ultimately killed by his people, who thought he was a wizard.

Encouraged by Thomas L. McKenney, then superintendent of Indian trade, Charles Bird King followed his successful government commission to paint the members of O'Fallon's delegation with a host of Indian portraits. By 1858, a so-called Indian Gallery consisting of 147 works, mostly by King, was brought to the Smithsonian Institution, where it was combined with an equal number of Indian paintings by John Mix Stanley. Together these paintings, according to Smithsonian secretary Joseph Henry, formed "perhaps the most valuable collection in existence of the illustrations of the features, costumes, and habits of the aborigines of the country. This Gallery is an object of special interest to all visitors to the national metropolis, and to none more so than to the deputations of Indians frequently called to Washington to transact business with the Government."[6]

[1] Quoted from Herman J. Viola, "Charles Bird King's Indian Gallery," *Art News,* 75 (December, 1976), 69.

[2] James D. Horan, ed., *The McKenney-Hall Portrait Gallery of American Indians* (New York, 1972), p. 238.

[3] Ibid.

[4] George Catlin, *Letters and Notes on the Manners, Customs, and Condition of the North American Indians* (London, 1844), II, p. 195.

[5] Ibid., p. 197.

[6] *Smithsonian Report for 1858* (Washington, D.C., 1859), p. 41.

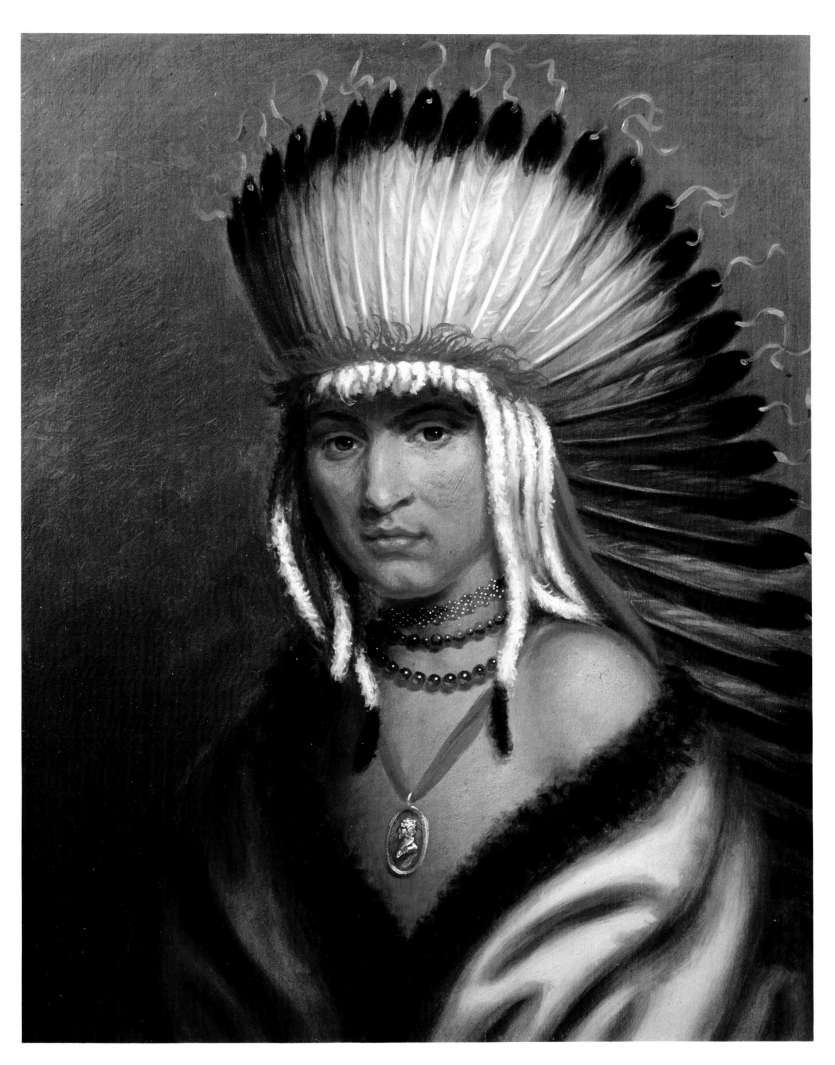

7. Charles Bird King. *Petalesharo (Generous Chief)—Pawnee Tribe.* 1821. Oil on canvas, 17½ x 14″. The White House Collection, Washington, D.C.

John W. Jarvis

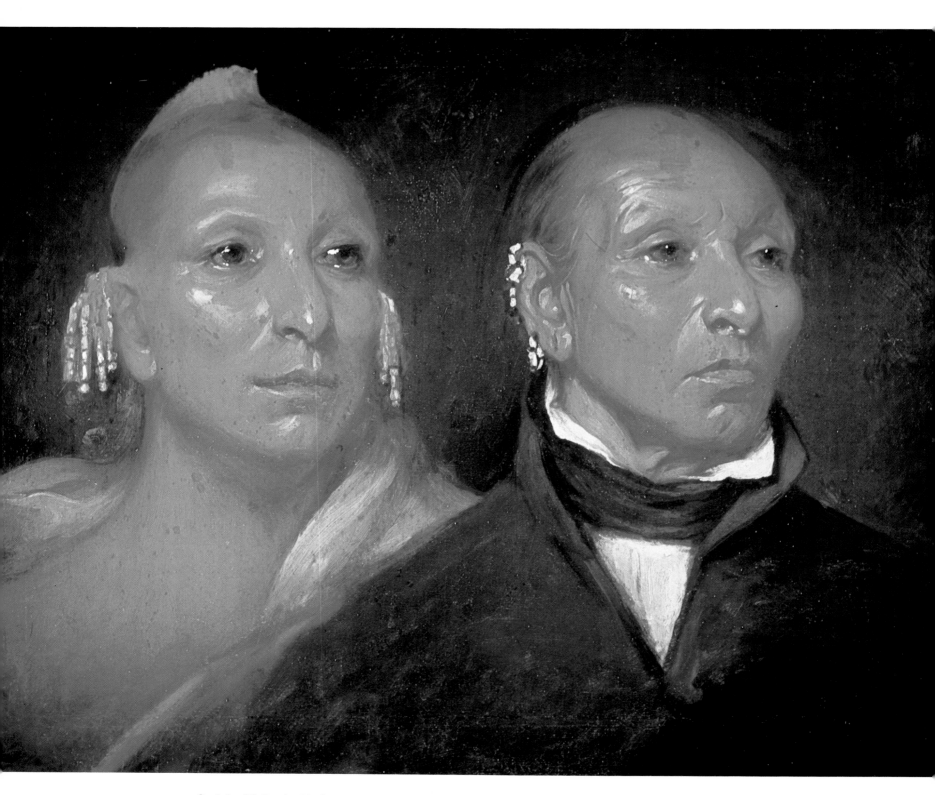

8. John W. Jarvis. *Black Hawk and His Son, Whirling Thunder.* c. 1833. Oil on canvas, 24 x 30". Thomas Gilcrease Institute of American History and Art, Tulsa, Okla.

Before the transfer of Charles Bird King's Indian portraits to the Smithsonian Institution in 1858, they hung proudly and appropriately on the walls of the War Department offices in Washington. It was perhaps here that the great chief of the Sauk and Fox, Black Hawk, viewed his compatriots in 1833 when he visited the nation's capital. He may not have felt the historical imperative suggested by Thomas McKenney, who wrote that year to his friend Jared Sparks that "this great gallery [is] . . . like wine, the longer it is kept, the better."[1] But it may well have been the impetus for his son Whirling Thunder and him to sit for their portraits with the flamboyant artist John W. Jarvis.

Unlike King's portraits, which have been compared to some of Delacroix's work of the same period, this isolated example of Jarvis's Indian portraiture evidences a cool, almost detached view typical of the Neoclassical school. Described as "firm, clear, dignified and unpretentious,"[2] Jarvis's work in this vein seems the antithesis of his character. "I found Jarvis . . . in great vogue," wrote Washington Irving in 1811. He was "painting all the people of note and fashion, and universally passing for a great wit, a fellow of infinite jest, in short 'the agreeable rattle.' "[3]

It is thought that this portrait of Black Hawk and his son was painted in the spring of 1833, when they visited Washington. Actually they were not visitors but prisoners, having been incarcerated at Jefferson Barracks the year before for a futile though frenzied war declared on the white settlers who had encroached on their Illinois lands. The artist, George Catlin, had recorded them in chains that summer. Despite Black Hawk's plea during his audience with President Jackson that they had felt "that, like Keokuck [his rival chief], they had come to visit the President, and like him, would be permitted to return to their homes,"[4] Black Hawk was confined at Fort Monroe, Virginia, for more than a month. He was then paraded through the "other Eastern cities . . . to be gazed at,"[5] as Catlin put it.

For more than mere curiosity's sake, two Europeans had gazed at another colorful group of Sauk and Fox in 1832. They were the Prussian explorer Prince Alexander Philip Maximilian of Wied-Neuwied and his Swiss artist, Karl Bodmer. In one of Bodmer's works, a group of Sauk and Fox stand peering across the Missouri River at St. Louis as if knowing somehow that the wind of civilization wafting westward foretold their doom.

9. George Catlin. *Black Hawk and Followers in Balls and Chains*, from the book *Souvenir of the North American Indians*. 1832. Pencil. Rare Book Division, Astor, Lenox, and Tilden Foundation, New York Public Library, New York City

10. Karl Bodmer. *Saukie and Fox Indians*. 1833. Sepia wash drawing, 6 x 9″. The Anschutz Collection, Denver

[1] Quoted in Herman J. Viola, *The Indian Legacy of Charles Bird King* (Washington, D.C. and New York, 1976), p. 15.

[2] E.P. Richardson, *Painting in America* (New York, 1965), p. 120.

[3] Quoted in Theodore Bolton and George C. Groce, Jr., "John Wesley Jarvis: An Account of His Life and the First Catalogue of His Work," *Art Quarterly,* 1 (autumn, 1938), 304.

[4] "Black Hawk at the Palace," *Daily National Intelligencer* (April 29, 1833), p. 3.

[5] George Catlin, *Letters and Notes on the Manners, Customs, and Condition of the North American Indians* (London, 1844), II, p. 211.

Peter Rindisbacher

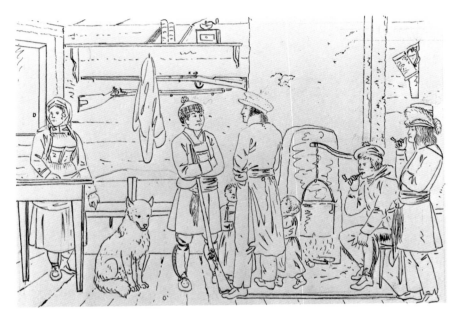

11. Peter Rindisbacher. *Colonists on the Red River in North America.* c. 1825. Pen and ink, 6⅜ x 8⅝". Public Archives of Canada, Ottawa

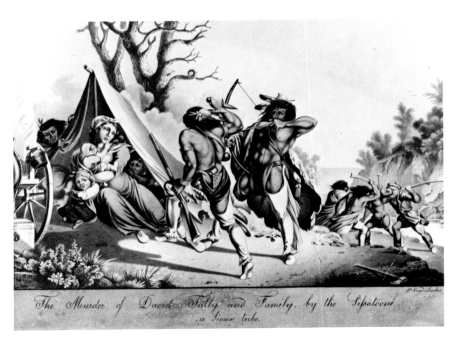

12. Peter Rindisbacher. *The Murder of David Tally [Tully] and Family by the Sissetoon Sioux, a Sioux Tribe.* c. 1825. Watercolor, 6½ x 11". West Point Museum Collection, United States Military Academy, West Point, N.Y.

The challenge of preserving the power and glory of the Western Indians in the early part of the nineteenth century was not exclusively that of established artists in the East. Peter Rindisbacher, a precocious Swiss youth who immigrated with his family to the Red River of Canada in 1821, found in the native American a spark for his genius as a painter. Tempered with a fastidious sense of decorative elegance and minute precision, Rindisbacher's watercolors convey the dynamic flow of Indian life as if capsulated in efflorescent gems.

Rindisbacher's style and powers of observation were developed not among dilettante comrades and patrons, but in the rudest and bitterest frontier circumstances. As part of the ill-fated Selkirk Colony, the Rindisbacher family suffered severely in trying to maintain subsistence in the new land. Prairie fires, grasshopper plights, and drought ultimately forced them to move south, but they persevered for five long years on the Canadian plains before abandoning their new home.

Two other families, the David Tullys and the Robert Campbells, who were discontented with the desperate life struggle on the Red River, left their Canadian homes in 1823 for greener pastures to the south. The Tullys, caught unaware by the belligerent Sisseton Sioux, lost their lives in a tragic confrontation near Grand Forks on the upper Red River. The Campbells escaped and returned to their colony to recount the grievous deed perpetrated by the Sioux. The event no doubt prevented many disgruntled colonists from leaving Canadian ground. It also provided a theme for one of Rindisbacher's finest works, a remarkable watercolor depicting the Tullys' last moments.

In 1829 the artist moved to St. Louis. That same year he completed one of his best compositions, *Indian Chief in War Dress.* A letter published later that year in the *St. Louis Beacon* points to Rindisbacher's immediate recognition in these civilized quarters.

Mr. Rindisbacher has marked out a new track, and almost invented a new style of painting—one, too, of much interest. His sketches of groups or single Indians, are deserving of the highest admiration. The proportions and development of muscle, in his delineations of the human figure, are extremely correct. There is a living and moving effect in the swell and contraction he gives to the muscular appearance of his figures, that evinces much observation, judgment and skill. Talent, I might almost say genius like his deserves encouragement, and, undoubtedly, were he in a place of more fashion and leisure, he would receive it. Those who have not yet examined his fine paintings of Indian dances lodges &c. will be well paid for their trouble by calling at his rooms and viewing a style of painting so new and novel.[1]

[1] Alvin M. Josephy, Jr., *The Artist Was A Young Man* (Fort Worth, 1970), p. 73.

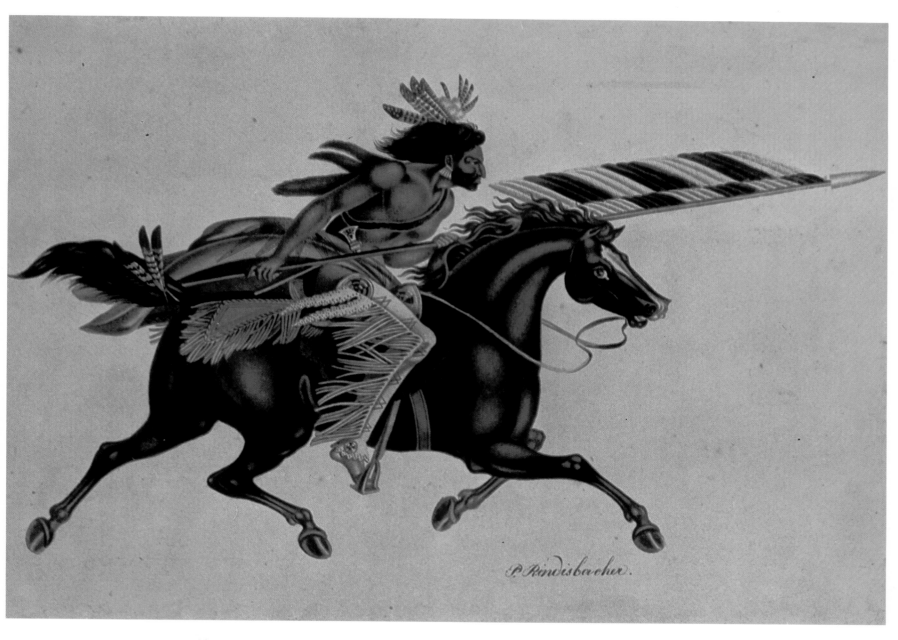

13. Peter Rindisbacher. *Indian Chief in War Dress.* c. 1825–29. Watercolor, 6½ x 9½″. West Point Museum Collection, United States Military Academy, West Point, N.Y.

She was built in Louisville during the winter of 1830–31 and christened the *Yellowstone* in anticipation of the distance she would penetrate the Western waters. One hundred thirty feet long and nineteen feet of beam, she could carry seventy-five tons while drawing less than six feet. She even sported a ladies' cabin in the stern hold.

St. Louis businessmen doubted anyone could navigate the muddy river to Fort Union, where the great Yellowstone and Missouri rivers meet. For the American Fur Company, however, there was no choice—either get into the steamboat business or get out of the trade. The maiden voyage of the *Yellowstone* in the summer of 1831 took her only as far as Fort Tecumseh, present-day Fort Pierre. She returned fully loaded with a cargo of "buffalo robes, furs, and peltries, besides ten thousand pounds of buffalo

14. Karl Bodmer. *Unloading the Steamboat Yellowstone, April 19, 1833.* Watercolor, 8¼ x 13¼". Joslyn Art Museum, Omaha, Neb. Northern Natural Gas Company Collection, © E. P. Dutton, *People of First Man,* edited by Davis Thomas and Karin Runnefeldt

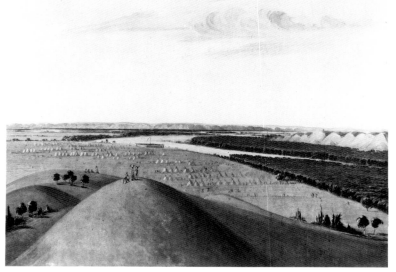

15. George Catlin. *Fort Union, Mouth of the Yellowstone.* 1832. Oil on canvas, 11½ x 14⅜". National Collection of Fine Arts, Smithsonian Institution, Washington, D.C.

tongues."[1] Pierre Chouteau, Jr., the distinguished trader who was in charge of the enterprise, termed it a great success.

In 1832 the *Yellowstone*'s second trip up the Missouri took her the total two thousand miles above St. Louis to Fort Union, her intended destination. Chouteau was on board, as was Major John F.A. Sanford, agent of the Missouri Indians, with a troop of Indians returning to their homes from a junket to Washington. Even Wi-jun-jon (see plate 6), the Assiniboin turncoat, stood proudly on the deck suited full dress *en militaire.* And beside them all was George Catlin, embarking on the greatest adventure of his life and one of the most phenomenal in the journals of art and history.

Of the voyage itself Catlin exclaimed that "no man's imagination, with all the aids of description that can be given to it, can ever picture the beauty and wildness of scenes that may be daily witnessed in this romantic country."[2] This heretofore undocumented beauty which Catlin recorded at every turn of the river was interspersed with innumerable hardships. Prince Maximilian, who took the same trip a year later, wrote in his journals of one such incident.

> April 27, 1833
> . . . We ran aground, about noon, on a sand bank, and were obliged to put out a boat to take soundings, but the wind, which blew with increasing violence from the open prairie on the south-west, drove us further into the sand bank. Every moment it became more furious; our vessel lay almost on her side, which the people endeavored to counteract by fastening her with strong cables to the trees lying in the water.... One of our chimneys was thrown down, and the foredeck was considered in danger; the large coops, which contained a number of fowls, were blown overboard, and nearly all of them drowned. As they got upon the sand banks they were afterwards taken up, with other things which we had been obliged to throw overboard; our cables had, happily, held fast, and, as the wind abated a little, Captain Bennett hoped to lay the vessel close to the bank, which was twenty feet high, where it would be safe but the storm again arose, and we got deeper and deeper into the sands.[3]

At the crest of the curve high on the Missouri River lay Fort Union, at that time the westernmost bastion of the American Fur Company. Established in 1830, Fort Union in that day was ruled over in baronial fashion by Kenneth McKenzie. Wrote Catlin of this Western lord:

> Mr. M'Kenzie is a kind-hearted and high-minded Scotchman; and seems to have charge of all the Fur Companies' business in this region, and from this to the Rocky Mountains. He lives in good and comfortable style, inside of the Fort, which contains some eight or ten log-houses and stores, and has generally forty or fifty men, and one hundred and fifty horses about him.
> He has, with the same spirit of liberality and politeness

George Catlin

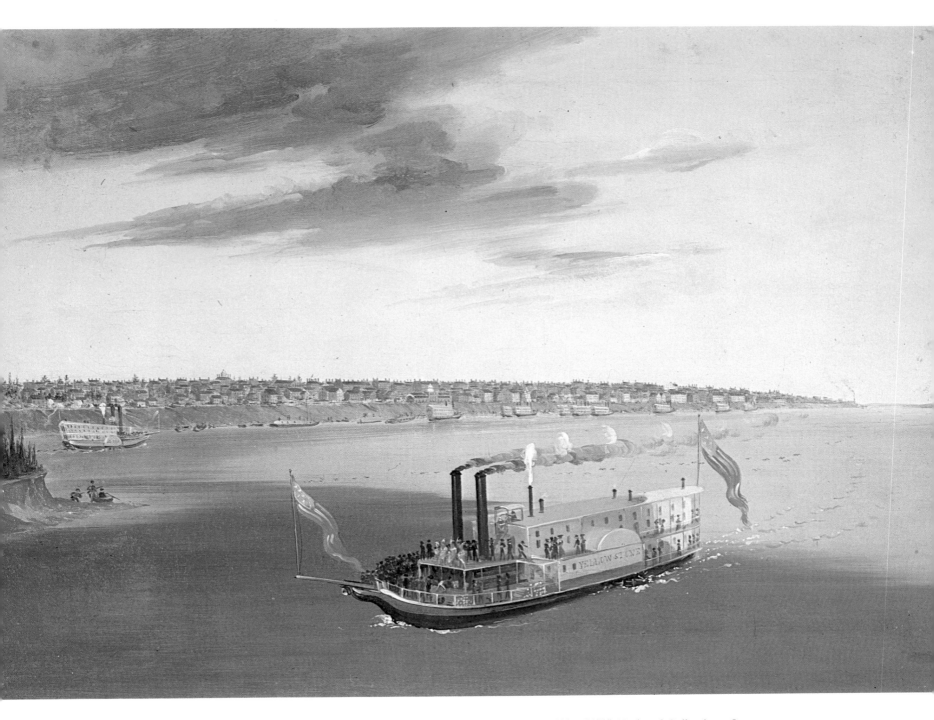

16. George Catlin. *St. Louis from the River Below.* 1832. Oil on canvas, 19⅜ x 26⅞″. National Collection of Fine Arts, Smithsonian Institution, Washington, D.C.

with which Mons. Pierre Chouteau treated me on my passage up the river, pronounced me welcome at his table, which groans under the luxuries of the country; with buffalo meat and tongues, with beavers' tails and marrow-fat; but *sans* coffee, *sans* bread and butter. Good cheer and good living we get at it however, and good wine also; for a bottle of Madeira and one of excellent Port are set in a pail of ice every day, and exhausted at dinner.[4]

[1] Quoted in Hiram M. Chittenden, *The American Fur Trade of the Far West* (New York, 1902), I, p. 340.
[2] George Catlin, *Letters and Notes on the Manners, Customs, and Condition of the North American Indians* (London, 1844), I, p. 15.
[3] Reuben Gold Thwaites, ed., *Travels in the Interior of North America* (Cleveland, 1905), I, p. 261.
[4] Catlin, op. cit., p. 21.

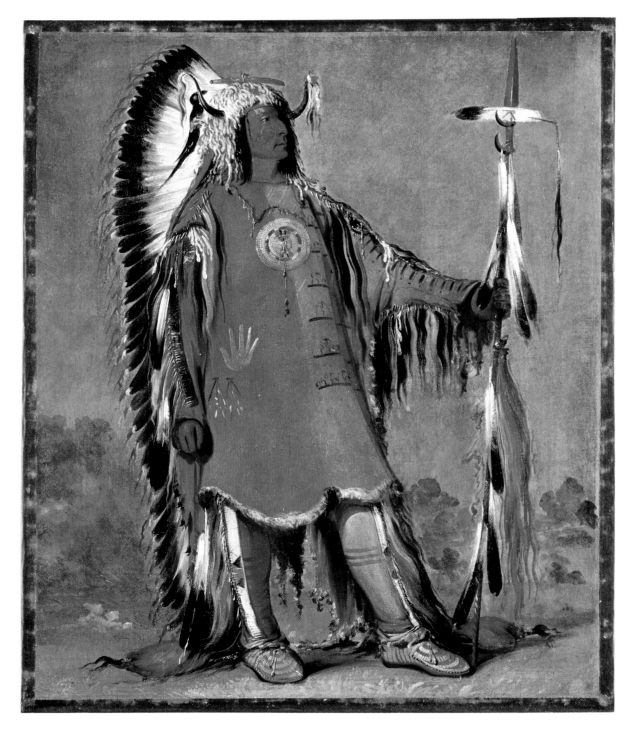

17. George Catlin. *Four Bears, Second Chief*. 1832. Oil on canvas, 29 x 24″. National Collection of Fine Arts, Smithsonian Institution, Washington, D.C.

18. Four Bear's painted and quilled shirt collected by Catlin in 1832. National Museum of Natural History, Smithsonian Institution, Washington, D.C.

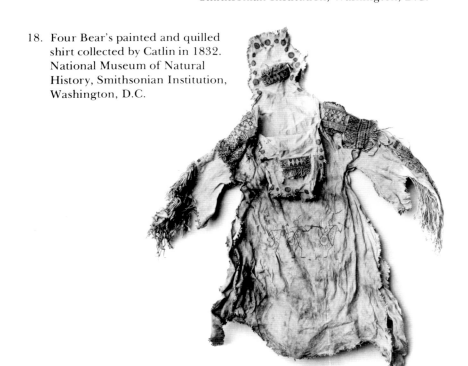

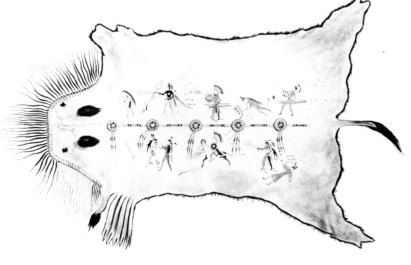

19. Karl Bodmer. *Facsimile of Four Bear's Painted Robe*. 1833–34. Lithograph, 18⅛ x 24⅞″. Buffalo Bill Historical Center, Cody, Wyo. Gift of Miss Clara Peck

For any of the explorers, artists, traders, or trappers who moved up and down the Missouri River in the early 1830s, the Mandan villages provided a necessary and welcome stop. By all accounts the most colorful member of the tribe was Mato-tope (Four Bears), who, though second chief, was according to George Catlin "undoubtedly the first and most popular man in the nation. Free, generous, elegant, and gentlemanly in his deportment—handsome, brave and valiant; wearing a robe on his back, with the history of all his battles painted on it, which would fill a book of themselves if they were properly enlarged and translated."[1]

Catlin's portrait of this eminent chief was painted on the artist's 1832 trip. On the day Mato-tope came to Catlin's temporary studio, he had spent all morning grooming himself. Everything about him was magnificent, and the finished full-length portrait is indeed one of Catlin's finest. The robe alone was a work of art, something the artist realized at once, and he purchased the exquisite garment as soon as the portrait was completed. As described by Catlin, the shirt

> was made of two skins of the mountain-sheep, beautifully dressed, and sewed together by seams which rested upon the arms; one skin hanging in front, upon the breast, and the other falling down upon the back; the head being passed between them, and they falling over and resting on the shoulders. Across each shoulder, and somewhat in the form of an epaulette, was a beautiful band; and down each arm from the neck to the hand was a similar one, of two inches in width (and crossing the other at right angles on the shoulder) beautifully embroidered with porcupine quills worked on the dress, and covering the seams. To the lower edge of these bands the whole way, at intervals of half an inch, were attached long locks of black hair, which he had taken with his own hand from the heads of his enemies whom he had slain in battle, and which he thus wore as a trophy, and also as an ornament to his dress. The front and back of the shirt were curiously garnished in several parts with porcupine quills and paintings of the battles he had fought, and also with representations of the victims that had fallen by his hand. The bottom of the dress was bound or hemmed with ermine skins, and tassels of ermines' tails were suspended from the arms and the shoulders.[2]

A year later Karl Bodmer painted two portraits of Mato-tope. Like Catlin, Bodmer and Maximilian were almost as fascinated by Mato-tope's art as by the man himself. Particularly alluring was a fine exploit robe, different from the one Catlin had described earlier, which Bodmer copied and Maximilian purchased from the venerable chief on their ascent of the Missouri in June of 1833.[3]

The figures on the robe which Bodmer copied, when compared with those on the shirt pictured in Catlin's painting, show a marked change, evidencing a very perceptible influence of Catlin's art on that of Mato-tope. As John C. Ewers has noted, the "heads were now painted in profile, the features sharply defined. Great care was taken in drawing a realistic human eye. The arms, legs, and bodies were well proportioned. . . . Even . . . some attempt at color modeling is suggested on the face and upper body of the warrior on the right."[4]

Unfortunately contact between the white man and the Mandan people ended in tragedy of massive proportions. The Mandan population, which in early 1837 was estimated to be about 1,600, was reduced by smallpox to fewer than 150 that year. The proud Mato-tope died an agonizing death that summer. On July 30 he spoke his final words to his people:

> My Friends one and all, Listen to what I have to say— Ever since I can remember, I have loved the Whites, I have lived With them ever since I was a Boy, and to the best of my Knowledge, I have never Wronged a White Man, on the Contrary, I have always Protected them from the insults of Others, Which they cannot deny. The 4 Bears never saw a White Man hungry, but what he gave him to eat, Drink, and a Buffaloe skin to sleep on, in time of Need. I was always ready to die for them, Which they cannot deny. I have done every thing that a red Skin could do for them, and how have they repaid it! Wth [sic] ingratitude! I have Never Called a White Man a Dog, but to day, I do Pronounce them to be a set of Black harted Dogs, they have deceived Me, them that I always considered as Brothers, has turned Out to be My Worst enemies. I have been in Many Battles, and often Wounded, but the Wounds of My enemies I exhalt in, but to day I am Wounded, and by Whom, by those same White Dogs that I have always Considered, and treated as Brothers. I do not fear *Death* my friends. You Know it, but to *die* with my face rotten that even the Wolves will shrink with horror at seeing Me, and say to themselves, that is the 4 Bears the Friend of the Whites—[5]

[1] George Catlin, *Letters and Notes on the Manners, Customs, and Condition of the North American Indians* (London, 1844), I, p. 145.

[2] Ibid., p. 146.

[3] The original robe is now in the collection of the Linden-Museum, Stuttgart. For description of the scene, see Davis Thomas and Karin Runnefeldt, eds., *People of First Man* (New York, 1976), pp. 202–3.

[4] John C. Ewers, "Early White Influence Upon Plains Indian Painting: George Catlin and Carl Bodmer Among the Mandan, 1832–34," in *Smithsonian Miscellaneous Collections* (Washington, D.C., 1957), CXXXIV, pp. 7–8.

[5] Annie H. Abel, ed., *Chardon's Journal at Fort Clark, 1834–1839* (Pierre, S.D., 1932), pp. 124–25.

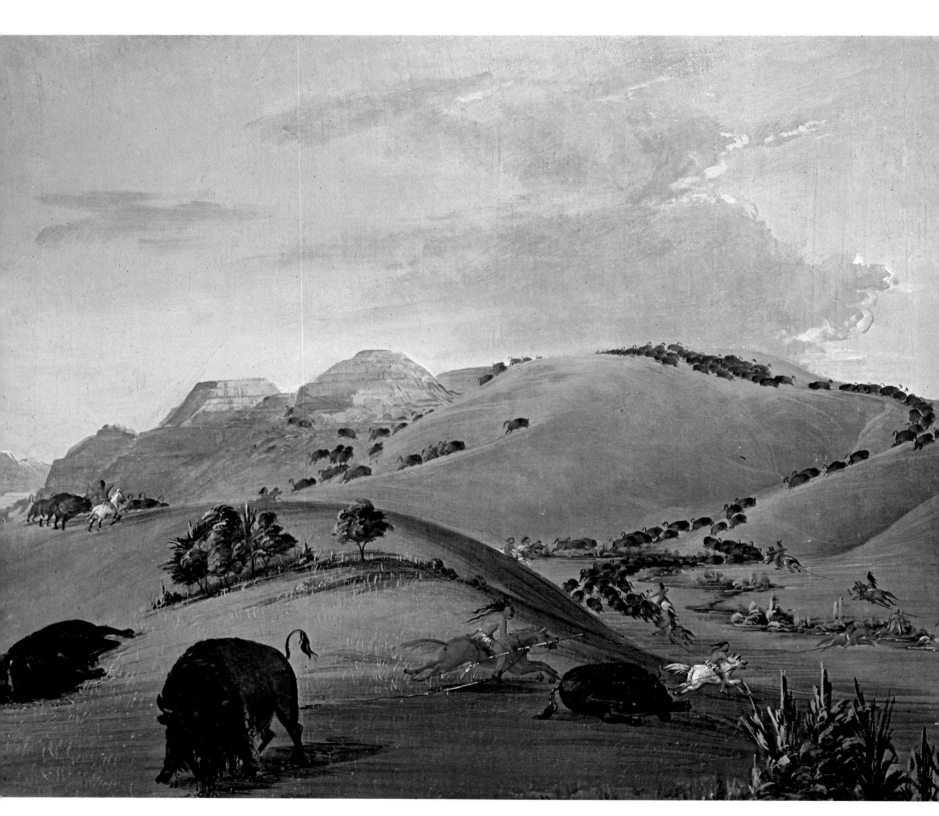

20. George Catlin. *Buffalo Chase, Mouth of Yellowstone.* 1832. Oil on canvas, 24 x 29". National Collection of
Fine Arts, Smithsonian Institution, Washington, D.C.

Shaggy monarchs of the prairie, the lumbering buffaloes were the marrow of the Plains Indian life. Providing food, shelter, clothing, and fuel as nominal necessities, they also promised an excitement equalled only in battle—the hunt. "Though from his bulk, and rolling gait," wrote Washington Irving from Captain Bonneville's 1836 account, the buffalo "does not appear to run with much swiftness; yet, it takes a staunch horse to overtake him, when at full speed . . . and a buffalo cow is still fleeter in her motion."[1]

For this reason the Indian, unless circumstances dictated otherwise, preferred to corner the beasts rather than run alongside as Catlin pictured them in his painting, *Buffalo Chase, Mouth of Yellowstone.* The most efficient method came to be known as the surround. It began with the methodical deportment of runners to circumvent the herd, and it generally ended in desperate turmoil. The artist Alfred Jacob Miller described a similar scene along the upper Green River in 1837.

On reaching their appointed places, the signal is given to a party in ambush, when all rush forward, *pell mell,* and ride round the herd, contracting the circle closer and closer. They then begin to discharge their arrows, which throws the animals into confusion, and a panic ensues. Each Hunter now selects the fattest animal near him, riding fearlessly into the crowd of animals, and sometimes drives an arrow completely through one of them. In a situation of this kind, the Hunter is often exposed to imminent danger, either from the fall of his horse in Buffalo wallows, or from the infuriated Buffalo, who often turns suddenly on his pursuer. The horses seem to enjoy the sport as much as the riders, being dexterous in avoiding an onslaught.

The activity, native grace, and self-possession of the Indians, the intelligence of their well-trained horses, and the thousands of Buffalo moving in every direction over the broad and vast prairie, form a most extraordinary and unparalleled scene.[2]

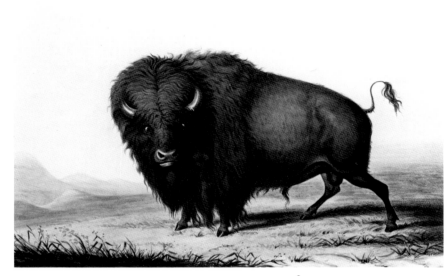

21. George Catlin. *American Buffalo.* 1844. Colored lithograph, 12 x 17⅝". Buffalo Bill Historical Center, Cody, Wyo. Gift of W. R. Coe Foundation

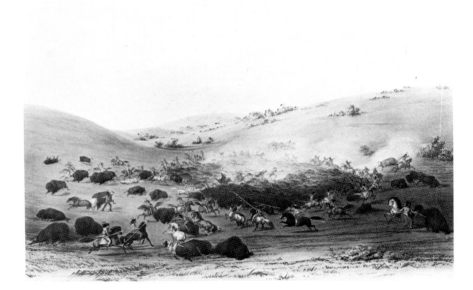

22. George Catlin. *Buffalo Hunt. A Surround.* 1844. Colored lithograph, 12 x 17⅝". Buffalo Bill Historical Center, Cody, Wyo. Gift of W. R. Coe Foundation

[1] Washington Irving, *The Rocky Mountains* (Philadelphia, 1837), II, p. 126.
[2] *Descriptive Catalogue of a Collection of Water-Colour Drawings by Alfred Jacob Miller in the Public Archives of Canada* (Ottawa, 1951), p. 39.

A private European exploring party, which included Prussian Prince Maximilian, his personal retainer David Dreidoppel, and the young Swiss artist Karl Bodmer, followed closely on Catlin's heels. Just one year after Catlin had voyaged west to Fort Union, this intrepid retinue boarded the *Yellowstone* in April of 1833 for a similar, though more extensive, tour. They intended to reach the Rocky Mountains before the summer's close, and to this end they pressed on beyond Fort Union after securing the service of the American Fur Company's keelboat, *Flora.* On August 9, in the company of David D. Mitchell, who had founded this distant outpost the summer before, they reached Fort McKenzie. It was to be their home for the next five weeks. The Rockies were still far out of reach, and the threat of hostile Indians brought their journey to a premature conclusion.

Despite the solemn promise of peace given earlier to Kenneth McKenzie by the Assiniboin and Blackfeet, Maximilian and his troop awoke on the morning of August 28 to the roar of muskets and the cry, "Levez-vous, il faut nous battre!" When they mounted the battlements they saw before them

the whole prairie covered with Indians on foot and on horseback, who were firing at the fort; and on the hills were several detached bodies. About eighteen or twenty Blackfoot tents, pitched near the fort, the inmates of which had been singing and drinking the whole night, and fallen into a deep sleep towards morning, had been surprised by 600 Assiniboins and Crees. When the first information of the vicinity of the enemies was received from a Blackfoot, who had escaped, the *engagés* immediately repaired to their posts on the roofs of the buildings, and the fort was seen to be surrounded on every side by the enemy, who had approached very near. They had cut up the tents of the Blackfeet with knives, discharged their guns and arrows at them, and killed or wounded many of the inmates, roused from their sleep by this unexpected attack. Four women and several children lay dead near the fort, and many others were wounded. The men, about thirty in number, had partly fired their guns at the enemy, and then fled to the gates of the fort, where they were admitted. They immediately hastened to the roofs, and began a well-supported fire on the Assiniboins.[1]

A few days after the battle a full band of Piegan Blackfeet arrived at Fort McKenzie. In Bodmer's view of the encampment, only a portion of their almost four hundred lodges can be seen. They stayed only a few days but offered the artist a colorful cross section of Indian life.

Among the group of Indians pictured in the left foreground of Bodmer's encampment scene appears one distinctive though unidentified Piegan warrior elegantly cloaked in a painted robe. He wears as a hat his rifle scabbard and in his left hand is gracefully poised a micmac pipe. Every detail of his adornment is drawn, even to the horse tracks symbolizing his feats as a collector of other men's mounts.

In the print of the encampment scene which later illustrated Maximilian's voluminous journal, this figure remained true to the original watercolor. Elsewhere though, Bodmer was not altogether candid in his pictorialization. The mounted figure on the far left side of the composition was extracted arbitrarily from a watercolor of a young Ponca painted at Fort Pierre in May of that year. The quiver which drapes so handsomely over the right shoulder of the other mounted warrior in the scene is of Mandan origin, probably not painted until the following winter on the lower Missouri.[2] For the ethnologist these artificial insertions in the name of art are misleading; they show that Bodmer's first allegiance was to aesthetic appeal and that subject matter and authenticity were often secondary considerations.

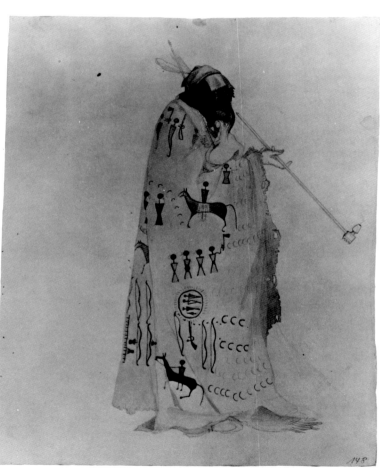

23. Karl Bodmer. *A Piegan Indian, Fort McKenzie, August 1833.* Watercolor, 12⅜ x 10″. Joslyn Art Museum, Omaha, Neb. Northern Natural Gas Company Collection, © E. P. Dutton, *People of First Man,* edited by Davis Thomas and Karin Runnefeldt

[1] Reuben Gold Thwaites, ed., *Travels in the Interior of North America* (Cleveland, 1906), II, p. 146.

[2] Elden Johnson, " 'Carl Bodmer Paints the Indian Frontier,' " in *Indian Leaflets 8–9–10 of The Science Museum* (St. Paul, 1955), unpaged.

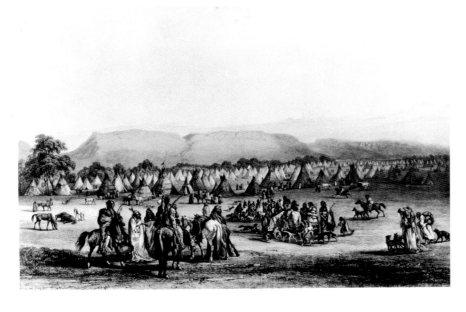

25. Karl Bodmer. *Fort McKenzie, August 28, 1833.* c. 1840. Aquatint, 11¾ x 16¾". Joslyn Art Museum, Omaha, Neb. Northern Natural Gas Company Collection, © E. P. Dutton, *People of First Man,* edited by Davis Thomas and Karin Runnefeldt

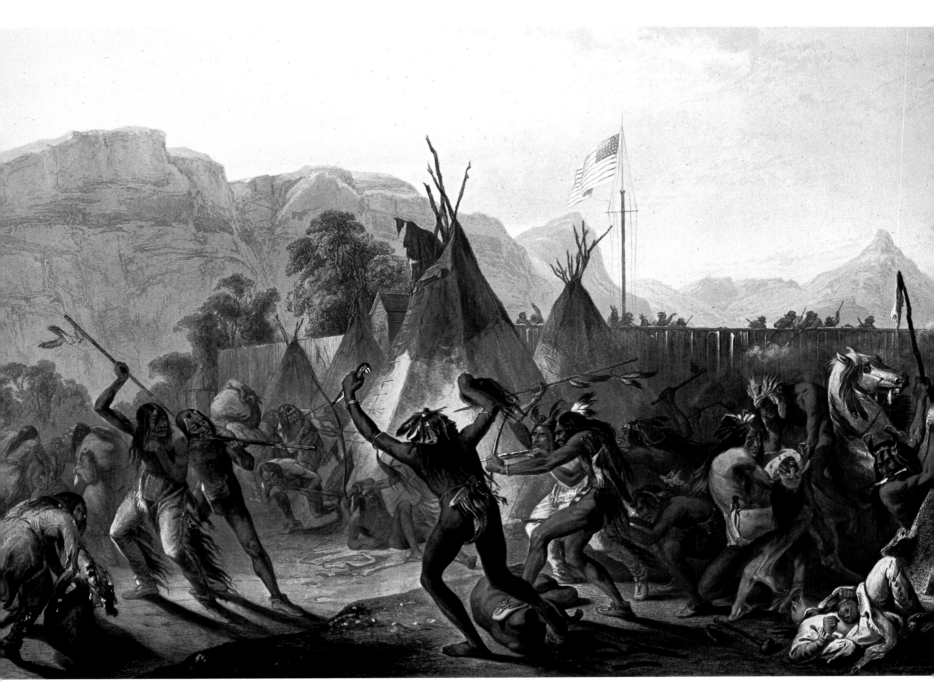

24. Karl Bodmer. *Encampment of the Piekann Indians.* 1840. Aquatint and etching, 17¾ x 24⅜". Amon Carter Museum, Fort Worth

Karl Bodmer

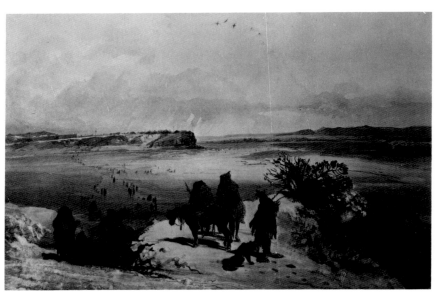

26. Karl Bodmer. *View of the Mandan Village Mih-tutta-hang-kush.* 1833. Watercolor, 11¼ x 16½″. Joslyn Art Museum, Omaha, Neb. Northern Natural Gas Company Collection, © E. P. Dutton, *People of First Man*, edited by Davis Thomas and Karin Runnefeldt

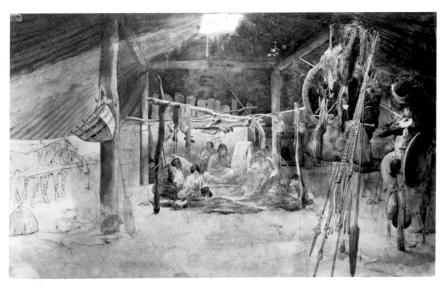

27. Karl Bodmer. *Interior of a Mandan Indian Earth Lodge.* 1833. Watercolor, 11⅜ x 16⅞″. Joslyn Art Museum, Omaha, Neb. Northern Natural Gas Company Collection, © E. P. Dutton, *People of First Man*, edited by Davis Thomas and Karin Runnefeldt

Maximilian and Bodmer spent the winter of 1833–34 at Fort Clark. McKenzie had invited the explorers to stay with him at Fort Union, but when he learned that Maximilian preferred to live among the Mandan, "in order more closely to study the Indian tribes in the neighbourhood,"[1] he graciously ordered the construction of a new building at Fort Clark in which they were to reside. The structure was completed by late November and became both residence and studio. "The large windows afforded a good light for drawing, and we had a couple of small tables and some benches of poplar wood, and three shelves against the walls, on which we spread our blankets and buffaloes' skins, and reposed during the night."[2]

The winter was cold, and even in the studio it was often impossible for Bodmer to work, as his paints and pencils often froze. Nonetheless, whenever possible, the artist welcomed Indians into his temporary home. On December 4 several Mandans visited, among whom were Beracha-Iruckcha (broken pot), reputed to be the strongest man in the tribe, and Mahchsi-Karehde (flying eagle), the tallest. Evidently a man of considerable prominence, Mahchsi-Karehde was elegantly adorned in a bear-claw necklace, a fan made of an eagle's wing, and a relatively plain painted robe, suitable for a young man, with handsome, quilled strip and roundels.

The Mandans stayed fairly close to home through the winter months. Bodmer's view of the bleak Missouri valley in his scene of Fort Clark and the Mandan village of Mih-tutta-hang-kush does not illustrate why. The frozen river fortunately provided simple access to the east side, where wood supplies abounded. The commodious earth-and-wickerwork lodges, often large enough to store prized horses inside overnight, demanded considerable fuel to maintain their comfort.

[1] Reuben Gold Thwaites, ed., *Travels in the Interior of North America* (Cleveland, 1906), III, p. 12.
[2] Ibid., p. 18.

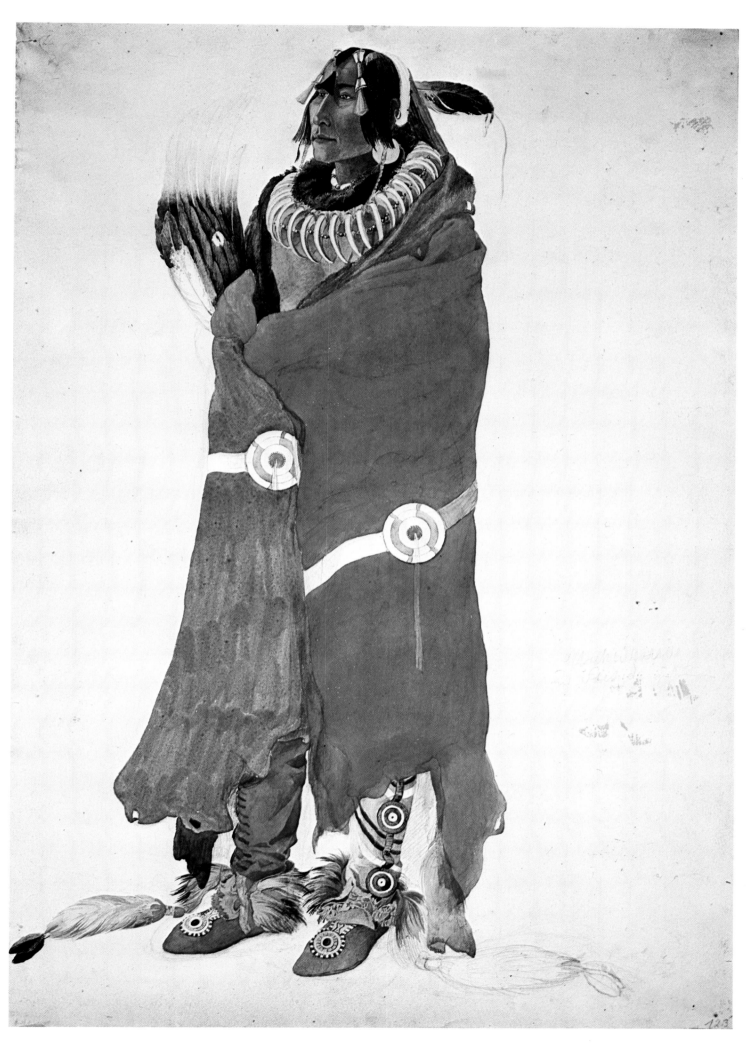

28. Karl Bodmer. *Mahchsi-Karehde (Flying Eagle), A Mandan Indian.* 1834. Watercolor, 16¾ x 11⅞". Joslyn
Art Museum, Omaha, Neb. Northern Natural Gas Company Collection, © E. P. Dutton, *People of First
Man,* edited by Davis Thomas and Karin Runnefeldt

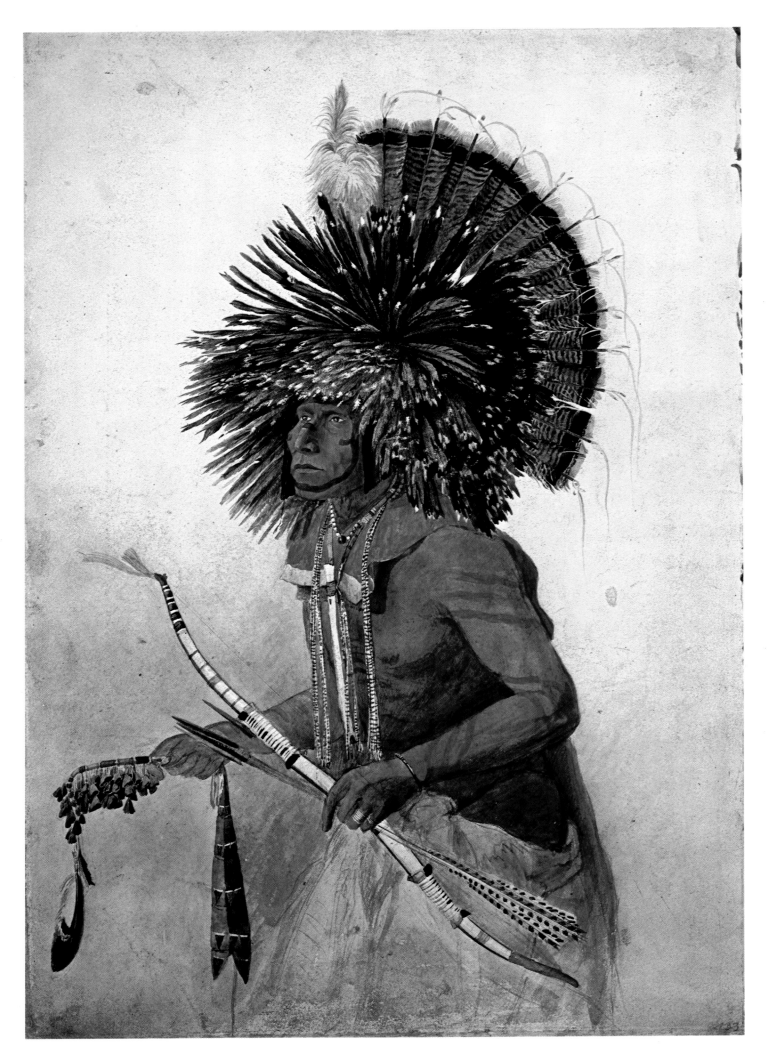

29. Karl Bodmer. *Pehriska-Ruhpa (Two Ravens), Chief of the Hidatsa on the Upper Missouri, as a Dog Dancer.*
March 1834. Watercolor, 17 x 11¾″. Joslyn Art Museum, Omaha, Neb. Northern Natural Gas
Company Collection, © E. P. Dutton, *People of First Man,* edited by Davis Thomas and Karin
Runnefeldt

One of the most spectacular scenes witnessed by Maximilian and Bodmer in their journeys took place in the early spring of 1834 while they were still residing at Fort Clark. In his journal for March 7, Maximilian described that memorable event, the Mandan dog dance.

In the afternoon the [dog] band approached the fort, and we heard the sound of their war whistles at the gates. A crowd of spectators accompanied the seven or eight and twenty dogs, who were all dressed in their handsomest clothes. Some of them wore beautiful robes, or shirts of bighorn leather; others had shirts of red cloth; and some blue and red uniforms. Others, again, had the upper part of their body naked, with their martial deeds painted on the skin with reddish-brown colour. The four principal dogs wore an immense cap hanging down upon the shoulders, composed of raven's or magpie's feathers, finished at the tips with small white down feathers. In the middle of this mass of feathers, the outspread tail of a wild turkey, or of a war eagle, was fixed. These four principal dogs wore round their neck a long slip of red cloth, which hung down over the shoulders, and, reaching the calf of the leg, was tied in a knot in the middle of the back. These are the true dogs, who, when a piece of meat is thrown into the fire, are bound immediately to snatch it out and devour it raw.

Two other men wore similar colossal caps of yellow owl's feathers, with dark transverse stripes, and the rest had on their heads a thick tuft of raven's, magpie's, or owl's feathers, which is the badge of the band. All of them had the long war whistle suspended from their necks. In their left hand they carried their weapons—a gun, bow and arrows, or war club; and in their right hand the schischikué peculiar to their band. It is a stick adorned with blue and white glass beads, with buffalo or other hoofs suspended to it, the point ornamented with an eagle's feather, and the handle with slips of leather embroidered with beads.

The warriors formed a circle round a large drum, which was beaten by five ill-dressed men, who were seated on the ground. Besides these, there were two men, each beating a small drum like a tambourine. The dogs accompanied the rapid and violent beat of the drum by the whistle of their war whistles, in short, monotonous notes, and then suddenly began to dance. They dropped their robes on the ground, some dancing within the circle, with their bodies bent forward and leaping up and down with both feet placed together. The other Indians danced without any order, with their faces turned to the outer circle, generally crowded together; while the war whistle, drum, and schischikué made a frightful din.[1]

Bodmer's picture of the Moennitarri warrior Pehriska-Ruhpa, dressed for a similar ceremony, remains today the most striking Indian portrait ever executed. The original watercolor is only half length and is relatively unanimated in posture and expression. It did not portray the scene described above, or as Catlin had seen it among the Sioux a year later near Fort Snelling. He termed it "a spirited dance," in which confusion reigned as each participant "sung forth his own deeds of bravery in ejaculatory gutturals, which was almost deafening."[2] Thus, in the aquatint of Pehriska-Ruhpa, Bodmer made significant changes to effect drama and relay the character of the scene.

[1] Reuben Gold Thwaites, ed., *Travels in the Interior of North America* (Cleveland, 1906), III, pp. 74–75.

[2] George Catlin, *Letters and Notes on the Manners, Customs, and Condition of the North American Indians* (London, 1844), II, p. 137.

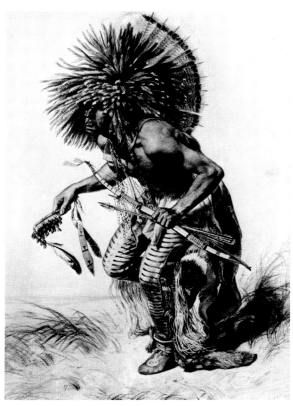

30. Karl Bodmer. *Pehriska-Ruhpa, Moennitarri Warrior in the Costume of the Dog Dance.* 1841. Charcoal, crayon, and watercolor, 18½ x 12¾". Glenbow-Alberta Institute, Calgary, Canada

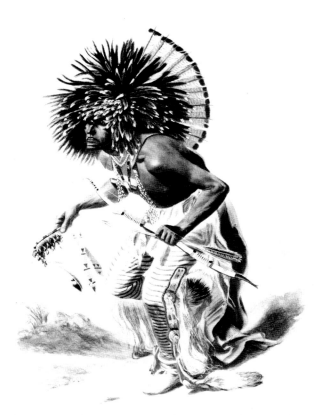

31. Karl Bodmer. *Pehriska-Ruhpa, Minitarri Warrior in the Costume of the Dog Dance.* c. 1840. Aquatint, 24⅞ x 18⅛". Buffalo Bill Historical Center, Cody, Wyo. Gift of Miss Clara Peck

They were known to the mountain men as *bourgeois*, those members of their own independent rank who commanded a group of trappers in the field. Captain Joseph Reddeford Walker, "being trustworthy and intelligent, received an appointment of this kind, and," according to Alfred Jacob Miller, "had many battles with the Indians."[1]

When the season's hunt was complete, the fur companies designated a place for the annual rendezvous. Miller met the illustrious Walker at the Green River rendezvous in 1837. A few years previous, Walker had led a party of trappers sixty strong from the central Rockies to the Pacific shore in search of new beaver ground. He had also served as Captain Bonneville's lieutenant for matters of trapping and trading in the Crow country prior to Miller's acquaintance. His was a life of "myth, fable, and saga all together,"[2] said Bernard DeVoto, and Miller confirmed the stature of the colorful Walker in his finished oil portrait completed sometime after the artist's return from the West.

The great success of the Rocky Mountain enterprises depended only in part on such sagacious sorts as Walker. Credit must also fall to the individual men who, as Miller described with his watercolor, *Trapping Beaver*, risked their lives each day and kept the business going.

In hunting the Beaver two or more trappers are usually in company. On reaching a creek or stream, their first attention is given to "sign." If they discover a tree prostrate, it is carefully examined to ascertain if it is the work of Beaver, and if thrown for the purpose of damming the stream, Foot prints of the animal on the mud or sand are carefully searched for, and if fresh, they then prepare to set their traps. One of these is baited with "medicine"—hidden under water, and attached to a pole driven firmly on or near the bank. A "float-stick" is made fast to the trap, so that if the Beaver should carry it away, the stick remains on the surface of the water and points out its position.

With all the caution the poor trappers take, they cannot always escape the Lynx eyes of the Indians. The dreadful war whoop, with bullets and arrows about their ears, are the first intimations of danger; They are destroyed in this way from time to time, until by a mere chance their bones are found bleaching on the borders of some stream where they have hunted.[3]

The Green River rendezvous of 1833, attended by Joseph Walker, was described ten years later by Matthew C. Field: "300 whites—3 Indian villages—Nepercys, Flatheads & Snakes—1500 lodges &c. The month of August—drinking—gaming, racing, singing, dancing, fighting, hunting, trading, fanfaronading, fishing, intriguing &c. &c. &c."[4] For one horse race at the 1843 rendezvous, Field reported the purse at "1 doz champagne, 1 Doz Hock, 6 leather shirts, 1 pair pistols, Indian trinkets *ad lib.* and 2 mules."[5]

In Miller's *Large Encampment Near the Cut Rocks*, which depicts the 1837 rendezvous, the hub of activity can be seen in the center distance. This is the great tent of the American Fur Company surrounded by the picturesque lodges of the tribes who have come to trade. "The first day," Miller recounted, "is devoted to 'High Jinks,' a species of Saturnalia, in which feasting, drinking, and gambling form prominent parts." The next day is more prosaic. "The accumulated furs of the hunting season are brought forth, and the Company's tent is a besieged and busy place."[6]

[1] Marvin C. Ross, *The West of Alfred Jacob Miller* (Norman, Okla., 1968), opp. p. 78.
[2] Bernard DeVoto, *Across the Wide Missouri* (Cambridge, Mass., 1947), p. 146.
[3] Ross, op. cit., opp. p. 111.
[4] Matthew C. Field, *Prairie and Mountain Sketches* (Norman, Okla., 1957), p. 149.
[5] Ibid., p. 150.
[6] Ross, op. cit., opp. p. 110.

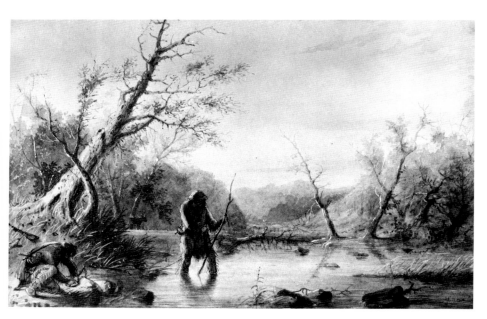

32. Alfred Jacob Miller. *Trapping Beaver.* 1859–60. Watercolor, 8⅞ x 13¾ ". The Walters Art Gallery, Baltimore

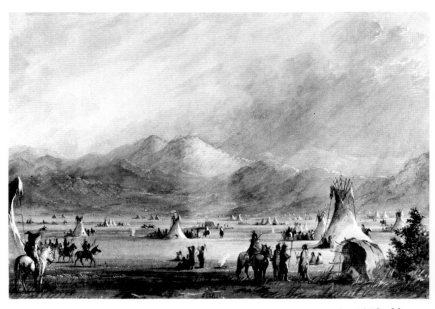

33. Alfred Jacob Miller. *Large Encampment Near the Cut Rocks.* 1859–60. Watercolor, 8⅝ x 12⅜". The Walters Art Gallery, Baltimore

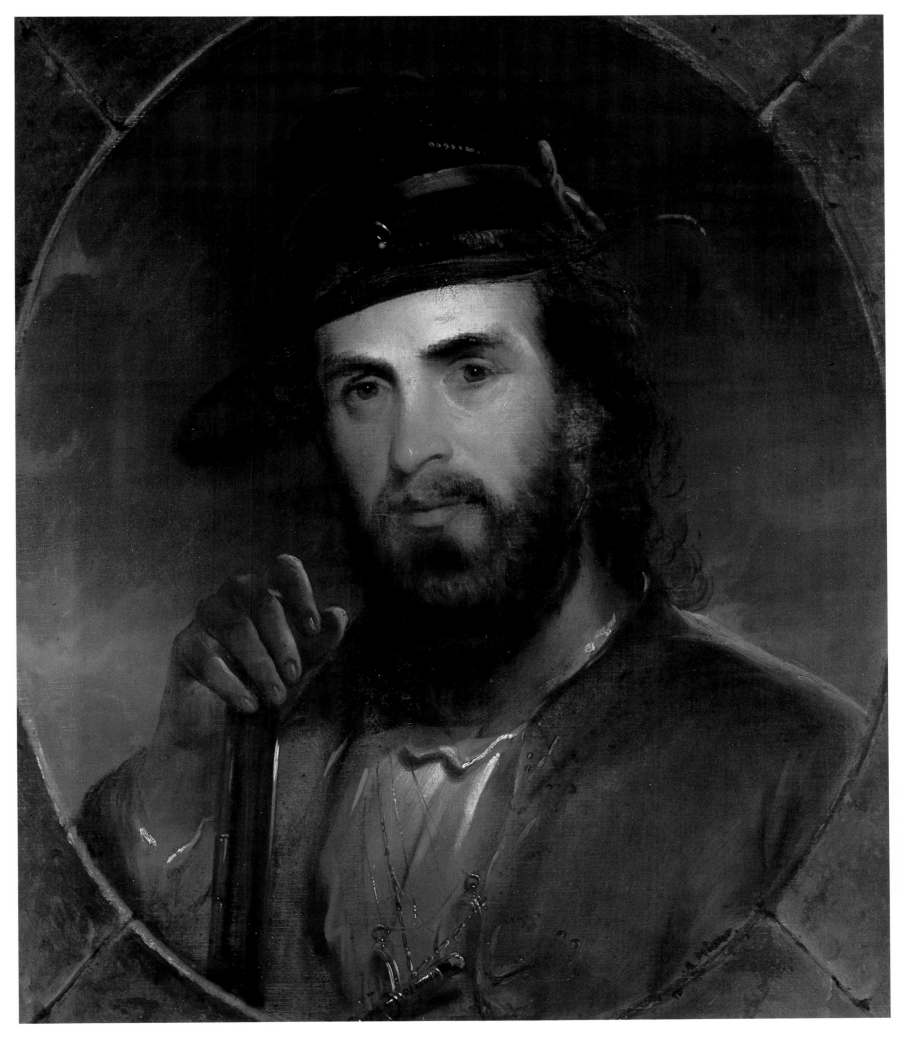

34. Alfred Jacob Miller. *Portrait of Captain Joseph Reddeford Walker.* n.d. Oil on canvas, 24 x 20″. Joslyn Art Museum, Omaha, Neb.

Alfred Jacob Miller

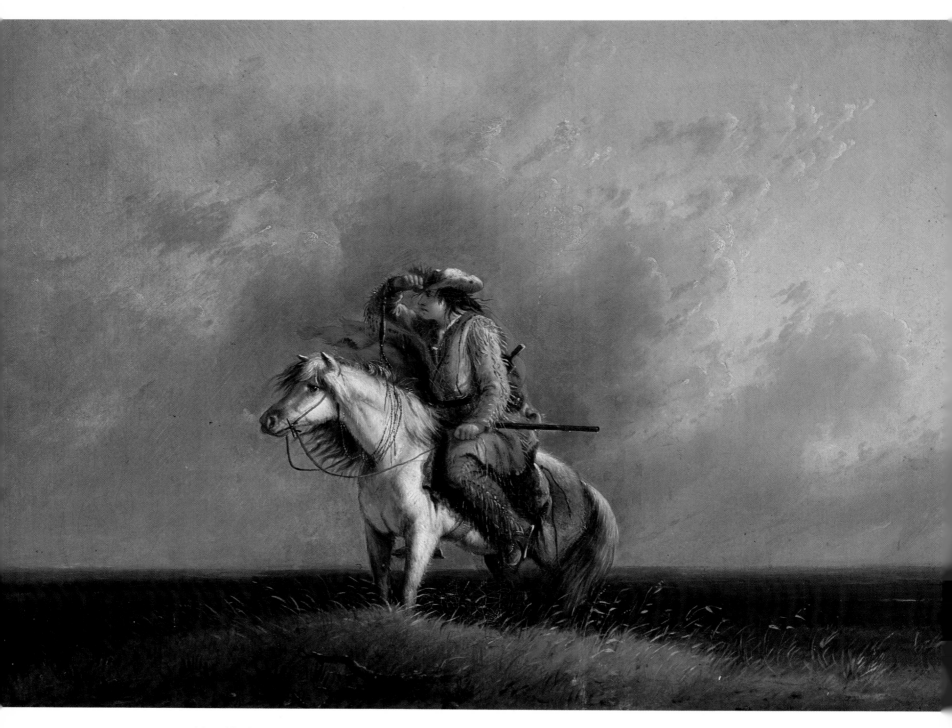

35. Alfred Jacob Miller. *The Lost Greenhorn.* n.d. Oil on canvas, 17⅞ x 23⅞". Buffalo Bill Historical Center,
Cody, Wyo. Gift of W. R. Coe Foundation

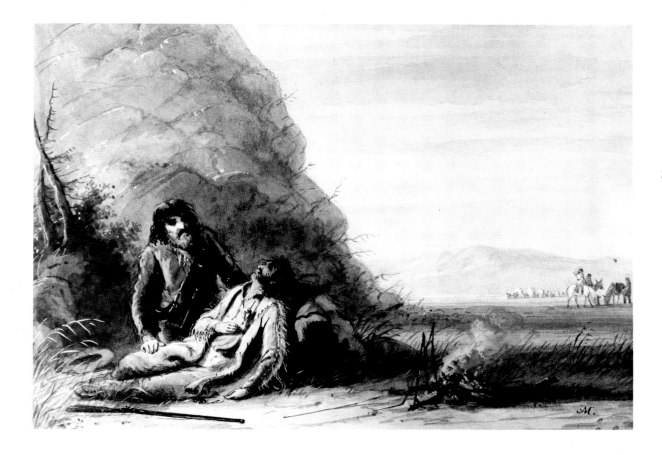

Getting to the Rocky Mountains was as inspiring and challenging an endeavor as any confronted once there. Matthew Field, in a letter to the *New York Tribune,* eulogized the vast prairie which lay in his path to the rendezvous of 1843. "I cannot trust myself to speak of the grandeur, sublimity, soft beauty and appalling wilderness—all of which have been passing, like a many changing panorama."[1] Francis Parkman, who followed the same path three years later, presented a different view. Beyond the banks of the Platte River, he wrote, "lay a barren, trackless waste—'The Great American Desert'—extending for hundreds of miles to the Arkansas on the one side, and the Missouri on the other. Before us and behind us, the level monotony of the plain was unbroken as far as the eye could reach....Of those who have journeyed there, scarce one, perhaps, fails to look back with fond regret to his horse and his rifle."[2]

Like a good mountain man, "a good plainsman 'is born, not made.' He must have within him a something unaccountable even to himself, which, however variable and circuitous the path of his wanderings, tells him constantly the direction of his return."[3] One of Miller's most popular depictions of Far Western life was that of *The Lost Greenhorn,* showing John, the forlorn cook of Sir Drummond Stewart's expedition. Tempted by the promise of the Buffalo District, John started off to test his neophyte skill at tracking and pursuing the shaggy beasts. Two days passed

before a rescue party found him, "crest fallen and nearly starved."[4]

"Meat's meat" was common parlance in the mountains. George Frederick Ruxton, who traveled widely in the West in the 1840s, noted that "from the buffalo down to the rattlesnake, including every quadruped that runs, every fowl that flies, and every reptile that creeps, nothing comes amiss to the mountaineers."[5] The Miller watercolor, *Free Trappers in Trouble,* pictures two desperate men found by the Stewart party near Independence Rock. They were on the verge of starvation, their ammunition exhausted. The last meal that had passed their lips was a couple of rattlesnakes they had succeeded in killing. When Captain Stewart queried, " 'Good God! how can you eat such disgusting food?' " one replied with bold candor, " 'This child doe'st *savez* what disgustin' is'—Wagh!"[6]

[1] Matthew C. Field, "From the Rocky Mountain Expedition," *New York Tribune* (September 18, 1843).

[2] Francis Parkman, *The California and Oregon Trail* (New York, 1847), pp. 81–82.

[3] R.I. Dodge, *The Plains of the Great West* (New York, 1877), p. 45.

[4] Marvin C. Ross, *The West of Alfred Jacob Miller* (Norman, Okla., 1968), opp. p. 141.

[5] George Frederick Ruxton, *Life in the Far West* (Norman, Okla., 1951), p. 98.

[6] Ross, op. cit., opp. p. 163.

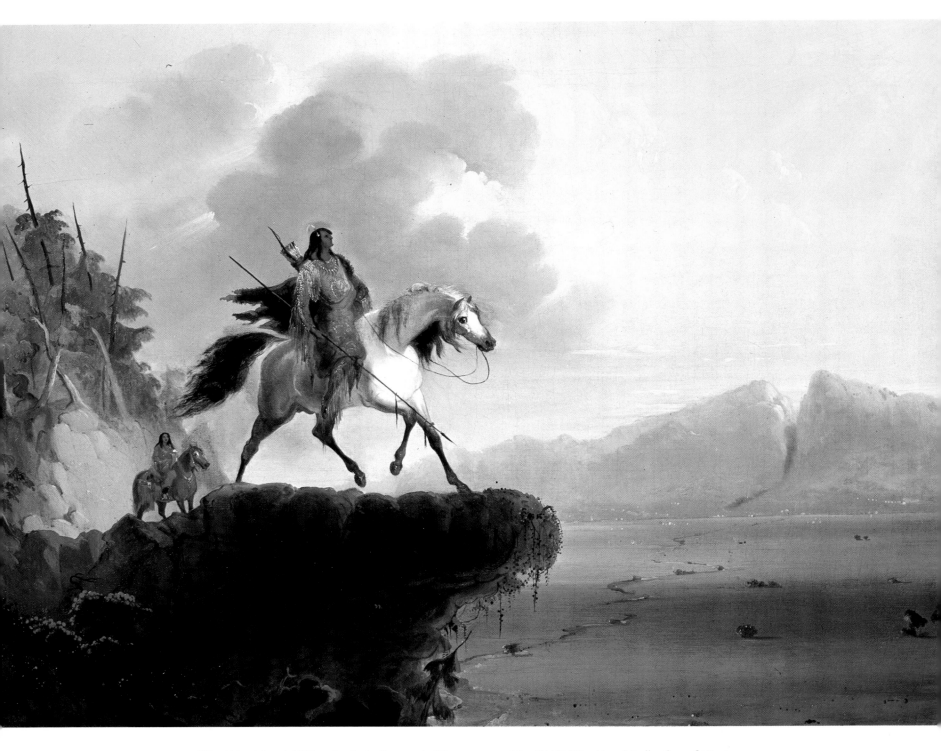

37. Alfred Jacob Miller. *Snake Indians*. n.d. Oil on canvas, 18 x 24½". The Gund Collection of Western Art—A Traveling Exhibition

Alfred Jacob Miller

At a spot overlooking the Cut Rocks, later a famous landmark of the Oregon Trail, Miller conceived this dramatic portrait of a mounted Snake Indian. Redolent with the majesty of nature and backed by the brilliant suffusion of Western light, the subject of this painting is statuesque in pose and proportion. In fact, Miller had recognized in the Indian something unique and unexplored in American art. "American sculptors," he wrote, "travel thousands of miles to study Greek statues in the Vatican at Rome, seemingly unaware that in their own country there exists a race of men equal in form and grace (if not superior) to the finest beau ideal ever dreamed of by the Greeks."[1]

Similarly for Francis Parkman, Arcadian visions colored his view of the Sioux with whom he visited during his 1846 travels west. The scene he set fits closely the theme and mood of Miller's painting.

> ... when the sun was just resting above the broken peaks, and the purple mountains threw their prolonged shadows for miles over the prairie; when our grim old tree, lighted by the horizontal rays, assumed an aspect of peaceful repose, such as one loves after scenes of tumult and excitement; and when the whole landscape, of swelling plains and scattered groves, was softened into a tranquil beauty; then our encampment presented a striking spectacle. Could Salvator Rosa have transferred it to his canvas, it would have added new renown to his pencil. Savage figures surrounded our tent, with quivers at their backs, and guns, lances or tomahawks in their hands. Some sat on horseback, motionless as equestrian statues, ... their eyes fixed in a steady unwavering gaze.... I do not exaggerate when I say, that only on the prairie and in the Vatican have I seen such faultless models of the human figure.[2]

There was an innocence and purity about Miller's world. His characters, whether trappers or Indians, seemed suspended in idyllic haze. Artistically, the effect was achieved with dry scumbling, a technique learned, no doubt, in Paris ateliers. Thematically, his vision had roots in the romantic idealism of the French school, though true to his own spirit, there was "none of its brutality and tragedy, even painting *Running Fight: Sioux and Crows* without shedding a drop of blood."[3]

38. Alfred Jacob Miller. *Running Fight: Sioux and Crows*. n.d. Watercolor, 8 x 11⅝″. Museum of Fine Arts, Boston. M. and M. Karolik Collection

[1] Marvin C. Ross, *The West of Alfred Jacob Miller* (Norman, Okla., 1968), opp. p. 64.
[2] Francis Parkman, *The California and Oregon Trail* (New York, 1847), p. 187.
[3] James Thomas Flexner, *That Wilder Image* (New York, 1962), p. 91.

Alfred Jacob Miller

39. Alfred Jacob Miller. *Indians Chasing a Deer.* n.d. Oil on canvas mounted on board, 21¾ x 27″. Kennedy Galleries, Inc., New York City

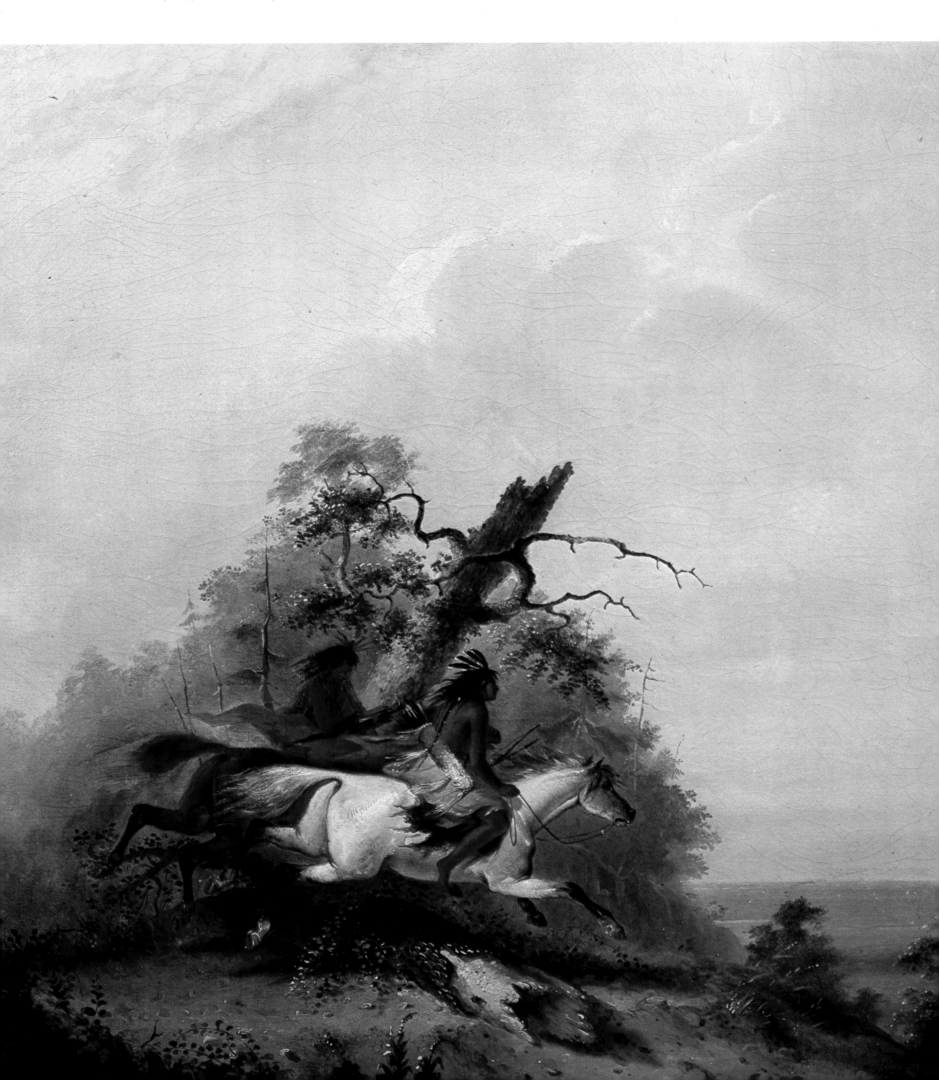

Americans learned and unlearned many myths about the Great Plains and Rockies during the nineteenth century, when the West was making history. Probably the most protracted debate over myth or reality centered on the question of whether Americans should think of the spread beyond the Mississippi as garden or desert. The desert theory, first perpetrated on history by Zebulon Pike, remained in its ascendency until well into the 1860s. Yet the desert hypothesis, while shattering some dreams, had certain utopian undertones of its own.

Henry M. Brackenridge, who traveled over fourteen hundred miles up the Missouri with a brigade of fur traders in 1811, observed:

> The prevailing idea, and with which we have so much flattered ourselves, of these western regions, being like the rest of the United States, susceptible of cultivation, and affording endless outlets to settlements is certainly erroneous. The [Indian] nations will continue to wander over those plains, and the wild animals, the elk, the buffaloe, will long be found there; for until our country becomes surcharged with population, there is scarcely any probability of settlers venturing far into these regions.[1]

To some, whose affection for the natural splendor and undisturbed Indian ways superseded their wish to conquer the wilderness, the seemingly untamable domain held the promise of future paradise. For George Catlin, the greatest idealist of them all, it went like this:

> This strip of country, which extends from the province of Mexico to lake Winnepeg on the North, is almost one entire plain of grass, which is, and ever must be, useless to cultivating man. It is here, and here chiefly, that the buffaloes dwell; and with, and hovering about them, live and flourish the tribes of Indians, whom God made for the enjoyment of that fair land and its luxuries. . . .
>
> And what a splendid contemplation . . . , when one (who has travelled these realms, and can duly appreciate them) imagines them as they *might* in future be seen, (by some great protecting policy of government) preserved in their pristine beauty and wildness, in a *magnificent park*, where the world could see for ages to come, the native Indian in his classic attire, galloping his wild horse, with sinewy bow, and shield and lance, amid the fleeting herds of elks and buffaloes. What a beautiful and thrilling specimen for America to preserve and hold up to the view of her refined citizens and the world, in future ages! A *nation's Park*, containing man and beast, in all the wild and freshness of their nature's beauty![2]

The reality of human need and greed prevailed. By the time a national park was formed, it was without place for the Indian and was assented to by Congress only when the land proved economically useless to the public.

[1] Henry Marie Brackenridge, *Views of Louisiana: Containing Geographical, Statistical and Historical Notices of that Vast and Important Portion of America* (Baltimore, 1817), p. 72.
[2] George Catlin, *Letters and Notes on the Manners, Customs, and Condition of the North American Indians* (London, 1844), I, pp. 261–62.

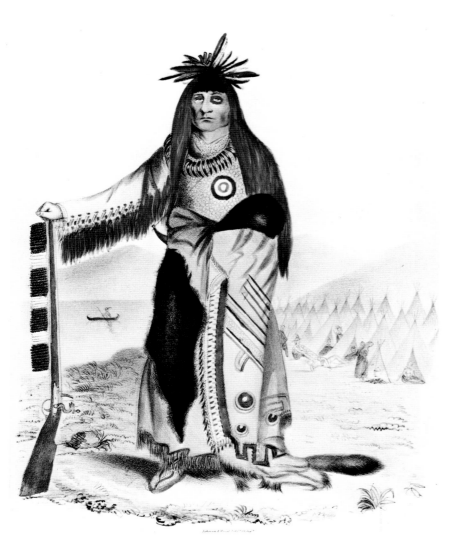

40. James Otto Lewis. *Waa-Na-Taa, or the Foremost in Battle.* c. 1835.
Lithograph, 18¼ x 11⅜". Amon Carter Museum, Fort Worth

Since we have known something of Eastman's pictures, and of Indians, we have ranked him as out of sight the best painter of Indian life the country has produced; a superior artist to Catlin—he has lived and painted for years among the Indians, where Catlin has spent months; his gallery now, is far more complete in all that relates to Indian character, than is Catlin's; and there is in the latter, an effort at effect, as apparent as in the truth of Eastman, to any one who has really seen Indians.[1]

With this bold critique the *St. Louis Republican* summarized a growing national feeling about the work of Seth Eastman, a lieutenant from Fort Snelling who in 1848 was to exhibit paintings at both the National Academy of Design and Cincinnati's Western Art-Union. His knowledge of the Sioux was particularly astute, and he was gauged by many as their most profound pictorial chronicler.

The following year he was engaged by the Office of Indian Affairs to illustrate the copious volumes of Henry R. Schoolcraft's *Indian Tribes of the United States*. He moved family and studio to Washington for the purpose and spent the next five years preparing the nearly three hundred drawings which embellished the first five parts of that definitive treatise.

While in Washington, Eastman completed one of his finest paintings, *Sioux Indians*. It depicts, in Eastman's cool, somewhat pellucid style, a group of Sioux preparing for a river crossing. The men puff and palaver as the women labor with the baggage, the scene being animated only with Hudson River School devices of interlocutors, billowing clouds, and the thrust of the riverbank.

Despite Eastman's prosaic view of Sioux life in this and other depictions, there was a grandness about the Sioux that other artists captured with facility. James Otto Lewis, commissioned similarly by the government, had portrayed the greatest of the Sioux chiefs in the 1820s. Wanata stands supreme, the lodges of his people spanning the distance behind him, his adornment emblematic of his profuse wealth and mighty achievements. He had deigned to receive Major Steven Long on his 1823 expedition to the headwaters of the St. Peter's River. Three fine dogs were roasted for the occasion and before the guests were seated in a huge buffalo-hide pavilion, "the air was perfumed by burning sweet grass."[2]

The portrait of Wanata was one of seventy-five paintings by Lewis that were lithographed and published in Philadelphia in 1835 as part of *The Aboriginal Port-Folio*. Though originally successful, the portfolio was ultimately crowded off the market by the better-known works of Seth Eastman, George Catlin, and McKenney and Hall. Lewis died in obscurity in New York City in 1858.

[1] *St. Louis Republican* (May 2, 1848), p. 5.

[2] James D. Horan, ed., *The McKenney-Hall Portrait Gallery of American Indians* (New York, 1972), p. 146.

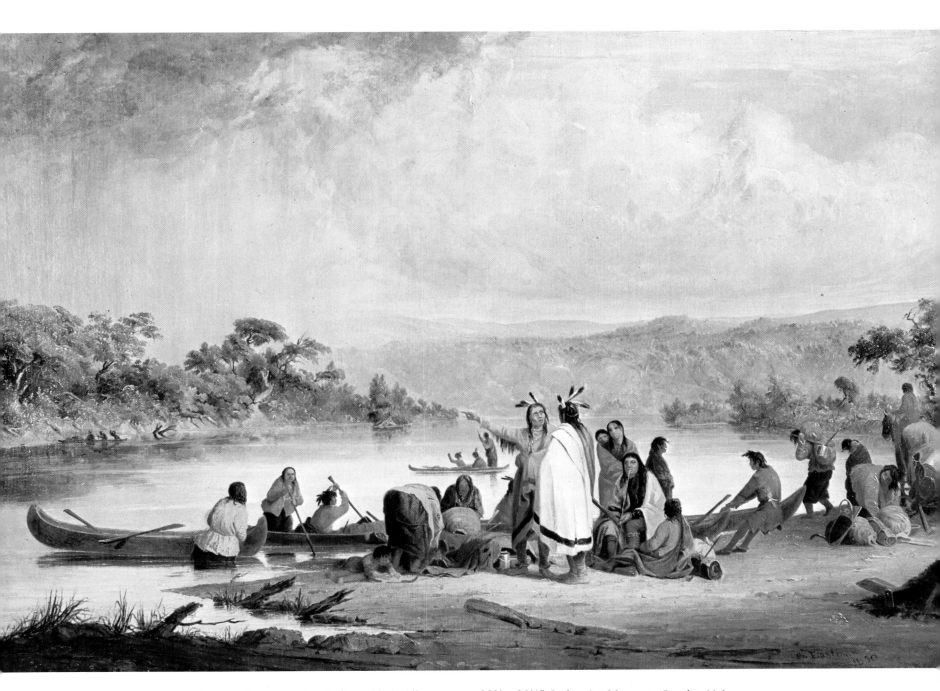

41. Seth Eastman. *Sioux Indians.* 1850. Oil on canvas, 26⅜ x 38½". Joslyn Art Museum, Omaha, Neb.

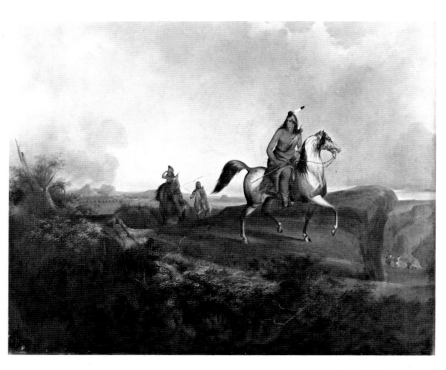

42. John Mix Stanley. *Black Knife, An Apache Warrior.* 1846. Oil on canvas, 42⅜ x 52″. Smithsonian Institution, Washington, D.C.

43. Henry C. Pratt. *View of the Maricopa Mountains, Rio Gila, Arizona, with the Maricopa Indian Village.* 1852. Oil on canvas, 33 x 48″. Kennedy Galleries, Inc., New York City

Another artist to enter the veritable cavalcade set upon compiling the true gallery of Western scenes and natives in the period before 1850 was John Mix Stanley. Determined to establish his own Indian Gallery, Stanley traveled broadly through the West for eleven years collecting material. In 1853, on Stanley's fourth trip, Isaac I. Stevens, then governor of Washington Territory, acknowledged the artist's efforts.

> Mr. Stanley may . . . with justice be regarded as one of the highest living authorities on Indian life and character, and a pictorial history by him, which illustrates the sports, amusements, domestic occupations, dress, wigwams, religious ceremonies, dances, ball plays, hunting, fishing, burials, in short, everything that tends to throw any light upon a race which is now fast melting away before the advance of civilization, must prove a valuable contribution to American history.[1]

Stanley's most ambitious journey into the Far West took place in 1846. He began his trek on the Santa Fe Trail with the romantic trader Josiah Gregg and continued west from Santa Fe in the employ of Colonel Steven Watts Kearny, crossing the desert to California. Stanley found beauty in the desert, especially along that part of the Gila River which "was traversed by a seam of yellowish-coloured igneous rock, shooting up into regular spires and turrets, one or two thousand feet in height."[2] The *National Intelligencer* referred to Stanley's rendition in bizarre terms, calling the painting a "ravishing view . . . disclosing an order of the vegetable kingdom and a style of geology as different from what prevail in our region of the continent as if they were the belongings to some other planet."[3]

Others in Kearny's entourage did not relish the sight of these Gila Valley crenellations. Lieutenant Henry S. Turner anxiously wrote in his journals for October 29: "Oh this country of cactus, mesquite bush and wild sage, remarkable for sterility and its broken mountainous surface, where it scarcely ever rains and where no verdure is visible except in the branches of cotton wood trees. When, oh, when shall I say goodbye to you—would that the time had arrived; of one thing I feel assured that no *earthly* power can ever induce me to return to it."[4]

There were more potentially ominous forces confronted by the expedition than those of nature's landscape. The venerated Apache chief Black Knife crossed their path along the upper reaches of the Gila, but offered no obstacle. In the vein of Thomas Sully's *The Passage of the Delaware,* Stanley's Apache peers warily over his shoulder at the train of men and horses pressing determinedly toward the Pacific.

Stanley viewed the Apaches and other Indians along his route as romantic models. However, a troop of artists who followed him saw the Indians and their land in more objective terms. John Russell Bartlett's 1850–53 survey of the United States–Mexican boundary included the official painter Henry C. Pratt. Pratt's view of the Maricopa vil-

John Mix Stanley

44. John Mix Stanley. *Chain of Spires Along the Gila River*. 1855. Oil on canvas, 31 x 42″. Phoenix Art Museum

lages along the upper Gila betrays the scientific bent of Bartlett's expedition as it portrays something of the quiescent splendor common to the works of Hudson River painters of the period. The brilliant light of the Southwest, along with the birds, plants, and people of the desert, distinguishes Pratt's scene from its Eastern counterpart. Yet the allegiance of man and nature, expressed as pastoral innocence and contentment, binds together the Eastern and Western traditions, separated only by distance.

[1] Quoted in F.W. Hodge, "A Proposed Indian Portfolio by John Mix Stanley," *Indian Notes,* 6 (October, 1929), 366.

[2] J.M. Stanley, "Portraits of North American Indians, With Sketches of Scenery, Etc. . . . ," in *Smithsonian Miscellaneous Collections* (Washington, D.C., 1862), II, p. 57.

[3] "Indian Gallery of Paintings," *National Intelligencer* (February 23, 1852).

[4] Dwight L. Clarke, ed., *The Original Journals of Henry Smith Turner* (Norman, Okla., 1966), pp. 96–97.

John Mix Stanley

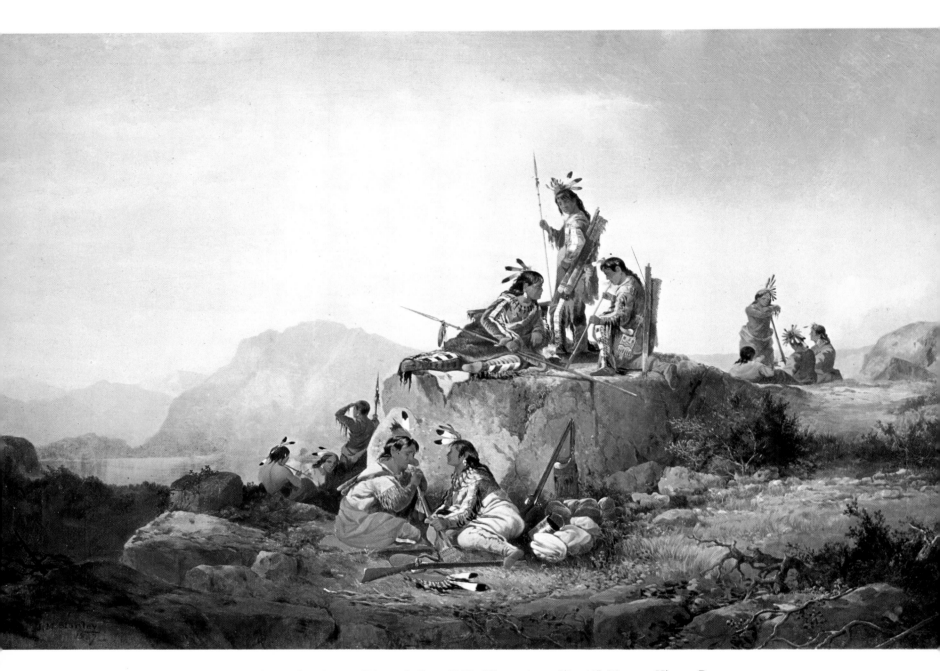

45. John Mix Stanley. *Group of Piegan Indians.* 1867. Oil on canvas, 27 x 41″. Western History Department, Denver Public Library

Stanley's most striking Indian studies resulted from his trip through the Northern Plains and Rockies with Isaac I. Stevens's 1853 expedition to survey a possible route for the transcontinental railroad. Stanley was employed as official artist at a fee of $125 a month, modest compensation for his experience as a traveler, his ability at dealing with Indians, and "his reputation, already so well established."[1]

Just as Stanley's paintings of the Kearny expedition had been used to embellish the 1848 Emory report,[2] the artist's watercolors taken along the "Northern Route" and finished versions completed later in oil filled the pages of the Pacific Railroad Surveys'[3] most impressive volume, number twelve.

The two paintings and the lithograph pictured here were inspired by a side trip from Fort Benton on the upper Missouri taken by Stanley, three *engagés*, and an American Fur Company interpreter. They went in search of the Three Buttes and a huge camp of Piegans, reported to be north of the Marias River. It was mid-September, the prairies were dry, and the traveling fast. It was not uncommon for them to span forty miles in a day. On the fourth day they reached "the Piegan band he [Stanley] was in search of, which consisted of ninety lodges, under their chief, Low Horn."[4]

Stanley's troop received a hearty welcome accented with an epicurean delicacy of berries in boiled buffalo's blood. After conversing with the principal chiefs, he persuaded the whole village to move south so that the Indian leaders might parley with Stevens at Fort Benton. Stevens's narrative later recounted Stanley's feat of diplomacy.

Thus a thousand Indians accompanied him as far as Milk river, where the main party remained to hunt, and the thirty principal men, with their families, came with him to Fort Benton, by nearly the same track he had followed in going. In eleven days he had gone 160 miles and back, effected the business he was sent for, made a number of sketches of the country and the Indians, and collected a partial vocabulary. The accompanying sketch is a view of the Three Buttes and the Blackfeet Indians engaged in the hunt, taken by Mr. Stanley on his return from Fort Benton.[5]

[1] Isaac I. Stevens, "Pacific Railroad: Northern Route," *Oregonian* (January 21, 1854), p. 1.

[2] See W.H. Emory, *Notes of a Military Reconnaissance, from Fort Leavenworth, Missouri to San Diego, California* (Washington, D.C., 1860).

[3] *Reports of Explorations and Surveys . . .* (Washington, D.C., 1848), XII, bk. I.

[4] Ibid., p. 114.

[5] Ibid.

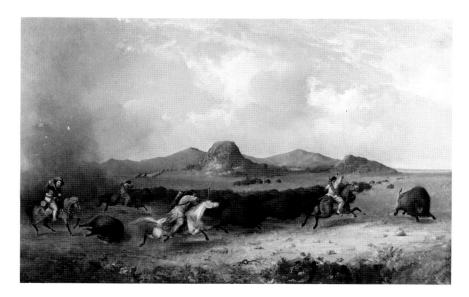

46. John Mix Stanley. *Buffalo Hunt.* 1855?. Oil on canvas, 40 x 62¼". Thomas Gilcrease Institute of American History and Art, Tulsa, Okla.

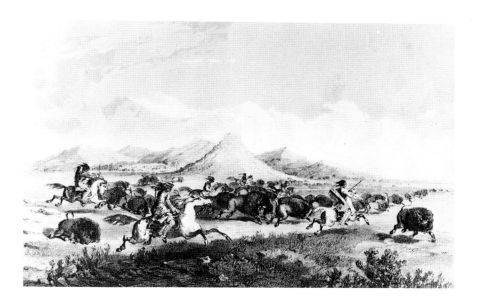

47. John Mix Stanley. *Blackfeet Indians—Three Buttes.* 1860. Colored lithograph, 5¾ x 8⅞". Western History Department, Denver Public Library

Stanley parted company with Kearny in San Diego after completing his assignment to supply finished sketches of the long march. He continued then on his own toward San Francisco aboard the U.S. sloop *Cyane.* It was there that the writer Edwin Bryant visited Stanley in an improvised studio.

Mr. Stanley, the artist of the [Kearny] expedition, completed his sketches in oil, at San Francisco; a more truthful, interesting, and valuable series of paintings, delineating mountain scenery, the floral exhibitions on the route, the savage tribes between Santa Fé and California—combined with camp-life and marches through the desert and wilderness—has never been, and probably never will be exhibited. Mr. Stanley informed

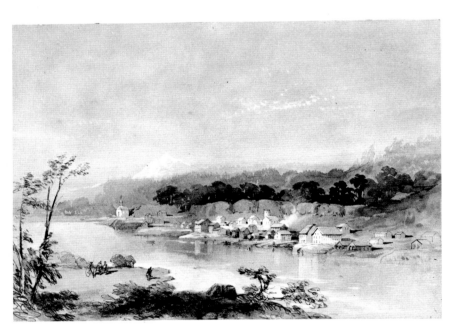

48. Henry J. Warre. *The American Village, Oregon City, in the Willamette Valley, September 2, 1845.* Watercolor and pencil, 9⅜ x 13⅛". Public Archives of Canada, Ottawa

us that he was preparing a work on the savage tribes of North America, . . . which, when completed on his plan, will be the most comprehensive and descriptive of the subject, of any that has been published.[1]

San Francisco was only the beginning of Stanley's odyssey. From here he journeyed north to Astoria, then by canoe more than a thousand miles up the Columbia River and her tributaries to investigate the interior reaches of the disputed Oregon Territory.

Not far south of the Columbia, on the fertile banks of the Willamette River, lay the burgeoning community of Oregon City, subject of one of the most consumingly beautiful views ever painted of a frontier town. Stanley visited Oregon City about a year after British Lieutenant Henry James Warre of the Royal Engineers had passed through. Warre called it "The American Village," terminus of the old Oregon Trail. Back in 1829, Warre explained, "three or four Canadians, retired servants of the Hudson's Bay Company, settled on the banks of the river Willamette, near the beautiful falls, where there is now, in 1846, a flourishing village with two churches, and 100 houses, store houses, &c."[2]

Known today primarily for his art, Warre, in his time, was a spy, responsible for reporting back to the British on the conditions in Oregon. He found the Americans already ensconced, with more on the way. The year preceding Warre's report, Kearny, on a summer's reconnaissance to the Rockies, had passed great numbers of Americans possessed of the Oregon fever. "It was ascertained by us that nearly all the emigrants of this season were going to the Wilhamet [*sic*] river, on which are said to be the best lands within our limits of the Columbia."[3]

Oregon City soon became the hub of commercial and political activity. As the first territorial capital, it supplied lumber for Californians in the gold-rush era; it prided itself on establishing the first newspaper west of the Mississippi and was the center for initial maritime and agricultural enterprise in the Northwest.

It is thought that Stanley spent the winter of 1847–48 in Oregon City, then departed for Hawaii. He returned to the United States via Boston and by 1850 had opened a traveling exhibition of his paintings in Troy, New York. The tour subsequently included New Haven, Hartford, and Washington, D.C. Americans, who had read and heard so much of Oregon, now had pictorial images on which to hitch their dreams.

[1] Edwin Bryant, *What I Saw in California* (New York, 1849), pp. 435–36.

[2] Capt. Henry J. Warre, *Sketches in North America and the Oregon Territory* (Barre, Mass., 1970), p. 20.

[3] Col. Steven W. Kearny, "Report of a Summer Campaign to the Rocky Mountains, Etc., in 1845," in *Annual Report of the Commanding General of the Army* (Washington, D.C., 1845), p. 212.

49. John Mix Stanley. *Oregon City on the Willamette River.* c. 1848. Oil on canvas, 26½ x 40″. Collection Mimi
d. Bloch, New York City

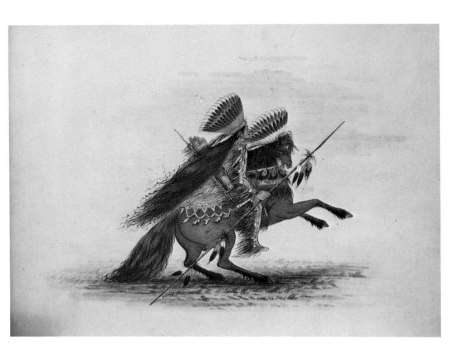

50. George Catlin. *The Jumper (He-Who-Jumps-Over-Every-One)*. 1832. Watercolor, 17 x 24″. Museum of the American Indian, Heye Foundation, New York City

Like other artist-explorers, Paul Kane was concerned with the disappearance of Indian life and culture. Raised in Toronto, he dedicated three years, 1845–48, to travel in the West, compiling profuse visual and verbal records throughout his journeys.

The Man that Always Rides might have been a brave of Blackfeet or Cree origin.[1] Kane wrote that these two tribes waged wars which were "kept up with unremitting perseverance from year to year; and were they as destructive in proportion to the numbers engaged as the wars of civilised nations, the continent would soon be depopulated of the whole Indian race; but, luckily, Indians are satisfied with small victories, and a few scalps and horses taken from the enemy are quite sufficient to entitle the warriors to return to their friends in triumph and glory."[2]

Before going west Kane traveled in Europe for two years and absorbed the spirit of Napoleonic Romanticism. Works from this era set dashing heroes against dramatic backgrounds. The staged effect of his horse and rider, the ominous clouds and distant glow, combine to create a timeless theater. However, Kane probably had more direct inspiration from Catlin, whose works he might have seen either in his Indian Gallery or in his 1841 tome which illustrated *He-Who-Jumps-Over-Every-One*. Whatever the influence on the Canadian, a strong similarity between their portrayals does exist, albeit Kane's horse is devoid of trappings and his Indian shorn of flowing tresses.

While Catlin's watercolor is simple by comparison, his written description of the Crow showman enhances the artistic interpretation.

I have painted him as he sat for me, balanced on his leaping wild horse with his shield and quiver slung on his back, and his long lance decorated with the eagle's quills, trailed in his right hand. His shirt and his leggings, and mocassins, were of the mountain-goat skins, beautifully dressed; and their seams everywhere fringed with a profusion of scalp-locks taken from the heads of his enemies slain in battle. His long hair, which reached almost to the ground whilst he was standing on his feet, was now lifted in the air, and floating in black waves over the hips of his leaping charger. On his head, and over his shining black locks, he wore a magnificent crest or head-dress, made of the quills of the war-eagle and ermine skins; and on his horse's head also was another of equal beauty and precisely the same in pattern and material.[3]

[1] See J. Russell Harper, *Paul Kane's Frontier* (Austin and London, 1971), p. 284.
[2] Quoted from Paul Kane, *Wanderings of an Artist*, reprinted in Harper, op. cit., p. 78.
[3] George Catlin, *Notes and Letters on the Manners, Customs, and Condition of the North American Indians* (London, 1844), I, p. 192.

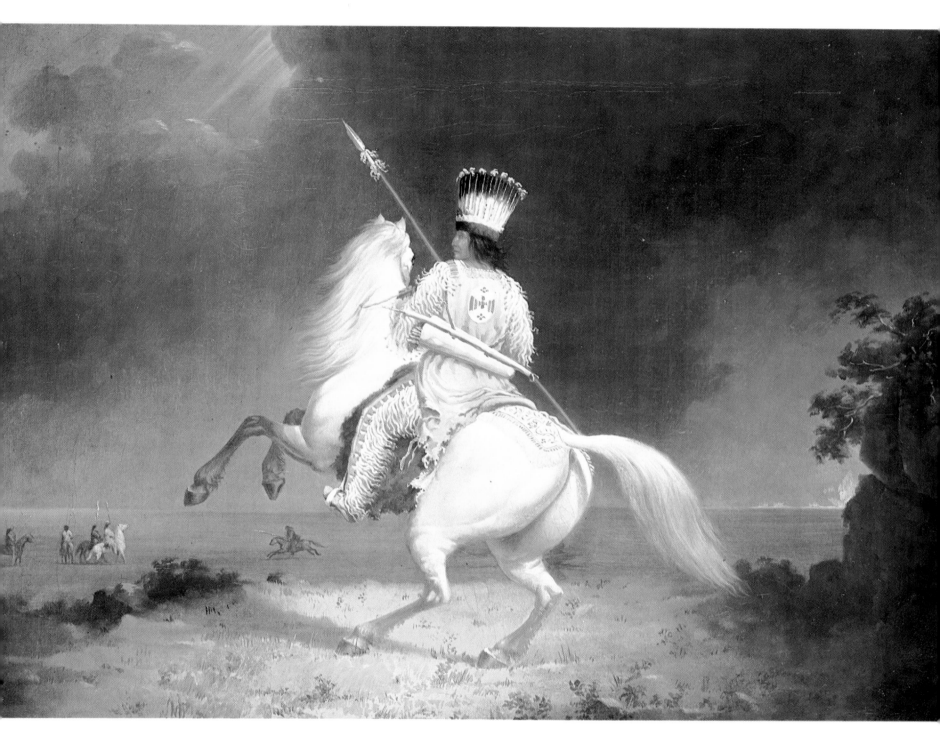

51. Paul Kane. *The Man that Always Rides.* n.d. Oil on canvas, 18¼ x 24″. Royal Ontario Museum, Toronto

From all that we have seen and learnt of the Chinnooks, we have been induced to estimate the nation at about twenty-eight houses, and four hundred souls. They reside chiefly along the banks of a river, to which we gave the same name; and which, running parallel to the sea-coast, waters a low country with many stagnant ponds, and then empties itself into Haley's bay. The wild fowl of these ponds, and the elk and deer of the neighbourhood, furnish them with occasional luxuries; but their chief subsistence is derived from the salmon and other fish, which are caught in the small streams, by means of nets and gigs, or thrown on shore by the violence of the tide. To these are added some roots, such as the wild liquorice, which is the most common, the shanataque, and the wappatoo, brought down the river by the traders.[1]

Forty-one years later, in 1846, while residing at Fort Vancouver, Paul Kane painted these Indians described by Lewis and Clark. The Canadian observed that, "the country which the Chinooks inhabit being almost destitute of furs, they have little to trade in with the whites."[2] However, Washington Irving, less than ten years earlier, told of "the

52. Chilkat blanket. Tlingit. Field Museum of Natural History, Chicago

one-eyed potentate Comcomly, who held sway over the fishing tribe of the Chinooks, and had long supplied the factory with smelts and sturgeons."[3] Comcomly, the chief who had greeted Lewis and Clark, died before Kane's arrival, yet there is no question that the Chinooks fished and sold their catch to whites.

Kane wrote disparagingly about some of the Chinook's customs, such as flattening the foreheads of infants, picking and eating insects out of each other's hair, and keeping slaves from other tribes. He painted their portraits and homes nonetheless. "In the villages they build permanent huts of split cedar boards. Having selected a dry place for the hut, a hole is dug about three feet deep, and about twenty feet square. Round the sides square cedar boards are sunk and fastened together with cords and twisted roots, rising about four feet above the outer level; two posts are sunk at the middle of each end with a crotch at the top, on which the ridge pole is laid, and boards are laid from thence to the top of the upright boards fastened in the same manner."[4]

In the center of the lodge, whether for religious or domestic use, was "a space six or eight feet square, sunk to the depth of twelve inches below the rest of the floor, and enclosed by four pieces of square timber. Here they make the fire, for which purpose pine bark is generally preferred. Around this fireplace, mats are spread, and serve as seats during the day, and very frequently as beds at night."[5]

Kane left a warm and inviting painting of a ceremonial lodge interior, but unfortunately no description of the rites. He ignored the classical effect of lighting caused by the roof's aperture, so admired by other Western artist-explorers. Neither was he struck by Northwest Coast Indian artwork, so prized by contemporary art devotees.

These Indians transformed trees into carved and painted masterpieces, regardless of their end purpose. The complex simplicity of geometric designs infused power into their abstractions of the natural world. The Chilkat blanket is emblazoned with silhouettes of killer whales. Explorers visited the Northwest Coast in the eighteenth century and traded to the Indians iron tools which facilitated carving and permitted further detailing. Their art was not otherwise affected and remains unique.

[1] *History of the Expedition Under the Command of Captains Lewis and Clark* (New York, 1902), II, p. 308.
[2] Paul Kane, *Wanderings of an Artist,* reprinted in J. Russell Harper, *Paul Kane's Frontier* (Austin and London, 1971), p. 94.
[3] Washington Irving, *Astoria, or Anecdotes of an Enterprise Beyond the Rocky Mountains* (Philadelphia, 1836), II, p. 219.
[4] Kane, op. cit., p. 95.
[5] *History of the Expedition . . .* , p. 319.

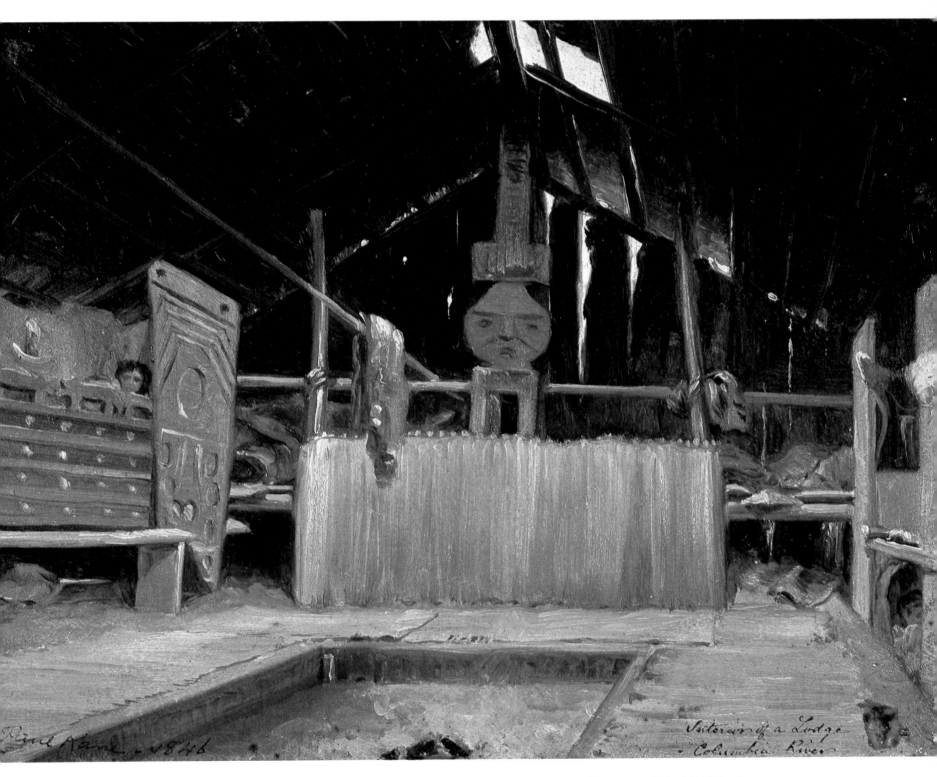

53. Paul Kane. *Interior of a Ceremonial Lodge, Columbia River.* 1846–48. Oil on paper, 9½ x 11½". Stark Museum of Art, Orange, Tex.

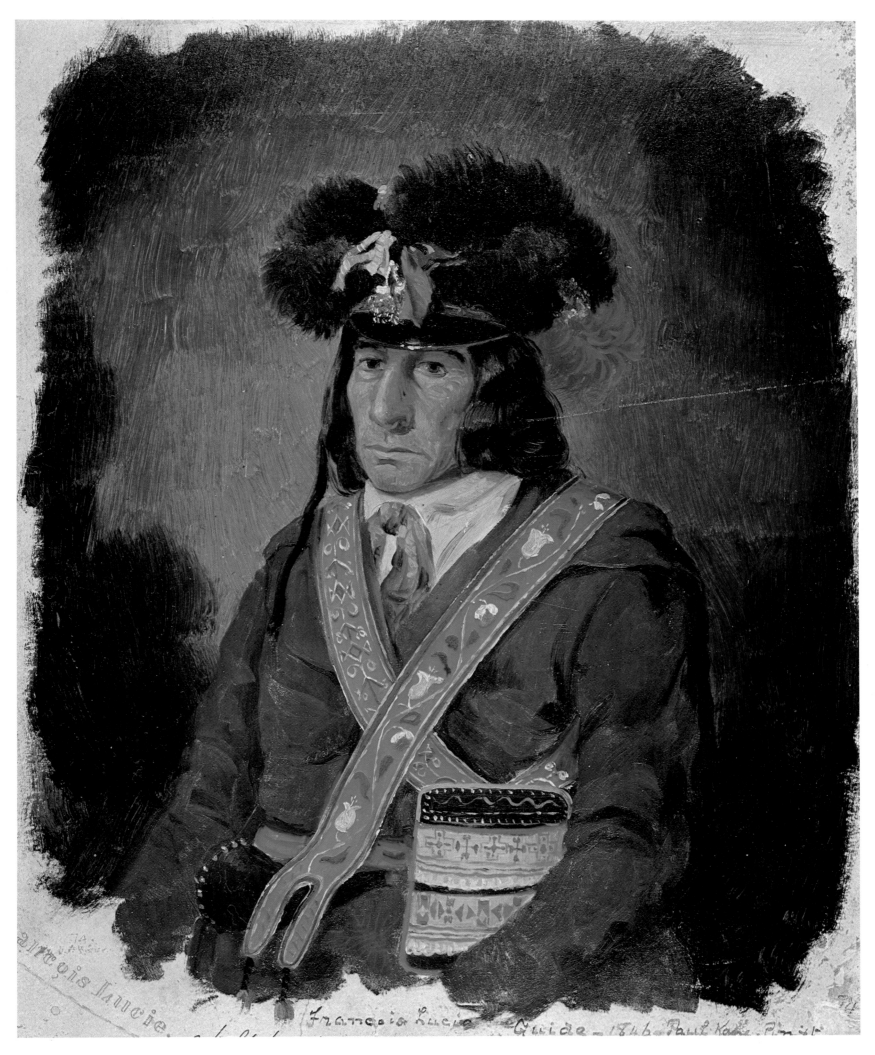

54 Paul Kane. *François Lucie, A Cree Half-breed Guide, Fort Edmonton.* 1846–48. Oil on paper, 10⅞ x 8¾".
Stark Museum of Art, Orange, Tex.

Paul Kane

55. Alfred Jacob Miller. *Pierre, Rocky Mountain Trapper.* c. 1837. Sepia wash, 6¾ x 9¼". Thomas Gilcrease Institute of American History and Art, Tulsa, Okla.

Buried amid the sublime passes of the Sierra Nevada are old men, who, when children, strayed away from our crowded settlements, and, gradually moving farther and farther from civilization, have in time become domiciliated among the wild beasts and wilder savages—have lived scores of years whetting their intellects in the constant struggle for self-preservation; whose only pleasurable excitement was found in facing danger; whose only repose was to recuperate, preparatory to participating in new and thrilling adventures.[1]

When these recluses deigned to come out of the woods, they occasionally supplied fur companies with pelts, hunted for traveling parties, tracked Indians, or guided government expeditions, emigrant trains, and railroad surveys. "It was the trader and trapper who first explored and established the routes of travel which are now, and always will be, the avenues of commerce in that region. *They* were the 'pathfinders' of the West, and not those later official explorers whom posterity so recognizes. No feature of western geography was ever *discovered* by government explorers after 1840."[2]

Of this unique breed, less might be known had it not been for the artist-explorer. At Fort Edmonton, Paul Kane hunted with François Lucie, a voyageur of Cree and white parentage. Some distance from the fort they came upon a grizzly and held fire on Lucie's instructions. "A younger man than he, who had his character to make, might have been foolish enough to have run the risk, for the sake of the standing it would have given him amongst his companions; but François had a character established, and would not risk attacking so formidable an animal with only two men."[3]

When the artist Alfred Jacob Miller accompanied Captain William Drummond Stewart, their companion was Pierre, a hunter whose father was a white Canadian and his mother an Indian. Praising the work of this seventeen year old, Miller added that Pierre wore "in his hat by way of ornament two turkey feathers, a fox-tail-brush, and his dear darling pipe, his solace in all his troubles."[4] Pierre enjoyed a dangerous game; he would single out a buffalo, first wounding and then teasing it. Despite warnings, the hunter persisted in this sport and eventually lost.

Albert Bierstadt spent several days in the fall of 1859 at Fort Laramie, from which Jim Bridger obtained provisions in late October and November of that year. Bierstadt sketched two portraits which probably are of Bridger, while the *Mounted Trapper* could be a younger version of that venerable figure. At about eighteen Bridger answered William H. Ashley's ad in the St. Louis *Missouri Republican* for "enterprising young men . . . to ascend the Missouri River to its source, there to be employed for one, two, or three years."[5] Bridger later "guided emigrant trains. He shepherded captains and colonels and generals and led their detachments by the hand. He ministered to settlers and explorers and surveyors and Mormons and railroad builders. He was an atlas of the West and a compendium of information to whoever needed geography or skill. He is the truest embodiment of the way of life that lingered on after its time."[6]

56. Albert Bierstadt. *Mounted Trapper.* c. 1859. Oil on board, 12½ x 9½". Thomas Gilcrease Institute of American History and Art, Tulsa, Okla.

[1] T.D. Bonner, *The Life and Adventures of James P. Beckwourth* (New York, 1858), p. iii.

[2] Hiram M. Chittenden, *The American Fur Trade of the Far West* (New York, 1902), I, p. ix.

[3] Quoted from Paul Kane, *Wanderings of an Artist,* reprinted in J. Russell Harper, *Paul Kane's Frontier* (Austin and London, 1971), p. 139.

[4] Marvin C. Ross, *The West of Alfred Jacob Miller* (Norman, Okla., 1968), opp. p. 53.

[5] J. Cecil Alter, *James Bridger* (Salt Lake City, 1925), p. 4.

[6] Bernard DeVoto, *Across the Wide Missouri* (Cambridge, Mass., 1947), pp. 377–78.

Artists of the

Early Frontier

Part of the reason behind the professed sentiment of Benjamin Franklin and a handful of supporters for making the turkey the national bird may have stemmed from the fact that he evidenced so many American traits. The turkey was big but not ponderous; he never put his head in the clouds, but flew close to the ground; and he was robust, colorful, and hard to bring down. "We startled a couple of Deer," wrote Audubon in April, 1843, on his way up the Missouri to Fort Union, "and a female Turkey flying fast; at my shot it extended its legs downward as if badly wounded, but it sailed on."[1]

In his painting of the *Wild Turkey*, Audubon combined two worlds of endeavor, science and art. This oil painting, a rich translation of Audubon's fresh, lucid watercolor technique for which he is best known, embodies the spirit of nature itself. It is as an artist that Audubon will be remembered. Yet his work was staunchly defended for its naturalism. " 'It is difficult to give a true picture of a bird with the same effect of perspective as a landscape, and the lack of this is no defect in a work on Natural History. Naturalists prefer the real color of objects to those accidental tints which are the result of the varied reflections of light necessary to complete picturesque representations, but foreign and even injurious to scientific truth.' "[2]

Audubon and his son, John Woodhouse, were seldom less than candid in their pictorializations of animals of the American West, which is surprising in light of some of the reports which came to them. John Woodhouse traveled through Texas in 1845 to collect specimens for *The Quadrupeds of North America*. No less than the Texas Rangers and Sam Houston gave him advice on where and how to hunt the dreaded jaguar. His counsel on the manners and habits of the illustrious Texas "jackass rabbit" was not so expert. Reported to be as big as a fox and have the appetite and stealth of a wolverine, the Texas jack was a distinct disappointment to Audubon when he beheld his first. One account had reported that " 'when it has killed any game, it climbs a tree and utters a howl of invitation to other animals. They come, eat, and die, because the flesh was poisoned by the Rabbit's bite. It descends from the tree and makes a meal from the quarry that its trick has put at its disposal.' "[3]

[1] Maria R. Audubon, *Audubon and His Journals* (New York, 1897), I, p. 461.
[2] Cuvier, quoted in Audubon, op. cit., II, p. 522.
[3] Quoted from Dr. Hernandez in Alice Ford, ed., *Audubon's Animals: The Quadrupeds of North America* (New York, 1951), p. 199.

57. John Woodhouse Audubon. *Texan Hare. Lepis Texianus.* 1848. Lithograph, 21⅞ x 27⅞". Amon Carter Museum, Fort Worth

58. John James Audubon. *Wild Turkey*. n.d. Oil on canvas, 45 x 33″. Thomas Gilcrease Institute of American History and Art, Tulsa, Okla.

William Jacob Hays

Of the host of artists who went west in the nineteenth century, few returned without some pictorial representation of the buffalo. Acknowledged as omnipresent, the animal became something of an aesthetic hallmark, because the artist who was thought to have painted the best bison was also thought to be the most knowledgeable about the West. Swiss artist Rudolph Friederich Kurz, who, incidentally, left no pictures of buffalo, maligned Catlin as a "Yankee humbug" for, among other reasons, "his buffalo herds . . . consist of nothing but bulls—no cows or calves."[1] And Bodmer, Kurz alleged, made the same error.

In his famous buffalo pictures, William Jacob Hays was criticized for leaving the buffalo grass too long, the buffalo humps too high, and the buffalo chips out entirely. To the last charge he laconically retorted that "as they are by no means a pleasant adjunct to a picture, I did not introduce them."[2] About the other censures, in which Audubon's *American Bison or Buffalo* was laudably compared as the correct view, Hays was less reserved. The "critic," he wrote, "must be joking when he refers to Audubon's plate of the buffalo. Audubon's written description is correct. He brought back a skin. This was set up by a taxidermist in New York who found it very difficult to do anything with it as he had no skeleton to place in it. Mr. Audubon made a reduced drawing from this with the camera lucida, the specimen was afterwards sent to Europe. And this is the carefully prepared plate, by which he attempts to judge my picture."[3]

Audubon, however, was not ignorant of the buffaloes' countenance, as a letter from him on the upper Missouri in May, 1843, shows. "This is a wild and melancholy looking district, but upon it countless multitudes of buffaloes live and die, even more by the arrow and the rifle bullet than by drowning, while attempting to cross the rapid Missouri. The shores are often strewed with carcases, on which the wolf, the buzzard and the raven gorge themselves, at leisure and undisturbed, for hunters rarely, if ever, shoot at any of them."[4]

George Catlin, in his travels by canoe down the Missouri in 1832, described a similar condition. The river at one point was blackened with buffalo, which terrified the small party and from which, Catlin admitted, "we were highly delighted to make our escape."[5]

Aside from Audubon and Hays, few major American animal painters reached the Far West. Peter Moran, part of Rosa Bonheur's and Edwin Landseer's American following, was an exception later in the century. He is thought to have preceded his brother Thomas into the West, making excursions as far as New Mexico and Wyoming in the late 1860s. His pencil-and-wash drawing of *Greedy Wolves over Dead Buffalo* is characteristic of America's romantic vision of the buffalo and its demise.

[1] J.N.B. Hewitt, ed. and Myrtis Jarrell, trans., *Journal of Rudolph Friederich Kurz* (Washington, 1937), pp. 130–31.
[2] *Turf, Field, and Farm* (April, 28, 1866), 266.
[3] Ibid. For a more complete account of this controversy, see Robert Taft, *Artists and Illustrators of the Old West* (New York, 1953), pp. 48–51.
[4] J.J. Audubon, "Rocky Mountain Expedition: Letter From Mr. Audubon," *New York Tribune* (May 10, 1843), from a clipping in the Western History Department, Denver Public Library.
[5] George Catlin, *Letters and Notes on the Manner, Customs, and Condition of the North American Indians* (London, 1844), II, p. 13.

59. Peter Moran. *Greedy Wolves over Dead Buffalo.* 1879–90. Pencil and ink wash, 7⅝ x 14¼". Amon Carter Museum, Fort Worth

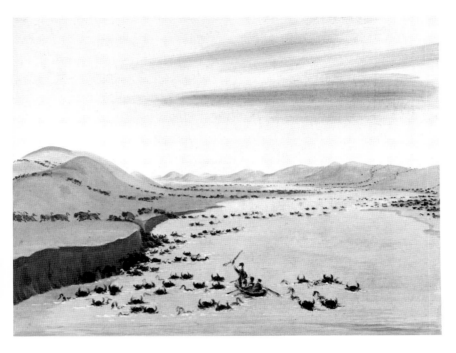

60. George Catlin. *Buffalo Herds Crossing the Upper Missouri.* 1832. Oil on canvas, 11¼ x 14½″. National Collection of Fine Arts, Smithsonian Institution, Washington, D.C.

61. John James Audubon. *American Bison or Buffalo.* 1845. Colored lithograph, 20⅞ x 26⅝″. Amon Carter Museum, Fort Worth

62. William Jacob Hays. *Herd of Buffalo.* 1862. Oil on canvas, 25½ x 47⅝″. Denver Art Museum. Fred E. Gates Collection

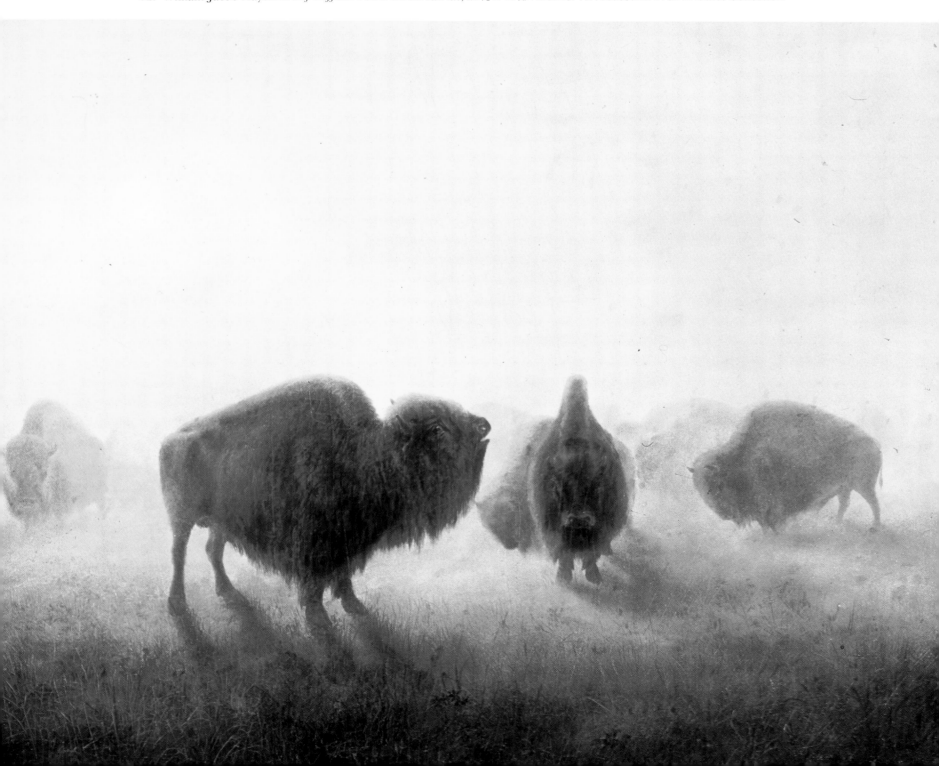

63. Kentucky flintlock rifle. c. 1820–30. .45 caliber. Length 52¾″. Winchester Museum, Buffalo Bill Historical Center, Cody, Wyo.

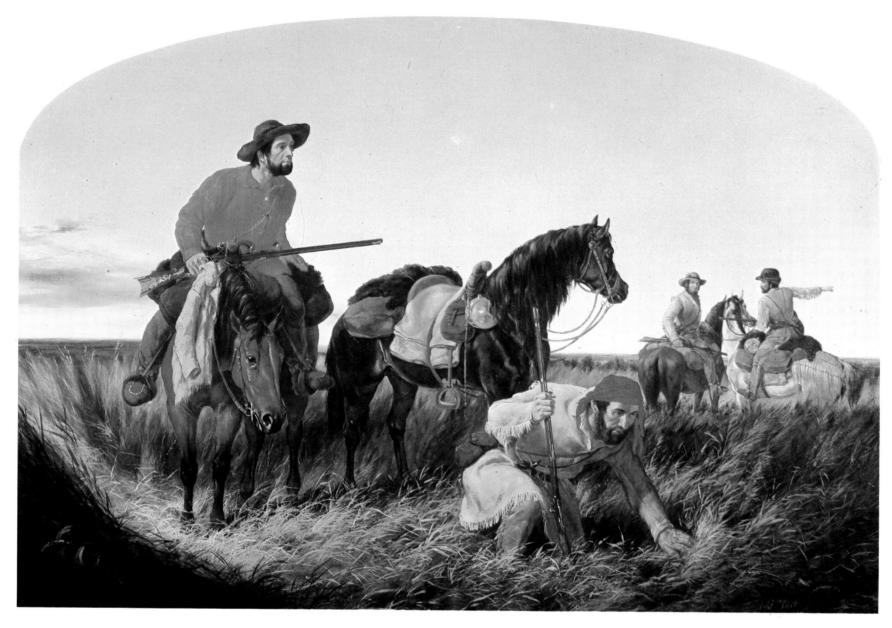

64. Arthur F. Tait. *Trappers at Fault.* 1852. Oil on canvas, 36 x 50″. Denver Art Museum. Helen Dill Collection

Among the influences that George Catlin exerted in his years of touring European capitals with his famed Indian Gallery was the encouragement of a young British painter, Arthur F. Tait, to come to America. Tait was interested in painting animals and scenes of outdoor life, and the American wilderness became his studio.

Within a few years of Tait's arrival in New York he was doing cooperative work for Currier & Ives. He soon became known in select parlors for his lustrous portraits of animals, domestic and wild. The public came to know him for his scenes of Adirondack and Far Western life and adventure as distributed by the enterprising lithographers. Tait never concerned himself with Western animals and never traveled farther west than Chicago, his inspiration coming primarily from the storehouse of material in New York's Astor Library.

Some have contended that his painting of *Trappers at Fault* is pure imagination; others feel that it might have been influenced by Paul Kane's depictions of mid-century Canadian buffalo hunters. Whatever the case, they are no doubt early-day buffalo runners, a tradition begun on the Northern Plains and witnessed as early as the 1820s by Peter Rindisbacher.

The hunters in Tait's painting carry lightweight Kentucky flintlock rifles, symbols of frontier firepower through the early 1830s. These elegant but impractical rifles were replaced in that decade by the percussion Plains rifles manufactured by the Hawken brothers in St. Louis.

Losing the trail was frustrating to a frontiersman, but of little notice compared to a prairie fire such as the one depicted in Tait's *Fire Fight Fire.* To stand and battle the blaze might succeed if conditions were right, yet few would dare, especially those who had read George Catlin's account. "But who has seen the vivid lightnings, and heard the roaring thunder of the rolling conflagration which sweeps over the *deep-clad* prairies of the West? Who has dashed, on his wild horse, through an ocean of grass, with the raging tempest at his back, rolling over the land its swelling waves of liquid fire?"[1]

[1] George Catlin, *Letters and Notes on the Manners, Customs, and Condition of the North American Indians* (London, 1844), II, p. 18.

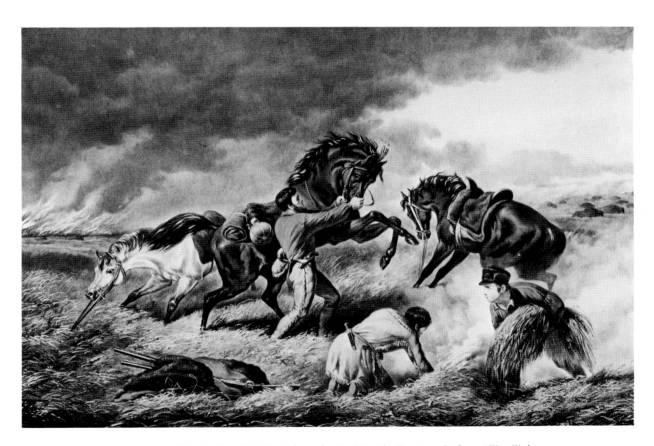

65. Arthur F. Tait. *Life on the Prairie. The Trappers Defense "Fire Fight Fire."* 1862. Toned lithograph, 18⅜ x 27¼". Lent by The Honorable Robert D. Coe, Cody, Wyo.

66. Beaver hat. The National Park Service, Grand Teton National Park

67. John James Audubon. *American Beaver*. c. 1845. Colored lithograph, 7 x 10⅝". Amon Carter Museum, Fort Worth

M id-nineteeth-century American painters continued to harken back to themes of the early West long after those days had passed into history. Such was the enduring glory of the trapper, and such was the vision of the artist William Ranney.

Located in West Hoboken, New Jersey, Ranney's studio, according to Henry Tuckerman,

> formed a startling contrast to most of the peaceful haunts of the same name, in the adjacent metropolis; it was so constructed as to receive animals; guns, pistols, and cutlasses hung on the walls; and these, with curious saddles and primitive riding gear, might lead a visitor to imagine he had entered a pioneer's cabin or border chieftain's hut: such an idea would, however, have been at once dispelled by a glance at the many sketches and studies which proclaimed that an artist, and not a bushranger, had here found a home.[1]

Like the frontier he painted, Ranney's works exhibited a natural truth and a fresh glow which critics claimed gave them a national flavor of their own. "A more characteristic introduction to *genre* painting in America can hardly be imagined," continued Tuckerman, for Ranney had struck on "a native and promising path."[2]

It was vaingloriously touted that the American trappers, Ranney's subjects, stood alone in their ability to deal with the wilderness. An experienced trader confirmed this when he had boasted to Captain Bonneville that one American trapper was " 'equal to three Canadians in point of sagacity, aptness at resources, self-dependence, and fearlessness of spirit. In fact, no one can cope with him as a stark tramper of the wilderness.' "[3]

Despite the professed American character and nationalistic interpretation of the trapper's frontier, the initial fortunes of this enterprise were born of British taste. Tradition has it that Beau Brummel started the fad by strolling through St. James's Park in a high-top beaver hat. At once all of London's "hatters were besieged for its duplicate, for every dandy must needs have one."[4] The American beaver, known in fable for his instinctive cunning and fabulous intelligence, was put to the test by this foppish demand. He was hunted relentlessly for the next twenty years until, near extinction, he found reprieve when the beaver hat fad passed. The test, however, had proved false the beaver's alleged intelligence quotient. In 1845 Audubon observed and published the fact that in "cunning the Beaver is greatly exceeded by the Fox, and but a few grades higher than the Muskrat in the scale of sagacity."[5]

[1] Henry Tuckerman, *Book of the Artists* (New York, 1867), pp. 431–32.
[2] Ibid., p. 432.
[3] Washington Irving, *The Rocky Mountains* (Philadelphia, 1837), I, p. 33.
[4] Percy H. Booth, *West Wind* (Los Angeles, 1934), p. 39.
[5] Alice Ford, ed., *Audubon's Animals* (New York, 1951), p. 206.

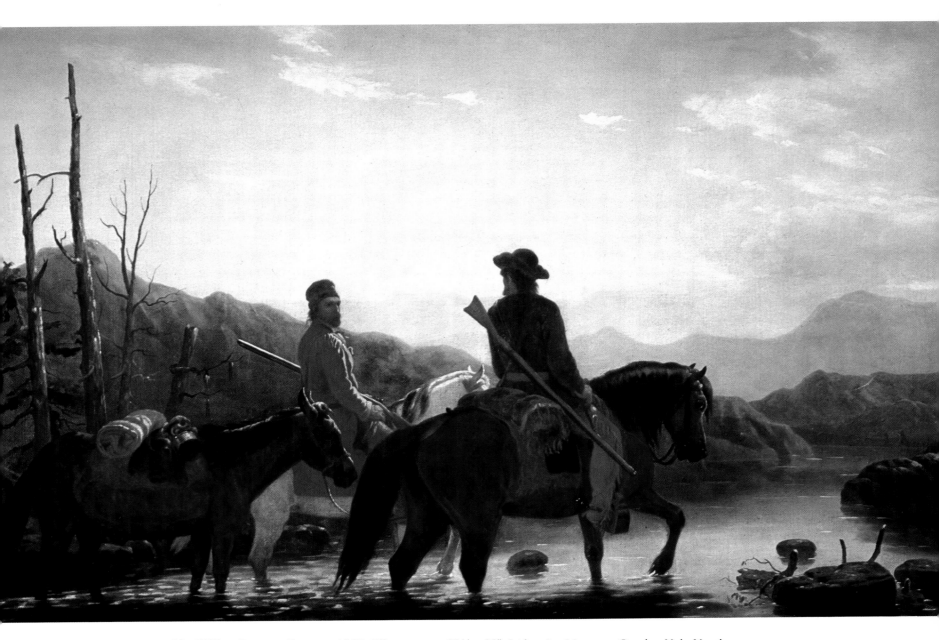

68. William Ranney. *Trappers.* 1856. Oil on canvas, 23½ x 36″. Joslyn Art Museum, Omaha, Neb. Northern
Natural Gas Company Collection

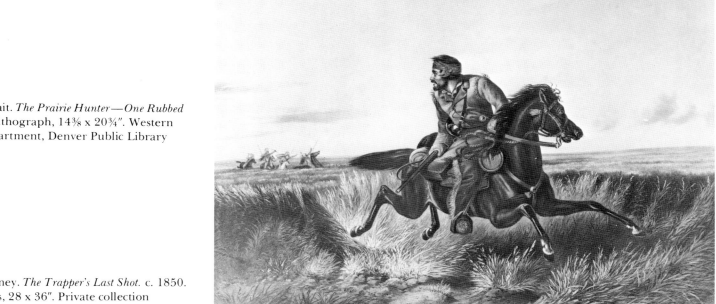

69. Arthur F. Tait. *The Prairie Hunter—One Rubbed Out.* 1852. Lithograph, 14⅜ x 20¾″. Western History Department, Denver Public Library

70. William Ranney. *The Trapper's Last Shot.* c. 1850. Oil on canvas, 28 x 36″. Private collection

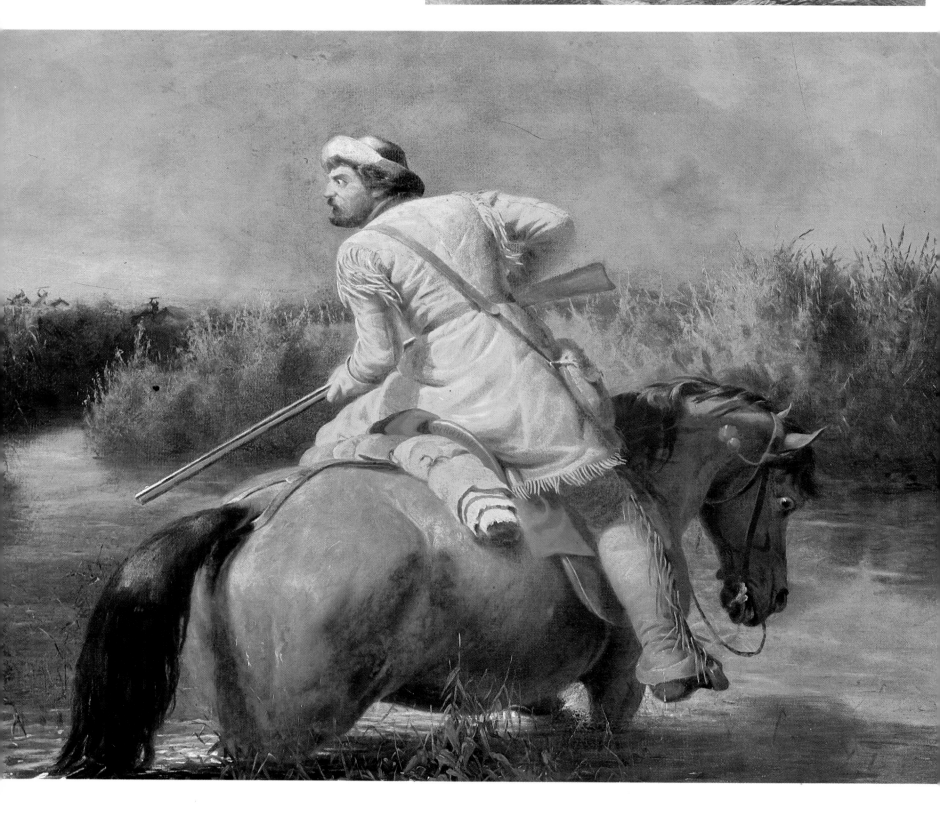

Blackfeet! Their very name sounded an exclamation of terror—their strength and vengeance occupied the minds of all who ventured into the Northern Plains and Rockies. Alfred Jacob Miller reverently dubbed them "the *bête noirs* [*sic*] of the mountains."[1] Among the free trappers and hunters they were subjects of the most hair-raising tales ever conceived around a campfire.

"The grace of God won't carry a man through these prairies!" commented Jim Bridger in 1837. "It takes powder and ball."[2] Bridger's companion, Joseph Meek, knew that lesson well when he started out to avenge the loss of his friend Manhead, leader among the Delaware, who had fallen to the Blackfeet the season before. Meek stole some Blackfeet horses as a countercoup and expected he had evened the score. The Blackfeet did not agree. Throughout the spring and summer of 1837 the trappers in Meek's party kept one eye on their traps and the other on the horizon.

One of the many skirmishes resulting from this feud occurred late in the spring when Meek and his trappers came upon a Blackfeet camp near the headwaters of the Madison Fork. They decided to pick a fight; the battle lasted two days. As recounted in later years, the incidents of this confrontation became clichés in nineteenth-century painting of Western adventure. "The trappers rode to the fight . . . and charged the Blackfeet furiously, . . . A general skirmish now took place. Meek, who was mounted on a fine horse, was in the thickest of the fight. He had at one time a side to side race with an Indian who strung his bow so hard that the arrow dropped, just as Meek, who had loaded his gun running, was ready to fire, and the Indian dropped after his arrow."[3]

One scene from the battle was even supposed to have been sketched from life by John Mix Stanley. "Just before getting clear of this entanglement," wrote Frances Victor, "Meek became the subject of another picture, by Stanley, who was viewing the battle from the heights above the val-ley. The picture which is well known as 'The Trapper's Last Shot,' represents him as he turned upon his horse, a fine and spirited animal, to discharge his last shot at an Indian pursuing."[4]

Stanley, of course, was nowhere near the scene. He did not even get into the Far West until 1845 and did not meet Meek until 1847. The tableau which Victor described comes directly from William Ranney's painting, *The Trapper's Last Shot,* produced in two versions in 1850 and distributed widely as engravings by the American Art-Union and the Western Art-Union. Currier & Ives even expanded its popular appeal by issuing a lithograph which became known to thousands.[5]

Stanley is known to have painted three similar works in 1851, two of which, *Flight of a Mountain Trapper* and *The Trapper's Escape,* pictured this same episode in Meek's life.[6] These pictures were consumed by the Smithsonian fire in 1865, but prior to their destruction Arthur F. Tait possibly had used their inspiration for two Currier & Ives prints, *A Check. Keep Your Distance* and *The Prairie Hunter—One Rubbed Out.* Among other mid-century artists who portrayed the popular subject were Charles Deas in his *Last Shot,* which has never been seen since it was distributed by the American Art-Union in 1857, and Louis Maurer, whose *The Last Shot* was distributed by Currier & Ives in 1858.

[1] Marvin C. Ross, *The West of Alfred Jacob Miller* (Norman, Okla., 1968), opp. p. 13.

[2] David L. Brown, "Three Years in the Rocky Mountains," *Daily and Weekly Atlas* (September, 1845).

[3] Mrs. Frances Fuller Victor, *The River of the West* (Hartford, 1870), pp. 229–30.

[4] Ibid., pp. 230–31.

[5] Francis S. Grubar, *William Ranney: Painter of the Early West* (Washington, D.C., 1962), pp. 33–34.

[6] *Portraits of North American Indians with Sketches of Scenery, Etc., Painted by J.M. Stanley* (Washington, D.C., 1852), pp. 40–41.

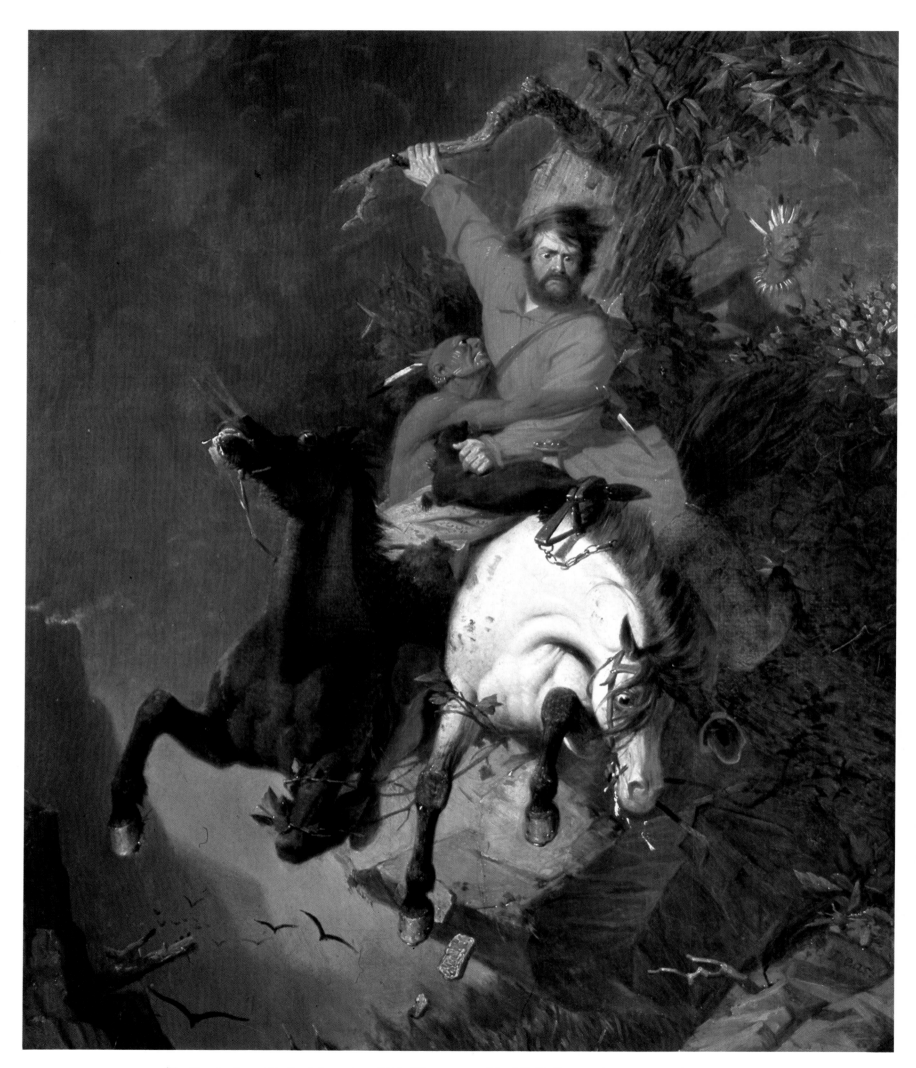

71. Charles Deas. *The Death Struggle.* c. 1845. Oil on canvas, 30 x 25″. Shelburne Museum, Inc., Shelburne, Vt.

It may have been his selection of Western subjects or the unpretentious directness of his style which prompted observers to comment on the "peculiar 'native American' zest"[1] of Charles Deas's paintings. On reviewing the mid-century arts in St. Louis, traveler and author Charles Lanman noted in 1846 that "the bright particular star, who uses the pencil here, is Charles Deas. . . . He makes this city his head-quarters, but annually spends a few months among the Indian tribes, familiarizing himself with their manners and customs, and he is honorably identifying himself with the history and scenery of a most interesting portion of the continent. The great charm of his productions is found in the strongly marked national character which they bear."[2]

On an expedition to the Pawnee villages in 1844, Deas won the name "Rocky Mountains." He dressed and acted the part of a trapper, "had a broad white hat—a loose dress, and sundry traps and truck"[3] with which to confront the wilderness. He also possessed a remarkable facility for "winning the good graces of the Indians. Whenever he entered a lodge it was with a grand flourish and a mock bow that would put even an Ottoman in ecstasies. And, as he said he was sure they did not understand English, he always gave his salutations in French and with a tone and gestures *so irresistibly comic that, generally, the whole lodge would burst into a roar of laughter,* though not the shadow of a smile could be seen on his face."[4]

Deas's painting and exploring career was cut short by a mental breakdown in 1847. Before that he had exhibited frequently in the American Art-Union, and, like Ranney, prints of his art found broad dissemination among the public. According to Henry Tuckerman, "those who were accustomed to look . . . into the rooms of the Art Union in New York, cannot fail to have seen . . . very spirited representations of Indian or hunter life. There was a wildness and picturesque truth about many of these specimens, in remarkable contrast to the more formal and hackneyed subjects around them."[5] *Death Struggle* is among the few extant paintings by Deas, though he was a prolific artist.[6] Prints of this work were distributed by the Art-Union.

The theme of voyageurs on a river, ably portrayed in Deas's *The Trapper and His Family*, was employed with great success by the artist. Though lacking the strength and mood of works with similar subject by his fellow St. Louis artist George Caleb Bingham, the Deas watercolor conveys an innocence commensurate with the simplicity of mountain life.

[1] Henry T. Tuckerman, *Book of the Artists* (New York, 1867), p. 425.
[2] Charles Lanman, *A Summer in the Wilderness* (New York, 1847), pp. 15–16.
[3] Lt. J. Henry Carleton, *The Prairie Logbooks* (Chicago, 1893), p. 28.
[4] Ibid., p. 100.
[5] Tuckerman, loc. cit.
[6] See John Francis McDermott, "Charles Deas: Painter of the Frontier," *Art Quarterly*, 13 (autumn, 1950), 293–311.

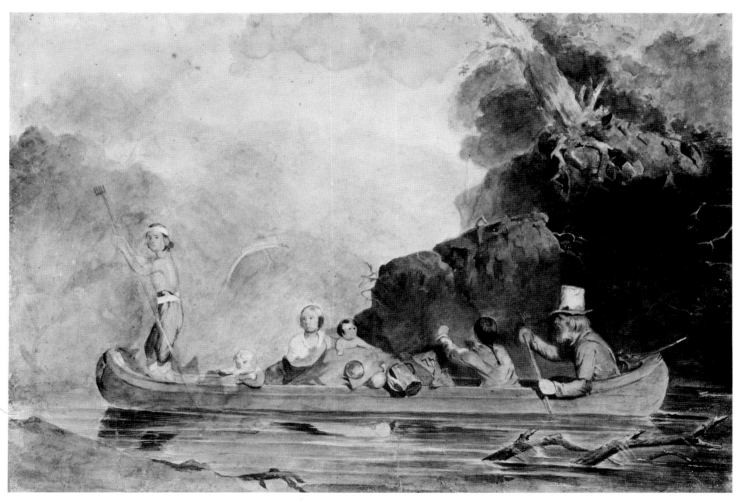

72. Charles Deas. *The Trapper and His Family.* n.d. Watercolor, 13⅜ x 19½". Museum of Fine Arts, Boston. M. and M. Karolik Collection

Carl Wimar

The splendor and histrionics associated with the mountain men and the Indians receded gradually as a theme for art and literature when new frontiers evolved in the 1840s and 1850s. Texas was annexed and made a state in one year, 1845. California and the Oregon Territory came under the United States wing in the same decade, and the Mormon cavalcade had opened the Great Basin as a promised land. America was on the move, and the direction was westward.

Among the artists who began to open their eyes to this new mobility was Carl Wimar, a painter from St. Louis. Like many frontier artists, he began by decorating signboards, coaches, and steamboats. At twenty-four he departed for Düsseldorf to learn something of art and theater. He studied primarily under Emanuel Leutze, coming away with a sense for history painting that could only be learned in that most fertile of German art schools. His is termed the "Düsseldorf *tableau* style," a sometimes uncon-

vincing means of representing action as "a moment frozen in time."[1] And though his lessons were German, Wimar's subjects breathed American spirit. "They call me the Indian painter," he wrote home in 1854, "and many thought I was a descendant of the Indians."[2]

It was during his stay in Düsseldorf and under the tutelage of Leutze that Wimar painted *The Attack on an Emigrant Train*. In its stylized grandeur the painting synthesized the trepidation and nightmarish experiences potentially inherent in the move west. Tales of this sort were as old as the Santa Fe Trail, but became more frequent as the roads west expanded and filled with emigrants. Josiah Gregg told of a nocturnal scare by Pawnees on his troop of wagons bound home from Santa Fe in 1838. After an initial burst of fire, Gregg writes that his camp dissolved in complete confusion.

> ... some, who had been snatched from the land of dreams, ran their heads against the wagons— others called out for their guns while they had them in their hands. During the height of the bustle and uproar, a Mexican servant was observed leaning with his back against a wagon, and his fusil elevated at an angle of forty-five degrees, cocking and pulling the trigger without ceasing, and exclaiming at every snap, *"Carajo, no sirve!"*—Curse it, it's good for nothing.[3]

Wimar had his own, less critical, encounter with an Indian attack. After his return to America in 1856 he found it profitable to make several trips up the Missouri to study Indians. The first journey took him to Fort Clark in 1858. "Scarcely had we arrived there," Wimar related to his friends in Düsseldorf, "when a number of squaws surrounded us and exhibited so many signs of their attachment to us that, for the time, we were quite overpowered. Fortunately I had but trifles about my person, for as the crowd became more dense, I felt their hands in all my pockets. It was a great relief when a party of our men followed and delivered us, else from 'pure Love' we would have been rifled of everything we possessed."[4]

Many artists of the West after Wimar depicted scenes of Indians attacking wagon trains. It became a popular theme which reached well into the twentieth century with dramatic versions by Frederic Remington, Charles Russell, and W.H.D. Koerner. F.O.C. Darley's wash drawing, probably painted in the 1860s, remains one of the most spirited renditions of such an encounter.

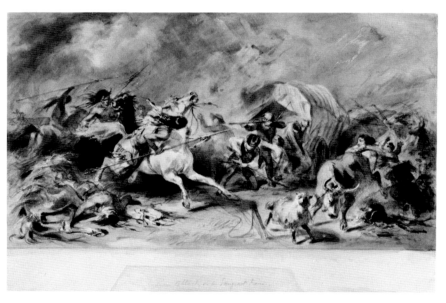

73. F.O.C. Darley. *Indian Attack on an Emigrant Train*. 1860–70. Wash over pencil on board, 10¼ x 18⅛". Museum of Fine Arts, Boston. M. and M. Karolik Collection

[1] Donelson F. Hoopes, "The Düsseldorf Academy and the Americans," in *The Düsseldorf Academy and the Americans* (Atlanta, 1972), pp. 22–23.
[2] William R. Hodges, *Carl Wimar* (Galveston, 1908), p. 15.
[3] Reuben Gold Thwaites, ed., *Early Western Travels* (Cleveland, 1905), XX, pp. 90–91.
[4] Quoted in Hodges, op. cit., p. 21.

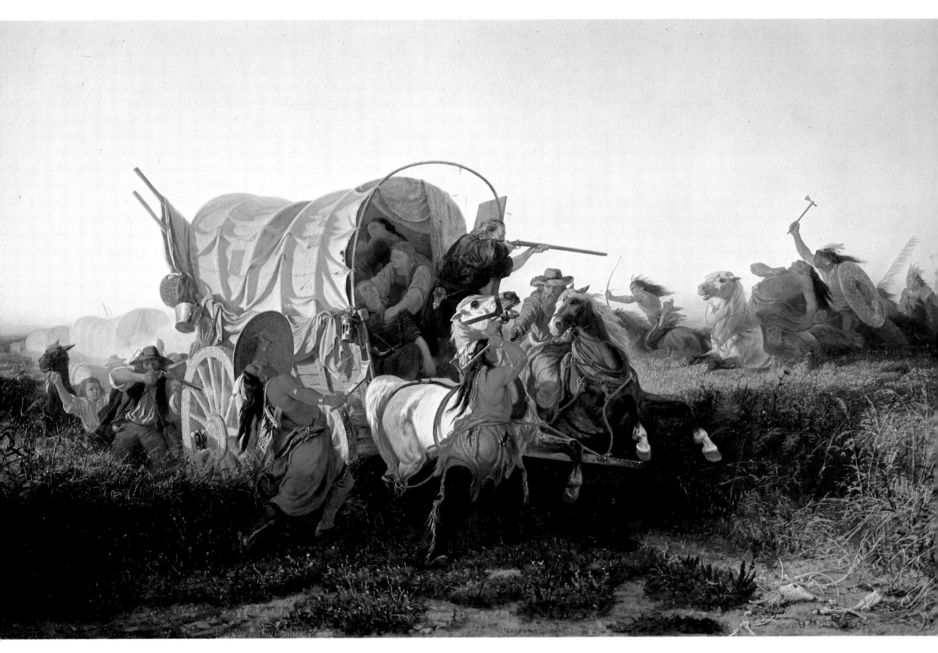

74. Carl Wimar. *The Attack on an Emigrant Train.* c. 1856. Oil on canvas, 55¼ x 79″. University of Michigan Museum of Art, Ann Arbor. Bequest of Henry C. Lewis

75. N. Orr after William Ranney. *Boone and His Companions.* 1854?. Engraving, 3½ x 4¾". Amon Carter Museum, Fort Worth

76. George Caleb Bingham. *Daniel Boone Escorting Settlers Through the Cumberland Gap.* 1851. Oil on canvas, 36½ x 50". Washington University Gallery of Art, St. Louis

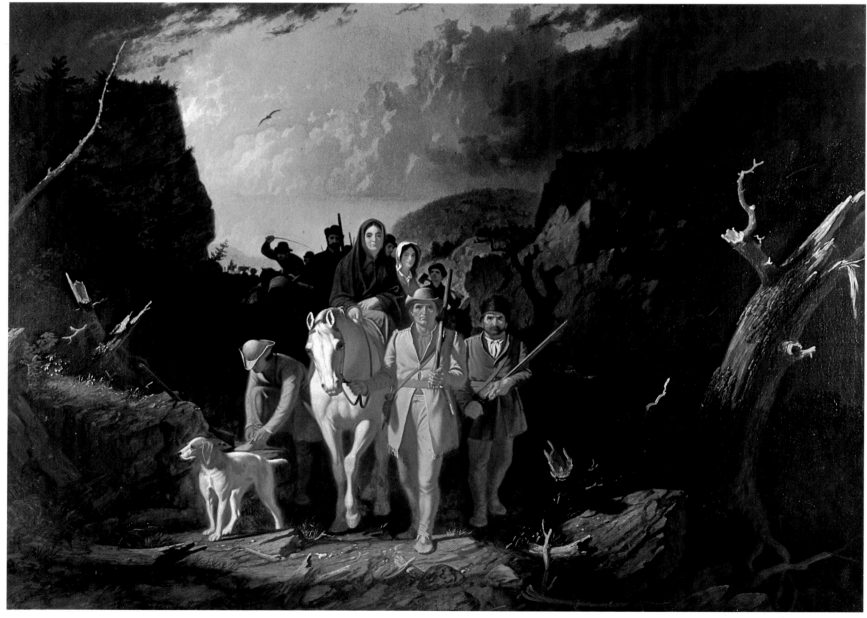

George Caleb Bingham

The same year that Carl Wimar returned from Europe to St. Louis, that city gave up her finest artist to Europe. It was 1856 when George Caleb Bingham arrived in Düsseldorf. He set up his studio next to Leutze's and began to work. Only one thing distinguished Bingham from Wimar—he was already well established as a painter of national recognition. It seems that he had come to the academy more intent on challenging Leutze than learning from him. Already Bingham had painted some of his finest works; he knew much of history painting, tableaux, and drama.

Five years before going to Germany, Bingham had completed his historic masterpiece, *Daniel Boone Escorting Settlers Through the Cumberland Gap*. Bingham's attraction to Boone as a subject emanated from a mid-century interest in historic frontier characters. For Bingham and other artists, "the character and exploits of a personality such as Daniel Boone . . . assumed heroic proportions—a kind of democratic homespun equivalent of a Ulysses-Hercules type."[1]

Bingham's portrayal of Boone and his companions bridging the Cumberland Gap embodied all the popular conceptions of his day. J.J. Audubon had described Boone in bold terms. "The stature and general appearance of this wanderer of the western forests approached the gigantic. His chest was broad and prominent; his muscular powers displayed themselves in every limb; his countenance gave indication of his great courage, enterprise, and perseverance; and when he spoke, the very motion of his lips brought the impression that whatever he uttered could not be otherwise than strictly true."[2]

Of the occasion, Boone spoke rather prosaically. " 'From the top of an eminence we saw with pleasure the beautiful level of Kentucky.' "[3] Timothy Flint, whose *Biographical Memoir of Daniel Boone* appeared in 1833, was less restrained. The event took on something resembling the fervor of the Second Coming.

The last crags and cliffs of the middle ridges had been scrambled over . . . they stood on the summit of Cumberland mountain, the farthest western spur of this line of heights. . . . What a scene opened before them! A feeling of the sublime is inspired in every bosom susceptible of it, by a view from any point of these vast ranges, of the boundless forest valleys of the Ohio. . . . From an eminence . . . they could see, as far as vision could extend, the beautiful country of Kentucky. They remarked with astonishment the tall, straight trees, shading the exuberant soil, wholly clear from any other underbrush than the rich cane-brakes, the image of verdure and clover. Down the gentle slopes murmured [a] clear limestone brook. Finley [*sic*] . . . exclaimed . . . "This wilderness blossoms as the rose; and these desolate places are as the garden of God."[4]

Bingham's elegant and richly Neoclassical interpretation of the scene pictures shadows of sublime brooding and spiritual light, but concentrates on the promise of human brawn and determination. It is impossible to say whether Bingham knew Flint's account when he painted his picture, but it is logical to assume that another artist, William Ranney, followed literary sources precisely. Ranney's version of the same episode coincides in almost every detail with John Peck's 1849 account.

Their dress was of the description usually worn at that period by all forest rangers. The outside garment was a hunting shirt, or loose, open frock, made of dressed deer skins. Leggins or drawers, of the same material, covered the lower extremities, to which was appended a pair of moccasins for the feet. The cape or collar of the hunting shirt, and the seams of the leggins were adorned with fringes. The under garments were of coarse cotton. A leathern belt encircled the body; on the right side was suspended the tomahawk, to be used as a hatchet; on the left side was the hunting-knife, powder-horn, bullet-pouch, and other appendages indispensable for a hunter. Each person bore his trusty rifle.[5]

[1] Francis S. Grubar, *William Ranney: Painter of the Early West* (Washington, D.C., 1962), p. 32.
[2] Maria R. Audubon, *Audubon and His Journals* (New York, 1897), II, p. 241.
[3] W.H. Bogart, *Daniel Boone and the Hunters of Kentucky* (Auburn and Buffalo, N.Y., 1854), p. 55.
[4] Quoted in Grubar, loc. cit.
[5] Bogart, op. cit., pp. 55–56.

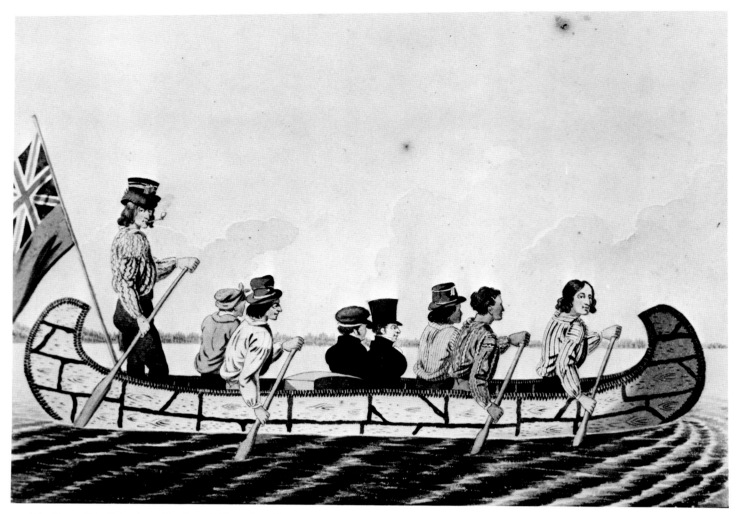

77. Peter Rindisbacher. *Company Officers in a Canoe.*
c. 1823. Watercolor, 7¼ x 10⅜″. Private
collection, London

78. George Caleb Bingham. *Study of the Fur Trader.*
1845. Pencil, 11⅞ x 9½″. Owned by the people of
Missouri

George Caleb Bingham

Were it not for Bingham's *Fur Traders Descending the Missouri,* it would be difficult to imagine that an American painter could evolve such an exquisite classicism and quiet dignity from the everyday life along that muddy river. Another artist, J. J. Audubon, had commented in 1843 that "no otters, beaver, muskrats, or even mink, is seen in or about the turbid waters of this mighty stream, the waters of which look more like a hog-puddle than any thing else to which I can compare it at present."[1]

There was an idyllic mystery which pervaded Bingham's vision of his frontier home and the life about him. He could not be concerned with muddy waters or tattered clothing, the ruckus of the rendezvous or the drama of an Indian depredation. His view was precise and intimate, reserved for the simple things in life that could be expressed in humanly touching and lyrical forms.

Bingham's work is alive with people. His paintings present them formally, in the fashion of an ordered world,

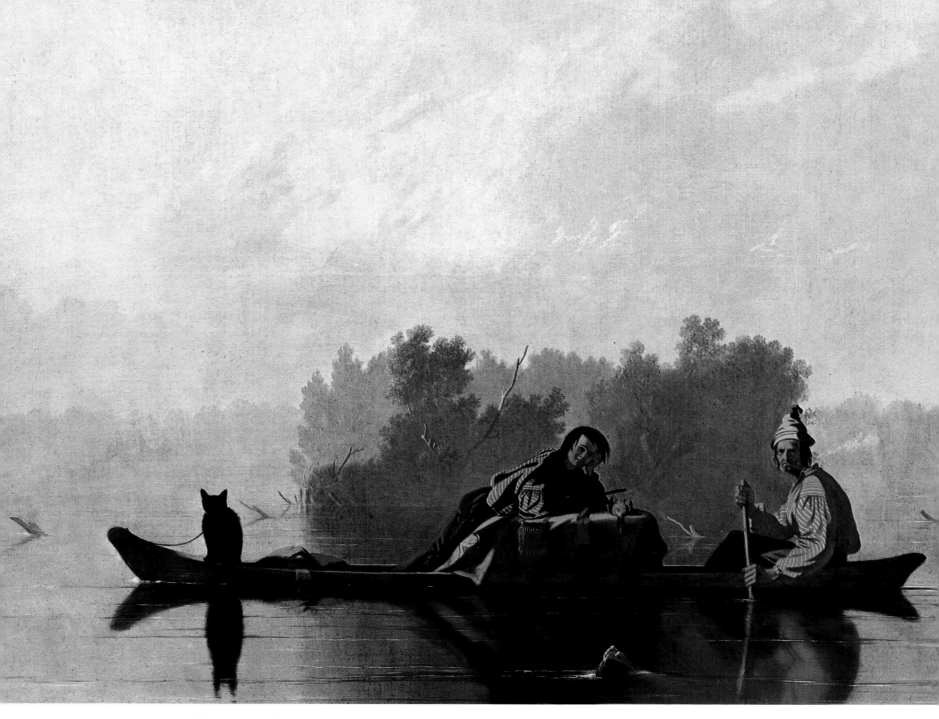

79. George Caleb Bingham. *Fur Traders Descending the Missouri*. 1845. Oil on canvas, 29¼ x 36¼″. The
Metropolitan Museum of Art, New York City. Morris K. Jessup Fund, 1933

and his drawings, more human because of their spon-
taneity, reveal the artist's conception of character on which
his paintings were constructed.

Washington Irving had described such men as appear in
Bingham's *Fur Traders Descending the Missouri* as indepen-
dent and clear of spirit.

The dress of these people is generally half civilized, half
savage. They wear a capot or surtout, made of a blanket,
a striped cotton shirt, cloth trowsers, or leathern legging,
moccasins of deer skin, and a belt of variegated worsted,
from which are suspended the knife, tobacco pouch and
other implements. . . . The lives of the voyageurs are
passed in wild and extensive rovings, in the service of
individuals, but more especially of the fur traders. . . .
They are dexterous boatmen, vigorous and adroit with
the oar and paddle, and will row from morning until
night without a murmur.[2]

Another artist with clear vision and ordered eloquence
lived along the Missouri for a short while. He was Peter
Rindisbacher, who came to St. Louis from Canada in 1829.
He brought with him images and memories of the voy-
ageurs from the Northern lakes and rivers, men in the
service of the powerful Hudson's Bay Company. Though
labored and sometimes technically worrisome as an
artwork, Rindisbacher's watercolor depicting *Company Offi-
cers in a Canoe* mirrors in brilliant and charming fashion the
straitlaced counterpart of the American fur trader.

[1] J.J. Audubon, "Rocky Mountain Expedition: Letter
From Mr. Audubon," *New York Tribune* (July 10, 1843),
from a clipping in the Western History Department,
Denver Public Library.
[2] Washington Irving, *Astoria, or Anecdotes of an Enterprise
Beyond the Rocky Mountains* (Philadelphia, 1836), I, pp.
47–48.

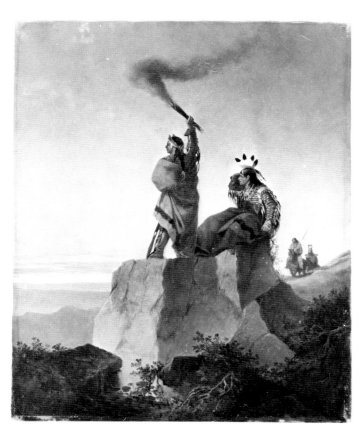

80. John Mix Stanley. *Indian Telegraph.* 1860. Oil on canvas, 20 x 15½". Detroit Institute of Arts. Purchase, popular subscription

Bingham's sense of drama languished in the wake of his ordered vision. The sobriety and objectivity of his observation caused his work to lack much of the picturesque aura embodied in paintings by fellow artists of the West. Neither his mountain men nor his Indians served history so much as art, because Bingham was, above all, a painter. His talents in this field excelled most of the other artists who came West. This is explained partially by the fact that he was willing to limit his sights and interests.

In his entire career Bingham is known to have painted only two Indian subjects, *The Concealed Enemy* and *Captured by the Indians.* His background was not sufficient to allow him to enter the field of Indian painting with confidence, nor was he inclined to nurture an understanding. "And, unlike Charles Deas and Charles Wimar, Bingham was not imaginative enough to be strongly attracted to the more fictional storytelling aspects of Indian deed and exploits."[1]

All this resulted in a stolid view of Indians. To some observers, the Indian in Bingham's *The Concealed Enemy* is defensible as an Osage; to others, he is simply a bald-headed Boston banker guised as a menacing American native. The classical composition and palette, reinforced with solid draftsmanship and sophisticated treatment of atmospheric perspective, invite plaudits from the student of art who reveres the purity of such American iconography. The anthropologist and the Western chronicler are perhaps less convinced, even though for Bingham this painting is extraordinarily provocative.

John Mix Stanley's *Indian Telegraph* is distinguished by a similarly formal composition and matter-of-fact presentation. Its emotional impact compares favorably with Bingham's work, as do most of the other pictorial elements except draftsmanship, in which Stanley was not Bingham's equal.

Regarding tribal identification, Stanley was credited in his own time as being the most reliable delineator of ethnographic detail. This painting depicts a Piegan signal corps seen by Stanley in the northern Rockies during his trip with the railroad survey of 1853. Yet, when his *Indian Telegraph* was distributed as a chromolithograph in the 1860s, Stanley's hometown paper, the *Detroit Free Press,* identified the subject as Apaches seen by Stanley in his march with Kearny through the Gila Valley.[2]

[1] E. Maurice Bloch, *George Caleb Bingham: The Evolution of an Artist* (Berkeley and Los Angeles, 1967), p. 110.
[2] "Stanley's Chromos," *Detroit Free Press* (September 19, 1869), p. 1.

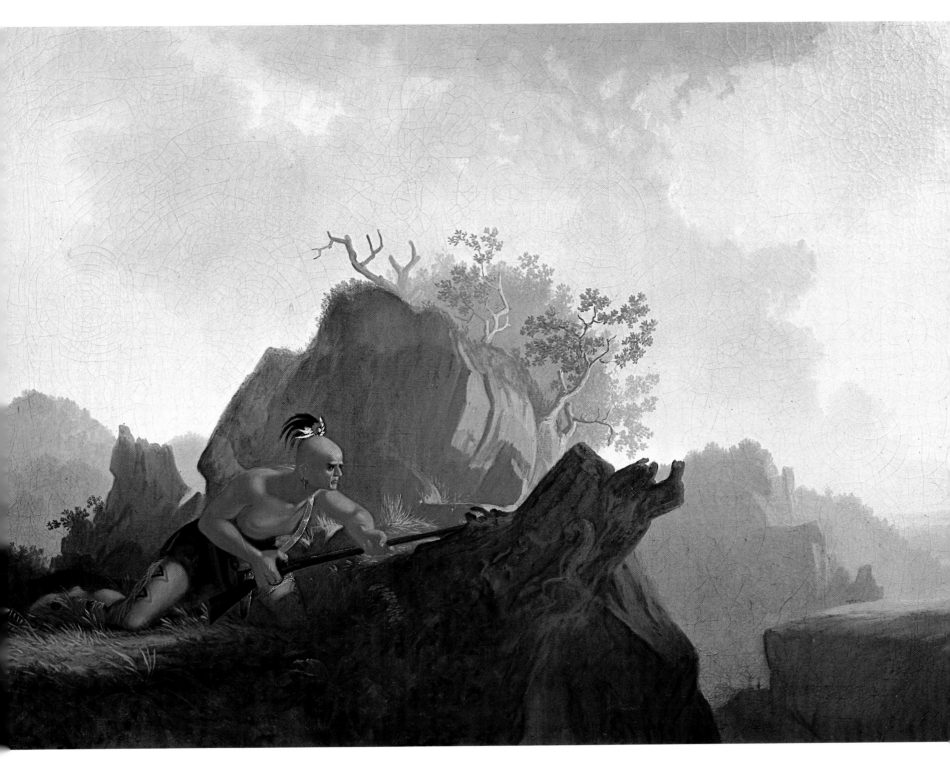

81. George Caleb Bingham. *The Concealed Enemy.* 1845. Oil on canvas, 28½ x 35½″. Peabody Museum, Harvard University, Cambridge, Mass.

George Caleb Bingham

Bingham was born to tell of life in a quiet way. The men who move about in his monumental canvases are at peace with their world and remain timeless in their serenity. In *Watching the Cargo,* Bingham's Missouri River boatmen have had the misfortune to run their steamboat aground; yet they appear oblivious to concern. They pass the time smoking and watching a summer fire.

This is quite a change from Karl Bodmer's views of steamboating and its perils. Instead of being threatened by ominous storms, torrential waters, and violent winds, Bingham's steamboat lays gently on her side as if waiting patiently for a nudge. Animation is created only through compositional devices, and even those are restrained by the solidity of the poses and the architectonic mass of cargo to the left.

The pageant of life on the river did come alive more than this for Bingham in several of his other paintings. The *Jolly Flatboatmen* series painted in the mid-1840s and 1850s flowed with the river's ebullience, in harmony with its commercial vitality. Bingham's *Boatmen on the Missouri* is a precursor to these scenes of mirth. The figures are somewhat livelier, one is even engaged in some sort of labor. Their flatboat seems almost in motion as it drifts toward the viewer.

The deliberate formal pyramidal composition, used by Bingham for the first time in his *Boatmen on the Missouri,* became a hallmark of his later style. It was also to influence other artists in the West, including the little-known painter F.R. Grist. Virtually no information is available on Grist, but he may be the same Franklin R. Grist listed by Groce and Wallace as a "genre painter of New Haven (Conn.) who exhibited at the National Academy in 1848."[1]

Grist accompanied Captain Howard Stansbury of the United States Army Topographical Engineers on an expedition from Independence, Missouri, to the Great Salt Lake in 1849. Grist's paintings appeared as illustrations in Stansbury's final report; they remain the most sophisticated pictorial accompaniment to any of the published accounts of early Western exploration.[2]

On July 25, the troop made a crossing of a North Platte tributary, Deer Creek. An enterprising fellow had constructed a ferry to accommodate the numerous travelers and charged $2.00 per wagon to cross the narrow but treacherous expanse of water.

The ferry-boat was constructed of seven canoes dug out from cotton-wood logs, fastened side by side with poles, a couple of hewn logs being secured across their tops, upon which the wheels of the wagons rested. This rude raft was drawn back and forth by means of a rope stretched across the river, and secured at the ends to either bank. Frail and insecure as was the appearance of this very primitive ferry-boat, yet all the wagons were passed over in the course of two hours, without the slightest accident, although many of them were heavily laden. The animals were driven into the stream and obliged to ferry themselves over, which they did without loss, although the river was now swollen by late rains and the current extremely rapid and turbid.[3]

Grist's print of the scene portrays the incident superbly, with the exception that the water looks neither rapid nor turbid. The lacy handling of the tree and the sureness in the treatment of the figures indicate that Grist was a well-trained draftsman. His concern for a stable composition of geometric arrangement evinces a schooling that, if not formal, is at least based on standard nineteenth-century instruction books.

[1] George C. Groce and David H. Wallace, *The New-York Historical Society's Dictionary of Artists in America 1564–1860* (New Haven, 1957), p. 167.

[2] For attribution, see Dale L. Morgan, *The Great Salt Lake* (Indianapolis, 1947), p. 233. For other illustrations, see Howard Stansbury, *An Expedition to the Valley of the Great Salt Lake of Utah* (Philadelphia, 1855).

[3] Stansbury, op. cit., pp. 60–61.

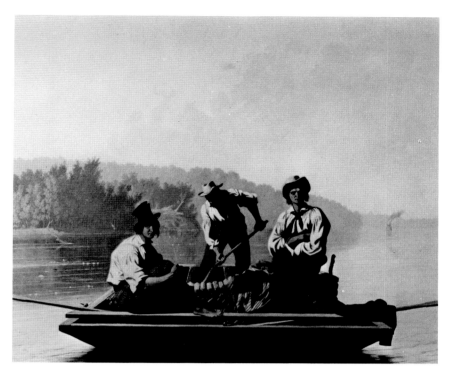

82. George Caleb Bingham. *Boatmen on the Missouri.* 1846. Oil on canvas, 25 x 30". Private collection

83. F. R. Grist. *Crossing the Platte, Mouth of Deer Creek.* c. 1852. Lithograph, 4⅝ x 7¾". Western History Department, Denver Public Library

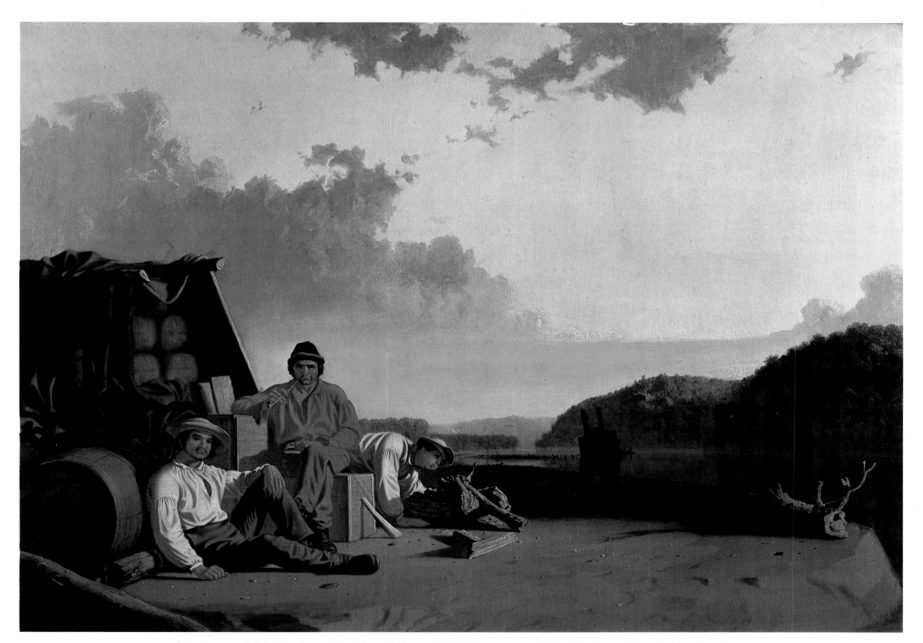

84. George Caleb Bingham. *Watching the Cargo.* 1849. Oil on canvas, 26 x 36". State Historical Society of Missouri, Columbia

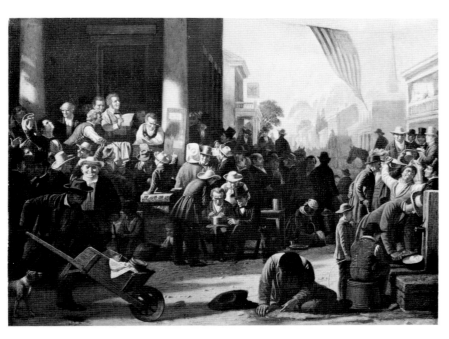

85. George Caleb Bingham. *Verdict of the People* (No. 2). After 1855. Oil on canvas, 22¾ x 30⅜". R. W. Norton Art Gallery, Shreveport,La.

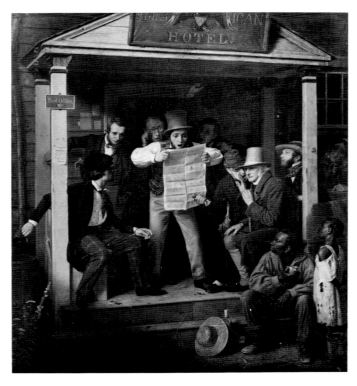

86. Richard Caton Woodville. *War News from Mexico.* 1848. Oil on canvas, 27 x 24¾". National Academy of Design, New York City

The vagaries of Western politics have borne little contrast to the national tradition. Whim and spite, under the pretext of liberated justice, prevailed on the frontier as they had in Philadelphia or Washington a century before. And, yet, it was the West which gathered the garlands of democracy and was held responsible for its longevity, not Boston or tidewater Virginia. "The rise of democracy as an effective force in the nation came in with Western preponderance," wrote Frederick Jackson Turner, "and it meant the triumph of the frontier—with all its good and with all its evil elements."[1]

George Caleb Bingham knew something of frontier politics before he painted what many feel to be his masterpiece, *The County Election.* He had entered the immodest profession in 1846, declaring himself a candidate for the Missouri legislature. Though that contest was lost, he won two years later and joined firsthand in the pulse of the democratic system.

This, the second of two versions of *The County Election,* was painted in 1852. In size it measures more than three by four feet, its monumentality confirmed by the fact that it contains upwards of sixty figures.

> Prominently on the right, on the main street of a western village, we have the place of voting, the court house, in the porch of which the clerks and judges are assembled—one of the judges, a thick pussy looking citizen, being engaged in swearing in a voter, a well-set Irishman in a red flannel shirt. Near by is a political striker, a distributor of tickets, *very* politely tendering his services in that regard to an approaching voter. Around and in front is the crowd, composed of many large and prominent figures—some engaged in earnest conversation, some drinking at a cake and liquor stand, some smoking and some hearing a paragraph read from a newspaper. But we cannot give a description of this painting. Several hours would not suffice fully to examine it, so numerous and life-like are the characters. Indeed it is full of reality, a seeming incarnation, prominent in figure, grouped and colored with admirable skill and effect. Persons of highly cultivated taste in the fine arts, and critics in general, will accord to it a remarkable degree of genius and merit.[2]

This picture was embraced by all America. In engraved form it played to the taste of the art savant and the public throng, to the conscience of the statesman and the everyday voter. It was testament in paint to the democratic process and was appropriately followed some years later by a piece even more exemplary of frontier politics, *Verdict of the People.* Here Bingham transferred to canvas "a *principle* in our government—the exercise of the elective franchise—and submission by the people to the will of the majority, . . . *colored* true to the requirements of the constitution, and the instincts of our people."[3]

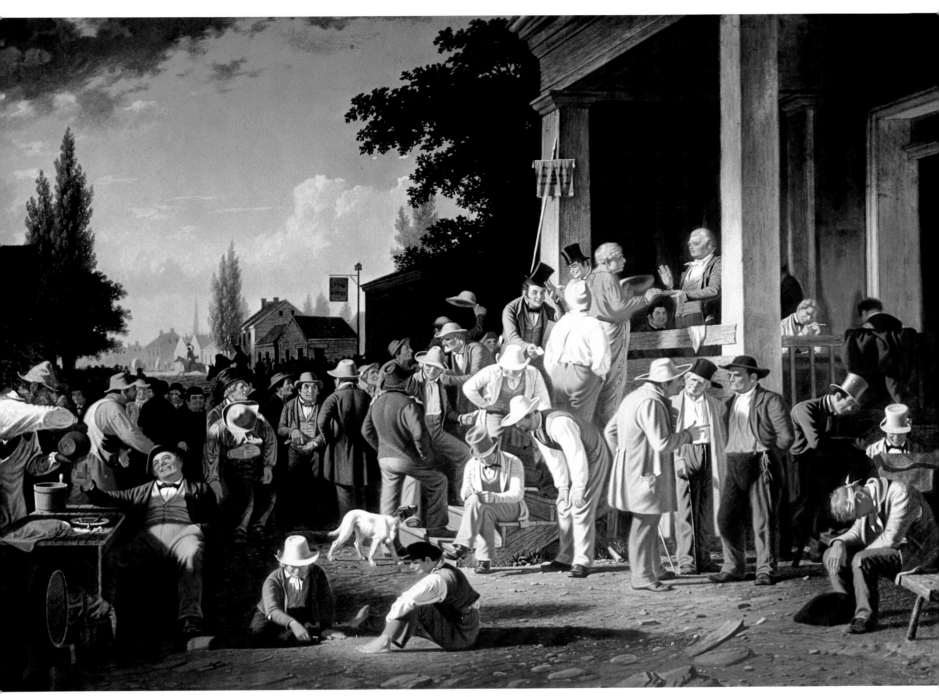

87. George Caleb Bingham. *The County Election* (No. 2). 1852. Oil on canvas, 36 x 51". Boatmen's National Bank of St. Louis

As provocative as Bingham's paintings may have been, he was not the only artist to discover the pictorial potential of frontier politics. Genre painter Richard Caton Woodville produced what was to become his most famous painting, *War News from Mexico,* which, if not Western in setting, was at least infused with regional sentiment. The Mexican War was America's first popular demonstration of Manifest Destiny. The eager ears in Woodville's handsomely composed portrayal of front-porch imperialism reveal a profound concern for the ultimate outcome of President Polk's not so honorable little war to the south.

[1] Frederick Jackson Turner, "The Significance of the Frontier in American History," *American Historical Association Annual Report for the Year 1893* (Washington, D.C., 1894), quoted in Martin Ridge and Ray A. Billington, eds., *America's Frontier Story* (New York, 1969), p. 22.
[2] *Missouri Statesman* (October 31, 1851).
[3] *Missouri Statesman* (May 16, 1856).

Bridging

the Continent

Emanuel Leutze

A broad gesture signals the climax—the emigrants have reached the final ridge of the final range. The blue Pacific lies ahead, and along with its salt air rides the promise of new life, an Eldorado as golden-hued as the sunset before them.

The independent Western mode and the irresistible pull of a frontier further west worked together to create a singular spirit. Pioneers, determined to succeed by the strength of their own limbs and a raw dependence on nature, pressed and then pressed again until the last river and ridge were crossed. Typical was a report from Independence, Missouri, on July 5, 1843.

> "A short time since, the Oregon Company left our neighborhood; they have with them a large amount of stock, about 200 wagons of all sizes and descriptions, and in all probability 800 or 1000 souls. They seem to be in high spirits and go out with joyous expectations. The aged and young—the hardy, virtuous pioneer—the timid and the wealthy, have each braced themselves up for the trip in anticipation of the glorious harvest that awaits them at their new home in the west."[1]

Emanuel Leutze knew the kinetics of this surge. He had seen it firsthand in the Colorado mining camps which he visited in the summer of 1861. He traveled west to make sketches for a great mural in the nation's capitol and, as he was a "most affable and sociable gentleman, free from that affectation too often found allied with genius,"[2] he absorbed much of the grassroots spirit.

True, it was idealized history painting as Düsseldorf artists like Leutze were wont to produce. Yet, there was life in it, too—real people, real motives, and real aspirations.

This painting, *Westward the Course of Empire Takes Its Way,* was Leutze's final attempt at narrative work; moreover, it heralded the demise of the Düsseldorf sway over American art. The theatrical German manner waned in favor of newer English and French persuasions. Some have referred to the picture as the denouement of the era,[3] others as its nemesis. The critic James Jackson Jarves reproached the picture as "the slop-work of the melodramatists, of whom Leutze was chief. Of all his frantic compositions, the fresco of Westward Ho! . . . painted in the Capitol at Washington is the maddest. A more vicious example in composition and coloring, with some cleverness of details, could not be presented to young painters. Confusion reigns paramount, as if an earthquake had made chaos of his reckless design, hot, glaring color, and but ill comprehended theme."[4]

[1] "The Far West," *New York Tribune* (July 5, 1843), from a clipping in the Western History Department, Denver Public Library.

[2] "Leutze, the Artist," *Rocky Mountain News* (September 5, 1861), p. 3.

[3] Donelson F. Hoopes, "The Düsseldorf Academy and the Americans," in *The Düsseldorf Academy and the Americans* (Atlanta, 1972), p. 32.

[4] James Jackson Jarves, *Art Thoughts* (New York, 1869), p. 297.

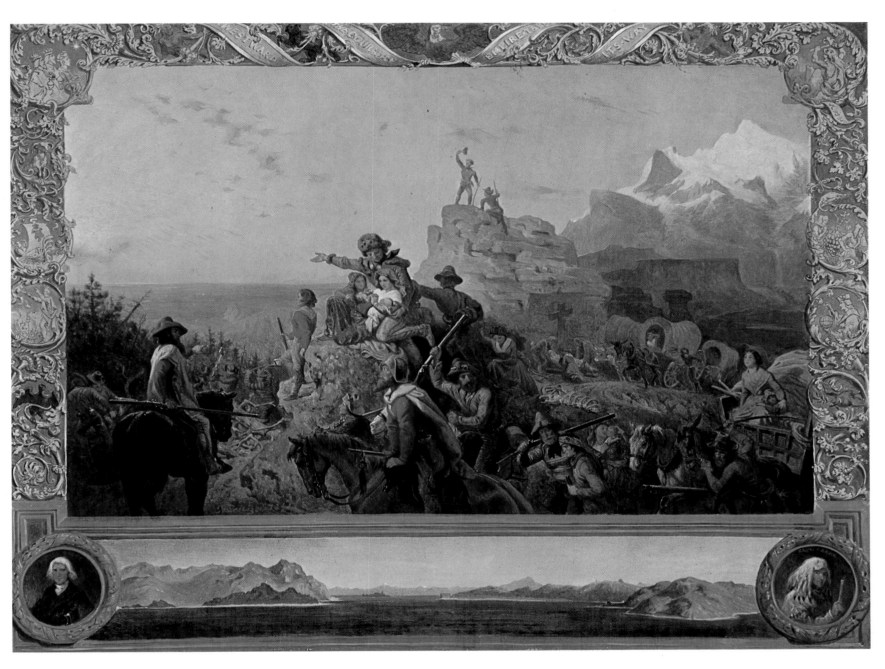

88. Emanuel Leutze. *Westward the Course of Empire Takes Its Way.* 1861. Oil on canvas, 33¼ x 43⅜″. National Collection of Fine Arts, Smithsonian Institution, Washington, D.C. Bequest of Sara Carr Upton

89. Frederick Piercy. *Independence Rock*. 1853. Brown wash, 4¼ x 6½".
Museum of Fine Arts, Boston. M. and M. Karolik Collection

90. Albert Bierstadt. *Nooning on the Platte*. 1858. Oil on paper mounted
on canvas, 6¾ x 12⅞". St. Louis Art Museum. Gift of J. Lionberger
Davis

"The wagons for this trip should be two-horse wagons, plain yankee beds, the running gear made of good materials, and fine workmanship, with falling tongues; and all in a state of good repair."[1] Such was the advice to emigrants offered by Peter Burnett, a proud new citizen of Linnton, Oregon Territory. His letters East were dated 1844. He had been in Oregon one season and already considered himself expert on the place as well as the journey to it. "The best teams," he continued, "are ox teams. Let the oxen be from three to five years old, well set, and compactly built." As for provisions, Burnett suggested "one hundred and fifty pounds of flour and forty pounds of bacon to each person. Besides this, as much dried fruit, rice, corn meal, parched corn meal, and raw corn, pease, sugar, tea, coffee, and such like articles as you can well bring. Flour will keep sweet the whole trip, corn meal to the mountains, and parched corn meal all the way."[2]

Though Burnett and a host of others encouraged people to venture west and assured them that the road to the Pacific was easily passable, later accounts set a different scene. By 1850, when the gold craze had surpassed in ardor all the exclaiming over the Willamette Valley, Easterners read news that possibly dissuaded a handful. Typical was a notice entitled "Highly Important to Overland Emigrants," which appeared in a New York paper that spring.

Intelligence was received in this place [St. Joseph] yesterday from the Bluffs, which is of the highest importance to emigrants. It is represented that there are about 3,000 teams at that point, and that they are continually arriving in large numbers—that every thing necessary for the emigrants is extremely high, and the supplies almost completely exhausted. Corn is selling at $2.25 per bushel, flour $5 per hundred, and other articles necessary for an outfit in the same proportion.[3]

Such warning did little to stem the tide of westward flow. St. Louis, Independence, Leavenworth, and St. Joseph continued to swell with waves of emigrants and fortune seekers. America was not to be held back.

Samuel Colman's *Ships of the Plains* portrays the canvas-covered conestogas rolling slowly westward, resolute in the quest for a new home. Though painted twenty years after the great migration, the scene holds all the force of the surge which peopled the continent from shore to shore.

Many of the landmarks passed by the Oregon "movers" and the Mormon pioneers in the 1840s had become household words by the gold-rush days. Of them all, probably Independence Rock has endured the longest in the popular mind. The original Mormon band passed the historic, inscribed rock in late June of 1847. Frederick Piercy, who journeyed from Liverpool to Salt Lake six years later, pictured his troop passing beneath the massive milepost. The Sweetwater River flows quietly in the foreground.

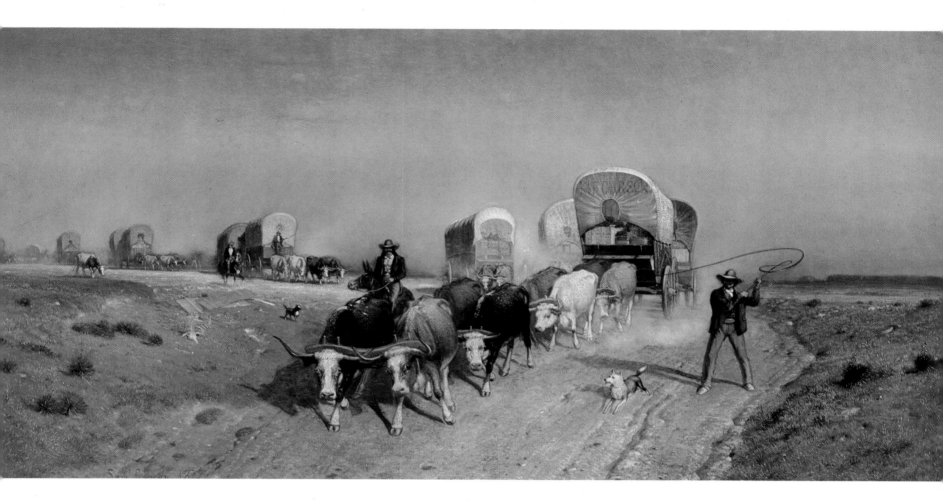

91. Samuel Colman. *Ships of the Plains.* 1872. Oil on canvas, 48 x 92″. Union League Club, New York City

Albert Bierstadt's charming sketch entitled *Nooning on the Platte* was done in 1858, when he ventured west to paint in the Wind River Mountains. It suggests the following description written by Peter Burnett for the benefit of would-be emigrants. "On the Platte, the only inconvenience arising from the road is the propensity to sleep in the daytime. The air is so pleasant and the road so smooth that I have known many a teamster to go fast asleep in his wagon, and his team stop still in the road. The usual plan was for the wagons behind to drive around him, and leave him until he waked up, when he would come driving up, looking rather sheepish."[4]

[1] Letter from Peter H. Burnett in the *New York Herald* (January 6, 1845), quoted in "Documents," *Quarterly of the Oregon Historical Society,* 3 (December, 1902), 417.
[2] Ibid., 418, 419.
[3] *New York Tribune* (May 16, 1850).
[4] Burnett, op. cit., 419–20.

92. Frederick Piercy. *View of Great Salt Lake City.* 1853. Pencil and brown wash, 7 x 10¾". Museum of Fine Arts, Boston. M. and M. Karolik Collection

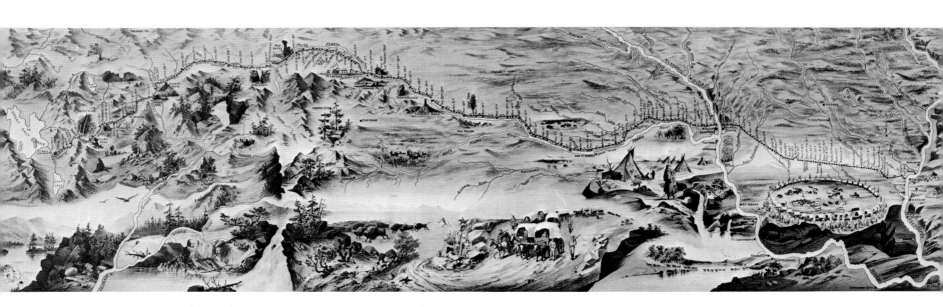

93. Unknown artist. *Route of the Mormon Pioneers from Nauvoo to Great Salt Lake.* 1899. Colored lithograph, 13⅝ x 41¾". Amon Carter Museum, Fort Worth

The lure of the West was sustained only in part by its material riches. For many, the abundant land also held promise of spiritual freedom. In 1859, the *Millennial Star*, an English publication of the Church of Jesus Christ of Latter-Day Saints, issued this tempting verse.

There's a land far away in the west,
a place by God assigned
'Tis there the wearied saint can rest,
Or a stranger safety find;
For there the prophets have declared
The house of God shall be,
On mountain tops it shall be reared
That all the world may see.
'Tis a favored country—deny it who can;
And there is a home for an honest man.[1]

Finding it impossible to remain in Illinois after the murder of their leader Joseph Smith, the Saints looked westward. Their salvation lay somewhere beyond the Rockies, they thought, though in February of 1846 when the vanguard of sixteen hundred Mormon pioneers crossed the frozen Mississippi, their Zion had no place on a map.

The vast Mormon cavalcade numbered twelve thousand souls by the autumn of 1846 when they halted for the season near Council Bluffs on the Missouri. They called the spot winter quarters, and it was here that they sheltered beneath the welcome arbor of cottonwood trees. Many died that winter but most survived to press on toward an unknown promised land. Spearheaded by a band of 146 led by Brigham Young, the pioneers began again the next April. Their Zion was still four months travel ahead at the place where the Wasatch Mountains touch the Great Salt Lake. Young's party arrived on July 24, an event celebrated since as "Pioneer Day."

Others who moved more slowly across the prairies soon received encouragement. A letter with the return address "Pioneer camp. Valley of the Great Salt Lake, August 2, 1847" was passed by special courier among the staggered groups of wagons. "We have delegated our beloved Brother Ezra T. Benson and escort to communicate to you by express the cheering intelligence that we have arrived in the most beautiful valley of the Great Salt Lake, that every soul who left Winter Quarters with us is alive and almost everyone enjoying good health."[2]

The English artist and chronicler Frederick Piercy painted and sketched many of the historic pioneer sites when he made the crossing to Salt Lake in 1853. His view of the Mississippi ford at Council Bluffs, where six hundred persons had perished in the winter of 1846–47, seems idyllic in its summer mantle of green.

Probably the most important picture produced by Piercy was his view of Salt Lake City. It appeared as an engraved illustration, along with his full verbal description, in his lavish account entitled *Route from Liverpool to Great Salt Lake Valley*, published in London and Liverpool in 1855.

In that year, Piercy estimated the population of the city to be between 10,000 and 15,000. It "is laid out on a magnificent scale, being nearly 4 m. square, and having streets 132 ft. wide, with 20 ft. side walks." Moreover, Piercy re-

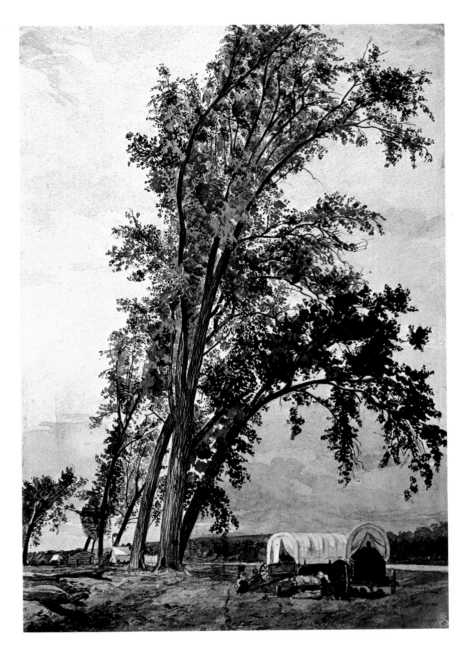

94. Frederick Piercy. *Council Bluffs Ferry and Group of Cottonwood Trees*. 1853. Watercolor, 10¼ x 7". Museum of Fine Arts, Boston. M. and M. Karolik Collection

ported, "through the city itself flows an unfailing stream of pure sweet water, which, by an ingenious mode of irrigation, is made to traverse each side of every street, whence it is led into every garden spot, spreading life, verdure, and beauty over what was heretofore a barren waste."[3] This surely was heaven on earth.

[1] Quoted from the *Millennial Star* (January 8, 1859), in Thomas E. Cheney, ed., *Mormon Songs From the Rocky Mountains* (Austin, 1968), p. 61.
[2] Quoted in *William Clayton's Journal* (Salt Lake City, 1921), p. 338.
[3] James Linforth, ed., *Route from Liverpool to Great Salt Lake Valley* (Liverpool and London, 1855), p. 109.

Fanny Palmer

Sheer power to effect public enthusiasm for the Far West required more than reports of the successful experiment consummated by the Latter-Day Saints. Frederick Piercy's words and pictures reached only the zealous; it took another English artist to create public fervor. This was Fanny Palmer, who came to America and settled with her family in Brooklyn in the 1840s.

Palmer was a true lady of the arts. Schooled in the best classrooms London could offer, she knew much of literature and music, and her ability as a a painter soon won the notice of printmakers Currier & Ives. She worked for them for approximately twenty-five years and in that time produced some of America's most reminiscent scenes.

Palmer's Western views were done in the 1860s. Her engaging, though improbable, 1866 view of the Rocky Mountains pictured hardy oxen pulling wagons westward. Two years later Currier & Ives published her famous *Across the Continent: "Westward the Course of Empire Takes Its Way,"* inspired by sketches she had made four years earlier. James Ives is thought to have assisted Palmer by drawing the figures for the finished lithograph and by selecting the title from Bishop George Berkeley's immortal stanza.[1] All the rest came from Palmer's fertile imagination and what she had heard of the great overland migrations of the previous decade.

President Zachary Taylor, in his message to Congress on December 27, 1849, had outlined the cause of the emigrant surge and had suggested an outlet for even more.

The great mineral wealth of California, and the advantages which its ports and harbors, and those of Oregon, afford to commerce, especially with the islands of the Pacific and Indian Oceans, and the populous regions of Eastern Asia, make it certain that there will arise in a few years large and prosperous communities on our western coast. It, therefore, becomes important that a line of communication, the best and most expeditious which the nature of the country will admit, should be opened within the territory of the United States, from the navigable waters of the Atlantic on the Gulf of Mexico to the Pacific. Opinion, as elicited and expressed by two large and respectable conventions, lately assembled at St. Louis and Memphis, points to a railroad as that which, if practicable, will best meet the wishes and wants of the people.[2]

Palmer's print, distributed widely in America and Europe, presented the West as a picturesque fairyland which invited pioneers to partake of its abounding wealth. The print also foretold the coming of America's transcontinental railroad. As pictorial propaganda this popularized image was countered only by the few who read the official government reports on the railroad surveys published between 1855 and 1861. Bemoaned one reviewer of these voluminous reports, "we may as well admit that . . . whatever route is selected for a railroad to the Pacific, it must wind the greater part of its length through a country destined to remain for ever an uninhabited and dreary waste."[3]

The optimism of Palmer's vision ultimately prevailed and was corroborated by artists like Thomas Otter in his renowned painting, *On the Road.* The rattle of wagons and the whistle of locomotives soon echoed together through the Plains and Rockies.

[1] Roy King and Burke Davis, *The World of Currier & Ives* (New York, 1968), p. 64.
[2] *Message of President Zachary Taylor Before Congress, Dec. 27, 1849,* quoted in Robert Taft, *Artists and Illustrators of the Old West* (New York and London, 1953), p. 1.
[3] *North American Review,* 82 (January, 1856).

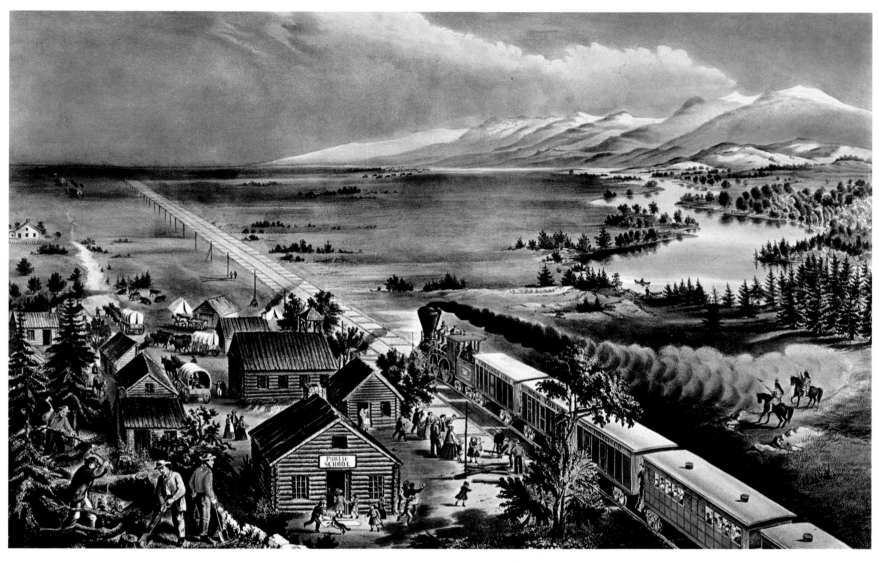

95. Fanny Palmer. *Across the Continent: "Westward the Course of Empire Takes Its Way."* 1868. Toned lithograph, 22¾ x 31⅝″. Amon Carter Museum, Fort Worth

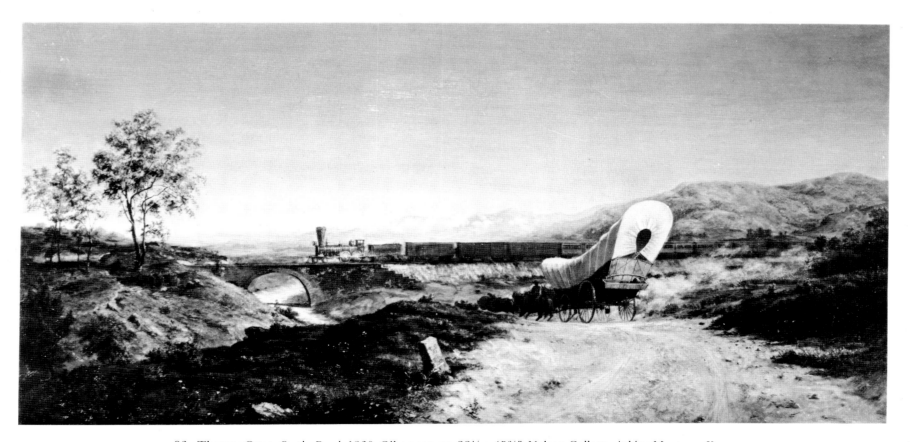

96. Thomas Otter. *On the Road.* 1860. Oil on canvas, 22⅛ x 45⅜″. Nelson Gallery–Atkins Museum, Kansas City, Mo. Nelson Fund

97. Unknown artist. *A Grand Fandango*, from the book *The Life and Adventures of Kit Carson*, by De Witt C. Peters. c. 1858. Engraving, 4⅞ x 3⅜". Buffalo Bill Historical Center Library, Cody, Wyo.

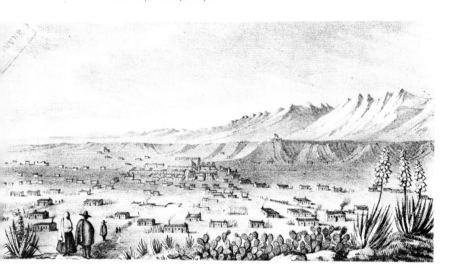

98. James Abert. *La Ciudad de Santa Fe.* c. 1847. Lithograph, 4¼ x 7". Western History Department, Denver Public Library

T. Worthington Whittredge

In even the earliest Western annals, Santa Fe appeared as an island of civilization in a sea of wilderness. Though bridges of commerce extended from the United States as early as 1821 to the famous Santa Fe trade, the town and its life remained isolated from American culture through most of the nineteenth century.

James Abert, a young lieutenant in the Topographical Engineer Corps, was ordered in 1846 to "make a map of New Mexico . . . and to furnish from the best statistical sources, an account of the population and resources, military and civil, of the province."[1] It was easier assigned than accomplished. He almost perished of fever crossing the prairies toward Santa Fe and was forced to convalesce at Bent's Fort, where his only solace was a few pulp companions—his copy of Horace, a Greek testament, and his sketchbook. When he finally recovered and continued on, a prairie fire almost consumed his tent one night. And on his return trip the blizzards and Indians hazed him relentlessly. Half his mules succumbed to freezing, the other half to the stealthy Pawnees. Santa Fe was no easy place to reach.

Abert first saw Santa Fe on September 27. He had traveled twenty-nine miles that day. Coming over a ridge about five o'clock, he remembered, "I caught sight of the flag of my country waving proudly over some low flat roofed buildings that lay in the valley. I knew this must be Santa Fé."[2] Kearny had raised the Stars and Stripes there less than a month before.

Abert was quick to fit into the Santa Fe life-style. The first afternoon he was strolling around the plaza like a native, enjoying the colorful market replete with melons, peppers, and kegs of Taos whiskey. After dark, Abert recounted even more color.

In the evening I attended a ball, here styled a fandango. The Mexican ladies had laid aside their "rebozas," and were clothed much after the manner of our own females. Stuffs most rich, and skirts of monstrous width or fullness. While sitting down they were wrapped in splendid shawls. These were generally thrown over the head like the reboza. They gazed round the room with great complaisance as they smoked their cigarritos. Waltzing forms the chief part of all their dances. The principal ones are the "cumbe," and the "Italiano." These people have an excellent notion of time, fine voices, and seemed to be enthusiastically fond of music.[3]

Not many other artists came to Santa Fe in the nineteenth century. Stanley had been there twice, and the Kern brothers, Edward and Richard, brought back pictures of its streets, but for as famous a place as it was in history and legend, it received sparse notice from artists. One of the

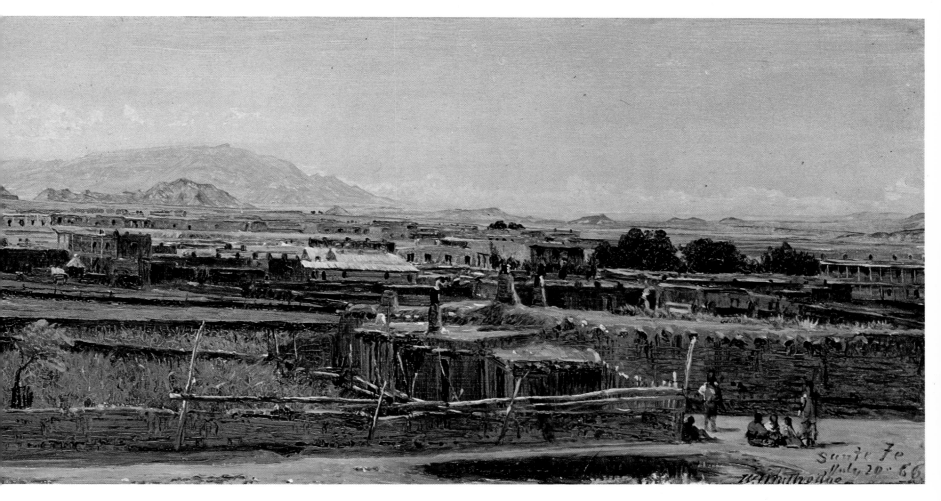

99. T. Worthington Whittredge. *Santa Fe.* 1866. Oil on canvas, 8 x 23⅛″. Yale University Art Gallery, New Haven, Conn. Lent by the Peabody Museum

few who dared was T. Worthington Whittredge, a painter of the Hudson River and the Rhode Island shore.

Whittredge was in Santa Fe during the summer of 1866. If any of his tales of painting in her streets are true, it is perhaps no wonder that it took another thirty years before artists arrived on the scene.

I was making a sketch of Santa Fe itself with its low adobe huts in the foreground and looking off over their flat grassgrown roofs to the great valley of the Rio Grande with the beautiful San Dia mountains in the distance. The picture was of good size and very nearly finished when an exceedingly rough-looking fellow with a broken nose and hair matted like the hair of a buffalo stepped up behind me and, with a loud voice, demanded to know what I asked for the picture. I told him it was not for sale. He broke out with a volley of cuss words and, putting his hand on his pistol, drew it forth and said he would like to know if there was anything in this world that was not for sale. I said I could not sell the picture, because it already had an owner and I was not the kind of man to go back on my word. He broke in: "You think probably that I haven't any money to buy your picture. I have got money enough to buy all the pictures you could paint in a hundred years and I made it all in sight of this ramshackle town, and I want that picture to take home with

me to the 'States', and I'm going to have it." Things were getting pretty serious, especially as he kept brandishing his pistol near my head with his finger on the trigger. I finally got on my feet, and looking him straight in the eye said: "My friend, you look pretty rough but I don't believe you are a fool. You can't have this picture. It is a sketch to make a large picture from. I live in New York, and my business is to paint big pictures and sell them at a thundering price, and if you have money enough to buy a high-priced picture I can accommodate you after I get back to New York." "Money," he ejaculated, "what will the big picture cost?" I told him about $10,000 without the frame. The frame would cost him about $2,000 more. This silenced him and I handed him my studio address. He took it, put up his pistol and marched off, and I have never seen him since.[4]

[1] W.H. Emory, *Notes of a Military Reconnaissance, From Fort Leavenworth, in Missouri to San Diego, in California, Including Part of the Arkansas, del Norte and Gila Rivers* (Washington, D.C., 1848), p. 43.

[2] James Abert, *Abert's New Mexico Report, 1846–'47* (Albuquerque, 1962), p. 45.

[3] Ibid., p. 46.

[4] Worthington Whittredge, *The Autobiography of Worthington Whittredge, 1820–1910* (New York, 1969), p. 49.

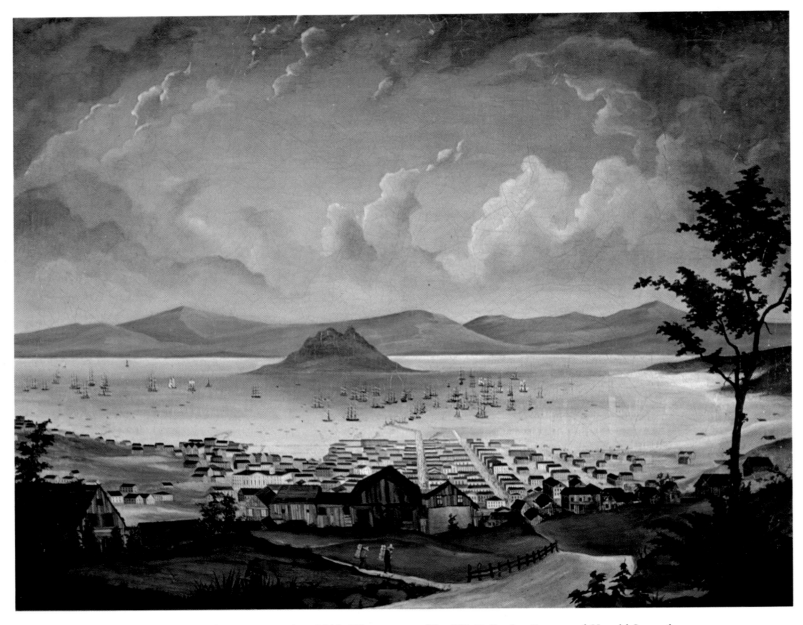

100. Joshua Peirce. *San Francisco.* 1849. Oil on canvas, 22 x 29". Collection Peggy and Harold Samuels

Joshua Peirce

In February of 1850 a newcomer to the West Coast commented on one of the unpleasant conditions during the rainy season.

> The mud in Francisco this winter was two, three, and four feet deep, making it impossible for most of the teams to travel, and, of course very little business done in that line; In fact a report is current that two or more mules, cart, driver and all were drowned, and nothing seen of them but the top of the driver's hat left on top of the mud. I will not vouch for the truth of this story, but so goes the report. They have now got a chain gang of prisoners and will no doubt benefit the streets greatly.[1]

Mud did not deter the hordes from traveling to San Francisco, which lay at the beginning of an aureate pathway. In one year, 1849, over thirty-five thousand hopeful people crowded across her wharves on their way to prospective riches. In that same year, no less than 775 vessels set sail from one Eastern port, New York—all bound for the Golden Gate.[2]

Among the seekers of fortune were many artists. William McMurtrie of Philadelphia made sketches of San Francisco in the spring of 1850 which Currier & Ives adapted for one of their most popular prints. Augusto Ferran, a teacher at the School of Art in Havana, and Louis le Breton of Paris also made historic views of the burgeoning city that year. None is more astonishing, however, than the brilliant and charming panorama of San Francisco thought to have been painted around 1850 by New York miniaturist Joshua

Peirce. It is a cameo portrait of California life at the apex of the gold-rush era.

Peirce's fetching city view pictures a host of ships at anchor in the harbor. Many of them had been abandoned as the crews jumped ship to try their luck in the gold fields. Others were in the lucrative business of conveying people to and from California. They sailed into and out of the port with frequency.

With the panacea of gold at stake, the business of transportation became one of speed. The scientist and inventor Rufus Porter promised in 1848 a round trip from New York to California via aerial transport in seven days for only $50 a ticket. Unfortunately, his scheme never got off the ground, but there were some ships which did almost fly—the great clippers. Baltimore and Philadelphia sent out the first clippers in early 1849, and they sailed around Cape Horn in less than 120 days, sixteen times slower than Porter had projected but a definite record for the day.

Fastest of all the ships was one designed by John Griffiths and Donald McKay—the *Flying Cloud*. She weighed nearly 1,800 tons, ran 225 feet along the deck, and was acknowledged as the largest merchant vessel on the water the day she was launched in June, 1851. On her maiden voyage she cleared for San Francisco and made the trip in an historic eighty-nine days.

[1] "Gold Rush Letter," *Southern California Quarterly*, 46 (September, 1964), 278.
[2] Jerry MacMullen, "Innocents Abroad," *Westways*, 59 (May, 1967), 11.

101. Joshua Peirce. *San Francisco* (detail)

102. E. Brown. *Clipper Ship "Flying Cloud."* n.d. Lithograph, 18½ x 27½". Esmark Collection of Currier & Ives, New York City

103. Unknown artist. *Pony Express Poster.* n.d. Lithograph, 31¾ x 45″.
Part of original Buffalo Bill Museum Collection. Buffalo Bill
Historical Center, Cody, Wyo.

104. Original Pony Express mochila. March 3, 1860. Leather, 17½ x
28″. Part of original Buffalo Bill Museum Collection. Buffalo Bill
Historical Center, Cody, Wyo.

According to historians, the pony express was never so much intended to succeed as a means of rapid communications transport as it was a "demonstration that the Central Overland Route to California was the most practicable, available means of communication and, eventually, the proper location of the Pacific Railroad."[1] Nonetheless, the fast-riding mail carriers opened one of the most dramatic, though short-lived, chapters in the history of the West.

An article in the April 3, 1860, *New York Times* gave the first timetable for the daring mail service to the Pacific: 124 hours to Salt Lake, 188 to Carson City, and 240 all the way to San Francisco. It was national news. They guaranteed ten-day delivery and charged $1.00 for a letter weighing under one-half ounce. Twenty-five letters made that first run, but a year later the daring riders were carrying as many as 150 in their leather mochilas.

Those chosen to ride the mails between Missouri and California were a special breed. In March of 1860 the San Francisco papers advertised the necessary qualifications— "WANTED: Young skinny wiry fellows, not over eighteen. Must be expert riders willing to risk death daily. Orphans preferred. Wages $25.00 per week. Apply, Central Overland Express, Alta Building, Montgomery Street."[2]

Frederic Remington, forty years later, produced one of the few definitive works illustrating the drama of the ephemeral art of carrying the mail. His *Coming and Going of the Pony Express* captures the spirit of that historic, transcontinental relay race against time.

Gradually the telegraph replaced the sprinting couriers. In September of 1861, there were only five hundred miles to ride between the ends of the telegraph lines. A month later the wires touched, and the dashing saga of rider and mail came to a close.[3]

[1] Lucius Beebe and Charles Clegg, *U.S. West: The Saga of Wells Fargo* (New York, 1949), p. 75.
[2] Paul A. Rossi and David C. Hunt, *The Art of the Old West* (New York and Toronto, 1973), p. 155.
[3] Beebe and Clegg, op cit., p. 86.

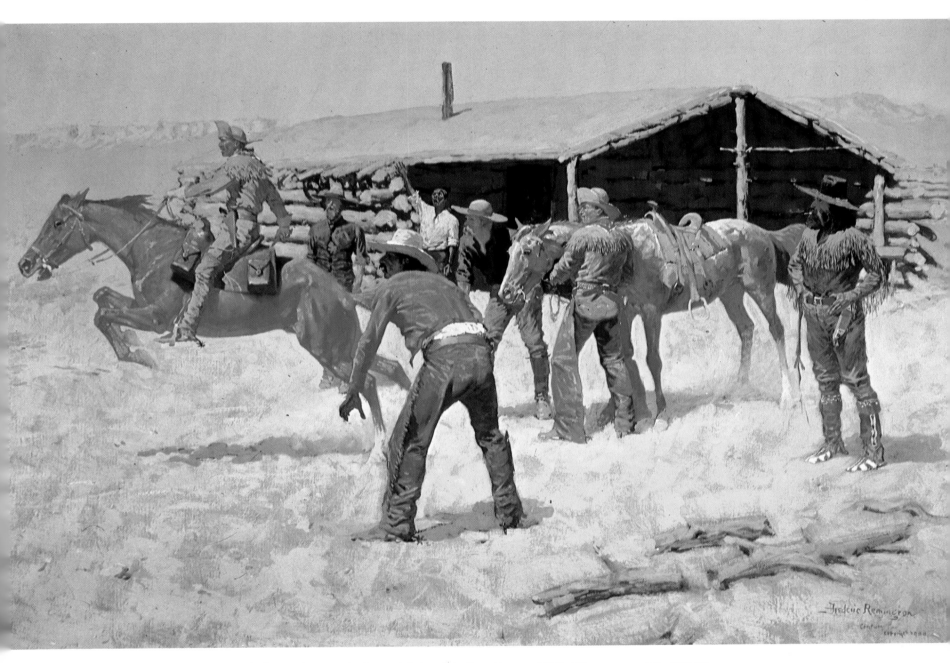

105. Frederic Remington. *Coming and Going of the Pony Express.* 1900. Oil on canvas, 26 x 39″. Thomas
Gilcrease Institute of American History and Art, Tulsa, Okla.

Following his own good advice, Horace Greeley went west in 1859. The ride must have been smooth as he commented later that coaches represented "Civilization, Intelligence, Government, and Protection."[1] Despite the expansion of steamship and railroad lines, coaches remained vital to the West, often providing the sole means of transportation.

Lewis Downing had worked with his father and brother in the carriage business before he set up a wheelwright shop in Concord, New Hampshire, in 1813. Later, journeyman J. Stephen Abbot teamed up with the wheelwright, and in 1865 the firm became known as Abbot, Downing and Co. The joint venture produced approximately three thousand vehicles in a forty-two-year period, exemplifying Downing's precept that "honesty, industry, perseverance and economy will ensure any person, with ordinary health, a good living and something for a rainy day."[2]

Abbot, Downing and Co. gained fame primarily from one product—the Concord coach. Made from iron and well-seasoned ash, the Concord was a rugged vehicle that could endure Western routes and offer the rider comparative comfort. Its clever construction "enabled the passenger compartment to roll rather than bounce and jerk whenever the vehicle hit the countless inevitable holes and ruts in the roads. The center of gravity was lower than on many other makes of coaches and therefore the Concord was less subject to tipping."[3]

Western travelers hailed the day of April 15, 1868.

A novel sight was presented in the Concord Railroad Yard, at noon Wednesday, in the shape of a special train of fifteen long platform cars, containing thirty elegant coaches from the world-renowned carriage manufactory of Messrs. Abbot, Downing & Co., and four long box cars, containing 60 four-horse set harnesses from James R. Hill & Co.'s celebrated harness manufactory, and spare work for repairing the coaches, such as bolts, hubs, spokes, thorough-braces, etc., all consigned to Wells, Fargo & Co., Omaha and Salt Lake City, the whole valued at $45,000 perhaps. It is the largest lot of coaches ever sent from one manufactory at one time, probably.[4]

Not only did the coaches promise a decent ride, but also they were a pleasure to see. The attractive vehicles had bright red bodies and yellow running parts, highlighted by brass and black oxhide fore and aft.

Each coach door had a "picture, mostly landscapes, and no two of the sixty are alike. They are gems of beauty, and would afford study for hours. They were painted by Mr. J. Burgum. The scroll work, executed by Mr. Chas. Knowlton, is very handsome, and varied on each coach."[5]

Burgum had worked for Abbot, Downing and Co. for many years. It is appropriate that the artist who embellished the famous Concords also pictorially recorded this historic event.

[1] Horace Greeley, "The Plains, as I Crossed Them Ten Years Ago," *Harper's Magazine*, 38 (May, 1869), 790.
[2] Edwin G. Burgum, "The Concord Coach," *Colorado Magazine*, 16 (September, 1939), 173.
[3] Oscar Winther, *The Old Oregon Country* (Stanford, Calif., 1950), p. 274.
[4] "A Train of Stage Coaches," *Concord Daily Monitor* (April 15, 1868).
[5] Ibid.

106. J. Burgum. *An Express Freight Shipment of 30 Coaches, April 15, 1868.* c. 1868. Oil on canvas, 20 x 40". New Hampshire Historical Society, Concord

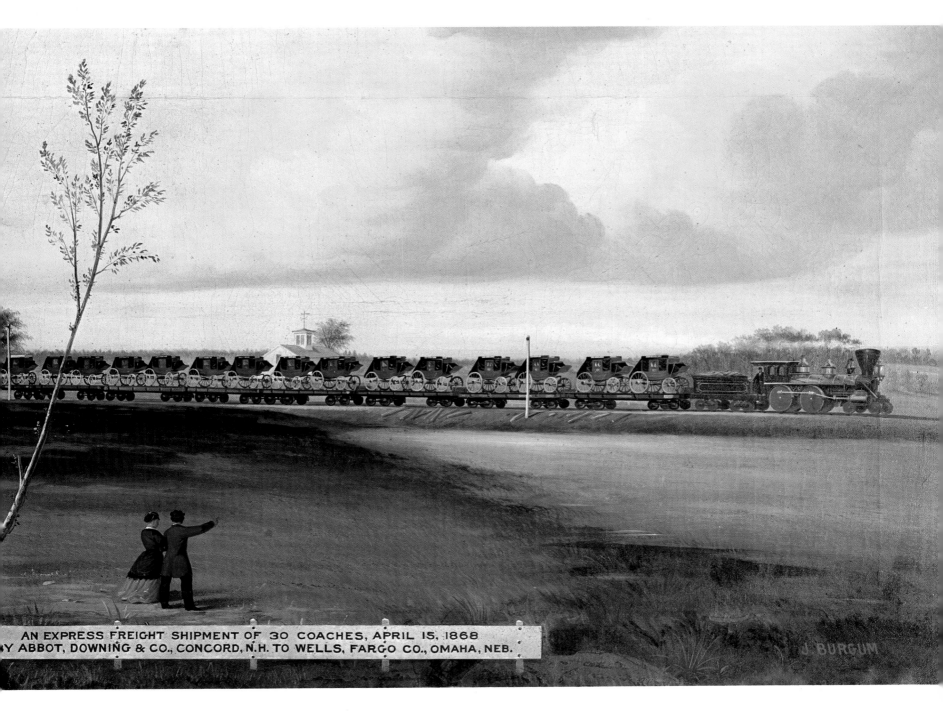

AN EXPRESS FREIGHT SHIPMENT OF 30 COACHES, APRIL 15, 1868
BY ABBOT, DOWNING & CO., CONCORD, N.H. TO WELLS, FARGO CO., OMAHA, NEB.

107. Deadwood-Cheyenne Stage Concord Coach. c. 1850 (reconstructed in 1966). Buffalo Bill Historical Center, Cody, Wyo.

108. Theodore R. Davis. *On the Plains—Indians Attacking Butterfield's Overland Dispatch Coach.* 1866. Wood engraving, 11⅛ x 16¼". Amon Carter Museum, Fort Worth

No. 2.	GOING WEST.			Jan. 1859.		
LEAVE.	**DAYS.**			**Hour.**	**Distance, Place to Place.**	**TIME ALLOWED**
St. Louis, Mo., and Memphis, Tenn.,	Monday	and	Thursday,	8.00 A.M	Miles.	No. Hours.
Tipton, Mo.	Monday	and	Thursday,	6.00 P.M	160	10
Springfield, "	Wednesday	and	Saturday,	7.45 A.M	143	37¾
Fayetteville, Ark.	Thursday	and	Sunday,	10 15 A.M	100	26¼
Fort Smith, "	Friday	and	Monday,	3.30 A.M	65	17½
Sherman, Texas.	Sunday	and	Wednesday,	12.30 A.M	205	45
Fort Belknap, "	Monday	and	Thursday,	9.00 A.M	146½	32¼
Fort Chadbourne, "	Tuesday	and	Friday,	3.15 P.M	136	30¼
Pecos River Crossing,	Thursday	and	Sunday,	3.45 A.M	165	36½
El Paso,	Saturday	and	Tuesday,	11.00 A.M	248½	55¼
Soldier's Farewell,	Sunday	and	Wednesday,	8.30 P.M	150	33½
Tucson, Arizona	Tuesday	and	Friday,	1.30 P.M	184½	41
Gila River,* "	Wednesday	and	Saturday,	9.00 P.M	141	31½
Fort Yuma, Cal.	Friday	and	Monday,	3.00 A.M	135	30
Los Angelos, "	Sunday	and	Wednesday,	8.30 A.M	254	53½
Fort Tejon, "	Monday	and	Thursday,	7.30 A.M	96	23
Visalia, "	Tuesday	and	Friday,	11.30 A.M	127	28
Firebaugh's Ferry, "	Wednesday	and	Saturday,	5.30 A.M	82	18
(Arrive) San Francisco,	Thursday	and	Sunday,	8.30 A.M	163	27

* The Station referred to on the Gila River is 40 miles west of the Maricopa Wells.

This Schedule may not be exact—all employes are directed to use every possible exertion to get the Stage through in quick time, even though ahead of this time.

No allowance is made in the time for ferries, changing teams, &c. It is necessary that each driver increase his speed over the average per hour enough to gain time for meals, changing teams, crossing ferries, &c.

Every person in the Company's employ will remember that each minute is of importance. If each driver on the route loses 15 minutes, it would make a total loss of time, on the entire route, of 25 hours, or, more than one day. If each one loses 10 minutes, it would make a loss of 16⅔ hours, or the best part of a day.

If each driver gains that time, it leaves a margin against accidents and extra delays.

All will see the necessity of promptness; every minute of time is valuable, as the Company are under heavy forfeit if the mail is behind time.

JOHN BUTTERFIELD, President.

109. Overland Mail Company. Butterfield Schedule, January, 1859. Huntington Library, San Marino, Calif.

For those who rode the Overland Mail there were about as many tales to tell afterward as there had been miles along the road. Even without any extraordinary mishaps, the bumps, dust, and bad food were enough to remember and the long, sleepless nights hard to forget. The coaches at night, as Mark Twain recounted, were as "dark as the inside of a cow,"[1] but that was little help against insomnia. Another traveler, Fitz Hugh Ludlow, described it aptly.

... It was a strange sensation, this; like being in an armchair, and sentenced not to get out of it from the Missouri to California.

I do not know whether it is necessary to inform anybody that the Overland Mail travelled night and day. I had known it always, but I never felt it till about twelve o'clock the first night out, when my legs began growing unpleasantly long, and my feet swelled to such a size that they touched all the boxes and musket-butts upon the floor. When these symptoms were further accompanied by a dull heat between the shoulders, and a longing for something soft applied to the nape of the neck, I wondered whether this was not what people on shore called wanting to go to bed. The facilities for such a gratification were so amusingly scanty that I concluded I must be mistaken. The back cushions of the wagon were stuffed as hard as cricket-balls, and the seat might have been the flat side of a bat. I tried fastening my head in a corner by a pocket-handkerchief sling; but just as unconsciousness arrived, the head was sure to slip out, and, in despair, I finally gave over trying to do anything with it.[2]

The most spotlighted episodes on the Overland, however, were not those of weary patrons staggering from the coaches after the 2,800-mile continental traverse. Rather, they were views such as *Stagecoach Overtaken by Indians*, painted by the pioneer Nebraska artist George Simons.

Scenes like this did take place, and on occasion there was even an artist in the midst. Theodore R. Davis, an illustrator for *Harper's Weekly*, rode the Butterfield Overland Dispatch in the winter of 1865, from Atchison to Denver. The first segment of the journey was recorded as pleasant and uneventful, the prairies unbroken except for herds of buffalo at intervals. Then the thought occurred to someone that the buffalo might be harbingers of a more ominous force. "It was possible," posed the skeptic, "that the Indians had driven the Buffalo toward us. This we thought to be very kind of Mr. John Indian, but entertained no desire on our part to receive his visits if he did send buffalo before him as cards of invitation."[3] Indians ignored this lack of hospitality, and the resulting confrontation became one of the most highly publicized stage rides in history. Accounts of the attack not only appeared in Kansas and Colorado papers, but also received national coverage in *Harper's Magazine, Harper's Weekly,* and the *New York Times.*

Apparently it was artist Theodore Davis who first saw the Indians and gave warning. Then, "Mr. D., the moment he

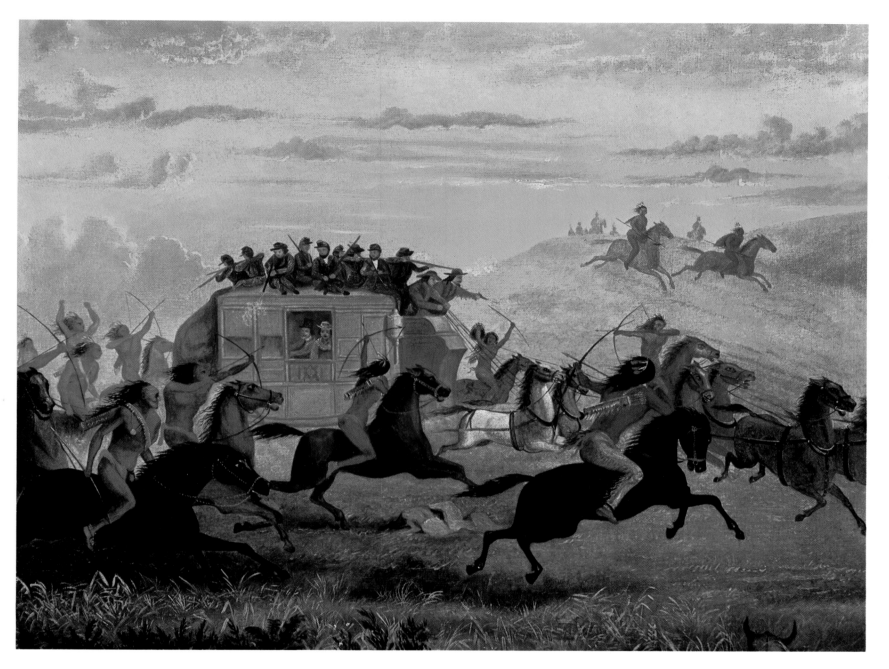

110. George Simons. *Stagecoach Overtaken by Indians.* 1880s. Oil on canvas, 19 x 25″. Joslyn Art Museum, Omaha, Neb.

gave the alarm, picked up his rifle and sent its contents at the most gaudily gotten up Indian, who not liking the dose ran off."[4] When the smoke finally cleared a day later, several men had perished, and the remainder continued into Denver under heavy guard. They had spent fifteen days on the Plains, days which easily could have been their last. "Cooper might have *his* Indians; we did not care for their company,"[5] bemoaned Davis.

[1] Mark Twain, *Roughing It* (Hartford, 1872), p. 37.
[2] Fitz Hugh Ludlow, *The Heart of the Continent* (New York, 1870), pp. 13–14.
[3] Theodore Davis, "General Brewester's Trip Over the 'Butterfield Overland Dispatch' Route," *Weekly Rocky Mountain News* (December 1, 1865).
[4] *Weekly Rocky Mountain News* (December 6, 1865).
[5] Ibid.

111. Currier & Ives. *Prairie Fires of the Great West.* 1871. Lithograph, 10
x 13¾″. Amon Carter Museum, Fort Worth

112. After Andrea T. Gavell. *Great Rock Island Route.* c. 1871. Inlaid mother-of-pearl and glass, 2′3″ x 8′4″.
Pioneer's Museum, Colorado Springs, Col.

After Andrea T. Gavell

In May of 1869 American shores were connected by iron rail. "It is difficult to realize . . . what a difference the completion of the overland route made. A trip from the East to West Coast that once required months was reduced to days."[1] When the Union Pacific and Central Pacific met in Promontory, Utah, they were only two of a myriad of railroad lines competing for Western business. By offering an alternative to traditional modes of frontier transportation and attracting Europeans through elaborate campaigns for riders and settlers, railroads accelerated settlement in the West.

Trains became an icon of Western folklore. Cowboys drove herds to their depots. Highwaymen robbed them. Whole towns would turn out to greet their arrivals. Songs were written about them. And they were portrayed by folk artists who thrived in the nineteenth century.

Andrea T. Gavell, a car builder for the Rock Island Railroad, innovated a means of decorating on clock faces. He drew directly on the glass, highlighting train views with mother-of-pearl. "Mr. Gavell's technique was adopted by other job men who were experts at carving and inlaying of mother-of-pearl in the construction of our old observation cars."[2] From one man's experimentation came a sizable demand for inlays, and around the turn of the century Rock Island contracted with the Western Sand Blast Company in Chicago to produce fifty pictures. Each differed in size and had varying types of engines and numbers of cars. The company sent these fifty to resort hotels for display as advertisements, never to be sold.

As a promotion, *Great Rock Island Route* must have had tremendous impact, if for no other reason than its sheer size. It measures over eight feet in length, including a four-inch walnut frame, while "Great Rock Island Route" is proclaimed in gold lettering on the glass about one-half inch thick. This version, now owned by the Pioneer's Museum, once hung in the old Alta Vista Hotel in Colorado Springs and was probably not one of Gavell's originals, as Pike's Peak and not Illinois scenery fills the background. Purportedly, the cowboy in the right-hand corner is Mr. Gilpin, father of photographer Laura Gilpin of Santa Fe and the person for whom Gilpin County was named. Whoever the artist was, he was familiar with the area and one of its prominent citizens.

Another railroad company, the Union Pacific, inspired a toy maker to create the *Warrior*. Currier & Ives offered *Prairie Fires of the Great West,* a small print available at modest cost. Trains became a symbol of American progress, and their images pervaded many facets of everyday life. Drowned in whistles and toots was Daniel Webster's advice of 1845: "What do we want with this region of savages and wild beasts, of deserts and shifting sands and whirlwinds of dust, of cactus and prairie dogs? To what use could we ever put those endless mountain ranges, impenetrable and covered to their bases with eternal snows? What could we do with a western coastline three thousand miles away, rockbound, cheerless, and uninviting!"[3]

[1] Everett L. DeGolyer, Jr., *The Track Going Back* (Fort Worth, 1969), unpaged.
[2] "Background of Mother-of-Pearl Pictures of Rock Island Trains," Rock Island Railroad: Department of Research, n.d., a paper in the Pioneer's Museum, Colorado Springs.
[3] Quoted in Don Russell, ed., *Trails of the Iron Horse* (Garden City, N.Y., 1975), p. 9.

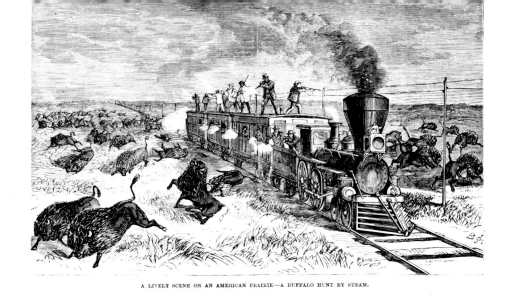

113. Unkown artist. *A Lively Scene on an American Prairie—A Buffalo Hunt by Steam,* from *Frank Leslie's Illustrated Newspaper,* November 28, 1868. Wood engraving. General Research and Humanities Division, New York Public Library, New York City

A LIVELY SCENE ON AN AMERICAN PRAIRIE—A BUFFALO HUNT BY STEAM.

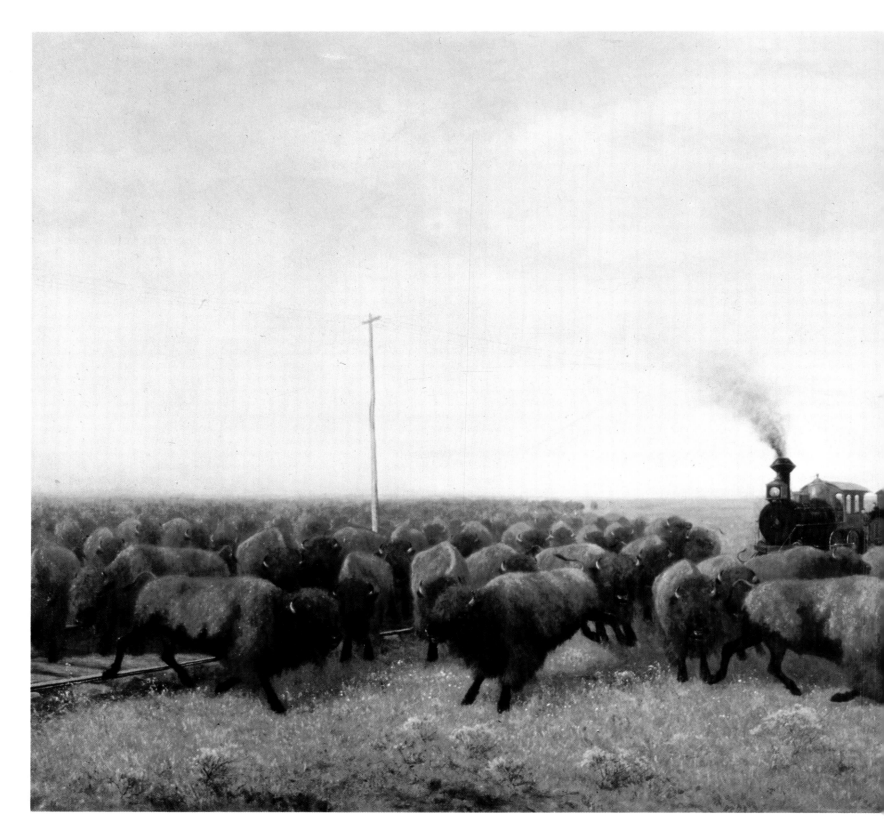

114. Newbold H. Trotter. *Held Up.* 1897. Oil on canvas, 42 x 51½". Smithsonian Institution, Washington, D.C.

Newbold H. Trotter

The visage of the vast prairies, seas of grass and tranquility that supported a multitude of animals and a myriad of Indian cultures, was inexorably altered by the iron tracks laid for the great smoke-belching behemoths. A minor obstacle lay in their path—herds of buffalo whose grazing territories had been partitioned by the railways. "Several of our party," recorded J.F. Meline, "who passed over this route frequently, between 1851 and 1857, inform us at that time, these immense plains, stretching in every direction around us, were covered with the buffalo—to such an extent, indeed, as frequently to impede the progress of trains."[1]

Buffalo impeded a few trains, of course. Some passengers complained, but others hoped for such intervention, providing an outlet for their great skill as hunters. On October 18, 1868, "the general ticket agents' 'Kansas excursion' over the Union Pacific railway, Eastern division" reached Fort Hayes, Kansas. " 'Where are you going?' asked a resident of Fort Hayes. 'To hunt buffaloes and Indians' was the prompt response of a dozen."[2]

A Lively Scene on an American Prairie—A Buffalo Hunt by Steam appeared in *Frank Leslie's Illustrated Newspaper* accompanying a story of the excursion's escapades. Chugging across the plains, the engine brought to the carload of occupants a vision of a country which "is as bald as the heads of our clerical delegation, and looks as lonely as a Kansas graveyard. Our impression is that the abundance of cayote holes will always make it a leaky country."[3]

Soon the excursionists spotted their woolly prey and rushed to the windows, arms poised for the kill. Running alongside the train for several miles was a herd of buffalo, oddly oblivious to the bullets which flew into their midst. The animals tired, then slowed down, while the train disgorged the sportsmen.

In a few minutes after, one of the herd, an immense female bison, fell on her knees, when all closed round her and one gallant sport out with a huge dirk and cut her throat. This daring act created a shout. Victory had perched upon the banner of the travelers, and what had been imagined an hour previously was at that important hour a stern reality—a bison had fallen. The army had conquered. A noble specimen of Box Americanus was lying at the feet of those whose faith had been made strong by the dying animal before them. Immediately some two dozen stalwart men out with pocket knives and deliberately attached the dead. It was an amusing spectacle, but as no provision had been made for the butchering, necessity mothered the invention, and but little time elapsed before both hind quarters, the head, eyes, tongue, tail, hoof and many parts of the hide were safely deposited in the baggage car. The hunt and chase were a success.[4]

[1] J.F. Meline, *Ten Thousand Miles on Horseback* (1867), quoted in Perry T. Rathbone, ed., *Westward the Way* (St. Louis, 1954), p. 258.
[2] *Denver Sunday Times* (February 25, 1900), p. 17.
[3] "Home Incidents," *Frank Leslie's Illustrated Newspaper* (November 28, 1868), p. 173.
[4] *Denver Sunday Times*, loc. cit.

Western

Grandeur

It would be a mistake to think that the grandeur of Western scenery was reserved province for the flamboyant vision of Albert Bierstadt. Artists from the very first reveled in the painter's paradise which opened before them on the plains and boldly confronted them in the monochrome granite mass of the Rockies. Catlin, Miller, Bodmer, and Stanley, among many others, brought before the world these sublime and incontestably grand sights. Of the nearly six hundred paintings in the famous Catlin Indian Gallery, for example, almost one hundred were pure landscapes.

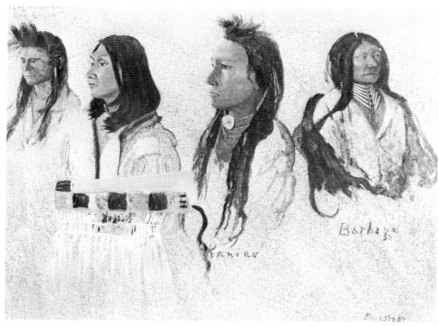

115. Albert Bierstadt. *Indians (Indians with Wampum)*. c. 1863. Oil on board, 13½ x 19". The New York Historical Society, New York City

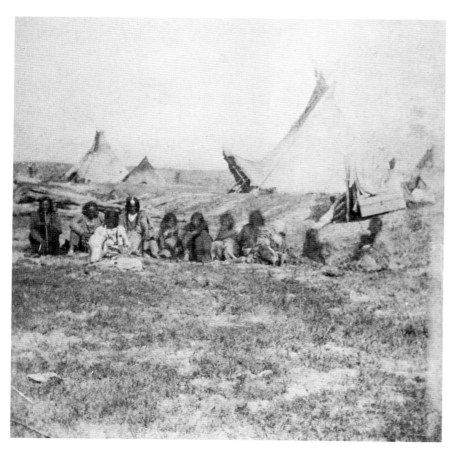

116. Albert Bierstadt. *Ogalillah Sioux, Horse Creek, Nebraska*. 1859. Photograph. The New York Historical Society, New York City

Only for the second half of the nineteenth century was Bierstadt truly king of the mountain. "But who can paint the mountains, the seas or the skies? And if Bierstadt could reproduce on canvas this miracle of the heavens, the art critics would say: 'It is utterly impossible—no living man ever looked upon such skies!' He who sees truly will no more place limits upon the divine love which pervades and suffuses it. In nature, as in human life, nothing is impossible."[1]

In 1859, on Bierstadt's first venture west, he traveled side by side with a host of gold seekers bound for Colorado riches. The land, it seemed, had been transformed as if by some alchemist's wizardry into a golden mirage. Most of the seekers, it turned out, were humbugged in the end; their slogans changed from "Pike's Peak or Bust" to "Busted by God." More than half of those who reached the Colorado gold fields had returned East by summer's end and with little more to show for themselves than sore feet, blistered hands, and empty pockets. Bierstadt was not part of that legion. Instead of coming back empty-handed, the young artist returned from a summer in the Wind River Mountains with an inspired vision of the Rockies—the altar of America's hope and the gilded chalice from which her dreams might flow.

Of all the positions to which Bierstadt ascended through the years, he has never been nominated to the rank of documentarian. Yet some of his earliest and finest pictures are both precise and documentary. He is credited with taking the first photographs along the Kansas route of the Oregon Trail. Frederick Lander, with whom he traveled in 1859, commented that Bierstadt and his Boston companion S.F. Frost had "taken sketches of the most remarkable of the views along the route, and a set of stereoscopic views of emigrant trains, Indians, camp scenes, &c., which are highly valuable and would be interesting to the country."[2]

These photographic studies provided Bierstadt with a pictorial source for one of the finest paintings from his 1859 trip, *The Wolf River, Kansas*. The artist also used the photographs to encourage his brothers, Edward and Charles, to go into the business of issuing stereographs of Western subjects. Bierstadt's photograph of the Wolf River was one of over fifty Western views published by the Bierstadt brothers in 1860. His studies of Indians in the same medium proved that he was interested in more than landscapes.

The September, 1859, issue of the *Crayon* quoted Bierstadt's observations from the field in the vicinity of Fort Laramie.

We have taken many stereoscopic views, but not so many of mountain scenery as I could wish, owing to various obstacles attached to the process, but still a goodly number. We have a great many Indian subjects. We were quite fortunate in getting them, the natives not being very willing to have the brass tube of the camera pointed at them. . . . When I am making studies in color, the Indians seem much pleased to look on and see me work; they have an idea that I am some medicine-man.[3]

[1] Albert D. Richardson, *Beyond the Mississippi* (Hartford, Conn., 1869), p. 497.
[2] Frederick W. Lander, *Maps & Reports of Fort Kearny, South Pass, & Honey Lake Wagon Road* (Washington, D.C., 1861), p. 5.
[3] *Crayon* (September, 1859), quoted in E.S. Wallace, "Albert Bierstadt, Artist," *The Westerners, New York Posse Brand Book*, 2 (New York, 1955), 20.

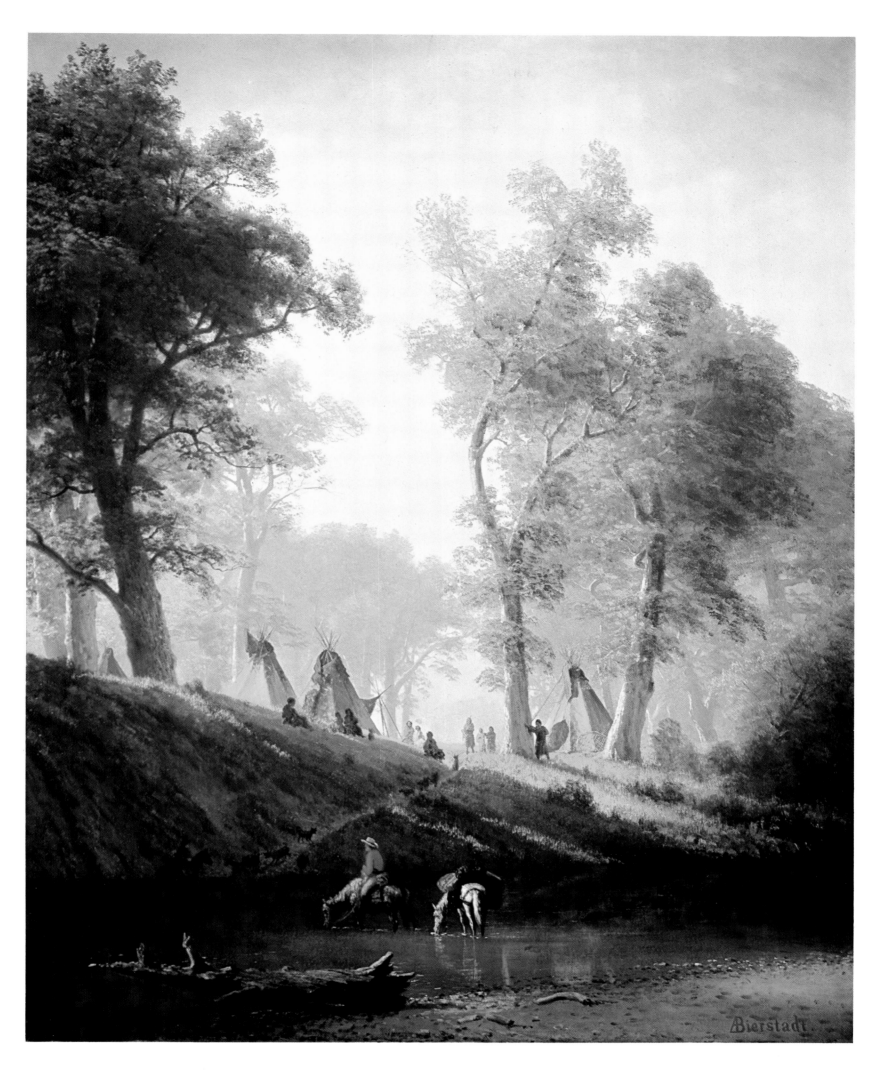

117. Albert Bierstadt. *The Wolf River, Kansas.* 1859. Oil on canvas, 48½ x 38¼″. Detroit Institute of Arts

118. Albert Bierstadt. *Moose.* 1859?. Oil on board, 14¼ x 18¾″. Collection Mr. and Mrs. Nicholas Wyeth

Wyoming's Wind River Mountains had wooed and won other great painters of the West before Bierstadt came beneath their awesome shadow in 1859. Alfred Jacob Miller had faced them brush in hand with a modest reverence that gave later painters the confidence to approach. Looking across a crystal lake in 1837, Miller had wondered at his own abilities and had made this invitation to those who would follow.

The most favorable time to view these Lakes (to an artist especially) was early in the morning or towards sunset;—at these times one side or the other would be thrown into deep purple masses, throwing great broad shadows, with sharp light glittering on the extreme tops,—while the opposite mountains received its full complement of warm, mellow & subdued light;—thus forming a *chiaro obscuro* and contrast most essential to the picturesque in color. . . . The scene in reality was charming, but would have required the pencil of a [William] Stanfield, [Joseph] Turner, or [Frederick] Church in giving it due effect and rendering it complete justice. Patiently it awaits the coming man.[1]

Stanfield and Turner were too distant and Church was not interested in the Rockies. The field was thus open to Bierstadt, and he proved up to the task. In his early paintings Bierstadt affected a remarkable balance between drama and scale. His *Thunderstorm in the Rocky Mountains* evokes an intimacy with nature rarely seen in his later, more grandiose designs. The fresh scent of the passing storm, the counterplay of shadow and sunbeam, and the delicate lacing of breeze across the water surface combine to create a special gem.

Much of the vitality captured in Bierstadt's *Thunderstorm in the Rocky Mountains* springs from the animation of the sunlit deer in the right foreground. Pert and nervous, they abound with life as if with the blink of an eye they would be off and out of sight.

Bierstadt was never a great animal painter, yet he knew enough in his early work to utilize them effectively. It was his animals which breathed life into scenes like this. Occasionally the artist's wildlife even gave a hint of personality of their own. His portrait of a young moose carries such a sense.

[1] Marvin C. Ross, *The West of Alfred Jacob Miller* (Norman, Okla., 1968), opp. p. 130.

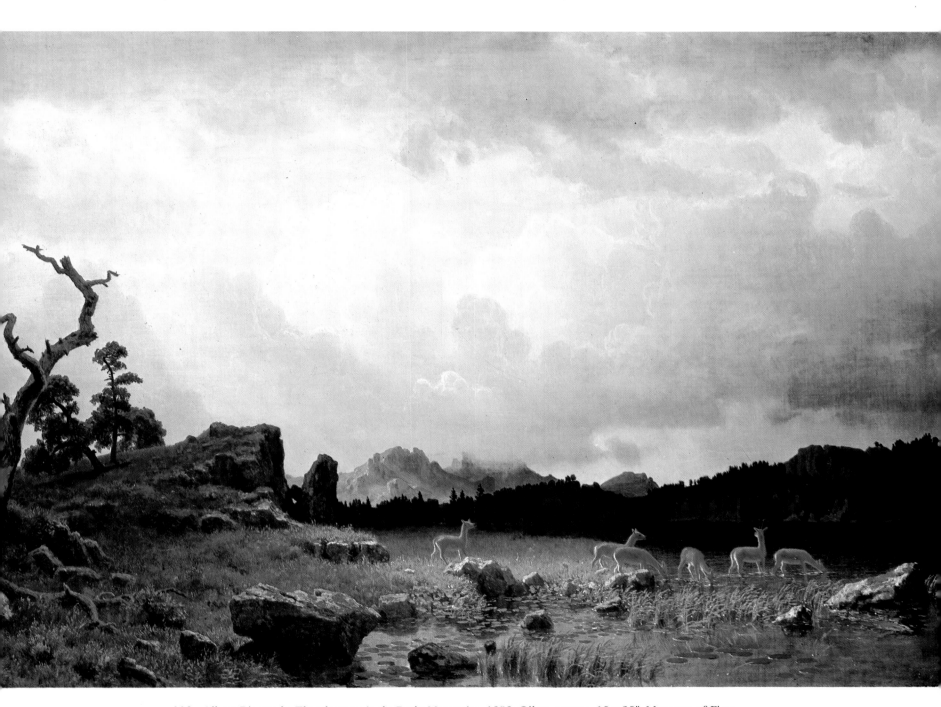

119. Albert Bierstadt. *Thunderstorm in the Rocky Mountains.* 1859. Oil on canvas, 19 x 29″. Museum of Fine
Arts, Boston. Given in memory of Elias T. Milliken by his daughters, Mrs. E. Hale and
Mrs. J. C. Perkins

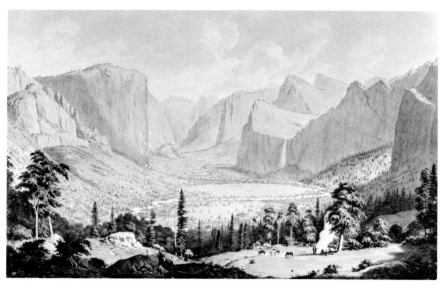

120. Thomas A. Ayres. *General View of the Great Yo-Semite Valley.* 1859. Colored lithograph, 18 x 24". Amon Carter Museum, Fort Worth

121. Albert Bierstadt. *Sierra Nevada Mountains (Yosemite Valley from Inspiration Point).* c. 1863. Oil on board, 18 x 24". Thomas Gilcrease Institute of American History and Art, Tulsa, Okla.

Patrons of the American Art-Union in 1857 were accustomed to viewing sublime scenes gleaned from vistas in the Catskills and along the Delaware River Gap. In contrast to these, a series of California drawings was exhibited that year which pictured the astonishing Yosemite Valley and must have caused some excited reactions. They were the work of Thomas Ayres, the first artist to behold its pictorial riches.

Twice in the mid-1850s Ayres had ventured into the Yosemite, once in 1855 and then again a year later. His first visit came at the invitation of James Mason Hutchings, a journalist from San Francisco who wished to use spectacles from Yosemite to launch his publishing venture, the *California Illustrated Magazine.* Hutchings knew of Ayres, one of several artist-argonauts with ability in the rendering of landscape views, and engaged him as artist for the expedition. Two Indians served as their guides that June in what might be called the first tourist party in the park.[1]

Following on the heels of Hutchings and Ayres was a parade of artists, photographers, and journalists in the late 1850s and early 1860s. William S. Jewett from New York is credited with the earliest painting of Yosemite; William Keith and Thomas Hill of England were the first artists to make a living from its pictorialization. But of the host, it was Albert Bierstadt whose versions echoed the loudest salvos.

Bierstadt's subsequent paintings have probably done more than all written descriptions to give persons abroad an adequate idea of the grandeur and beauty of that wonderful gorge, whose granite precipices rise from 3,000 to 4,400 feet above the valley, and whose waterfalls make leaps of 500 to 1,500 feet clear, losing themselves in spray on the bosom of the air, or tossing like veils of lace on the breeze. The striking merit of Bierstadt in his treatment of Yosemite, as of other western landscapes, lies in his power of grasping distances, handling wide spaces, truthfully massing huge objects, and realizing splendid atmospheric effects. The success with which he does this, and so reproduces the noblest aspects of grand scenery, filling the mind of the spectator with the very sentiment of the original, is the proof of his genius.[2]

Other critics were not so convinced of Bierstadt's talents or the validity of his observation. His enormous panorama, *Domes of the Yosemite,* captured public acclaim, but such works, according to James Jackson Jarves, addressed only those "Americans, who associate them with the vulgar idea of 'big things,' as business."[3] Clarence King quoted artist Hank Smith in 1871 as less than devoted to Bierstadt's grand persuasion.

'It's all Bierstadt and B__ and B__ nowadays! What has he done but twist and skew and distort and discolor and belittle and be-pretty this whole doggoned country? Why, his mountains are too high and too slim; they'd blow over in one of our fall winds.'

'I've herded colts two summers in Yosemite, and honest now, when I stood right up in front of his picture, I didn't know it.'

'He hasn't what old Ruskin calls for.'[4]

Although all the external facts of nature were in evidence, many felt that these stupendous paintings were "disenfranchised of sentiment and imagination," that "nature's best is left out."[5] In his less ostentatious works, Bierstadt did not avoid nature, but here the neglect was obvious. Wrote another observer of *Domes of the Yosemite,* "an effect in nature is that which draws all her various details to unity. Sunshine will do it, atmosphere will do it, mists and shadows will do it, and an ordering of parts and happy falling of lines will do it; but if the beauty of none of these, be given what can our effects be worth?"[6]

Bierstadt's smaller general view of Yosemite entitled *Sierra Nevada Mountains* reflects the harmony between man and nature which the artist sought despite his reputation to the contrary. The essentials of nature are here unobscured by the element of theater.

Early sources indicate that Bierstadt traveled into Yosemite in the company of two other artists, Thomas Hill and Virgil William, according to one account,[7] or Virgil Williams and Enoch Perry, according to another.[8] Whichever account is correct, all of these artists arrived at one time or another, and Thomas Hill ultimately came to stay. He built a studio there in 1888 and became known as the artist of Yosemite. He was a virtuoso with paint when he wished to be, a hack, too, when he wanted.

Yosemite, shortly after Bierstadt's first visit and in part as a result of his work there, was set aside for "public use, resort and recreation,"[9] in a bill passed and signed by President Lincoln. By this time, so many painters had exposed the picturesque qualities of the valley that the public could think in no other terms. Remarked one visitor when asked for his impression after first seeing Yosemite, "so skillfully is the view arranged for pictorial effect, [it] was that of looking upon some perfect picture."[10] The tourist would

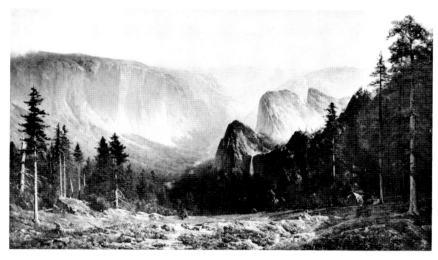

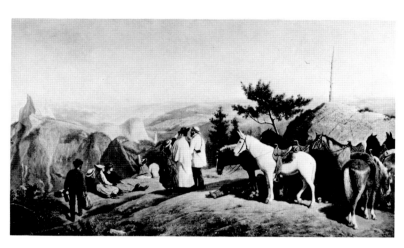

122. Thomas Hill. *Great Canyon of the Sierras—Yosemite.* 1871. Oil on canvas, 6′ x 10′. E. B. Crocker Art Gallery, Sacramento

123. W. Hahn. *Looking Down at Yosemite Valley from Glacier Point.* 1874. Oil on canvas, 27¼ x 46″. California Historical Society, San Francisco/San Marino

not be denied such joy. Within a few years the valley teemed with people. "They climb sprawlingly to their saddles like overgrown frogs pulling themselves up a streambank through the bent sedges, ride up the valley with about as much emotion as the horse they ride upon, and comfortable when they have 'done it all,' and long for the safety and flatness of their proper homes."[11] W. Hahn perhaps pictured such an assortment of adventures in his *Looking Down at Yosemite Valley from Glacier Point.*

[1] See Jeanne Van Nostrand, "Thomas A. Ayres: Artist-Argonaut of California," *California Historical Society Quarterly,* 20 (September, 1941), 275–79.

[2] "Art Beginnings on the Pacific," *Overland Monthly,* 1 (August, 1868), 114.

[3] James Jackson Jarves, *Art Thoughts* (New York, 1871), p. 299.

[4] Clarence King, *Mountaineering in the Sierra Nevada,* ed. Francis P. Farquhar (New York, 1935), p. 223.

[5] Jarves, loc. cit.

[6] "The Domes of the Yo Semite," *Nation,* 4 (May 9, 1867), 379.

[7] "Art Beginnings on the Pacific," 114.

[8] Fitz Hugh Ludlow, *The Heart of the Continent* (New York, 1870), p. 419.

[9] Quoted in *National Parks and the American Landscape* (National Collection of Fine Arts, Washington, D.C., 1972), p. 102.

[10] Quoted in Earl Pomeroy, *In Search of the Golden West* (New York, 1957), p. 46.

[11] Ibid., p. 52.

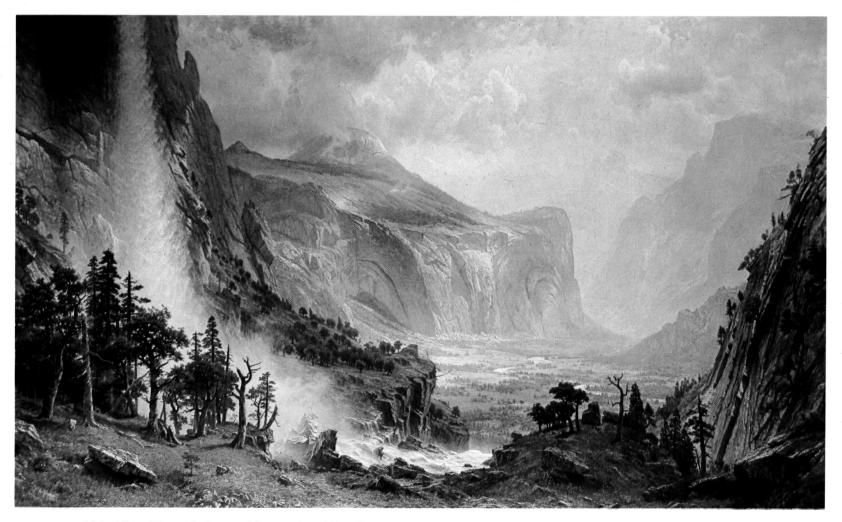

124. Albert Bierstadt. *Domes of the Yosemite.* 1867. Oil on canvas, 9′8″ x 15′. St. Johnsbury Athenaeum, Inc., St. Johnsbury, Vt.

125. Albert Bierstadt. *Buffalo Head*. n.d. Oil on board, 13¼ x 15¼".
Buffalo Bill Historical Center, Cody, Wyo. Gift of Carman H.
Messmore

Our artist, though a good shot, and capable of going to market for himself wherever there was any game, as well as most people, had seen enough buffalo-hunting in other expeditions to care little for it now, compared with the artistic opportunities which our battue afforded him for portraits of fine old bulls. He accordingly put his color-box, camp-stool, and sketching-umbrella into the buggy, hitched a team of the wagon-horses to it, and, taking one of our own party in with him, declared his intention of visiting the battle-field solely as "our special artist."[1]

It was in north central Kansas along the banks of the Republican River that Bierstadt in 1863 conceived his great apotheosis, *The Last of the Buffalo*. Through the course of several days he joined in the hunt as observer, popping in and out of his buggy, erecting his big blue sketching umbrella to paint what his companion Fitz Hugh Ludlow termed the "moral grandeur in a brute."[2]

Bierstadt's handsome *Buffalo Head* probably resulted from his studies on the prairies during that hunt. In Ludlow's book *The Heart of the Continent*, published seven years after the artist and he crossed the West together, Bierstadt provided an illustration entitled *Buffalo Charge*. The composition suggests that the artist had long held the idea of a painting which pitched Indian and buffalo in mortal combat.[3]

It was not until 1888 that Bierstadt brought his concept to full fruition in *The Last of the Buffalo*. Intended for display in the 1889 Paris Exposition, one of two versions of the picture was completed in January of 1888.[4] The huge painting hung in the Paris Salon, but a selection committee made up of American artists rejected it for the Exposition, "considering it out of keeping with the developing French influence in American painting."[5]

Bierstadt was profoundly shaken by the rebuff. "Why my picture was rejected I, of course, do not know," he commented upon hearing the news. "I have endeavored to show the buffalo in all his aspects and depict the cruel slaughter of a noble animal now almost extinct. The buffalo is an ugly brute to paint, but I consider my picture one of my very best."[6] A new day was dawning, and the "chromo-tinkers," as one paper dubbed the painters of Impressionist persuasion who had run Bierstadt out, were in the ascendant.

[1] Fitz Hugh Ludlow, *The Heart of the Continent* (New York, 1870), p. 62.

[2] Ibid., p. 68.

[3] Gordon Hendricks, "The First Three Western Journeys of Albert Bierstadt," *Art Bulletin*, 46 (September, 1964), 342.

[4] This is the canvas now owned by the Corcoran Gallery of Art, Washington, D.C.; it is larger than the Buffalo Bill Historical Center's version reproduced here.

[5] From an undated clipping in the *New York World*, quoted in Gordon Hendricks, *Albert Bierstadt: Painter of The American West* (New York, 1973), p. 291.

[6] *New York World* (March 31, 1889), quoted in Hendricks, op. cit., 286.

126. Albert Bierstadt. *Buffalo Charge,* from the book *The Heart of the Continent* by Fitz Hugh Ludlow. c. 1863. Engraving. Collection P. H. Hassrick

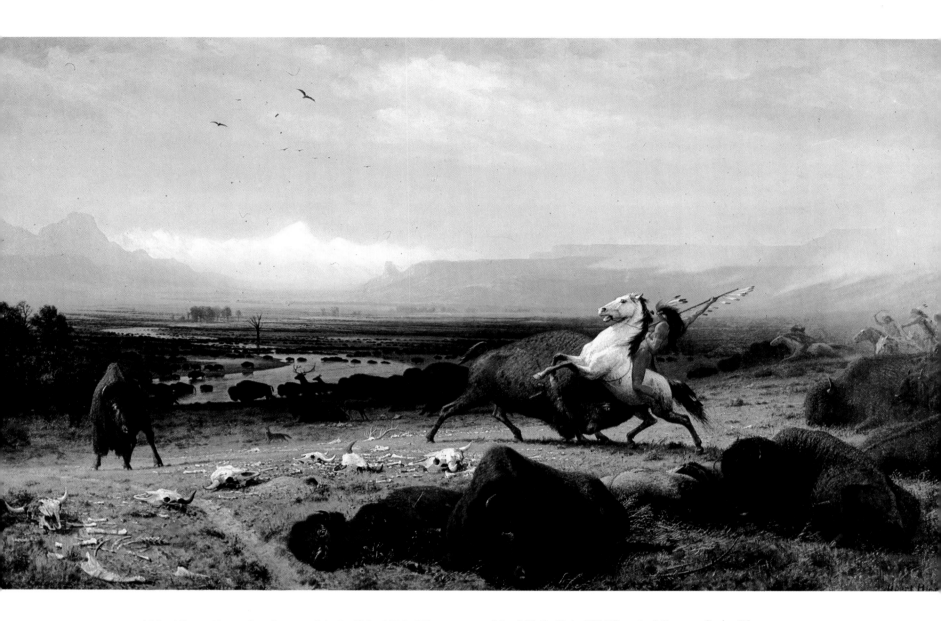

127. Albert Bierstadt. *The Last of the Buffalo.* 1889. Oil on canvas, 60 x 96″. Buffalo Bill Historical Center, Cody, Wyo.

America's farthest frontier was Alaska. Its mountains, coastlines, and glaciers were a place where an artist with a penchant for wandering and a rueful heart might escape for solace and inspiration. The summer and fall of 1889 found Bierstadt there. He traveled through the Canadian Rockies to Vancouver on the newly completed Canadian Pacific Railroad. He then boarded the steamer *Ancon,* which was to take him north. But Ketchikan was his last major port, for at Loring Bay the ship went aground on a reef, and Bierstadt was left stranded for five days until another steamer came by headed south.

The Wreck of the "Ancon," Loring Bay, Alaska shows the fresh and unpretentious core of Bierstadt's art. The frequent criticism, that "all the beauty of his pictures is on the surface, and is visible at first sight,"[1] does not apply to this or to other of Bierstadt's freely executed field studies. The brilliant cadmium yellow wheel covers standing boldly against the monochrome sea and clouds offer a fullness of expression by the simplest of means. Bierstadt was truly a master of an intimate world as well as progenitor of the grandiose sweep.

It is the small studies such as this and *Alaska,* thought to have been painted on the same trip, which hold popular attention today. Yet with the grand as well as the intimate, Bierstadt's place in American art is guaranteed. The reason is not that his works "are as gratifyingly vulgar and healthy as a great, good Falstaffian belch,"[2] as one recent critic has asserted. Rather, it is because he brought much of what America dreamed about to reality, and he dared to confront the prodigious and exotic wilderness to do so.

Artists are now scattered, like leaves or thistle blossoms, over the whole face of the country, in pursuit of some of their annual study of nature and necessary recreation. Some have gone far toward the North Pole, to invade the haunts of the iceberg with their inquisitive and unsparing eyes—some have gone to the far West, where Nature plays with the illimitable and grand—some have become tropically mad, and are pursuing a sketch up and down the Cordilleras, through Central America and down the Andes. If such is the spirit and persistency of American Art, we may well promise ourselves good things for the future.[3]

[1] *New York Times* (May 2, 1867).
[2] William Wilson, " 'Pack-In Painters' at USC Gallery," *Los Angeles Times* (December 13, 1976).
[3] From the *Cosmopolitan Art Journal,* 3 (September, 1859), quoted in *The Natural Paradise, Painting in America 1800–1950* (The Museum of Modern Art, New York, 1976), pp. 80–81.

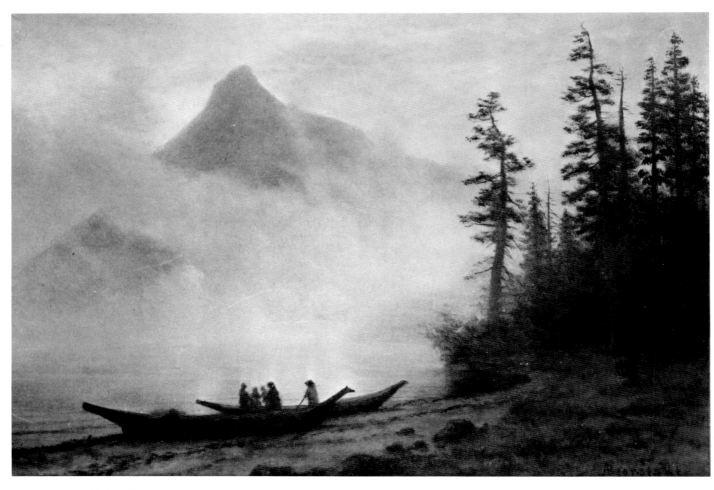

128. Albert Bierstadt. *Alaska.* 1889?. Oil on canvas, 14 x 20″. Indianapolis Museum of Art. Gift of Mrs. Addison Bybee

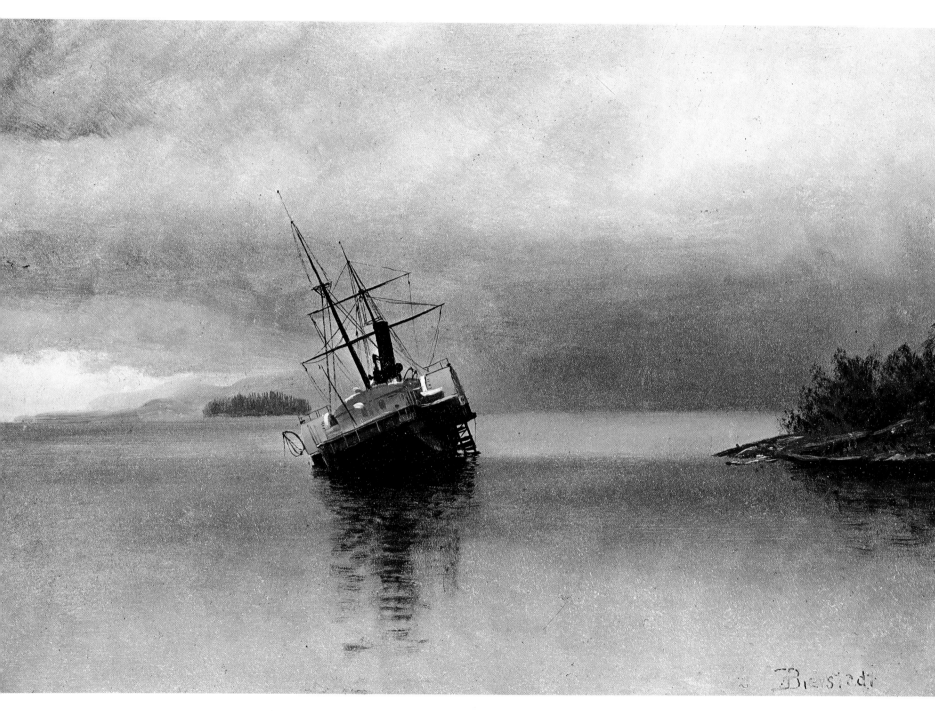

129. Albert Bierstadt. *The Wreck of the "Ancon," Loring Bay, Alaska.* 1889. Oil on canvas, 14 x 19¾". Museum
of Fine Arts, Boston. M. and M. Karolik Collection

130. Alfred T. Agate. *Shaste Peak.* 1840. Engraving, 4⅝ x 7″. Western History Department, Denver Public Library

131. Steve Harley. *South End of Hood River.* 1927. Oil on canvas, 20 x 33½″. Abby Aldrich Rockefeller Folk Art Collection, Williamsburg, Va.

The fickle sea and treacherous coast had extended a rude welcome to another group of artists almost fifty years before Bierstadt watched the *Ancon* break and sink at Loring Bay. On July 18, 1841, two illustrious artist-explorers, part of Charles Wilkes's United States Exploring Expedition, arrived off a bar at the mouth of the Columbia River. They were Alfred Agate of New York and Titian Ramsay Peale of Philadelphia, and they had been on the sea since the summer of 1838. The American shore must have looked good to them, at least until their ship, the frigate *Peacock,* was caught by the cross tides and stuck fast on the bar. The pounding surf then made quick work of her.

Everyone escaped to shore, and due to conspicuous heroism by the crew most of the expedition's notes and equipment survived. Peale and Agate were later assigned the survey of Oregon and northern California. Under the direction of Lieutenant Emmons, the party proceeded up the Willamette Valley via an Indian trail, over the Klamath Mountains, and into the Sacramento Valley.

Peale's journal entry for September 22 recalled a bad day on the trail.

> The day's journey was a most arduous one although we gained by 16 or 18 miles; one or two horses fell down the steep side of the mountains [Umpqua Mountains] with their packs but were recovered with some little delay;— the bag containing my bed and wardrobe was torn open by the brush and carelessness of the men in charge, and the case containing my drawing instruments was broken and all the instruments, my sketch book and journal lost with all my notes and drawings, from the time of our landing in Oregon after the wreck of the Peacock.[1]

Though the trip was rugged, there were moments of great beauty. Peale wrote again that "the summit of Mount Tshasty [*sic*] presented a beautiful view from our camp when its snow was illuminated by the pink rays of the setting sun, while the base remained invisible to us."[2] Agate's painting of the scene was later used in engraved form to illustrate Wilkes's narrative.

The mountain ranges of the Pacific coast invited many artists after Agate. Paul Kane, John Mix Stanley, James Madison Alden, and Albert Bierstadt were among many to paint the conic crests of citadels like Hood, St. Helens, and Rainier. A little-known artist of French descent, Alexander F. Loemans, flourished in the Vancouver area in the mid-1890s and painted some of the most intriguing views of these mountains. Loemans was an itinerant painter imbued with the spirit of romanticism. Compared with the precise interpretation of Agate, in which nature functioned more as a symbol of an ordered world, Loemans's vision is turbulent and exotic.

The romantic veil disappeared gradually as man intruded and rearranged nature to his own needs. Steve Harley's crisp twentieth-century look at Mount Hood illustrates the result of this emphatic interruption.

[1] Jessie Poesch, *Titian Ramsay Peale 1799–1885 and His Journals of the Wilkes Expedition* (Philadelphia, 1961), pp. 28–30.
[2] Ibid., p. 48.

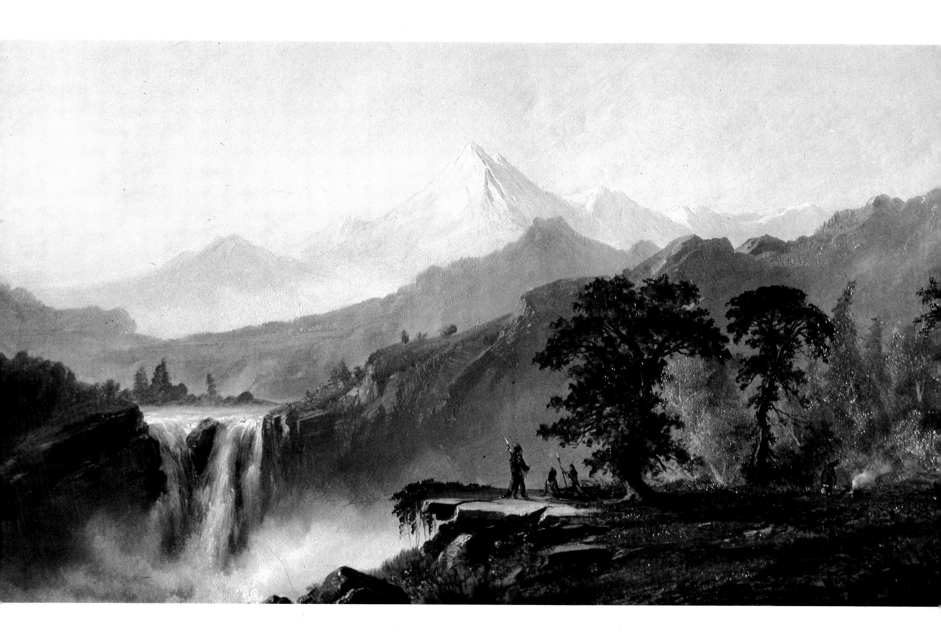

132. Alexander F. Loemans. *Indian Breakfast (Mount Hood)*. n.d. Oil on canvas, 19 x 34½". Collection Mr. and Mrs. Royal B. Hassrick

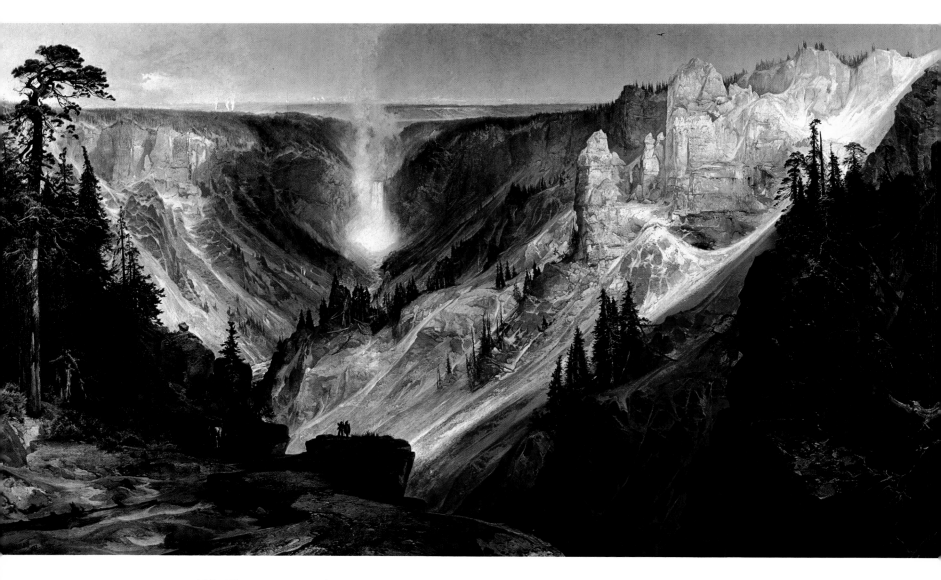

133. Thomas Moran. *The Grand Canyon of the Yellowstone.* 1872. Oil on canvas, 7′ x 12′. National Collection of Fine Arts, Smithsonian Institution, Washington, D.C.

Thomas Moran

Mountain men John Colter and Jim Bridger brought back the first reports of the fabulous wonders to behold in Yellowstone. In 1849 Bridger had beguiled members of Captain Howard Stansbury's expedition to the Great Salt Lake with wild tales.

> He [Bridger] gives a picture, most romantic and enticing, of the head waters of the Yellow Stone. A lake, sixty miles long, cold and pellucid, lies embosomed among high precipitous mountains. On the west side is a sloping plain, several miles wide, with clumps of trees and groves of pine. The ground resounds with the tread of horses. Geysers spout up seventy feet high, with a terrific, hissing noise, at regular intervals. Waterfalls are sparkling, leaping and thundering down the precipices, and collect in the pool below. The river issues from this lake, and for fifteen miles roars through the perpendicular cañon at the outlet.[1]

An organized expedition to prove the verity of Bridger's claims did not reach Yellowstone until 1870, under the leadership of Henry Dana Washburn, then surveyor general of the Montana Territory. The expedition's scribe, Nathaniel Langford, brought back an otherworldly impression, especially of the Grand Canyon of the Yellowstone. The falls, he wrote, are "very beautiful; but the broken and cavernous gorge through which it passes, worn into a thousand fantastic shapes, bearing along its margin the tracks of grizzly bears and lesser wild animals, scattered throughout with huge masses of obsidian and other volcanic matter—the whole suggestive of nothing earthly nor heavenly—received at our hands, and not inaptly as I conceive, the name of 'The Devil's Den.'"[2]

There were two artists who accompanied the Washburn expedition, Walter Trumbull and Private Charles Moore. Their pencilings were quaint at best and offered little idea of what had been seen. The following year, that situation was remedied. Geologist Ferdinand Vandiveer Hayden entered Yellowstone's trackless wilderness, and with him were two of the greatest picture men in the business—photographer William Henry Jackson and painter Thomas Moran.

Jackson and Moran often worked hand in hand. According to Jackson, Moran "was interested in photography and gave unstintingly of his artistic knowledge especially with regard to the problems of composition."[3] Jackson's photograph of *The Grand Canyon of the Yellowstone* was no doubt worked out in conjunction with the painter and has remained one of the classic Western photo images of the nineteenth century. However, the Jackson photographs and Moran's deft sketches such as *In the Canyon* were only a prelude to pictorial greatness. "So far as I am concerned, the great picture of the 1871 expedition was no photograph," wrote Jackson, "but a painting by Moran of Yellowstone Falls. . . . It captured, more than any other painting I know, the color and the atmosphere of spectacular nature."[4] Moran never received a finer acknowledgment.

134. William H. Jackson. *The Grand Canyon of the Yellowstone.* 1871. Photograph. United States Geological Survey, Denver

135. Thomas Moran. *In the Canyon.* 1871. Pencil on paper, 5⅛ x 7¾". . National Park Service

[1] Lt. John Williams Gunnison, *The Mormons, or Latter-Day Saints, in the Valley of the Great Salt Lake* (Philadelphia, 1852), p. 151.

[2] Nathaniel P. Langford, *The Discovery of Yellowstone Park* (Lincoln, Neb., 1972), p. 28.

[3] From Jackson's *Diaries,* quoted in Beaumont Newhall and Diana E. Edkins, *William H. Jackson* (Fort Worth, 1974), p. 138.

[4] William Henry Jackson, *Time Exposure* (New York, 1940), p. 200.

Thomas Moran

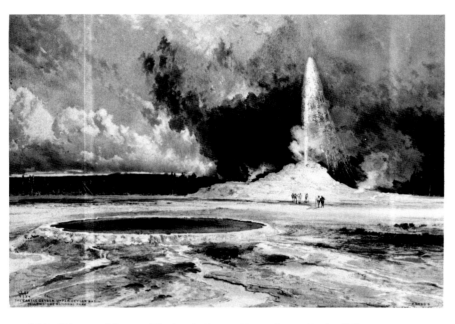

136. Thomas Moran. *The Castle Geyser, Upper Geyser Basin, Yellowstone National Park.* 1876. Chromolithograph, 9¾ x 14". Buffalo Bill Historical Center, Cody, Wyo. Gift of Miss Clara Peck, 1971

137. F. J. Haynes. *Stagecoaches, Loaded at Mammoth, Yellowstone National Park.* 1903. Photograph. F. Jay Haynes Photo–Haynes Foundation, Bozeman, Mont.

Visually speaking, it was Thomas Moran who brought America around to the realization that Yellowstone must be preserved. Hayden lobbied with Moran's watercolors before countless Congressional hearings through the winter of 1871–72. It was no easy fight, but the Hayden forces declared victory on March 1, 1872, when President Grant signed the bill making Yellowstone the first national park in the world.

Moran had visited almost all sections of Yellowstone during the Hayden expedition. His pencil sketches and watercolors pictured the full range of splendor. Old Faithful, which appeared in Moran's beautifully translucent watercolor of 1873, was probably the greatest attraction from the time of its discovery the year before Moran arrived. The Washburn expedition was leaving Yellowstone after nearly a month of exploring when the members stumbled on the great geyser basin around Old Faithful. As Langford remembered:

> We had within a distance of fifty miles seen what we believed to be the greatest wonders on the continent. We were convinced that there was not on the globe another region where within the same limits Nature had crowded so much of grandeur and majesty with so much of novelty and wonder. Judge, then, of our astonishment on entering this basin, to see at no great distance before us an immense body of sparkling water, projected suddenly and with terrific force into the air to the height of over one hundred feet. We had found a real geyser. In the valley before us were a thousand hot springs of various sizes and character, and five hundred craters jetting forth vapor.[1]

So popular was the Yellowstone imagery that Moran found a ready market for a portfolio—fifteen chromolithographs depicting scenes in Yellowstone and the Rocky Mountains, produced by Louis Prang in 1876. These prints directed public attention west.

In 1881 Bierstadt arrived in Yellowstone for a brief tour. He later confessed to a reporter from the *New York Express* that he had gone west expressly to study the geysers. "To use the word wonderful is simply to use a relative term. But I have never been so impressed with the infinite divinity of the types of nature as I was by these . . . geysers."[2]

Bierstadt later sent President Arthur several Yellowstone paintings for the White House. These portraits of nature's wonders apparently impressed Arthur, for he soon went to see them for himself. And on his heels, accepting the presidential sanction, came the public, their numbers by the turn of the century swelling to the tens of thousands. Thus began the "tourist's frontier in the Far West, a bridgehead of civilization as striking and as insistent as the frontiers of the trappers, hunters, and miners that preceded it."[3]

[1] Nathaniel P. Langford, *The Discovery of Yellowstone Park* (Lincoln, Neb., 1972), pp. 106–7.
[2] Quoted in "Albert Bierstadt, the Artist, in the Yellowstone Park," *Denver Republican* (November 7, 1881), p. 3.
[3] Earl Pomeroy, *In Search of the Golden West* (New York, 1957), p. 3.

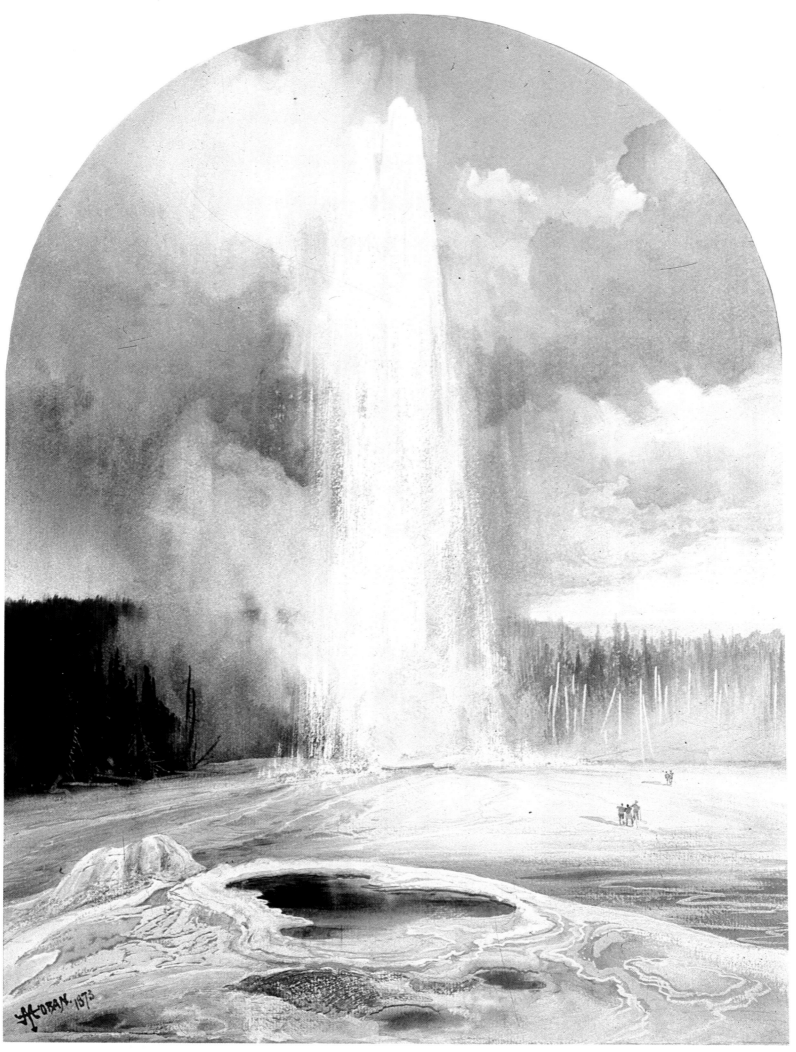

138. Thomas Moran. *Old Faithful*. 1873. Watercolor, 13½ x 10″. Kennedy Galleries, Inc., New York City

Moran's fluid watercolors and majestic oils produced after his trip to Yellowstone won something more than public and congressional acclaim; they dazzled the eye of another geologist, Major John Wesley Powell. Before he knew it, Moran was back on the trail, this time bound for the Grand Canyon of the Colorado.

A letter home to his wife, Mary, was addressed from Kanab, August 13, 1873. Moran had seen the great chasm.

> After dinner (flour cake and bacon) we struck out for the Cañon. On reaching the brink the whole gorge for miles lay beneath us and it was by far the most awfully grand and impressive scene that I have ever yet seen. We had reached the Cañon on the second level or edge of the great gulf. Above and around us rose a wall of 2000 feet and below us a vast chasm 2500 feet in perpendicular depth and ½ a mile wide. At the bottom the river very muddy and seemingly only a hundred feet wide seemed slowly moving along but in reality is a rushing torrent filled with rapids. A suppressed sort of roar comes up constantly from the chasm but with that exception every thing impresses you with an awful stillness.[1]

Moran's watercolor, *From Powell's Plateau,* was painted from that point. It and other studies were later adapted for Moran's most important Grand Canyon painting, *The Chasm of the Colorado.* When completed in 1874, the vast canvas was purchased by Congress for $10,000 to be displayed across from its companion, *The Grand Canyon of the Yellowstone,* in the Senate lobby.

A thunderstorm in the far left distance contrasts with the brilliant stream of sunlight which intensifies the chromatic cliffs to the right. It was seen from Powell's favorite perch, and he described it as follows:

> In the immediate foreground you look down into a vast amphitheatre, dark and gloomy in the depths below, like an opening into a nadir hell. A little stream heading in this amphitheatre runs down through a deep, narrow gorge until it is lost behind castellated buttes, and its junction with the Colorado can not be seen. On the left there is a cliff [and] towering crags and pinnacles, buttressed below and resting on a huge mass of horizontal stratified formations, presenting a grand facade of storm-carved rocks.[2]

Moran returned to this place many times in later years. In 1892, William H. Jackson photographed the artist and his son, Paul, on the rim. Jackson was there to make photographs which would compete with Moran's grand views. "Jackson made negatives of the great sweep of the Cañon embracing a view of about 125 miles," wrote Moran. "His photographs will be nearly 7 feet long by 30 inches high."[3]

[1] Amy O. Bassford, ed., *Home-Thoughts, From Afar* (East Hampton, N.Y., 1967), p. 39.

[2] Quoted in Thurman Wilkins, *Thomas Moran: Artist of the Mountains* (Norman, Okla., 1966), p. 87.

[3] Bassford, op cit., p. 91.

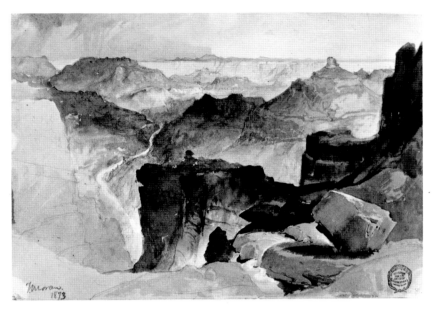

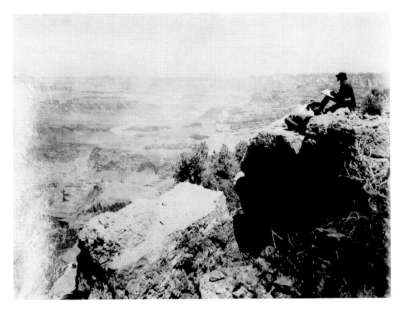

139. Thomas Moran. *From Powell's Plateau.* 1873. Watercolor, 7½ x 10½". Cooper-Hewitt Museum, The Smithsonian Institution's National Museum of Design, New York City

140. William H. Jackson. *Thomas Moran Sketching at Grand Canyon.* 1892. Photograph. East Hampton Free Library, New York

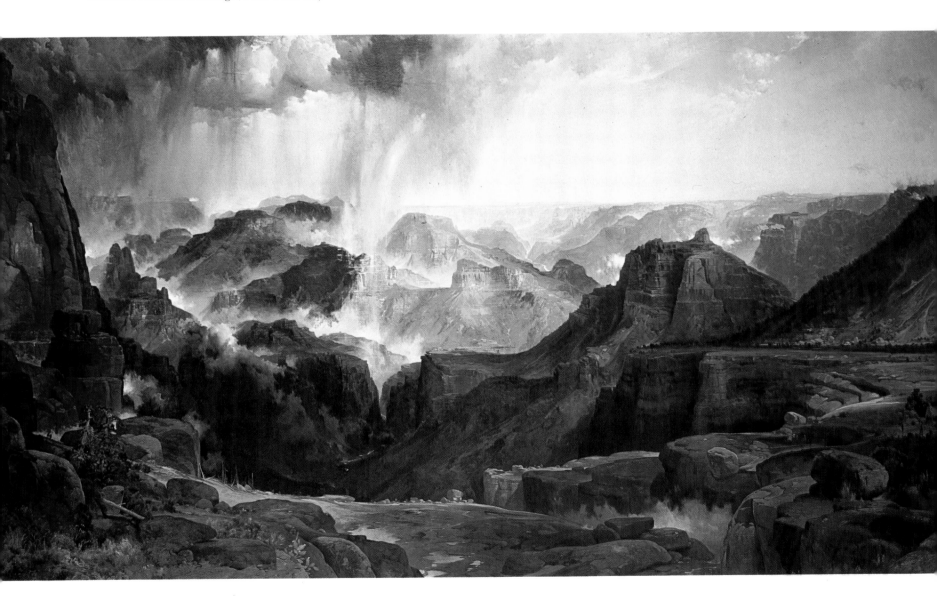

141. Thomas Moran. *The Chasm of the Colorado.* 1873–74. Oil on canvas, 7′ x 12′. United States Department of the Interior, Washington, D.C. Courtesy of the National Collection of Fine Arts

Evolving

Frontiers

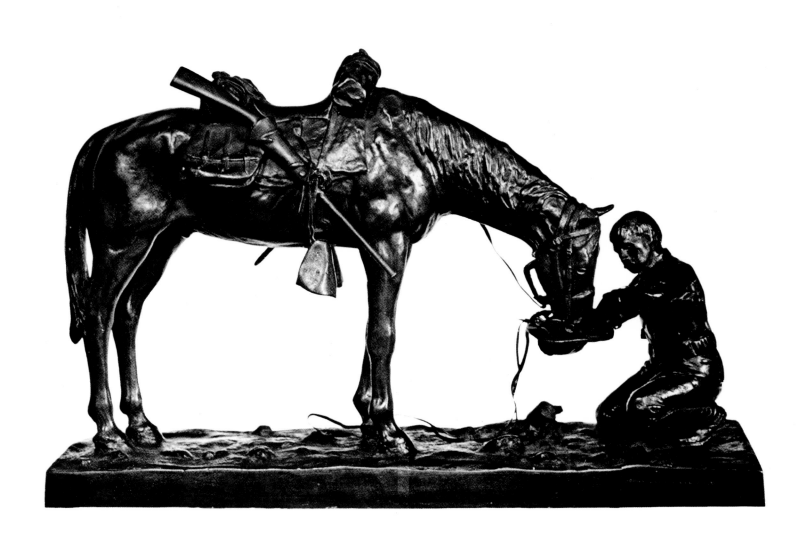

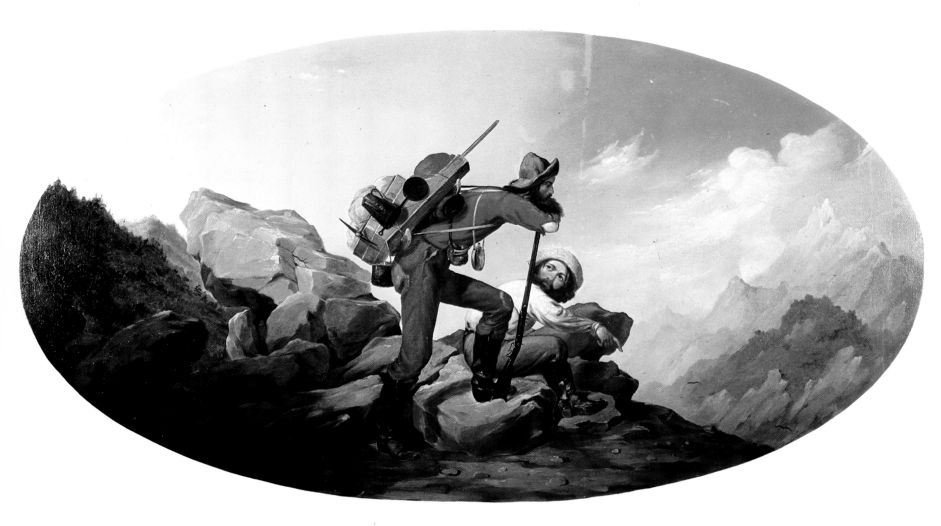

142. E. Hall Martin. *Mountain Jack and a Wandering Miner.* 1850. Oil on canvas, 39½ x 72". The Oakland Museum, Calif. Gift of Concours d'Antiques, the Oakland Museum Association

James W. Marshall spent the winter of 1847–48 in the Sierra Nevada Mountains supervising the construction of a sawmill on the American River. "Monday 24th [January, 1848] this day some kind of mettle was found in the tail race that looks like goald. Sunday 30th clear I[t] has been all the last week our metal had been tride and proves to be goald it is thought to be rich We have pict up more than hundred dollars worth last week."[1] This entry in Marshall's diary changed the course of Western history.

The ranks of Americans who had been moving west at a steady pace were suddenly swelled by a flood of people filled with gold fever. John A. Sutter, Marshall's employer, had tried in vain to keep the discovery quiet, but word of mouth proved as effective as a telegraph. The *Daily Union,* a newspaper in the nation's capital, carried the story in September.

This placer was discovered some time since . . . but kept a secret till May last, when the golden chicken burst its shell; and [it] is now a full-grown cock, whose crowing has woke up all California and will yet disturb the slumbers of other lands. The El Dorado of fiction never prompted dreams that revelled in gold like the streams which shout their way from the mountains of California. They roll with an exulting bound, as if conscious that their pathway was paved with gold.[2]

Three months later the president himself, James K. Polk, verified gossip in his message to Congress of December 5. " 'The accounts of the abundance of gold in that territory,' intoned the clerk, as he read, 'are of such an extraordinary character as would scarcely command belief were they not corroborated by authentic reports of officers in public service.' "[3]

Optimists like Martin's *Mountain Jack and a Wandering Miner* and thousands of others threw down their ploughshares, purchased mining equipment, and set off with camping gear on their backs. "In New York and Boston and Chicago men danced to 'The Sacramento Gallup' and 'The Gold Diggers Waltz,' or sang the song that was on every lip: 'I soon shall be in mining camp / And then I'll look around, / And when I see the gold dust there, / I'll pick it off the ground.' "[4]

The Independent Gold Hunter On His Way to California, 350 miles from St. Louis with only 1,700 left to reach the Sierra Nevadas, was a one-man ad for the necessities of mining. A pick, shovel, and pan were the basics, to which he added a teakettle, knives, a scale, smoked fish, and sausage. Pacific coast merchants listed outlandish prices for such gear. "Tin pans have found a ready sale at $8 each; shovels at $10; a trough scooped out of a log, with a willow sieve on it, $100; and boards at the rate of $500 for a thousand feet."[5] These charges probably explain the phrase under the lithograph's title—"I Neither Borrow nor Lend."

143. Unknown artist. *The Independent Gold Hunter on His Way to California.* c. 1850. Lithograph, 13⅞ x 10″. Amon Carter Museum, Fort Worth

[1] James Marshall's diary, quoted with permission from The Henry Huntington Library, San Marino, California.
[2] *Daily Union* (September 22, 1848), reprinted in Martin Ridge and Ray A. Billington, eds., *America's Frontier Story* (New York, 1969), p. 533.
[3] Ray A. Billington, "The Overland Ordeal," *Westways,* 59 (May, 1967), 12.
[4] Ibid.
[5] Letter from Monterey, Upper California, July 3, 1848, published in *Daily Union* (Washington, D.C.), and reprinted in Ridge and Billington, loc. cit.

144. Peter Moran. *Threshing Wheat, San Juan.* 1879–90. Watercolor, 7⅜ x 13⅜". Amon Carter Museum, Fort Worth

145. William Hahn. *Harvest Time, Sacramento Valley.* 1875. Oil on canvas, 37¼ x 69½". The Fine Arts Museums of San Francisco

Wheat-growing by Americans came about in this way. During the first decade of greatest gold output, there was wide trial of agricultural production, chiefly for home use and to displace imports. This was successfully done with many products that did not require much skilled labor, but the crops which could be most easily, quickly and cheaply produced were demonstrated to be cereal grains. . . . For these reasons, California fell into wheat at first just as do all other new countries.[1]

Dr. Hugh J. Glenn received his degree in 1849, married that same year, and proceeded to invest his entire savings of $110 in a quarter interest in an ox team. The next year Glenn ventured to the gold fields of California. With his claim's earnings he invested first in freight wagons and teams and then in a Sacramento livery establishment, the sales of both enterprises producing considerable profits. "Dr. Glenn made his first purchase of the Jacinto grant in December, 1867. He has now 45,000 acres under cultivation. He farms 15,000 acres himself, and rents 10,000 acres to G.W. Hoag. . . . Of this year's crop, Dr. Glenn says although he has on hand 325,000 (140 lb.) sacks, he thinks they will not hold the wheat."[2]

George W. Hoag, "Dr. Glenn's super-machine builder," commissioned Andrew Putnam Hill "to journey up the Sacramento to Jacinto to paint the world's record harvest scene of Dr. Glenn and his crew threshing with their machine 'Monitor' in 1875."[3] Hill's painting, the central composition of the Agricultural Warehouses' poster, featured the great red wheat eater encircled by a variety of attendant harvest operations. San Francisco's *Pacific Rural Express* of May 6, 1876, illustrated the painting on its front page and claimed it to be "peculiarly a California scene. The immense separator and the engine to drive its hungry jaws and rattling beaters, the ever widening circle of the headers and header wagons, the mules dragging away the quickly accumulating straw, the owner in his carriage and the overseer on horseback supervising the small army of men required to do the work, the bright sunlight flooding the scene—all these are characteristics of our peerless harvest scenes."

Hill was also a photographer and ardent conservationist, who, "to save the magnificent redwoods of Big Basin from fence post fate, lived on fifteen cents a day while fighting for the forest during a legislative session at the state capitol."[4] Peter Moran and California genre painter William Hahn chose to portray the less-mechanized operations of threshing wheat in the West. The relative serenity of their depictions is in marked contrast to Hill's; this is paradoxical, since all three works were produced in the same era. The *Pacific Rural Press* was glowing in its praise of progress, Hoag's genius, and Hill's depiction. "In the breadth and scope of its representation the picture is symbolic of our California agriculture. It is the embodiment of enterprise, of action and of success. It is a stirring scene. It is fitting to awaken among our friends abroad a new appreciation of what may be styled the magnificent in our agriculture."[5]

146. Andrew Putnam Hill. *George Hoag's Steam Threshing Outfit and Crew Setting New One-day World's Record.* 1878. Lithograph, 26 x 34⅞". F. Hal Higgins Library of Agricultural Technology, University of California, Davis

1 Prof. Edward J. Wickson, quoted in Rodman W. Paul, "The Beginnings of Agriculture in California: Innovation *vs.* Continuity," *California Historical Quarterly,* 52 (spring, 1973), 19.
2 "California Harvest Scene—Dr. Glenn's Farm in Colusa County," *Pacific Rural Press* (May 6, 1876).
3 Colusa County Historical Society, *Wagon Wheels,* 1 (August, 1951), unpaged.
4 *Sunset Magazine* (July, 1914), quoted in *Wagon Wheels,* op. cit.
5 "California Harvest Scene."

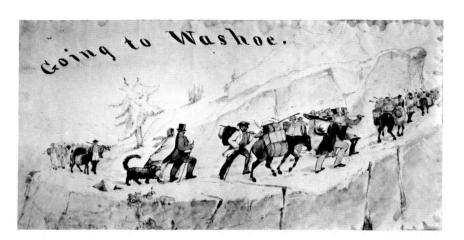

147. G. Rogers. *Going to Washoe.* c. 1860. Watercolor. Private collection

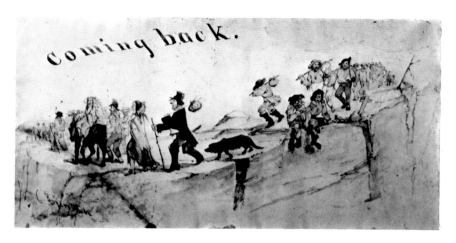

148. G. Rogers. *Coming Back.* c. 1860. Watercolor. Private collection

Number IV of the "Miners Pioneer Ten Commandments of 1849" was specific concerning permissible Sunday pastimes.

> Thou shalt not remember what thy friends do at home on the Sabbath day, lest the remembrance may not compare favorably with what thou doest here. Six days thou mayest dig or pick all that thy body can stand under, but the other day is Sunday; yet thou washest all thy dirty shirts, darnest all thy stockings, tap thy boots, mend thy clothing, chop thy whole week's fire-wood, make up and bake thy bread and boil thy pork and beans that thou wait not when thou returnest from thy long-tom weary. For in six days' labor only thou canst not work enough to wear out thy body in two years; but if thou workest hard on Sunday also, thou canst do it in six month.[1]

Charles Nahl's painting shows some miners following the commandment, while others interpret not working to mean playing. The authenticity and vitality of this work reflect the California genre painter's empathy for a prospector's life.

Nahl did not reach California until 1850, after his half-brother Hugo and he had sailed from the port of New York via the Isthmus of Panama. The fourth of three generations of artists, young Nahl had studied with a Paris painter of heroic battle scenes and retained an eye for detail which observed all facets of mining life. The brothers worked in the field, Charles sometimes selling his sketches in exchange for gold dust at the camps and in Sacramento. They moved to San Francisco in 1852 and established an art and photographic gallery and studio. Here, Hugo designed the California state seal, and Charles the bear on its flag. Although a fire in Sacramento engulfed most of Charles's paintings and sketches of miners and their voyage, he continued to paint from his vivid memory.

The Nahl brothers were fortunate to have had a trade, for many gold seekers became paupers.

> . . . A great many of the letters sent to the States are written by designing men in a way to favor their speculating movements; they give you an account only of the few lucky ones; you have only heard one side of the story, and that the bright side. Where one man has dug a pound or made a small fortune, it has been heralded over the world, inducing thousands to sacrifice their property at home, and endanger their lives to get to this country—the land of gold and plenty, the land of promise, the land where thousands have come and thousands are coming, and still thousands are destined to return to their homes, the dupes of speculating and designing men, poorer in health, in morals and in pocket than when they came.[2]

The Sierra Nevadas lost their golden aura to Pike's Peak and the Nevada ranges. The fifty-niners in *Going to Washoe* and *Coming Back* were probably leaving California for the

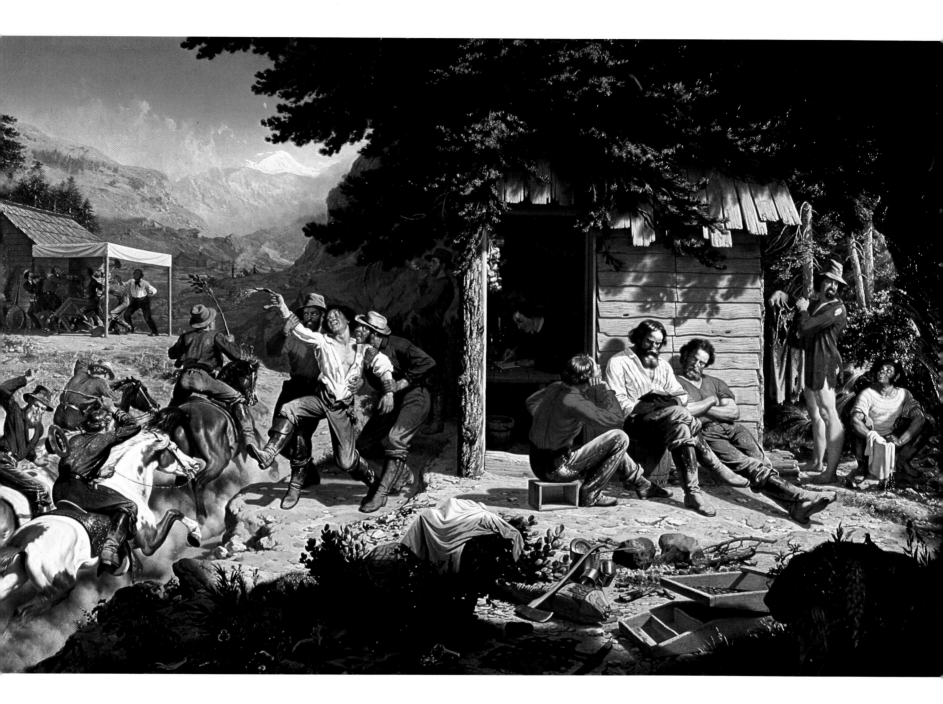

149. Charles Nahl. *Sunday Morning in the Mines.* 1872. Oil on canvas, 6′ x 9′. E. B. Crocker Art Gallery, Sacramento

Comstock Lode of the Washoe District in Nevada, regardless of what any watercolors foretold. Good news traveled faster than bad, although the bad was there for the looking. "Many had started from their farms, their shops and stores, with no knowledge of mining and on reaching the mountains, not finding gold scattered over the surface, or in every locality they chanced to sink their shovels, were disconcerted. They knew nothing of the circumstances under which gold is found, or of the indications that pointed to its discovery; and, perchance, they stumbled upon a good prospect, they were but little acquainted with the proper method of working it to advantage. ... Is it strange that such miners were not successful?"[3]

[1] Harry T. Peters, *California on Stone* (Garden City, N.Y., 1935), p. 153.
[2] "Gold Rush Letter," *Southern California Quarterly,* 46 (September, 1964), 278.
[3] C.M. Clark, *A Trip to Pike's Peak and Notes by the Way, etc.,* ed. Robert Greenwood (San Jose, 1958), p. 89.

James Walker

Aprospector in California wrote home on a letter headed with a lithograph of vaqueros roping a bear. "I send this pic showing how the Spaniards catch the bears in Cal. You must be good children and I will send you some gold in all my letters to show you the way it grows here."[1]

Another California genre painter, James Walker, depicted not the gold rush, but scenes of West Coast vaqueros. Born in England in 1819, he was in Mexico City at the start of the Mexican War in 1846. He escaped to join American efforts as an interpreter and later returned with the occupation army. Two years later he established a studio in New York City.[2] Walker fought in the Civil War, the experience providing material for several historical paintings. Of artists who portrayed the war, Tuckerman opined that "among the most successful as regards accuracy and spirit are the paintings of Mr. Walker."[3] On visits to California he found new material, the vaquero, whose heyday had preceded Walker by many years and whose customs he also recorded with accuracy and spirit. It is ironic that this English immigrant to New York City should have chosen to delineate a Western character of Spanish tradition, who was the precursor of the all-American cowboy.

Spanish missionaries first settled in California in 1769, bringing with them crosses and cows from whose tallow and hides they hoped to profit in trade with New England merchants. The padres, often sons of nobility, were expert horsemen who taught riding skills to the Mexican workers and Indians so they could manage the ever-increasing herds. In 1834, with California declaring its allegiance to Mexico, the padres were relieved of their mission range, opening up the land for the rancheros, who became the first real cattle barons of the West.

The vaqueros chose elaborate garb and accouterments, as evidenced in *Cowboys Roping a Bear*. Their chaparajos were of cut leather studded with silver, and silver adorned their horses' trappings. Saltillos, or Mexican blankets, rolled up behind the saddles, lent further flair to the well-trained mounts. Topped with a flat sombrero and heeled with taloned spurs, the vaquero cut a dashing figure complemented by his deft talent for riding and roping. Will James observed:

> . . . the Spanish California Buckeroo (by that I mean the American cowboy what kept up the early California Spanish style in rig and work) uses a altogether different saddle than the cowboy further east; the horn is higher and wrapped heavy so the turns will grab holt. The riggin is centre fire and the cinch hangs straight down from the middle of the saddle tree.
> . . . The buckeroo of them centre fire countries on riding a bucker or any mean horse sets back pretty well and sticks his feet ahead with stirrup leathers what are set that way. They're a good saddle to ride a mean horse, being there's some jolt it gets you away from; it rocks more and the cantle don't come up and hit you like the double ring would on a kinky back. That's why the contest riders use the centre fire 'most always in the rodeos.[4]

As with other Western characters, the vaquero's meteor burned out quickly. War with Mexico left the ranchos unprotected. The once large herds of cattle, so needed by the gold-crazed populace, were either decimated by marauders or slaughtered for prospectors with few spared for procreation.

[1] Letter entitled "The Grizzly and His Captors," quoted with permission from The Henry Huntington Library, San Marino, California.
[2] "The Western Frontier," *Denver Art Museum Quarterly* (summer, 1966), unpaged.
[3] Henry T. Tuckerman, *Book of the Artists* (New York, 1967), p. 493.
[4] Will James, *Cowboys North and South* (New York, 1926), pp. 14 and 17.

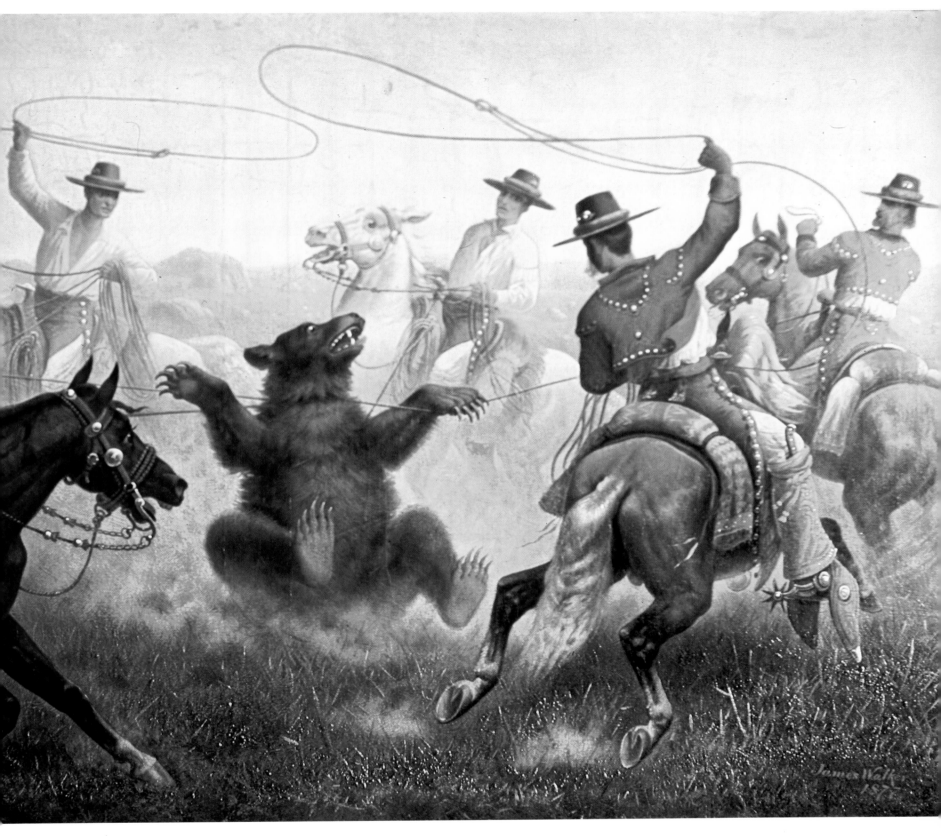

150. James Walker. *Cowboys Roping a Bear.* 1877. Oil on canvas, 30 x 50″. Denver Art Museum

Charles M. Russell

151. Charles M. Russell. *Charlie Himself.* c. 1915. Wax and cloth on plaster base, height 11¾". Amon Carter Museum, Fort Worth

In an article praising Charles Russell's vital skill with clay and wax, the author, Sumner Matteson, also commented on his costume. "An Indian sash, a soft shirt, and a sombrero are essential to his attire, whether on the range or in the ball-room."[1] True to character, the artist molded himself as others saw him, and true to his humor, he molded his self-image in caricature.

Another writer was able to look beyond the costume and into Russell's personality.

> The man who may rival Remington and some day surpass the world's best animal painters possesses an individuality born of a close communion with the breath of life as realized in the far reaches of the west. He is cast in powerful mold. There is an amplitude of shoulders that tempts womankind to admire. There is a leonine head closely cropped and well set upon a neck like a Dorian column. The face glows with perfect health. It is frank and inviting. It is a face full of power as well. The features are large and suggest the strength and more of the mobility that he has stolen from his Indian friends and transferred to canvas. Deep-set, penetrating blue-gray eyes have a direct gaze. The nose is slightly aquiline and the mouth is firm, the lips long and tightly closed. A square, massive chin bespeaks decision.[2]

Russell's natural mien blended into Western life. He grew up in St. Louis, yet nurtured a boyhood dream to visit the West. His parents attempted to distract their son, even sending him to a military academy, but he only continued to fill the margins of pages with cowboys and Indians. When they finally relented and in 1879 sent Russell west at the age of fifteen, his expectations were met, and he resided there for the rest of his life.

The young greenhorn tended sheep, trapped and hunted, and worked cattle and horses as a night wrangler. He passed many daylight hours sketching and painting, and in the early days when art was but a pastime for him, he produced one of his first oils, *Cowboy Camp During the Roundup.* It was finished in 1887.

Word of Russell's talent spread rapidly, but as late as 1891 he still entertained no thought of leaving the cowboy life for that of an artist. "He tells us that he is fond of the work, and the only reason he does not follow it is because there is not enough money in it. We believe, however, that in his particular line he has no equal, and that his pictures would, if properly handled, bring him a fortune."[3]

Finally, in 1892, Russell did set up a studio, and his experiences as a cowboy provided inspiration for the rest of his life. Seven years later he painted *Get Your Ropes,* portraying himself as the central figure. After singing to cows and stars and fighting heavy eyelids, a night herder probably enjoyed waking the crew at dawn.

[1] Sumner W. Matteson, "Charles M. Russell, the Cowboy Artist," *Leslie's Weekly* (March 3, 1904), 204.

[2] *Daily Independent* (Helena, May 13, 1901), p. 5.

[3] *River Press* (Lewiston, Mont., August 27, 1891), p. 3.

152. Charles M. Russell. *Get Your Ropes.* 1899. Watercolor and gouache, 19⅞ x 29¼″. Private collection

153. Charles M. Russell. *Cowboy Camp During the Roundup.* c. 1887. Oil on canvas, 23½ x 47¼″. Amon Carter Museum, Fort Worth

A fundamental part of cowboy lore revolved around the cattle drive. In the decades after 1850, when railheads were few and far between, drives provided the only outlets for the ranchers' hooved investments and for adventuresome men. Wages were low, troubles plenty—stampedes, blizzards, droughts, swollen rivers, dust, heat, and occasional confrontations with irate settlers and Indians. "Yet the cowboys went eagerly, many of them no more than boys testing themselves against the unknown as other young men had always done by going off to war or shipping out before the mast."[1]

Besides enduring the test of a cattle drive, a cowboy could make fast friends and feel the pride of working successfully with a team. Perhaps he sensed the historicity of his vocation, for the cattle-drive era was short-lived.

One of his memorable experiences must have been celebrating with fellow cowboys who had paychecks in hand. Charles Russell was working on a ranch in Judith Basin in the autumn of 1881. His boss and some of his neighbors had scheduled a joint cattle drive, hoping to reach a railhead without encountering winter weather. As a night herder, Russell tended the beeves while the cowhands went to town for pre-drive shenanigans. The next day the revelers related their exploits. Although the artist did not produce *In Without Knocking* until 1909, they later testified to the accuracy of Russell's recollections.[2]

The Hoffman Hotel's owner must have been shocked at the intrusion of his five patrons in such an unorthodox

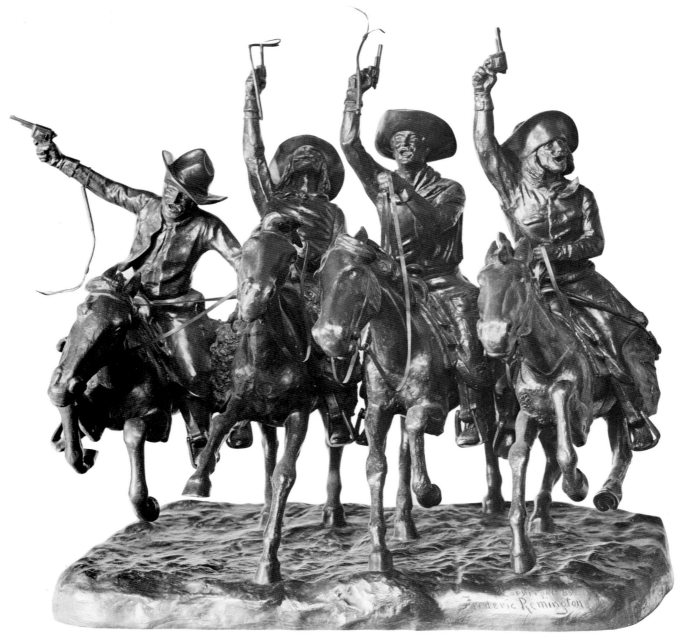

154. Frederic Remington. *Coming Through the Rye.* 1905. Bronze, height 27½″. Buffalo Bill Historical Center, Cody, Wyo. Gift of W. R. Coe Foundation

manner. However, cow towns were used to serving a dichotomous and hard-working public—cowhands and settlers. For the former there were a variety of activities, such as gambling, drinking, visiting brothels, and sleeping it off. The settlers traditionally disapproved, while the merchants made a killing.

For Russell the action involved in cowboy life nurtured his inspiration and natural bent. "Looking at an old church painting this morning, he [Russell] said, 'why if I made that picture, I would have the walls tumbling down.' And that is so. Every picture he makes is revelation and action."[3]

Action also dictated Frederic Remington's *Coming Through the Rye,* a heroic-size plaster replica of which was entitled *Shooting Up the Town.* Ranch life was a little easier

than trail life, yet after a week of it cowboys were understandably ready to let off a little steam. Remington's sculpture was praised for recalling "the days when the Saturday night frolic of the cowboys who came to town was the chief social institution of the week in border towns."[4]

[1] William H. Forbis, *The Cowboys* (New York, 1973), p. 142.
[2] See Frederic G. Renner, *Charles M. Russell* (Austin and London, 1966), opp. p. 87.
[3] *Great Falls Daily Tribune* (April 8, 1906), p. 8.
[4] Anabel Parker McCann, "Decorative Sculpture at the Lewis & Clark Exposition," *Pacific Monthly,* 14 (July, 1905), 87.

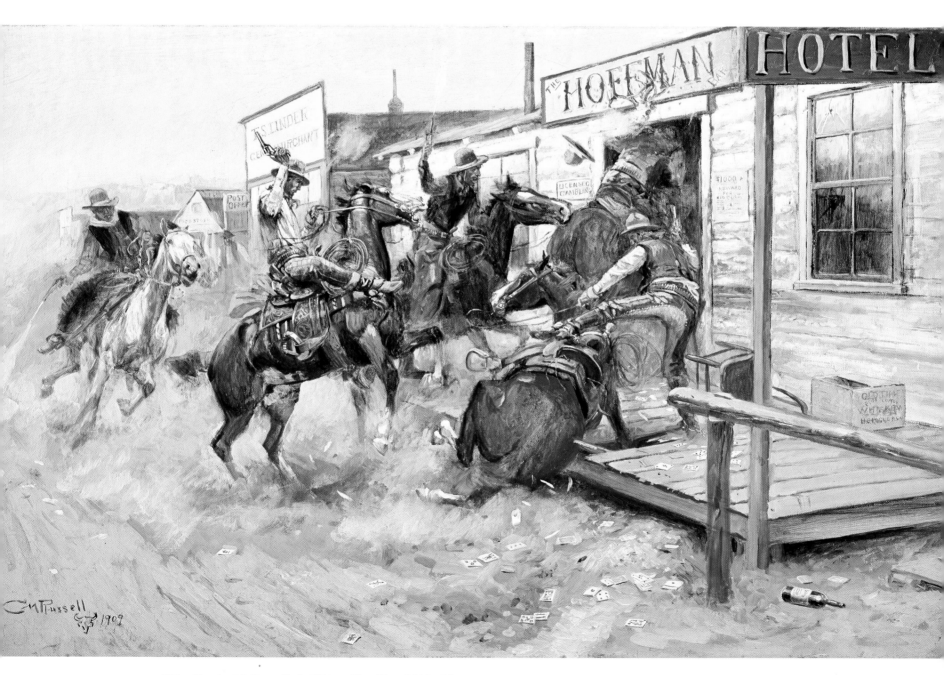

155. Charles M. Russell. *In Without Knocking.* 1909. Oil on canvas, 20⅛ x 29⅞″. Amon Carter Museum, Fort Worth

In "The Story of the Cowpuncher" by Charles Russell, the author has Rawhide Rawlins reminiscing about the old days, its characters, and its yarns.

"It put me in mind of the eastern girl that asks her mother: 'Ma,' says she, 'do cowboys eat grass?' 'No, dear,' says the old lady, 'they're part human,' an' I don't know but the old gal had 'em sized up right. If they are human, they're a separate species. I'm talkin' about the old-time ones, before the country's strung with wire an' nesters had grabbed all the water, an' a cowpuncher's home was big. It wasn't where he took his hat off, but where he spread his blankets. He ranged from Mexico to the Big Bow River of the north, an' from where the trees get scarce in the east to the old Pacific. He don't need no iron hoss, but covers his country on one that eats grass an' wears hair. All the tools he needed was saddle, bridle, quirt, hackamore, an' rawhide riatta or seagrass rope; that covered his hoss."[1]

Some six years after leaving the range for a studio, Russell was asked by the owner of the Silver Dollar saloon in Great Falls to depict scenes for his wall appropriate to the clientele.[2] He created what is known as the "Sunshine Series," four watercolors which reflect both Russell's humor and his cow days.

Just a Little Sunshine shows the cowboy in an idyllic state—resting from work, gazing at the open land, and

156. Charles M. Russell. *Just a Little Sunshine.* c. 1898. Watercolor, 13⅛ x 9¾"; *Just a Little Rain.* c. 1898. Watercolor, 13⅛ x 10¾"; *Just a Little Pleasure.* c. 1898. Watercolor, 13⅜ x 10⅜"; *Just a Little Pain.* c. 1898. Watercolor, 13⅜ x 10⅜". Amon Carter Museum, Fort Worth

smoking a cigarette. The spell ends with *Just a Little Rain*. The soggy sentinel has the herd peaceful, although perhaps not for long since the cows will probably soon begin drifting. Then "the cowboys ride rapidly back and forth along their front and check them up as much as possible, gradually forcing the leaders around to face the storm, when they halt for a while and then start afresh, but for this they would be many miles away by the time the storm had passed."[3]

After the sun and rain comes *Just a Little Pleasure.* Frank Linderman wrote about his friend Russell that "in his early days here in Montana, Charley was a boy among men who drank, so that from those days up to within seventeen years of his passing, Charley drank."[4] The cowboy awaiting plea-sure has received liberal libations and soon will be liberated from his profered pay. The women who peddled their wares in cow towns often caused cowboys to suffer *Just a Little Pain* for their pleasure.

[1] Charles M. Russell, *Trails Plowed Under* (Garden City, N.Y., 1944), p. 1.
[2] See Frederic G. Renner, *Charles M. Russell* (Austin and London, 1966), p. 102.
[3] Granville Stuart, *Studies of Western Life* (Spokane, Wash., n.d.), unpaged.
[4] Frank Bird Linderman, *Recollection of Charley Russell* (Norman, Okla., 1963), p. 10.

As subject matter for some of his canvases, Charles Russell selected the Royal Canadian Mounted Police, whose well-known courage and colorful attire appealed to his propensity for drama. Having wintered with the Bloods in Canada and living close to the border, Russell knew the Mounties' stories and portrayed them throughout his career.

Established in 1873, the Royal Canadian Mounted Police (originally called the North-West Mounted Police) found a thriving trade in lawlessness on the Northern Plains. Their task was not only to patrol the area for inevitable red and white confrontations, but also to apprehend traffickers in whiskey, guns, and horses. One of their first acts was the takeover of Fort Whoop-up. From the Montana Territory to this Canadian outpost had come wagonloads of valuable contraband liquor. Each successful delivery called for traders and Indians to whoop it up, hence the fort's appellation.

157. Charles M. Russell. *When Law Dulls the Edge of Chance.* 1915. Oil on canvas, 29 x 48″. Collection W. E. Weiss, Cody, Wyo.

Horse rustling was less easy to detect and control. The Blackfeet nation, which had roamed the Canadian and American plains, could no more respect the border as a barrier than relinquish their tradition of stealing mounts. The April 13, 1911, edition of the *Great Falls Tribune* contained an article about the thievery of White Quiver which perhaps inspired Russell's *Single-handed.* The crafty Piegan was relentless in his stealing of Crow horses. One time he was arrested, his booty returned to its owner; he escaped and fled to Canada with the same bunch of horses. The Mounties arrested him, and once more White Quiver eluded restraints. For the third time he stole the same herd of horses, ending up on the Blackfeet reservation in Montana. "Among the ponies was a pinto which White Quiver traded to Bad Wound, who later sold the horse to Charles M. Russell. This was the horse called 'Monte,' which Russell was to ride for nearly twenty-five years."[1]

Whites controlled the whiskey trade, yet Indians had no exclusive rights to horse stealing. Unlike the Plains Indians, who stole as a matter of honor, whites did it for the money. Some ran their liberated steeds to Canada, where they sold them, and the clever thieves returned with horses to sell in Montana. Russell portrayed the perils of this vocation in *When Law Dulls the Edge of Chance,* showing how the mounted police earned their reputation for always getting their man.

Russell held a series of exhibitions in Canada beginning in 1912. Many dignitaries attended, but Russell did not kowtow to them. "It is said that during his Calgary exhibit when anyone wished to see the artist it was necessary to go out to the chutes and corrals where he would be squatting on his boot heels talking to the Indians or the cowboys."[2] Despite this seeming indifference to clientele, the next year Russell displayed his paintings at a special show in Saskatoon for the Prince of Wales. The residents of High River, Alberta, later bought *When Law Dulls the Edge of Chance,* "by public subscription and presented it to the Prince when he attended the Calgary Stampede in 1919."[3] Some time after he abdicated to become the Duke of Windsor, the picture appropriately was returned to the land of its origin.

[1] Frederic G. Renner, *Charles M. Russell* (Austin and London, 1966), opp. p. 62.

[2] Ramon F. Adams and Homer E. Britzman, *Charles M. Russell: The Cowboy Artist* (Pasadena, Calif., 1948), pp. 202–3.

[3] *Montana, the Magazine of Western History,* 24 (autumn, 1974), unpaged.

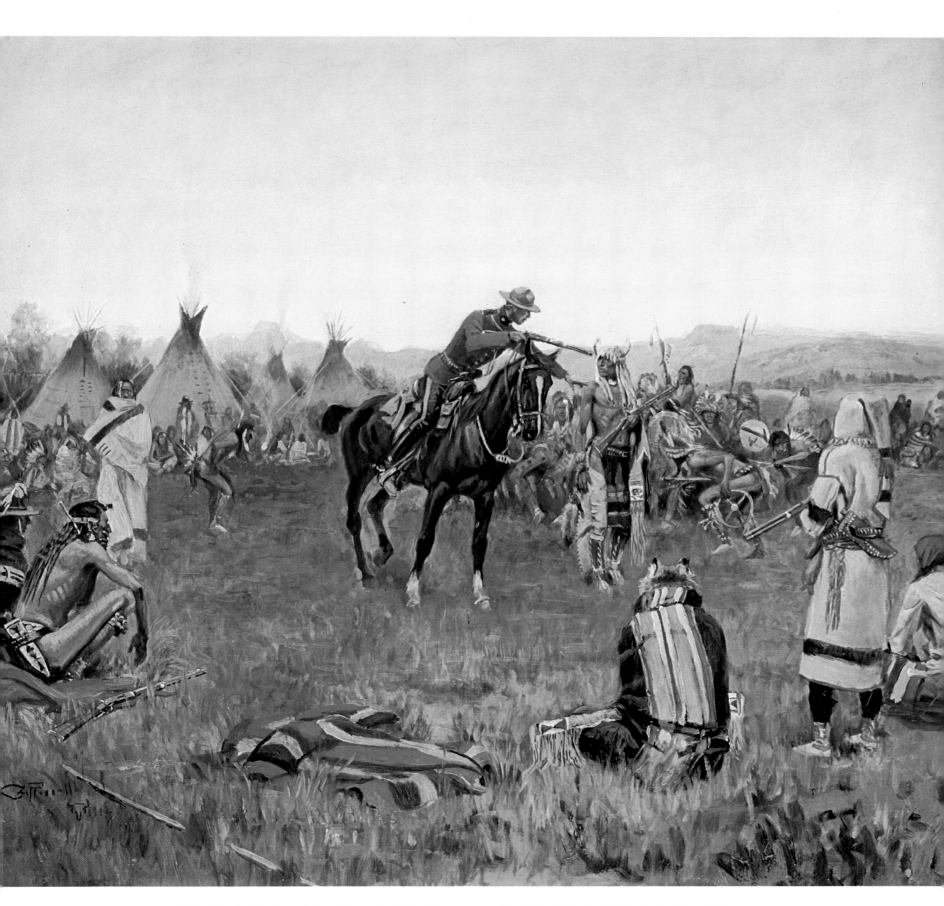

158. Charles M. Russell. *Single-handed*. 1912. Oil on canvas, 30 x 33″. Collection W. E. Weiss, Cody, Wyo.

Charles M. Russell

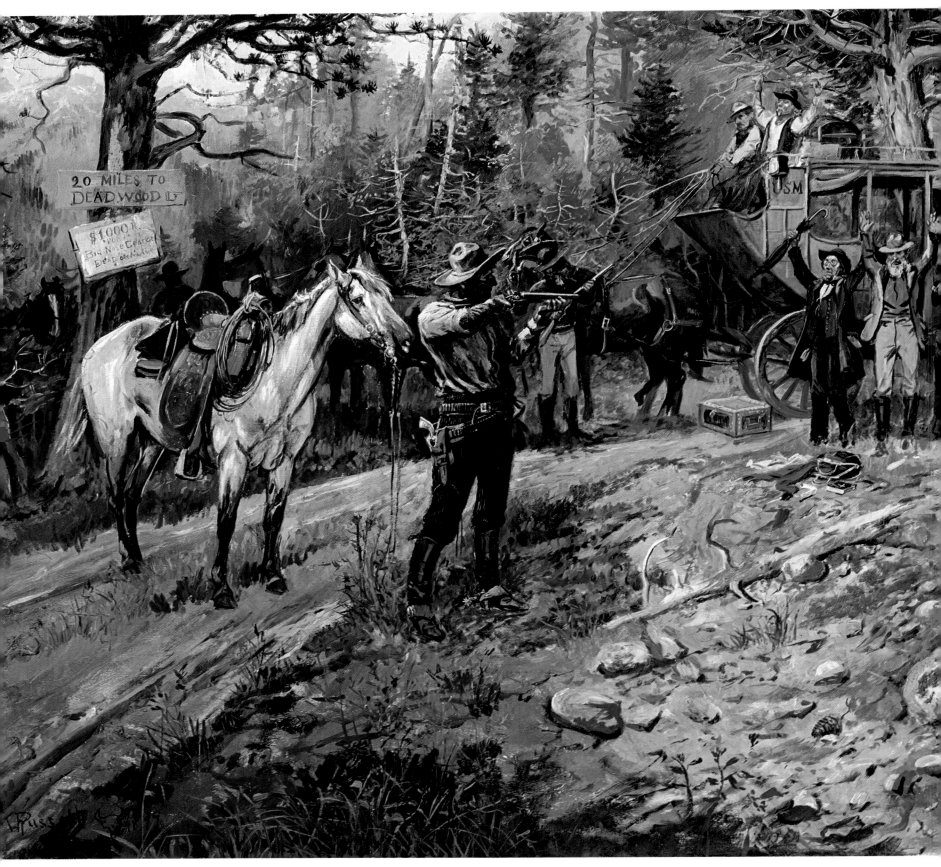

159. Charles M. Russell. *The Hold Up.* 1899. Oil on canvas, 30⅜ x 48¼″. Amon Carter Museum, Fort Worth

Big Nose George, standing by his white horse in Russell's painting, had found that a holdup was "convenient to himself and necessary for the maintenance of his gang of associated robbers in appropriate luxury and magnificence in the town of Deadwood, which was just then at the six-shooter and dance hall stage of its progress from a mining camp toward decency and orderly existence."[1] His philosophy was not appreciated by many.

A colorful assortment of stagecoach passengers was stopped twenty miles from Deadwood that day in the 1880s. "One, swinging down from the saddle and flinging open the stage door, stood with his finger on the trigger, and said, in a cold, businesslike way: 'Gentlemen, you understand the situation. Hold up your hands and step out. Don't offer any objections, please, for it's unpleasant to have to deal with them. Six steps back there. There you are, three in a row and proper as your wife in church. Now, what have you to contribute to the relief of our widows and orphans? My hat is something of a treasure box. Just step up and relieve yourselves of your ready cash.'"[2]

One of the passengers was named Isaac Katz, nicknamed Ikey. Loaded with cash to open a new store, Mr. Katz was relieved of every penny, even that stashed in his underwear. Disconsolate, Ikey asked Big Nose George for subsistence money and was told: "'Ah! no, Ikey. I will have to thresh another crop of oats before I grubstake you.'" At George's hanging Ikey was heard to say, "'Say, Shorge, you thresh them oats yet?'"[3]

Newell Convers Wyeth painted a different version of an outlaw's life, one more desperate than Big Nose George's. Wyeth's man has retreated to a rocky haven and totes "the usual arms carried by the road-agents . . . a brace of revolvers, a large-bore, double barreled shot gun, cut short in the barrel, and a bowie knife."[4] This arsenal may have saved him from George's fate.

[1] *Great Falls Sunday Tribune* (June 30, 1901), p. 10.
[2] Ibid.
[3] Ibid.
[4] C.P. Connolly, "The Story of Montana," *McClure's Magazine*, 27 (August, 1906), 349. Wyeth's *The Outlaw* was an illustration in the September, 1906, issue of this magazine.

160. Newell Convers Wyeth. *The Outlaw.* 1906. Oil on canvas, 50 x 30″. First National Bank of Arizona, Phoenix. Fine Arts Collection

Charles M. Russell

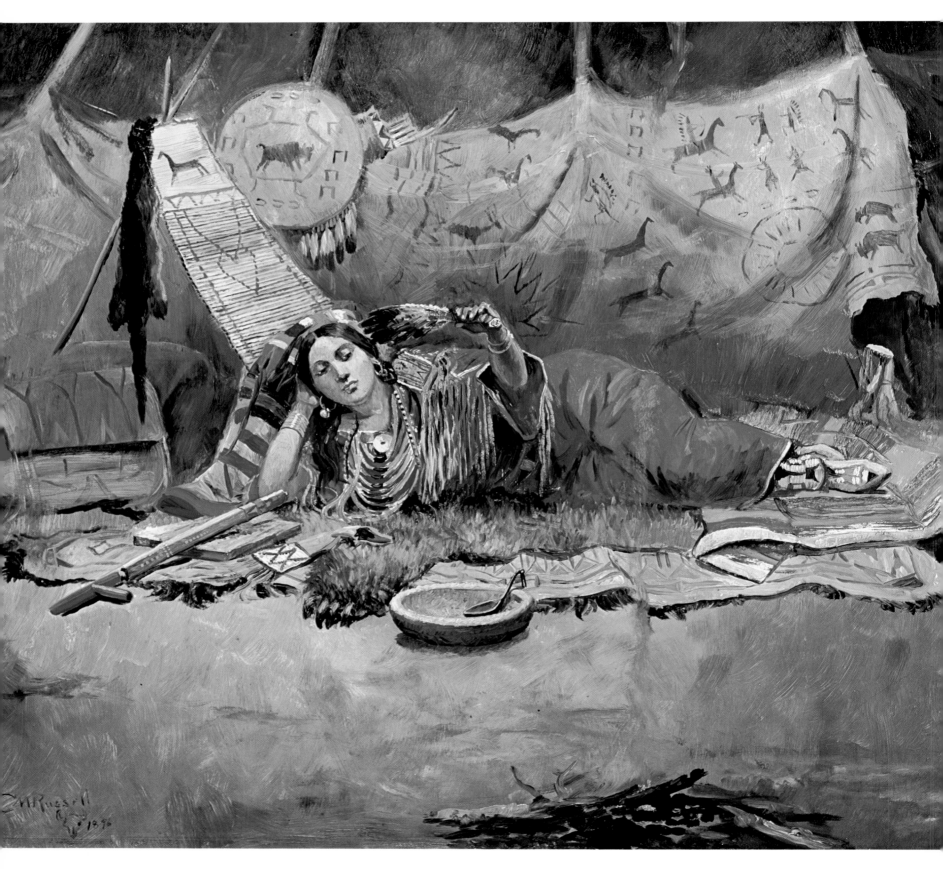

161. Charles M. Russell. *Keeoma*. 1896. Oil on panel, 18½ x 24½″. Amon Carter Museum, Fort Worth

Russell was known as Ah-wah-cous (Horns that Fork, or Antelope) to the Blood Indians of Canada and as White Indian to cronies, some of whom thought he favored one too. In 1888 he spent the winter with the Bloods and befriended Sleeping Thunder, a young brave. Nancy Russell wrote that "through their friendship, the older men of the tribe grew to know Charlie and wanted him to marry one of their women and become one of them. The Red Men of our Northwest love and think of Charlie as a kind of medicine man because he could draw them and their life so well."[1] Keeoma was one of Russell's subjects that winter.

Russell's love and admiration for the Indian was incontestable; yet, curiously, many of his best known paintings of Indian women show them in degrading attitudes. Keeoma assumes a coquettish pose, appearing suggestively bored. Miller portrayed his share of frolicking, long-haired beauties, yet would agree with James P. Beckwourth's dictated account that "all Indian women are considered by the stronger sex as menials: they are thoroughly reconciled to their degradation, and the superiority of their 'lords and masters' is their chiefest subject of boast. They are patient, plodding, and unambitious although there are instances in savage life of a woman manifesting superior talent, and making her influence felt upon the community."[2]

Such a woman was Pine Leaf, whose brother's murder when she was twelve years old resulted in her vowing never to marry until she had avenged his death by slaying one hundred of his enemies. Amusing to the old veterans at first, Pine Leaf soon captured their admiration. "She seemed incapable of fear, and when she arrived at womanhood, could fire a gun without flinching, and use the Indian weapons with as great dexterity as the most accomplished warrior."[3]

Miller told of an Indian woman cut of similar cloth. She took up the challenge of chasing a buffalo.

No sooner does she reach the animal than she must watch his every movement,—keep an eye to her horse and guide him,—must look out for rifts and Buffalo wallows on the prairie,—guard against the animal's forming an angle goring,—manage bow and arrows, or lance— and while both are at full speed to wound him in a vital part;—To do all this requires great presence of mind, dexterity, and courage,—and few women are found amongst them willing to undertake or capable of performing it.[4]

Pine Leaf and the buffalo chaser were exceptions, and perhaps their type was rare when Russell went west. Whatever the explanation, Russell chose to exclude this fascinating breed of Indian women from among his subjects.

[1] Nancy C. Russell, *Good Medicine* (Garden City, N.Y., 1929), p. 21.
[2] T.D. Bonner, *The Life and Adventures of James P. Beckwourth* (New York, 1858), p. 212.
[3] Ibid., p. 202.
[4] Marvin C. Ross, *The West of Alfred Jacob Miller* (Norman, Okla., 1968), opp. p. 90.

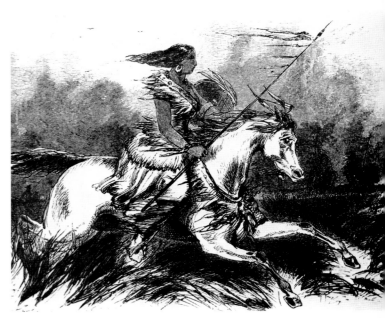

162. Unknown artist. *Pine Leaf*, from the book *The Life and Adventures of James P. Beckwourth* by T. D. Bonner. c. 1856. Engraving, 4⅞ x 7½". Buffalo Bill Historical Center Library, Cody, Wyo.

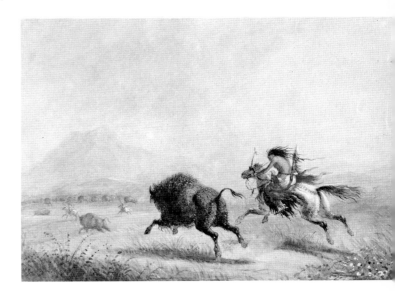

163. Alfred Jacob Miller. *Buffalo Chase—by a Female.* 1837. Watercolor, 8⅞ x 12¼". The Walters Art Gallery, Baltimore

Charles M. Russell

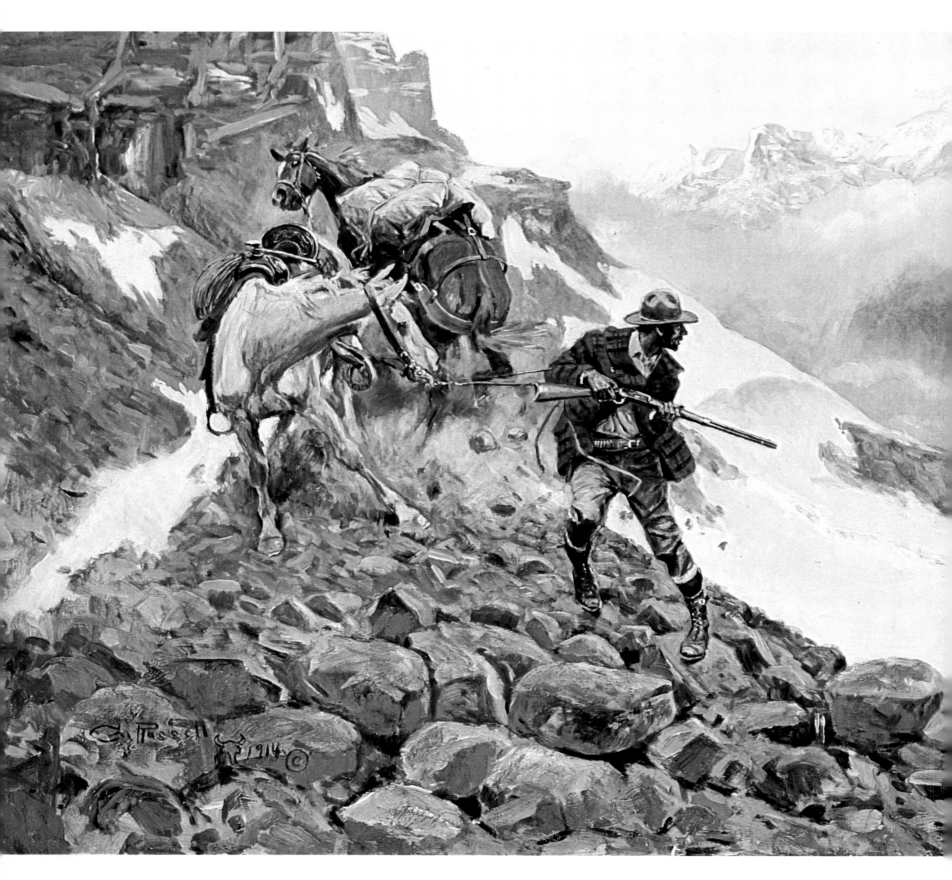

164. Charles M. Russell. *Whose Meat?*. 1914. Oil on canvas, 30¼ x 48″. Private collection

Young Russell had been rescued from a hungry day by Jake Hoover, a Montana mountain man. The greenhorn had just left a sheep ranch, determined to locate any other job than watching woollies. From Hoover's generosity developed a two-year partnership and Russell's inculcation with mountain life and animals.

The partners lived in Hoover's cabin on the South Fork of the Judith River. At rest in the evenings, Russell would sketch his day's observations while Hoover spun yarns like this: "He had been out prospecting and, upon returning to camp one evening, he found that a silvertip had visited him in his absence and a pair of gum boots were missing. 'All summer and fall,' said Hoover, 'I saw gum boot tracks in the mountains, an' as there's no sign of camps or other humans, damned if I don't believe it was that bear wearing my boots.' "[1]

The mountain man's humor masked a deep respect, for hunters knew the ferocity of grizzlies. "They no sooner see you than they will make at you with open mouth. If you stand still, they will come within two or three yards of you, and stand upon their hind feet, and look you in the face, if you have fortitude enough to face them, they will turn and run off; but if you turn they will most assuredly tear you to pieces."[2]

The period around 1914, when *Whose Meat?* was completed, represents the apex of Russell's talents as a painter. His colors found harmony with eye and nature, his scenes captured the essence of the moment, and his draftsmanship allowed him to portray the intensity of life masterfully. Comments in an earlier review from the *Great Falls Tribune* could easily describe this picture.

Russell has made the rich, warm colors of frontier finery, with which other painters of western art bedeck their men and women, secondary to the sombre colorings of the vast reaches of the ranges and the endless desolation of the barren foothills and mountains. Each summer is spent in the open, camping here and there, now among the Indians, then with his cowboy friends, and at other times away from all human habitation, alone with his inspirations and the scenes of animal life and frontier landscapes which he loves and so faithfully depicts.[3]

[1] Ramon F. Adams and Homer E. Britzman, *Charles M. Russell: The Cowboy Artist* (Pasadena, Calif., 1948), p. 46.
[2] John C. Ewers, ed., *Adventures of Zenas Leonard, Fur Trader* (Norman, Okla., 1959), p. 11.
[3] *Great Falls Tribune* (December 21, 1902), p. 11.

Charles M. Russell

That an artist with no formal training could produce *Lewis and Clark on the Lower Columbia* testifies to Russell's innate ability. Watercolor, one of the most challenging of mediums, requires deft skill and consummate patience. The picture successfully conveys the humid, hazy atmosphere of the area; the composition with the Indians emerging from the fog is a reminder of the continual discoveries that Lewis and Clark made on their expedition.

Russell, however, employed poetic license when he brushed this scene, for the encounter probably took place on the shore.

Wednesday 20 [November, 1805].— . . . As we went along the beach we were overtaken by several Indians, who gave us dried sturgeon and wappatoo roots, and soon met several parties of Chinnooks returning from the camp. When we arrived there we found many Chinnooks, and two of them being chiefs, we went through the ceremony of giving to each a medal, and to the most distinguished a flag. Their names were Comcommoly and Chillahlawil. One of the Indians had a robe made of two sea-otter skins, the fur of which was the most beautiful we had ever seen; the owner resisted every temptation to part with it, but at length could not resist the offer of a belt of blue beads which Chaboneau's wife wore round her waist.[1]

Although the artist never visited the lower Columbia, Russell did follow Lewis and Clark's path part way down the Missouri. His friend Frank Linderman accompanied him and related that "Charley had with him the journals of Lewis and Clark. Sometimes he read paragraphs aloud, particularly when they were about our surroundings. . . . 'Them old boys could go *up* this river with a load an' we can't even go *down* the damned thing without getting stuck forty times a day,' he [Russell] said as he stepped into the water to get the boat off a bar."[2]

Linderman was a deputy to the Montana secretary of state when the legislature commissioned Russell to create a mural which would adorn the capitol. He began work on *Lewis and Clark Meeting Indians at Ross' Hole,* and Linderman observed:

Painting this large mural gave him little trouble—none at all compared to his distress when, necessarily present at a joint session of the House and the Senate, he was requested to reply to a formal speech of congratulatory acceptance of the picture. He stampeded for the door, frightened. He was literally dragged to the Speaker's station by laughing friends. It was a terrible ordeal for him. As he stood there his mouth opened once or twice but uttered no sound—none, at least, that reached me; his right arm and then his left made one quick, restricted gesture each; and then, with an embarrassed nod to the cheering audience, he bolted. The mural belonged to the state of Montana.[3]

The large mural, Russell's most grandiose historical narrative, referred to an event of September 5, 1805. "We discovered a large encampment of Indians: when we had reached them and alighted from our horses, we were received with great cordiality. A council was immediately assembled, white robes were thrown over our shoulders, and the pipe of peace introduced. After this ceremony, as it was too late to go any further, we encamped, and continued smoking and conversing with the chiefs till a late hour."[4] On the right are Lewis and Clark with their interpreter. Sitting on the ground in front of them is Sacajawea, the Shoshone Indian woman who was their guide. York, the only Black on the trip, stands on the far right. "From their camp of buffalo skin lodges at the left, the Indians are issuing forth and advancing toward the white men. . . . As a compliment to their strange white brothers whom they are about to meet, the Indians have mounted their best horses."[5]

Lewis and Clark's expedition changed the course of America's Western history. Appropriately, for one of the West's most renowned painters, subjects from their historic trip resulted in one of his finest watercolors and his largest oil.

[1] *History of the Expedition Under the Command of Captains Lewis and Clark* (New York, 1902), II, pp. 270–71.

[2] Frank Bird Linderman, *Recollections of Charley Russell* (Norman, Okla., 1963), p. 66.

[3] Ibid., pp. 99–100.

[4] *History of the Expedition . . . ,* p. 141.

[5] Ramon F. Adams and Homer E. Britzman, *Charles M. Russell: The Cowboy Artist* (Pasadena, Calif., 1948), p. 287.

165. Charles M. Russell. *Lewis and Clark Meeting Indians at Ross' Hole.* 1912. Oil on canvas, 11'5¼" x 24'9". Montana Historical Society, Helena

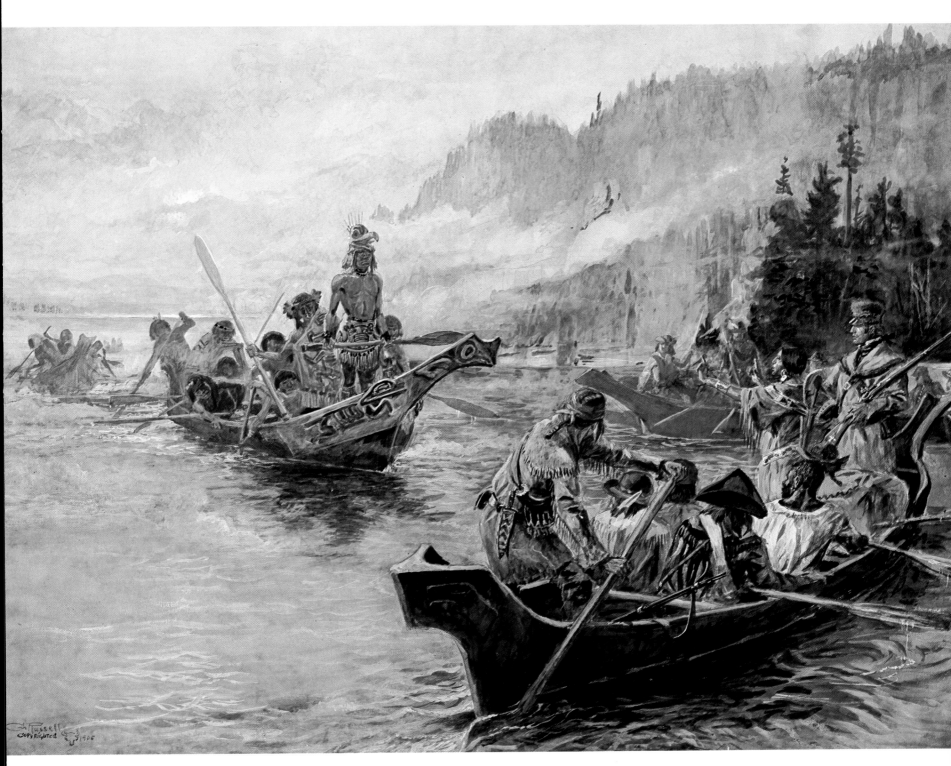

166. Charles M. Russell. *Lewis and Clark on the Lower Columbia*. 1905. Watercolor, 18⅞ x 23⅞". Amon Carter Museum, Fort Worth

167. Frederic Remington. *The Last Cavalier.* 1895. Oil on canvas, 23 x 35″. Collection Mr. and Mrs. Lawrence H. Kyte, Cincinnati

It was a bleak couple of winters that fell on the Northern Plains in 1885 and 1886, somber in color with their frozen skies and drifting snow and grave in their impact on what had once been America's most colorful frontier. Blizzards brought more than melancholy and discomfort; they beckoned disaster in their gales. For even those herds and men who survived the cruel winters emerged shaken in the spring. History and fate had turned a new page for them—an era was ended.

Frederic Remington had from his youth embraced the drama of cowboy life. At thirty-four, when he joined forces with Owen Wister to illustrate an article in *Harper's Magazine,* "The Evolution of the Cow-Puncher," the saga of the cowboy was a fundamental part of his life and art. Squinting from under their wide-brimmed hats, feet firmly in their stirrups, Remington's cowboys were barons of a heroic past. They had known the open range, the long drives, the roundups, and the freedom of riding the line. Now their day was done. Barbed wire crossed the plains in menacing strands, overgrazing forced ranchers to block off fields for hay, and necessary gates along the fences broke the rhythm and dulled the cadence of riding the range. This is all told with empathy and reverence in Remington's *The Fall of the Cowboy.*

The Last Cavalier, which appeared in the same Wister article, differs slightly from most of Remington's works. Typically, Remington presented facts rather than conclusions in his early paintings. Here, however, the artist deviated from this course. The cowpuncher is one, perhaps the last, of a long and esteemed line of horsemen from the pages of history. The apotheosis struck Wister profoundly. "The Last Cavalier," he wrote, "will haunt me forever. He inhabits a Past into which I withdraw and mourn. In a measure there is compensation, for the lime light glares no longer, nor the noon sun—But makes the figures tender as they move across the hills."[1]

[1] Letter from Owen Wister to Remington dated August 25, [1895], in the Remington Papers, Remington Art Museum, Ogdensburg, N.Y.

Frederic Remington

I have got a receipt for being *Great*—everyone might not be able to use the receipt, but I can. D— your *"glide along"* songs—they die in the ear—your Virginian will be eaten up by time—all paper is pulp now. My oils will all get old mastery—that is, they will look like *pale molases* [*sic*] in time—my watercolors will fade—but I am to endure in bronze—even rust does not touch.—I am modeling—I find I do well—I am doing a cowboy on a bucking broncho and I am going to rattle down through all the ages.[1]

Thus Remington wrote excitedly to his friend Owen Wister in 1895. He had labored with armatures and clay all that summer, and the results were heartening. No longer was he relegated to a two-dimensional world. His inherent feeling for form in the round was proven beyond a doubt in his first effort, *The Bronco Buster.*

The art critic Arthur Hoeber was quick to recognize the impact of this departure in Remington's art.

> . . . The energy and restlessness that actuated the work of Mr. Remington have found another vent, and the transition is not altogether surprising or unexpected. Breaking away from the narrow limits and restraints of pen and ink on the flat surface, Remington has stampeded, as it were, to the greater possibilities of plastic form in clay, and in a single experiment has demonstrated his ability adequately to convey his ideas in a new and more effective medium of expression. . . . It is . . . quite astonishing that the difficulties of technique in the modelling in clay should have been overcome so readily and with such excellent results as this maiden effort shows.[2]

Remington began his career as a sculptor by casting his bronzes with the Henry-Bonnard Bronze Works, who employed the traditional French sand-casting method. Around the turn of the century, Remington switched foundries and began using the Roman Bronze Works, casting his sculpture by the lost-wax technique. The cast of *The Bronco Buster* shown here is one of about ten produced by the Roman Bronze Works in which Remington adorned his cowboy in woolly chaps. The whereabouts of less than half of these is known today.

The cowboy and bucking horse was a subject which Remington employed frequently in his paintings during the mid-1890s. *Blandy,* one of his most successful versions of that theme, was in fact a commissioned portrait of a rancher engaged in his favorite pastime. A successful bronc ride was challenging, a test of a man's stamina and brawn. Nothing counted, however, unless one's horse was an ornery, nonstop, fire-breathing bucking machine, the kind who will "sure take a man thru some awful places and sometimes only one comes out. Such doings would make a steeplechase as exciting as a fat man's race; that horse is out to get his man and he don't care if he goes himself while doing the getting."[3]

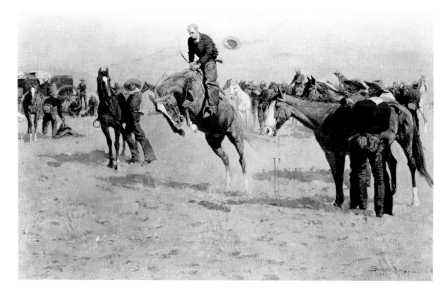

170. Frederic Remington. *Blandy.* n.d. Oil on canvas, 27 x 40″. R. W. Norton Art Gallery, Shreveport, La.

[1] Undated [1895] letter from Remington to Wister, Owen Wister Papers, Manuscript Division, Library of Congress, Washington, D.C.
[2] Arthur Hoeber, "From Ink to Clay," *Harper's Weekly,* 39 (October 19, 1895), 993.
[3] Will James, *Cowboys North and South* (New York, 1926), p. 43.

Frederic Remington

171. *Frederic Remington in the West.* c. 1900. Sepia gelatin print, 2¼ x 3¼″. Amon Carter Museum, Fort Worth

172. Olaf Seltzer. *A Dude's Welcome.* 1909. Oil on canvas, 18 x 24″. Amon Carter Museum, Fort Worth

Ⅰn 1890 Remington granted an interview with the writer Cromwell Childe from the *Republican,* a Denver newspaper. Remington had been in the business of illustration less than five years, and already he was counted an authority on Western life and particularly on the study of horse flesh. Remington knew that horses were as different as the men who rode them, and his paintings revealed the perception of his observations.

When in New York, his [Remington's] afternoons are spent in the saddle, the mornings given up to work. His studio is a curious place. The walls are lined and the corners piled up with saddles and bridles and bits of trappings of the ranchman and the Mexican horseman. There are studies of all types of horses scattered about. Remington himself is a sturdy, stocky man of fine physique, tall, round-faced and smooth shaven. He has the artistic temperament to a dot, but it is an athletic one.[1]

So well versed was Remington on matters of horses that his art became somewhat instinctive. "My drawing is done almost entirely from memory," he confessed. "I understand the horse so that every movement of his has fixed itself upon me."[2] Despite this equestrian knowledge and Western orientation, Remington remained throughout his life a classic dude. As pictured in 1900 at the foot of the Colorado Rockies, the artist, broadly wedged onto a flat saddle and attired in jodhpurs and English riding boots, looked at home in the saddle but not on the range. Quite consciously though, his mannerisms and life-style were more nearly Western. His friend Poultney Bigelow once remarked about Remington's affectation of Western jargon. "I have seen Englishmen totally at a loss to understand the speech of Remington—indeed some did not recognize it as our common language."[3]

Despite the fact that Remington was himself a dude of the first rank, he knew well the tests which confronted the true cowboy. Running wild horses out of the mountains provided them with some of the most challenging and exciting moments. When Remington painted *The Cowboy,* his testament to their way of life, he pictured such a scene where balance, sureness, and bravado are requisite to survival and getting the job done.

Olaf Seltzer, a protégé of Charles Russell's, captured something of the lighter side of cowboy life—the spirit of a little cowboy fun at the expense of a hapless dude. *A Dude's Welcome* epitomizes the clash of East and West and the dictum that one man's pleasure is another man's pain.

[1] Cromwell Childe, "A Study of the Horse," *Republican* [1890], from a clipping in the Western History Department, Denver Public Library.
[2] Ibid.
[3] Poultney Bigelow, "Frederic Remington; with Extracts from Unpublished Letters," *Quarterly of the New York State Historical Association,* 10 (January, 1929), 46.

173. Frederic Remington. *The Cowboy.* 1902. Oil on canvas, 40¼ x 27⅜". Amon Carter Museum, Fort Worth

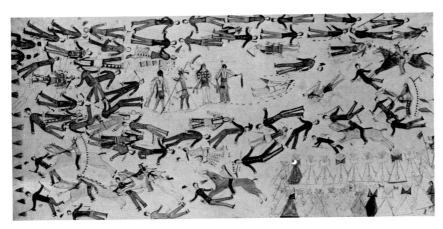

174. Kicking Bear. *Battle of Little Bighorn.* c. 1894. Pictograph commissioned by Remington. Southwest Museum, Los Angeles

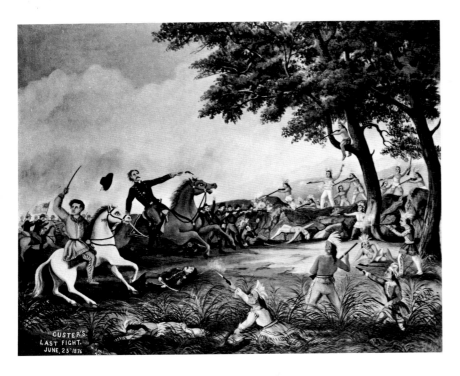

175. W. J. Wallack. *Custer's Last Fight.* c. 1876. Oil on canvas, 65½ x 78". Buffalo Bill Historical Center, Cody, Wyo. Gift of Edgar William and Bernice Chrysler Garbisch

The final episode in the long and bitter war between Indian and white forces on the frontier ended in a combination of spiritual frenzy and mechanical wizardry. The Teton Sioux took to the incorporeal, the Seventh United States Cavalry to science, and in the end science prevailed. It all happened at Wounded Knee, where Ghost shirts and Winchesters confronted the rapid-fire Hotchkiss guns. The struggle was not long fought.

Frederic Remington came to the scene of Wounded Knee shortly after the incident. He interviewed the victorious soldiers on Uncle Sam's side. They could say little, a fact which Remington euphemistically dismissed as soldiers' modesty. "They told me their stories," he noted, "in that inimitable way which is studied art with warriors. To appreciate brevity you must go to a soldier. He shrugs his shoulders, and points to the bridge of his nose, which has had a piece cut out by a bullet, and says, 'Rather close, but don't amount to much.' "[1]

Remington's impressions of the battleground appeared in a *Harper's Weekly* article entitled "The Sioux Outbreak in South Dakota." Two weeks earlier that magazine had illustrated the artist's dramatic painting, *The Last Stand.* Some have said that this is a depiction of Custer's last stand but it is not. Neither is it Wounded Knee, from which Remington had recently returned. Instead, the scene is a generic one, portraying the harried forces in blue at a critical juncture in battle.[2]

Unlike a plethora of Western artists, some good but most mediocre, Remington produced no major work on the subject of Custer's demise. That he was intrigued by the subject, however, is testified to by the fact that in 1898 he commissioned one of the veterans of the Little Bighorn, Kicking Bear, to paint his rendition of the fatal encounter. Kicking Bear pictured himself in the center of the action, standing to the right of Sitting Bull, Rain in the Face, and Crazy Horse. The battle boils around them as the Sioux women back in their village wave a captured American Flag—a proclamation of victory.

Explanations for Custer's countermanding orders, for his underestimation of Indian strength, and for the precise details of the battle have never been forthcoming. Conjecture has generated tremendous creative imagination on the part of historians and artists alike. One of the most spurious yet delightfully naive interpretations came from the brush of artist W.J. Wallack. Very little is known of Wallack except perhaps that his painting, *Custer's Last Fight,* proves that he, like most Americans of his day, knew next to nothing about the Custer finale.

[1] Frederic Remington, *Pony Tracks* (New York, 1895), pp. 49–50.
[2] See Don Russell, *Custer's Last* (Fort Worth, 1968), p. 41.

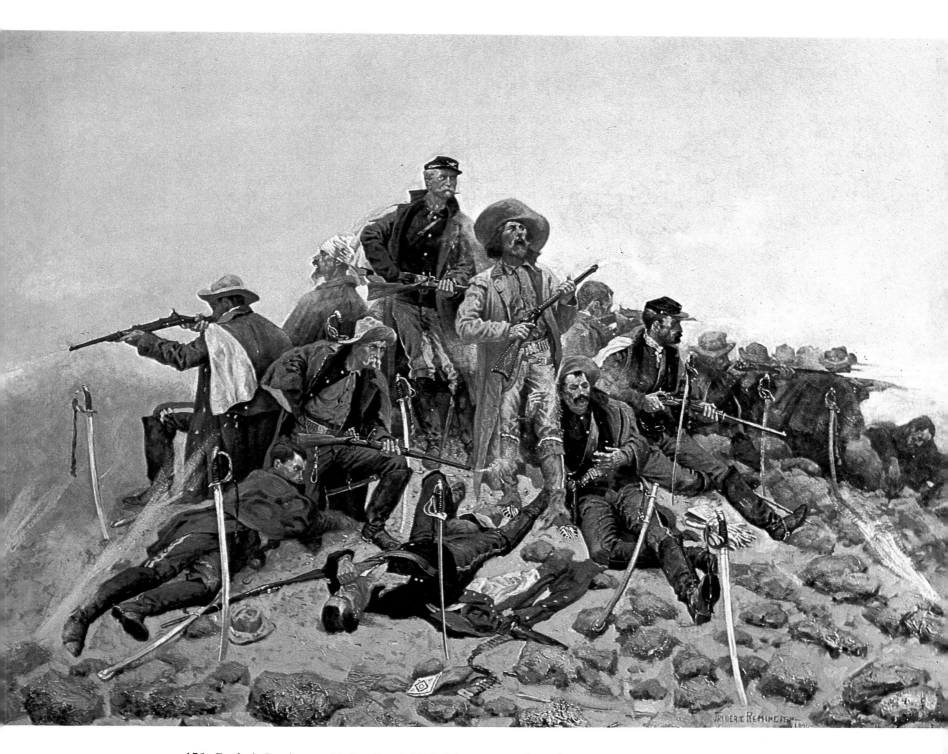

176. Frederic Remington. *The Last Stand.* 1890. Oil on canvas, 47 x 64″. Woolaroc Museum, Bartlesville,
Okla. Collection of Western Art and Artifacts

Although Remington was known for a full range of Western subjects, in the years up to the turn of the century his attention focused on the military. The soldier was the embodiment of fundamental truth in Remington's mind. Nowhere could a fuller, richer commitment to life be found than in the uniformed man, and nowhere were they more resolute in their dedication to duty than on the frontier.

Remington never joined any branch of the armed services, yet he thrived on identification with them. It was in Sibly tents on the northern prairies, on long desert marches through the San Carlos Agency, and in dry camp along the Texas border that he found his closest friends. Among soldiers he felt a man in a man's world.

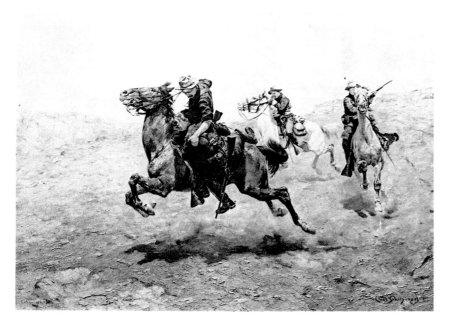

177. Charles Schreyvogel. *My Bunkie.* 1899. Oil on canvas, 25¼ x 34". The Metropolitan Museum of Art, New York City. Gift of Friends of the Artist, 1912

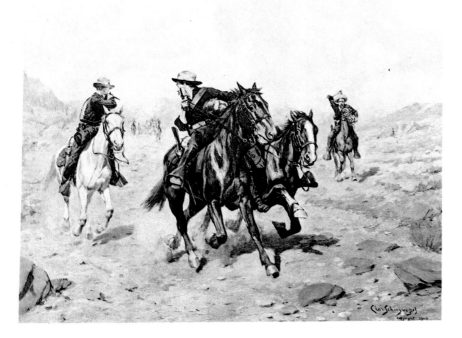

178. Charles Schreyvogel. *Saving Their Lieutenant.* 1906. Oil on canvas, 24½ x 30½". Kennedy Galleries, Inc., New York City

It was appropriate then that Remington's second, and to many his most successful, work in bronze was a military subject. *The Wounded Bunkie,* limited to fourteen castings, depicted two comrades in full retreat. One bunkie is gravely wounded and is kept in the saddle thanks to the strength and able horsemanship of his companion. The subject was new for Remington only in its adaptation to sculpture. A similar pose and the adroit counterbalance of live and dead weight at full gallop had already provided the impact for the central composition in Remington's famous painting, *A Dash for the Timber* (plate 1).

One critic who saw the piece in wax before it was first cast deigned to admit that "I think it is art."[1] For despite the forthright drama and perceptive handling of form, detail, and anatomy, many found fault with the lack of academic tenets seen in this and other of Remington's bronzes. Especially painful to Remington was an opinion that he heard often, that his bronzes were conceived as illustrations rather than as sculptures. It was a criticism which persisted long after his death.

The subject of art versus illustration came to play an increasingly important role in Remington's life as his career progressed. Although he supported himself primarily through work as an illustrator until the last few years of his life, he longed fervently to find recognition as a fine artist rather than as an illustrator. His ascendancy to the hallowed ranks of fine art was threatened and perhaps even delayed by a bitter and foolish controversy between himself and a fellow artist of Western subjects, Charles Schreyvogel.

Schreyvogel, an impoverished and rather humble painter from Hoboken, rose to fame overnight when his painting, *My Bunkie,* was awarded the Thomas B. Clark Award at the annual exhibition of the National Academy of Design in 1900. The *New York Herald* exposed the first threat by invidious comparison. "In subject the picture is akin to those of Frederic Remington. But it is wholly different in treatment. The instantaneous photographic effects which Remington is so fond of introducing in his galloping horses are wholly absent."[2] For the next several years critics made comparable pairings, much to Remington's chagrin. "In his preference for color work, as in his preference for soldier scenes and western life," observed critic Gustav Kobbe, "Mr. Schreyvogel resembles Mr. Remington, but unlike this artist, he does not paint for color reproduction, feeling as he does that no color process yet devised does strict justice to the original colors of the artist."[3]

Remington, at one point, attempted to raise criticism of Schreyvogel's works. A controversy ensued, and Remington came out the loser. He eventually retreated, leaving Schreyvogel to his own devices. His jealousy and spite for Schreyvogel never subsided, and Schreyvogel continued to adapt themes that Remington had previously explored, as exemplified in his 1906 canvas *Saving Their Lieutenant.*

[1] From *Town Topics* (October 22, 1896), quoted in Maria Naylor, "Frederic Remington: Part II: The Bronzes," *Connoisseur,* 185 (February, 1974), 139.

[2] "'My Bunkie,' Which has Made Hoboken Artist Famous," *New York Herald* (January 1, 1900).

[3] Gustav Kobbe, "Schreyvogel's American Soldiers Pictures," *Uncle Sam's Magazine,* quoted in James D. Horan, *The Life and Art of Charles Schreyvogel* (New York, 1969), p. 28.

179. Frederic Remington. *The Wounded Bunkie.* 1896. Bronze, height 20¾″. Buffalo Bill Historical Center, Cody, Wyo. Gift of W. R. Coe Foundation

180. Unknown Cheyenne artist. *Battle Scene.* 1875. Pencil, 5¼ x 8¼".
Buffalo Bill Historical Center, Cody, Wyo.

The Indians of the Western plains did not require white incursion to work refinements in their martial arts. Among the Crow, warfare had for generations been a prime focal point for the entire tribe. Social standing was commensurate with military prowess, and only through distinction as a warrior might a man and his family rise in importance within the tribe. Crow religion was even inextricably tied to war. "Every single military undertaking was theoretically inspired by a revelation in dream or vision; and since success in life was so largely a matter of martial glory, war exploits became the chief content of prayer."[1] The Crow Sun Dance and the tobacco ritual were filled with military implications. At secular gatherings as well, men rejoiced in recounting their hostile deeds. An elderly Crow, No-shinbone, enumerated his feats of bravery for anthropologist Robert Lowie in 1907.

> I captured a gun.
> I captured a bow.
> I led a war party that killed an enemy.
> I was shot.
> I killed a horse.
> I shot a man.
> I brought home ten horses.
> I went to war about fifty times.
> The Dakota were harrying me, I shot one of them.[2]

In addition to boasts, Indians recorded their exploits in pictures, adorning their clothing and tepees with tales of valor. Some of the most charming and beautiful of these depictions were produced by a group of Cheyenne warriors taken prisoner in 1875 and shipped to Fort Marion, Florida. While incarcerated, they were encouraged by their overseer, Captain Richard H. Pratt, to tell in paint of their life on the plains. The pencil drawing of an intertribal battle was done by one unidentified warrior of that group.

The Crow brave in Remington's *Ridden Down* has seen his last military exploit and will not live to tell of it. He braces himself for the inevitable. Perhaps he will become part of tribal lore; he became part of Remington's.

There is nothing in this painting to separate the viewer from the impact of imminent death. The Crow and his spent pony stand out boldly before the monochromatic union of prairie and sky. Attention focuses on them. This counterbalance of a firmly drawn central figure and reduced color values of the landscape behind suggest an ambivalence in Remington's work. Unwilling to depart from his traditional style, yet admitting the virtues of Impressionism, Remington in this painting evinces a stylistic transition.

[1] Robert H. Lowie, *The Crow Indians* (New York, 1935), p. 215.
[2] Quoted in ibid., p. 218.

181. Frederic Remington. *Ridden Down*. 1905. Oil on canvas, 30¼ x 51⅜". Amon Carter Museum, Fort Worth

Frederic Remington

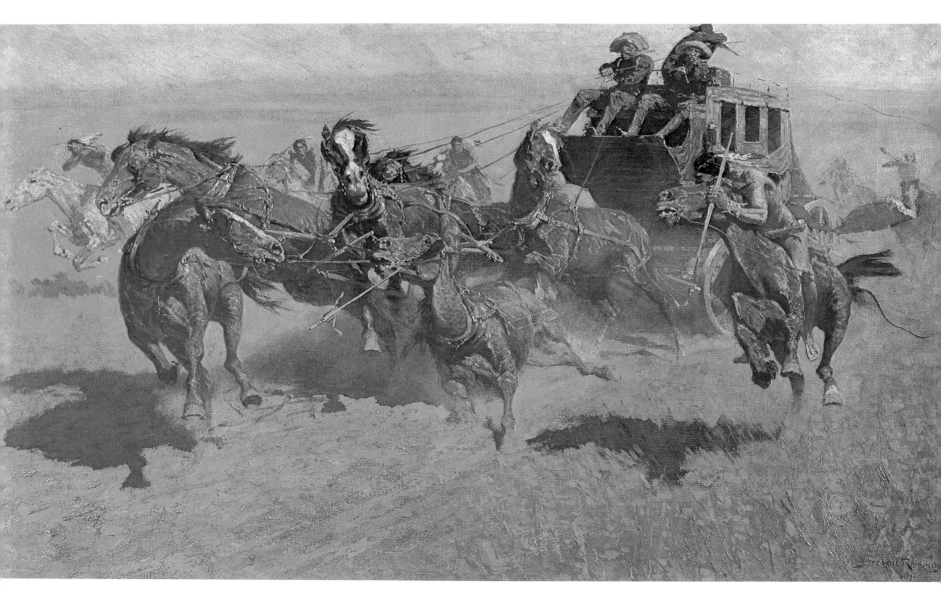

182. Frederic Remington. *Downing the Nigh Leader.* c. 1907. Oil on canvas, 30 x 51". Collection Mrs. Lincoln Ellsworth, New York City

The scope of Remington's art was truly remarkable. He felt at home in the field of sculpture, he was revered as one of the best illustrators of his day, and he exhibited as a fine artist next to contemporary painters at major expositions in Paris, Chicago, Philadelphia, and elsewhere. His sense of timing was equally astonishing. One week he could be painting *in situ* on the battle line in Cuba or South Dakota and the next week at home in his magnificent studio mentally thumbing through the pages of history for imagery. He was at ease in many worlds.

In later years, when he delved into historic themes of the Old West, his versatility showed its fullest impact. *Downing the Nigh Leader* was exemplary. Harkening back to the days of the Overland Mail, Remington captured the romance of Western coaching. His style, consisting of a traditional narrative focus, was infused with a romantic realism and his own intense form of Impressionism. This somewhat unlikely combination won tremendous popular favor and allowed Remington to keep abreast of his times as a painter, yet still rely on the past for inspiration.

As time passed Remington found it more and more necessary to look back over his shoulder as the historic West moved further into history. Only the landscape remained the same, and it was for the purpose of observing that landscape and studying Western light that he traveled west in later years. In 1907 Remington said, "My West passed utterly out of existence so long ago as to make it merely a dream. It put on its hat, took up its blankets and marched off the board; the curtain came down and a new act was in progress."[1]

By that year Remington was known as "the fountainhead of all authentic portrayals of the 'Wild West.' "[2] His painting *Downing the Nigh Leader* was allied with mass consumption of all things Western. One writer referred to it as "a scene immortalized by Frederic Remington's brush and carried to all nations of the earth by 'Buffalo Bill.' "[3]

The *Old Stage Coach of the Plains,* painted six years before, not only derived inspiration from history but was historic in itself. One of Remington's earliest nocturnal paintings, it indicated a new direction for the artist which he would explore with great success in the years to follow. In addition, this was one of the first of his works to be illustrated in color. It appeared as a frontispiece in *Century Magazine* in January of 1902. The next year Remington signed an exclusive contract with *Collier's* for twelve paintings a year to be illustrated in full color.

[1] Perrington Maxwell, "Frederic Remington—Most Typical of American Artists," *Pearson's Magazine,* 18 (October, 1907), 407.
[2] Edward J. Wheeler, ed., "Frederic Remington—A Painter of the Vanishing West," *Current Literature,* 43 (November, 1907), 521.
[3] Ibid., 525.

183. Frederic Remington. *Old Stage Coach of the Plains.* 1901. Oil on canvas, 40¼ x 27¼". Amon Carter Museum, Fort Worth

Frederic Remington

Extremely interesting has been Mr. Remington's development from an illustrator into a painter. It has been slow, not because of any lack of ability, but because there always was such a demand for his illustrative work that he could not very well give it up or even relax from it sufficiently to devote the necessary time to painting as distinguished from illustrating. But the pictures, more than twenty in number, which he recently exhibited in the Knoedler galleries showed him as a painter—and a painter who knew the American Indian, his habits, his life and his abiding places.[1]

Among the pictures mentioned at Knoedler's was Remington's vibrant *The War Bridle*. He knew when he completed this and the other paintings for the exhibition that they would stand as his greatest achievements as a painter. All his life he had wanted to portray horses in motion so that the paint, the contrasts of color value, and the scintillating light would effect as much action as the physical thrust of the horses on the canvas.

Wherever he finds them Mr. Remington makes his horses stand out in this way as having something like personality. They are lean, wiry, and mischievous animals that he paints in such pictures as "The War Bridle". . . . You observe them with a certain zest. They move as though on springs. Their heels play like lightning over the earth. You feel them hurling themselves along in the hunt, going nervously into action to the crack of bullets, or struggling not unthoughtfully with the cowboy who would conquer their trickiness. It all makes an exhilarating spectacle, and these pictures are filled besides with keen, dry air and dazzling light. The joy of living gets into Mr. Remington's work.[2]

[1] Gustav Kobbe, "Painters of Indian Life," *New York Herald* (December 26, 1909).
[2] Royal Cortissoz, "Frederic Remington: A Painter of American Life," *Scribner's Magazine,* 47 (February, 1910), 192.

184. Frederic Remington. *The War Bridle.* 1909. Oil on canvas, 27 x 30". Private collection. On loan to the Buffalo Bill Historical Center, Cody, Wyo.

There could be no sound more exhilarating than the thunder of hooves as a hunter took up the chase after a buffalo herd and no sound so devastating as the roar in a cowboy's ears when his beeves spooked and a stampede was on. Get them turned, get them slowed, get them stopped was all that went through his mind. Halt those "bovine meteors"[1] before they destroyed themselves and all that happened into their path. First they must be caught, then guided, then encircled until finally man was once again in control of nature. Sometimes the losses were counted in more than pounds of precious beef.

... That night it come up an awful storm. It took all four of us to hold the cattle and we didn't hold them, and when morning come there was one man missing. We went back to look for him, and we found him among the prairie dog holes, beside his horse. The horse's ribs was scraped bare of hide, and all the rest of horse and man was mashed into the ground as flat as a pancake. The only thing you could recognize was the handle of his six-shooter. We tried to think the lightning hit him, and that was what we wrote his folks down in Henrietta, Texas. But we couldn't really believe it ourselves. I'm afraid it wasn't the lightning. I'm afraid his horse stepped into one of them holes and they both went down before the stampede.[2]

In both bronze and paint Remington suggested the drama of such senseless terror and desperate human recourse. His *Stampeded by Lightning* spares nothing in the stirring test of man and beast. Set against a blackened sky and the darting horns of a frenzied herd, a cowboy and his pony, numbed with fright and determination, surge for the lead. Harmonized in color and syncopated to the thunder of heaven and earth, Remington's depiction has never been equaled in paint.

The model for a bronze of the same subject stood finished in Remington's studio the day of his death. A few castings were later authorized by his widow, Missie, proving once again that the artist could conceive as boldly in bronze as in paint. In such work as this, Remington's spirit still lives today, confirming for those who pause to consider history and art together, the probity of Owen Wister's observation: "Remington is not merely an artist, he is a national treasure."[3]

[1] Philip Ashton Rollins, *The Cowboy* (New York, 1922), p. 256.
[2] E.C. Abbott and Helena Huntington Smith, *We Pointed Them North* (New York, 1939), p. 43.
[3] Owen Wister, "Remington—An Appreciation," *Collier's*, 34 (March 18, 1905), 15.

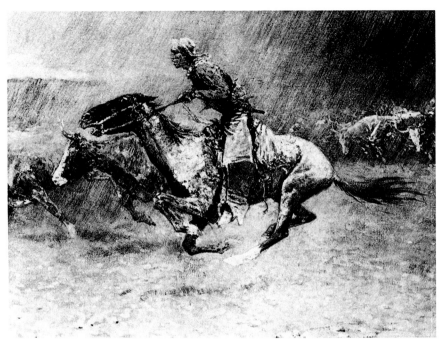

186. Frederic Remington. *Stampeded by Lightning* (detail). 1908. Oil on canvas. Thomas Gilcrease Institute of American History and Art, Tulsa, Okla.

185. Frederic Remington. *The Stampede*. 1910. Bronze, height 22⅝″. Amon Carter Museum, Fort Worth

Solon H. Borglum

Remington's first and last sculptures brought to the world the image of America's hero, the cowboy. However, it was another sculptor, Solon Borglum, who is credited with initially immortalizing the Western horse and rider in bronze. Like Remington, Borglum enjoyed life on a ranch of his own. Remington's had been in Kansas, Borglum's in Nebraska.

As described in later years, Borglum's life on the ranch involved more than the usual chores and long-sung hardships. He harbored a sense of destiny for the Western land and its people, and within it he wove the course of his own art.

Many a time he would urge or lead his pony up some undiscovered ridge of country and, reaching the top, he would sprawl on the sand hill and watch the wind mow paths in the bunch grass below or, looking over the stretch of silent plain and hill to the illimitable blue beyond, he would unwittingly know himself a part of a great inexplicable Something that he could not understand or express. Or after a stampede, as he sat in the saddle or stood beside his horse at night alone, with the sweating flank of the herd before him, and the hills and his cabin back of him somewhere in the blackness, the fierce epic of the plains wrote itself into his heart.[1]

Fortune had it that the waving prairie grass would not be Borglum's home for long. The ranch was given up for Paris and the Académie Julian. Though he remained in the academy only a few months, Paris became his home for the next four years. He was married there, returning to the West only for a brief honeymoon to show his bride the frontier. The Borglums shared their first days together in South Dakota at the Crow Creek Agency (plate 192), where Borglum made preliminary studies for the finest of his works, *On the Border of the White Man's Land.*

Man and nature are in harmony in this bronze. The Indian and his horse seem as one—united in purpose and in stature. Without the physical dynamics involved in Remington's sculptural work, Borglum has achieved visual mobility and emotional presence.

[1] Arthur Goodrich, "The Frontier in Sculpture," *World's Work,* 3 (March, 1902), 1860–61.

187. Solon H. Borglum. *On the Border of the White Man's Land.* 1906. Bronze, height 19″. The Metropolitan Museum of Art, New York City. Rogers Fund, 1907

Charles Schreyvogel

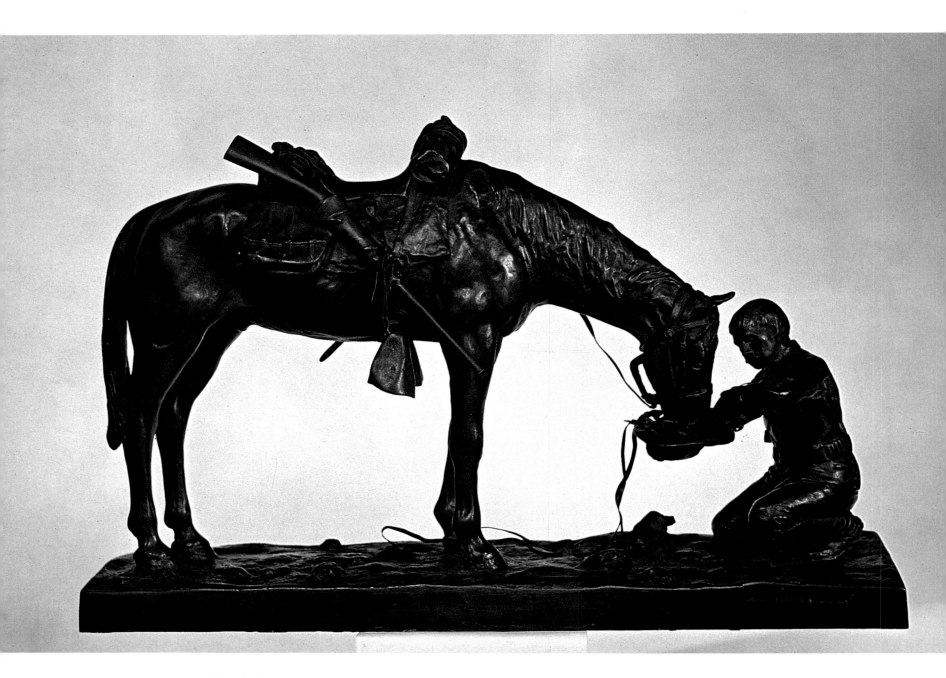

188. Charles Schreyvogel. *The Last Drop.* 1900. Bronze, height 12″. National Cowboy Hall of Fame, Oklahoma City, Okla.

The art of Charles Schreyvogel resonated with the clamor of frontier violence. His most typical scenes involved cavalry attacks or retreats, the agony of piercing bullets, or the slash of sabers. There was little room in these tableaux of heroicism for simplicity of life or eloquence of mood. Yet Schreyvogel was reputed to be the mildest of men, calm and reasoning, the very antithesis of his sanguinary expression.

That quiet side of Schreyvogel's character emerged from time to time in his work, and when it did the results were astonishing. His bronze, *The Last Drop*, is a case in point. Conceived originally as a model for his painting of the same title, the bronze depicts a soldier sharing the last drafts from his canteen with his trusted steed. The intrepid warrior humbles himself before his mount, knees to the ground as if acknowledging the realization that even in war, or perhaps especially then, man comes to know compassion. For Schreyvogel the piece provided a simple, genuine outlet for his inherent belief in human worth.

From cavalryman to cowboy, reliance on the horse reigned. Illustrator and author Will James noted that most think of dog as man's best friend.

With me, my weakness lays towards the horse. My life, from the time I first squinted at daylight, has been with horses. I admire every step that crethure [*sic*] makes, I know them and been thru so much with 'em that I've come to figger a big mistake was made when the horse was classed as an animal. To me, the horse is man's greatest, most useful, faithful, and powerful friend. He never whines when he's hungry or sore footed or tired, and he'll keep on a going for the human till he drops.[1]

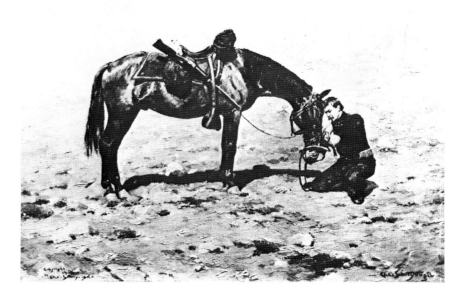

189. Charles Schreyvogel. *The Last Drop.* 1900. Oil on canvas, 16 x 20″. Private collection

[1] Will James, *Smoky* (New York and London, 1926), p. v.

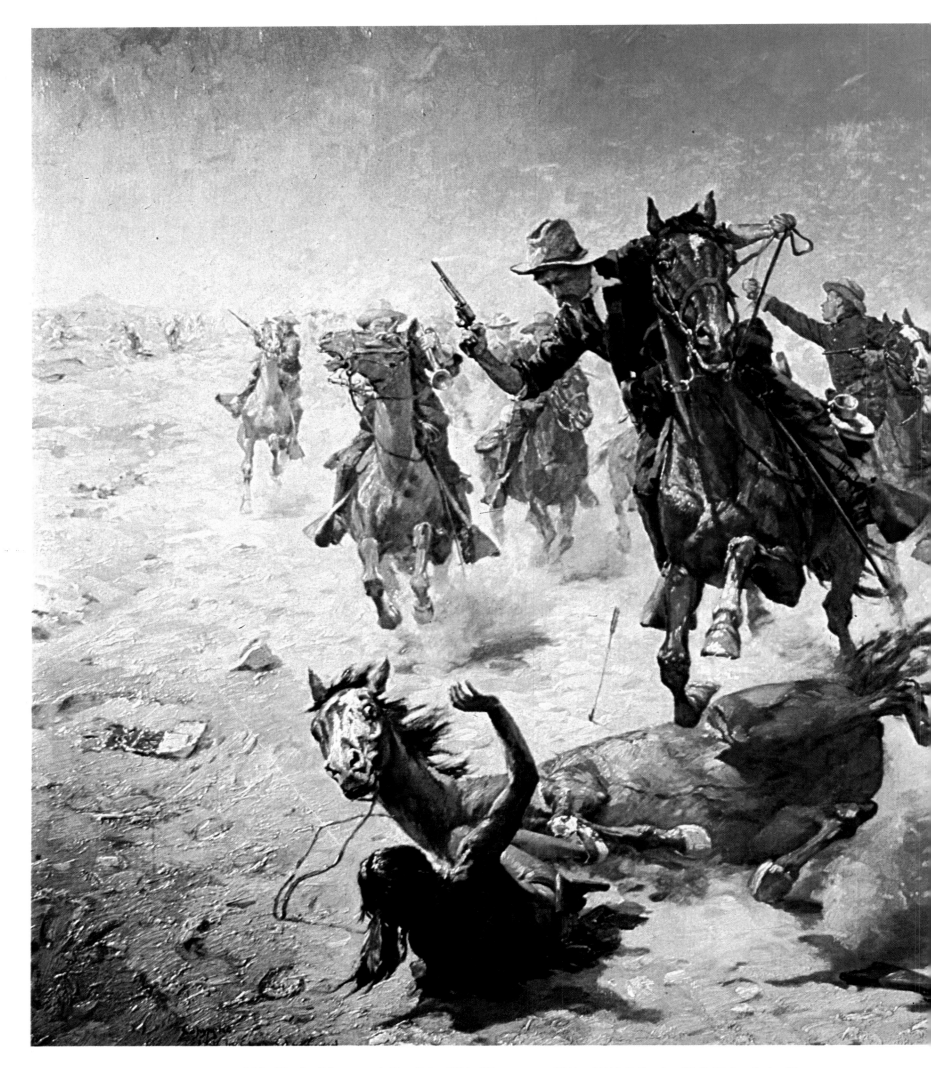

190. Charles Schreyvogel. *How Kola.* 1901. Oil on canvas, 25½ x 34½″. Collection W. E. Weiss, Cody, Wyo.

Charles Schreyvogel

With a compassion and sensibility which would allow two enemies to find a common ground, Charles Schreyvogel in 1901 produced one of America's most consuming narrative paintings, *How Kola*. It was basically a simple story, one with an Androcles plot and a frontier setting. An Indian saves a soldier who is lost and freezing on the prairies. The soldier later returns to his retinue and, before too many years pass, is found among General George Crook's cavalry in the Battle of the Rosebud. The skirmish waxes hot. The alternatives are limited to kill or be killed when all at once a voice at gun-sight's end screams, "How, Kola." The trigger finger is arrested, and two out of a field of frenzied warriors affirm in somewhat bewildered fashion the universal human rule of friendship.

Exactly who this pair was remains unclear though, according to contemporary sources, the story "was known to any gathering of veterans of Crook's campaign."[1] More important was the fact that Schreyvogel chose the account for the theme of a painting. By doing so, the artist opened up an avenue for understanding in his otherwise blatantly one-sided *oeuvre*. To Schreyvogel, the Indian was cast as villain, the cavalry as omnipotent conqueror. That the artist would deign to consider such an exchange of sensibilities is redeeming, even though it is important to note that Schreyvogel decided to picture white man saving red and not the other way around.

[1] *Leslie's Weekly* (December, 1901).

William Fuller

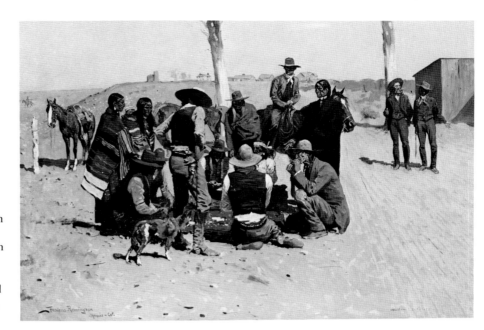

191. Frederic Remington. *A Monte Game at the Southern Ute Agency.* 1901. Oil on canvas, 27 x 40″. Permanent collection, Lovelace Foundation for Medical Education and Research, Albuquerque, New Mexico. On permanent loan courtesy of the W. Randolph Lovelace II estate

192. William Fuller. *Crow Creek Agency D.T.* 1884. Oil on canvas, 24⅝ x 51¾″. Amon Carter Museum, Fort Worth

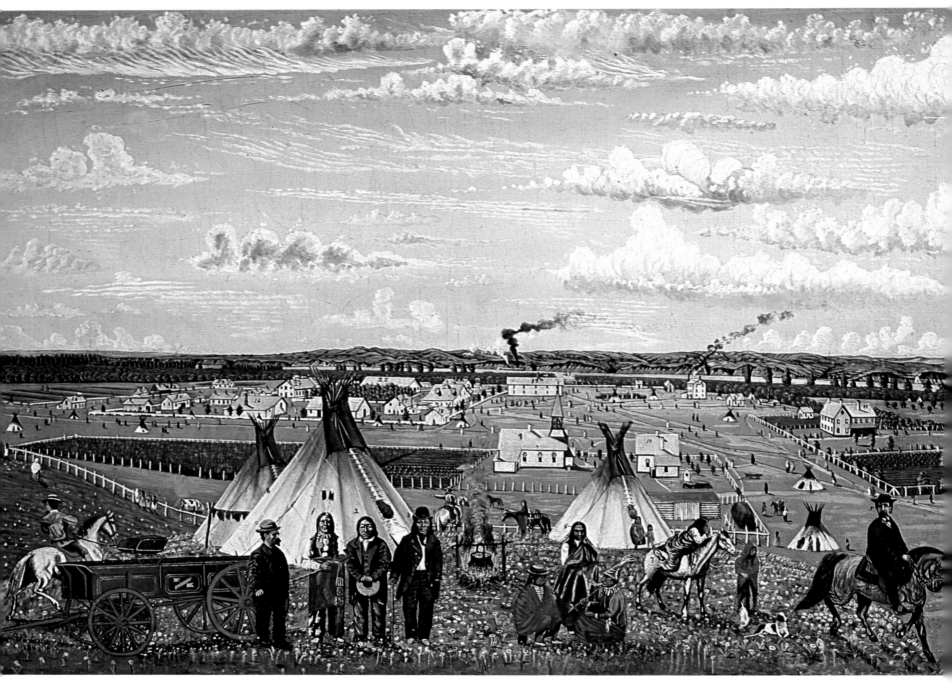

Traveling on the Oregon Trail along the plains, Francis Parkman forecast the Indians' future.

Great changes are at hand in that region. With the stream of emigration to Oregon and California, the buffalo will dwindle away, and the large wandering communities who depend on them for support must be broken and scattered. The Indians will soon be corrupted by the example of the whites, abased by whisky and overawed by military posts; so that within a few years the traveller may pass in tolerable security through their country. Its danger and its charm will have disappeared altogether.[1]

Not twenty years later the starving and rebellious Santee Sioux of Minnesota were in captivity. Colonel Clark Thompson selected in 1863 a confinement site near Fort Thompson, Crow Creek Agency, Dakota Territory. Unhappy there, the Santee were moved to Nebraska and replaced with Yanktonnais, Yankton, and Teton Sioux.

Parkman's prophesy proved true. The Indians were reduced to living off government annuities and rations; schools and churches were their new preoccupations.

A visitor, Mrs. Solon Borglum, described the area in 1899. "The agency was located on the east bank of the Missouri river, six miles above the point at which Crow Creek empties into the Missouri. Its buildings stood on a broad strip of river bottom about 200 yards wide, flanked on the river side by a large grove of cottonwood trees and on the east side by cliffs."[2] William Fuller's painting once hung at the agency. Employed as a carpenter for Crow Creek, "every other year Fuller apparently took a two-month vacation and used the time to paint; a painting took him approximately ten weeks to complete."[3]

Fuller, in his appealingly naive manner, numbered the important portraits and wrote their names on the backs of the canvases. Number 1 is White Ghost. The only Indian in traditional garb, he never accepted the white men as equals, yet avoided fighting with them. White Ghost purportedly advised Custer against fighting the Tetons. Number 2, Drifting Goose, was admitted into the Catholic church after two of his three wives had died. As chief of a band of Hunkpapa Sioux, he did not sign a treaty until 1888, when he permitted his head warrior to sign for him. A cousin of White Ghost, Wizi, is number 3. Receptive of white ways, Wizi mediated disputes between red and white men. Mark and Wallace Wells, sons of a Santee mother and white father, who helped the Sioux through the transition, are numbers 4 and 5.[4]

The 1870 discovery of gold in the Black Hills terminated a fragile peace, and in 1875 the area was opened up for miners at their own risk. White Ghost spoke:

You have driven away our game and our means of livelihood out of the country, until now we have nothing left that is valuable except the hills that you ask us to give up. . . . The earth is full of minerals of all kinds, and on the earth the ground is covered with forests of heavy pine, and when we give these up to the Great Father we know that we give up the last thing that is valuable either to us or the white people.[5]

While life on a reservation was alien to most Indians, betting was not, as is manifested in Remington's painting of the Utes. He wrote for the caption, "As the Indians gather about the trader's store at Ignacio, Colorado, some one of them before long spreads his blanket on the sand and begins to deal monte. He soon has patrons. A dozen or more games may be in progress, and they do not attract the interest of the outsider after three days. They are so open, so all in the sunlight, that one almost forgets that gambling is a vice."[6]

[1] Francis Parkman, *The California and Oregon Trail* (New York, 1849), p. 229.
[2] Quoted in a manuscript by Roscoe E. Dean, M.D., "The Story of the Crow Creek Agency Picture," in the Amon Carter Museum of Western Art, Forth Worth.
[3] Jan M. Dykshorn, "William Fuller's Crow Creek and Lower Brule Paintings," *South Dakota History*, 6 (fall, 1976), 413.
[4] Dean, loc. cit.
[5] Quoted in Virginia Irving Armstrong, comp., *I have spoken* (Chicago, 1971), pp. 100–101, from the U.S. Commissioner of Indian Affairs, *Annual Report 1875*.
[6] "A Monte Game at the Southern Ute Agency," *Collier's Weekly*, 27 (April 20, 1901), 12–13.

Dispensing

the Legend

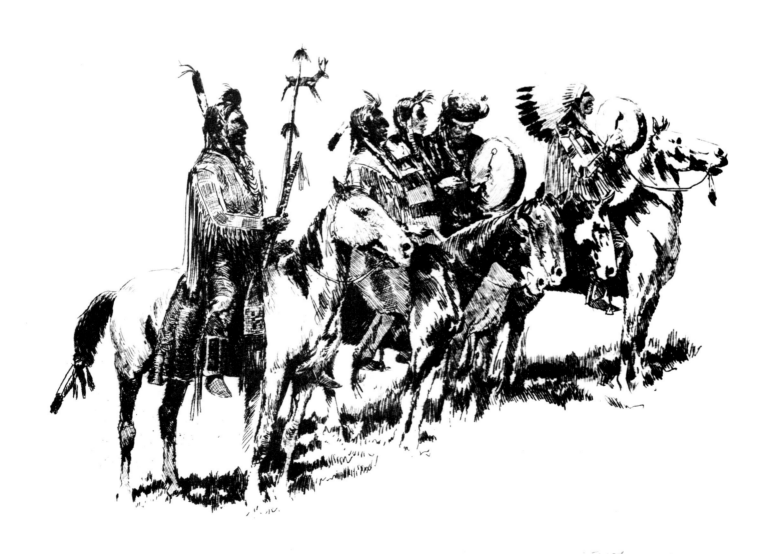

Henry F. Farny

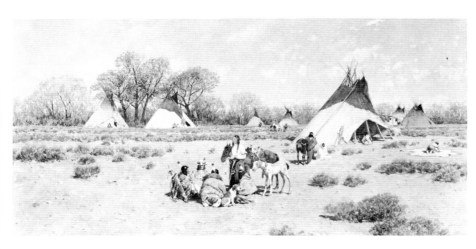

193. Henry F. Farny. *Cheyenne Camp.* 1892. Watercolor, 12 x 24".
Cincinnati Art Museum. Gift of William Proctor in memory of his
father, Harley Proctor

The close of the nineteenth century brought to the artists' conception of American Indians a reminiscence approaching nostalgia. These people of nature, whose curiosity and friendliness had been shared with early explorers and pioneers and then displaced for years by their bellicose reaction to white intrusion, were depicted on canvases in their original state. Artists often reverted to the *Days of Long Ago* rather than the reality of reservation life.

After a total of five years' travel to European art centers, Henry F. Farny devoted his talents to creating images of a legend passed. This was no quick decision, for Farny did not venture west until the age of thirty-four, in 1881. That summer, stories of Sitting Bull's surrender appeared in most newspapers. Since the 1876 Battle of the Little Bighorn the Sioux chief and his small band of followers had eluded capture, rarely knowing a moment of peace yet loathing submission. Their Canadian refuge proved cold, the band was starving, and Sitting Bull's resolve weakened with tales that his daughter was being held hostage in chains. Upon surrender his poignant words must have stung many. "I do not come in anger toward the white soldiers. I am very sad. My daughter went this road. Her I am seeking. I will fight no more. I do not love war. I never was the aggressor. I fought only to defend my women and children. Now all my people want to return to their native land. Therefore I submit."[1]

That fall Farny headed west to see Sitting Bull at the Standing Rock Agency, Dakota Territory. Although the prisoner had been removed, the newcomer was intrigued by the scenery and native inhabitants which he encountered. "The plains, the buttes, the whole country and its people," he ardently declared, "are fuller of material for the artist than any country in Europe."[2] Farny returned to Cincinnati, his home, with more than memories. He had made sketches, taken photographs, and obtained a variety of Indian accouterments.

Neither from an ethnographic nor an illustrative vantage point did Farny choose to portray Indians. He placed them in their environment, where they were vital and important, not overwhelming and warlike, and he paid as much heed to the landscape as to the figures. In *Days of Long Ago,* the pacific state of the Indians is complemented by lacy trees, content animals, and the pastel hues of hillside and cliffs above. His works, usually in gouache or watercolor, like *Cheyenne Camp,* have a freshness, lightness, and balance between man and nature.

[1] Sitting Bull, 1881, quoted in Virginia Irving Armstrong, comp., *I have spoken* (Chicago, 1971), p. 126.
[2] Quoted in Robert Taft, *Artists and Illustrators of the Old West* (New York and London, 1953), p. 219.

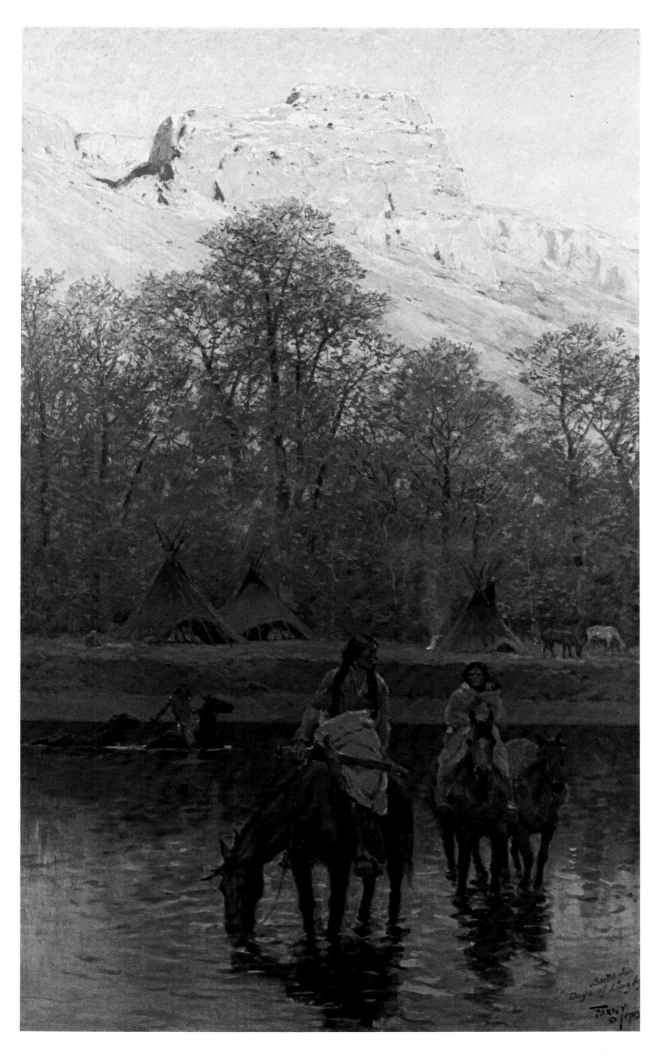

194. Henry F. Farny. *Days of Long Ago.* 1903. Oil on canvas, 36 x 22″. Buffalo Bill Historical Center, Cody, Wyo.

Henry F. Farny

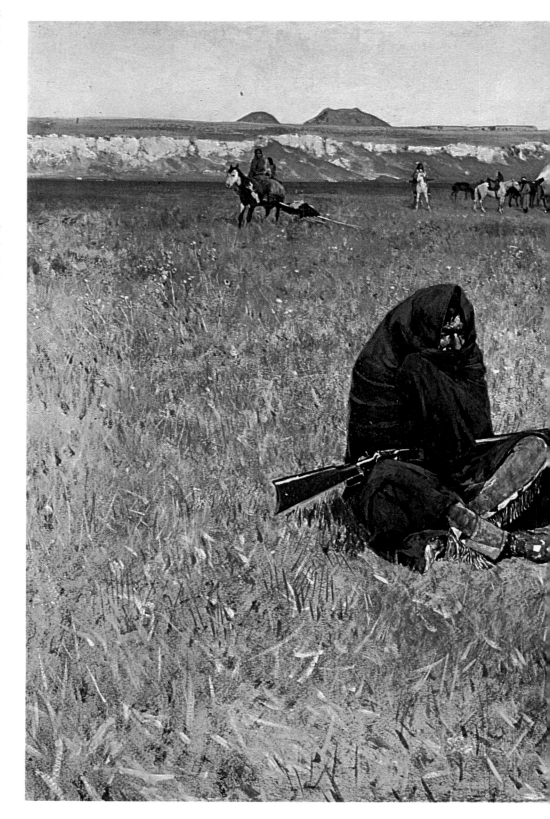

195. Frederic Remington. *Missing.* 1899. Oil on canvas, 29½ x 50″. Thomas Gilcrease Institute of American History and Art, Tulsa, Okla.

Marching across the Northern Plains in search of a lost scouting party, George A. Custer recalled the discovery of shod horse tracks covered with those from Indian ponies. For miles soldiers followed the trail, hoping for their comrades' deliverance, yet mistrusting their hopes and fearing the worst. "It was not death alone that threatened this little band. They were not riding simply to preserve life. They rode, and doubtless prayed as they rode, that they might escape the savage tortures, the worse than death which threatened them."[1] Their fears were met.

The Captive was labeled "The Prisoner" as an illustration in the February 13, 1886, edition of *Harper's Weekly.*[2] "This imaginative scene is excellently done," commented Robert Taft, adding that "if a realist were criticizing the painting he might observe that the prisoner, stripped of all clothes save his trousers, was treated with more consideration than was usually shown Indian captives. Farny, however, could not paint his captive in a state of complete nudity and expect to get the picture exhibited."[3]

The theme is unusual, for Farny typically avoided the gruesome side of Indian customs. He did, however, distract the viewer's attention and dichotomize the scene with his background of everyday events continuing regardless of the victim's discomfort. Men are gathered in front of a tepee talking, a rider drags a travois, while others mill about the village. The viewer is left with no hint of what preceded, though he is sure of the captive's ultimate fate.

Fourteen years later Frederic Remington explored a similar theme in his paintings. His extensive experience and travels with Western troops had engendered in the artist a deep respect for men who risked their lives patroling the West. An imprisoned soldier would be better dead than lead, as is the one in *Missing.* Indians acted on the premise that a released prisoner would return to attack them again, hence few survived. If possible, troopers would kill themselves rather than face a tortured captivity.

Remington and Farny lived during the zenith of sympathy for the Indian, the latter understanding and the former recoiling at the sentiments of Helen Hunt Jackson and her kind. Remington reviled, " 'Try to avoid bloodshed,' comes over the wires from Washington. 'Poor savages!' comes the plaintive wail of the sentimentalist from his place of security; but who is to weep for the men who hold up a row of brass buttons for any hater of the United States to fire a gun at? Are the squaws of another race to do the mourning for American soldiers? Are the men of another race to hope for vengeance? Bah!"[4]

[1] Gen. G.A. Custer, *My Life on the Plains* (New York, 1874), p. 76.
[2] *Henry F. Farny 1847–1916* (Cincinnati Art Museum, 1965), unpaged.
[3] Robert Taft, *Artists and Illustrators of the Old West* (New York and London, 1953), p. 223.
[4] Frederic Remington, *Pony Tracks* (New York, 1895), p. 48.

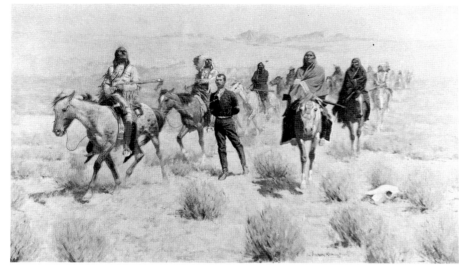

196. Henry F. Farny. *The Captive.* 1885. Watercolor, 22⅜ x 40⅛". Cincinnati Art Museum. Gift of Louise Fleischmann Tate and Julius Fleischmann

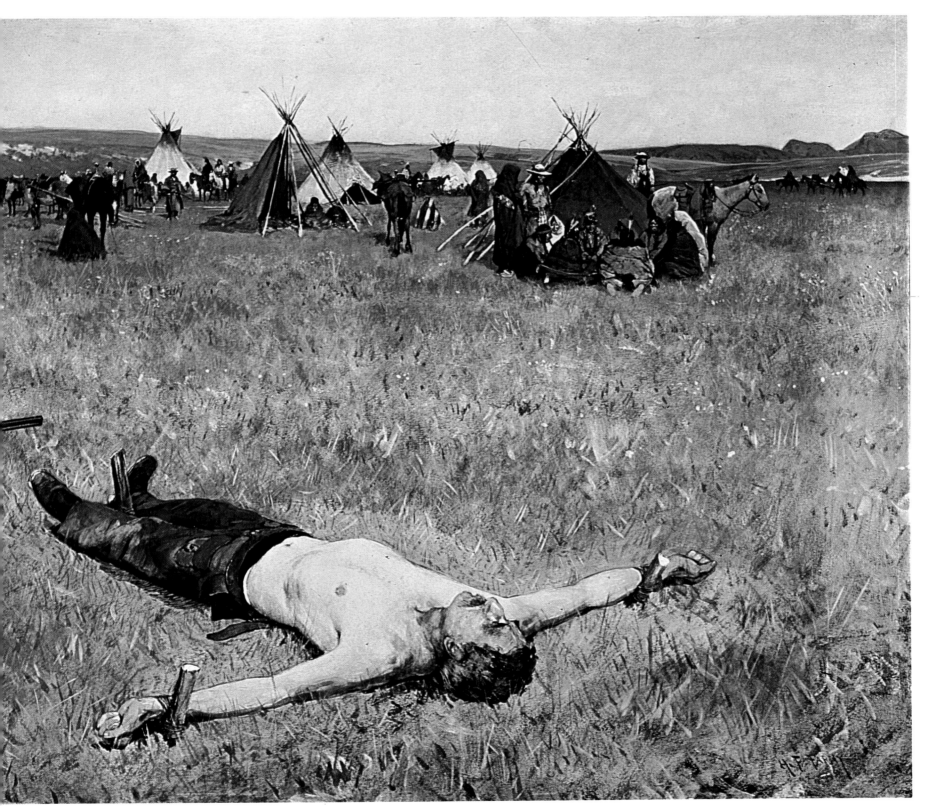

197. Sioux beaded buffalo robe. c. 1870. Buffalo hide and beads, 71½ x 92″. Denver Art Museum

198. Henry F. Farny. *The Song of the Talking Wire.* 1904. Oil on canvas, 22⅛ x 40″. The Taft Museum, Cincinnati

Farny gained his reputation as an Indian painter from the wide distribution of magazines containing his pictures. In search of material for his illustrations and studio collection, he made numerous trips east and west. The year following his 1881 visit to the Standing Rock Agency, Farny went to Washington, D.C., where he saw six Zuni visitors. The Indians had come to the capital because of Frank H. Cushing, an anthropologist who had lived with them and documented their traditions. This encounter resulted in Farny's illustrations for Cushing's subsequent magazine articles.

An excursion over the Northern Pacific Railroad in 1883 brought the artist his long-sought meeting with Sitting Bull and more periodical illustrations. For *Century Magazine* the artist went to Montana the next year,[1] and his last recorded trip west, the following year, was to Fort Sill, Oklahoma. "After the early 1890s Farny was little occupied with magazine illustration. He stayed mostly at home in Cincinnati where patronage was good. . . . Until his death in 1916, he continued to produce paintings on his favorite theme relying largely upon his Indian paraphernalia, live Indian models, and his keen memory."[2]

The detail and landscape of his later paintings continued as integral parts of the whole, while the scenarios were mostly drawn from his imagination. "In depicting the Indian he was sympathetic but realistic. In much of his work he seemed to take particular delight in portraying contrasts between civilizations."[3] Farny's contrasts translated into quiet statements rather than dramatic conflicts, as evidenced in *The Song of the Talking Wire*. The hunter has stopped in the midst of his trek home with provisions, his ear against a branchless tree, his brow furrowed. True, the red man had been awed by the novelties brought by progress, yet he was not alone in his reaction. Almost forty years before this scene, Albert D. Richardson had written, "the telegraph is a perpetual miracle. No familiarity however long, makes it prosaic."[4]

Farny's message, mildly prosaic itself, loses some impact because he cloaked the listener in a female's robe. Such geometric designs were painted and worn by married women. The Sioux painted hide robe, pictured separately, was created specifically for girls' puberty rites. Of a box-and-border variety, the adornment has a "succinctness of design and brilliant features like the . . . lozenge spots, contrasting with the highly controlled black box and pendant enclosures."[5] This hide had been collected by Prince Maximilian of Wied-Neuwied on his trip with Karl Bodmer, who used it in a portrait of a Sioux woman. Farny probably had the robe in *The Song of the Talking Wire* among his studio collection, unaware of its purpose.

[1] See Robert Taft, *Artists and Illustrators of the Old West* (New York and London, 1953), pp. 220–22.
[2] *Henry F. Farny 1847–1916* (Cincinnati Art Museum, 1965), unpaged.
[3] Taft, op cit., p. 224.
[4] Albert D. Richardson, *Beyond the Mississippi* (Hartford, Conn., 1869), p. 518.
[5] Ralph T. Coe, *Sacred Circles* (London and Bradford, 1976), p. 188.

Edward Borein

199. Edward Borein. *Crow Singers.* n.d. Etching, 5⅞ x 7⅞". Collection Katherine H. Haley, Ventura, Calif.

Edward Borein was one of a handful of early artists devoted to the Western scene who was actually born there. He grew up on a ranch in California and for the first half of his life applied his energies to ranch work and a restless wandering which took him through the Northern Plains and Rockies and deep into the Southwest.

Along with a devout affection for the West nurtured by his free life as a cowboy, Borein also fostered along the way a knack for drawing what he saw. Though the vigor of his draftsmanship always excelled his skill, Borein became known as a facile and spontaneous recorder of cowboy and Indian life.

It was not until he was thirty-four that Borein decided to pursue a career as a professional artist. Thus, in 1907 he picked up his belongings and moved to New York City. His Forty-second Street studio soon burgeoned with life, becoming the favorite haunt for other important Western figures such as Will Rogers, Charles Russell, and Joe DeYoung.

Although he later moved back to California, setting up a permanent studio in Santa Barbara, Borein's truest art lessons came from his Eastern ties. He had been a friend of Childe Hassam, and from this association and lessons taken at the Art Students League, Borein began to see light as an Impressionist. His watercolors and prints flickered with the patterns of sunshine and shadow. Forms even became sources of light in themselves, as seen in Borein's watercolor *Crow Medicine Man.* The Indians and their ponies radiate. The pictorial rhythms of their feathered lances and the broad washes of watercolor, which Borein commonly employed, embraced the very cadence of Indian life. The subtle flow of light and shade in his etching, *Crow Singers,* illustrates why Borein, above all else, is remembered today as a printmaker.

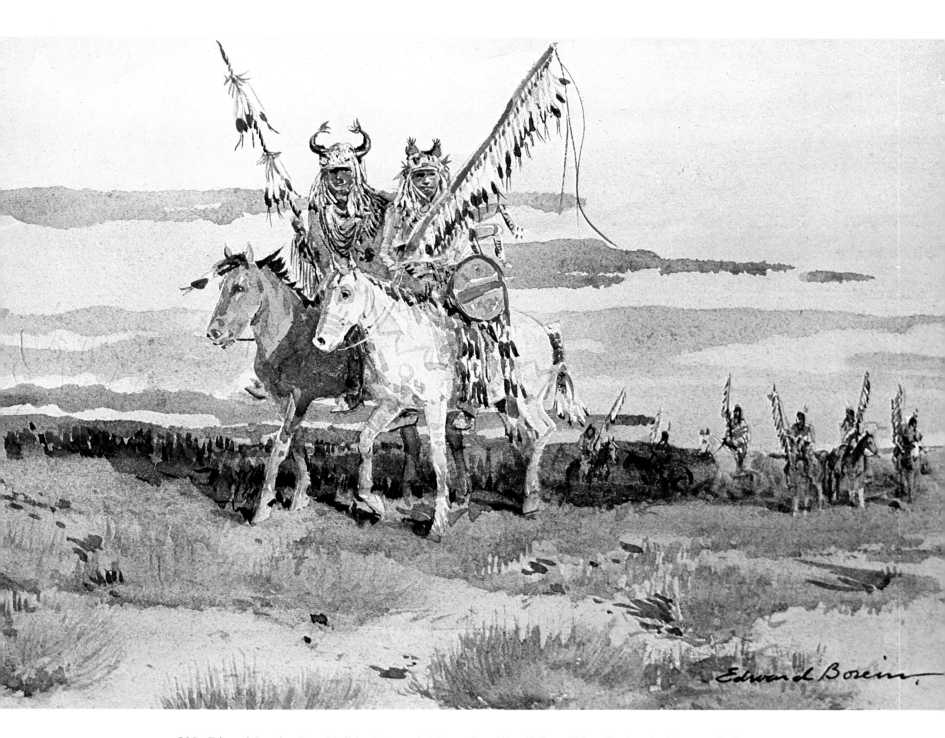

200. Edward Borein. *Crow Medicine Man.* n.d. Watercolor, 6⅜ x 8⅞″. Buffalo Bill Historical Center, Cody, Wyo. Gift of Mr. and Mrs. C. C. Moseley

Newell Convers Wyeth

In the 1925 Boston edition of Francis Parkman's *The Oregon Trail* appeared a vibrantly decorative illustration entitled *An Indian War Party*. It had been painted by Newell Convers Wyeth, the most revered and influential American illustrator of his day.

That Wyeth chose to illustrate the Parkman book is testament to its stature as a classic. Fifteen years before, the artist had vowed to remove himself from the grips of Western themes. "With five years of almost incessant work, mostly western in character, I have experienced a remarkable change. My ardor for the West has slowly, but with increasing impetus, been dwindling, until my desires to go there to paint its people are already lukewarm. The West appealed to me as it would to a boy; a sort of external effervescence of spirit seemed to be all that substantiated my work."[1]

Parkman was different, however. He had gone west "with a view of observing the Indian character. Having

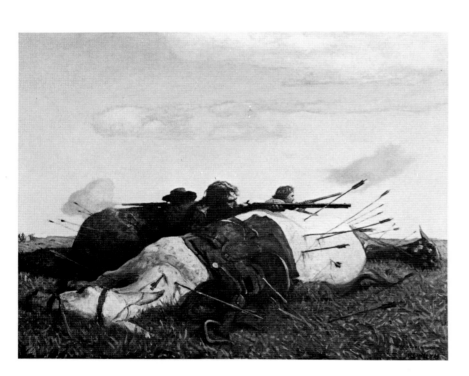

201. Newell Convers Wyeth. *A Fight on the Plains.* 1916. Oil on canvas, 32 x 40". Private collection

from childhood felt a curiosity on this subject, and having failed completely to gratify it by reading, I resolved to have recourse to observation."[2] Parkman's reports filled a great literary void, and Wyeth felt compelled to add his own interpretation. The original publication had been basically without illustration. In the 1892 Little, Brown, and Company edition, Frederic Remington had been engaged to provide pictures, and now in 1925 it was Wyeth's turn.

As Parkman described the scene, *An Indian War Party* was set not far from Fort Laramie.

We had a hint now and then that our situation was none of the safest; several Crow war-parties were known to be in the vicinity, and one of them, that passed here some time before, had peeled the bark from a neighboring tree, and engraved upon the white wood certain hieroglyphics, to signify that they had invaded the territories of their enemies, the Dahcotah, and set them at defiance. One morning a thick mist covered the whole country. Shaw and Henry [Chatillon] went out to ride, and soon came back with a startling piece of intelligence; they had found within rifle-shot of our camp the recent trail of about thirty horsemen. They could not be whites, and they could not be Dahcotah, since we knew no such parties to be in the neighborhood; therefore they must be Crows. Thanks to that friendly mist, we had escaped a hard battle; they would inevitably have attacked us and our Indian companions had they seen our camp.[3]

Wyeth took on few other Western assignments in the years after 1910. Those stories he did illustrate ranged from Helen Hunt Jackson to Buffalo Bill. Wyeth enjoyed the imagery of history, and one of his most telling pieces shows thirteen-year-old Buffalo Bill in his first Indian fight. The incident had taken place in 1885, only a decade after Parkman's experience. Again the scene was near Fort Laramie with the difference being that the Sioux were now the avengers rather than the Crow. To protect themselves, Cody and his companions had shot their mules and formed a barricade as a prelude to attack. "The Sioux drew up when they saw how quickly Simpson's wit had built a barricade for us. Then the arrows began to fly and among them spattered a few bullets. We were as sparing as possible with our shots. Most of them told. I had already learned how to use a rifle, and was glad indeed that I had. If ever a boy stood in need of that kind of preparedness I did."[4]

[1] *The Star* [Wilmington, Delaware], (January 23, 1910), quoted in Douglas Allen and Douglas Allen, Jr., *N.C. Wyeth* (New York, 1972), p. 53.
[2] Francis Parkman, *The California and Oregon Trail* (New York, 1849), p. 143.
[3] Ibid., pp. 150–51.
[4] Col. William F. Cody, "The Great West That Was," *Hearst's Magazine,* 30 (September, 1916), 197.

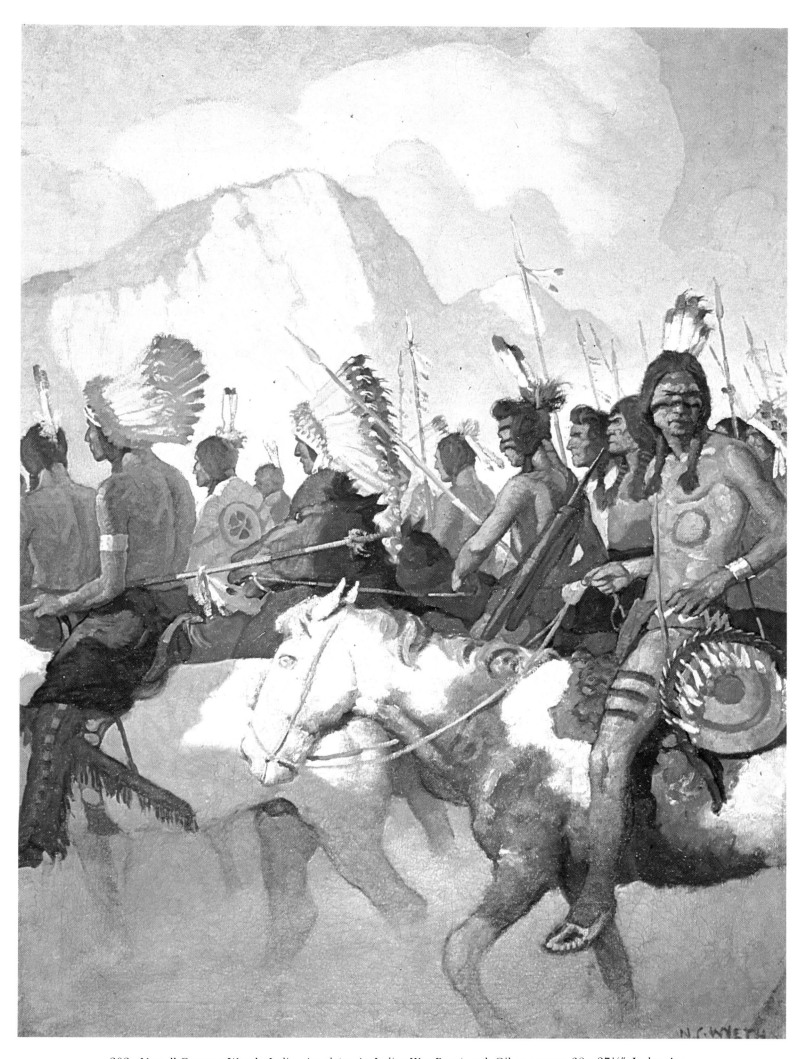

202. Newell Convers Wyeth. *Indian Attack* (or *An Indian War Party*). n.d. Oil on canvas, 38 x 27½". Joslyn Art
Museum, Omaha, Neb. Northern National Gas Company Collection

T he Red man was the true American
They have almost gon. but will never
be forgotten
The history of how they faught for
their country is written in blood
a stain that time cannot grinde
out
their God was the sun their Church
all out doors their only book
was nature and they knew all its pages
C M Russell[1]

Artists, answering the Western beckon, found the American native suitable to their palettes and persuasions. He was depicted in the role of noble savage, framed in portraits, shown helping and hindering white men, and finally

ennobled in the waning days of his freedom. The cycle completed itself.

Bacon's Western allegory was conceived while the artist studied in Munich from 1905–9 under Professor Heinrich Von Bügel, an animal and genre painter. With this background plus training at the Detroit Art School, Bacon hired out as a cartoonist for the *Detroit Free Press* and the *Detroit News*. In 1915 he joined the Ford Motor Company and became head of the photographic department, then head of art work there and also the personal artist for Henry Ford.

Conquest of the Prairie catapulted Bacon into prominence when it was given a place of honor at a 1922 exhibition at Munich's Glass Palace. His daughter Dorothy wrote that "Irving R. Bacon was a rapid and accurate painter, with such expert knowledge of color, design and anatomy &

203. Charles M. Russell. *The Last of His Race.* 1899. Pen and ink, 15 x 25¼". C. M. Russell Museum, Great Falls, Mont.

excellent memory that he was able to paint excellent portraits, landscapes and animal studies from memory and without models. . . . When we were children he amused us once by swiftly painting our portraits on our hands, which we proudly exhibited around the neighborhood."[2] She also states that Bacon journeyed with William F. Cody and executed many paintings for him. No record of this survives, yet *Conquest of the Prairie* did once hang in Buffalo Bill's Irma Hotel in Cody, Wyoming.

While Bacon simply adopted a theme for his canvas which conveys the passing of a way of life, Charles Russell lived through the transition and was profoundly affected. Although the medium of *The Last of His Race* and its cartoon-like effect are distractions from Russell's poignant message, he would have agreed with Francis Parkman's observation.

. . . Change has grown into metamorphosis. For Indian tepees, with their trophies of bow, lance, shield, and dangling scalp-locks, we have towns and cities, resorts for health and pleasure seekers, with an agreeable society, Paris fashions, the magazines, the latest poem, and the last new novel. The sons of civilization, drawn by the fascinations of a fresher and bolder life, thronged to the western wilds in multitudes which blighted the charm that lured them.[3]

[1] Charles M. Russell, "The Fighting Cheyennes," 1916, a letter in the William E. Weiss, Jr., Collection, Buffalo Bill Historical Center archives, Cody, Wyoming.
[2] Letter from Mrs. S.S. Robins (née Dorothy Bacon), June 3, 1973, in the Buffalo Bill Historical Center archives, Cody.
[3] Quoted in William R. Hodges, *Carl Wimar* (Galveston, 1908), p. 28.

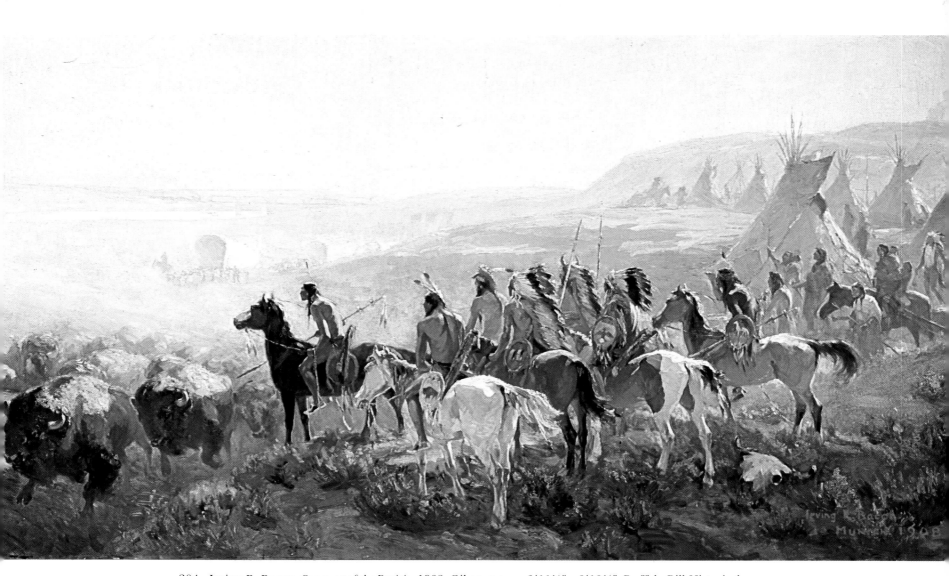

204. Irving R. Bacon. *Conquest of the Prairie*. 1908. Oil on canvas, 3′11¼″ x 9′10½″. Buffalo Bill Historical Center, Cody, Wyo. Gift of the Newells

Quiet

Passing

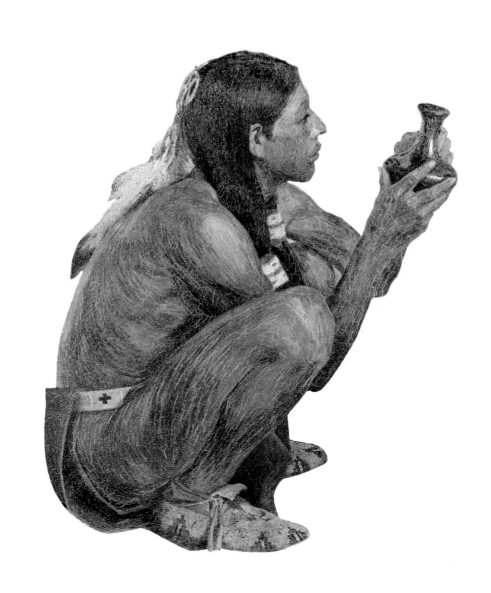

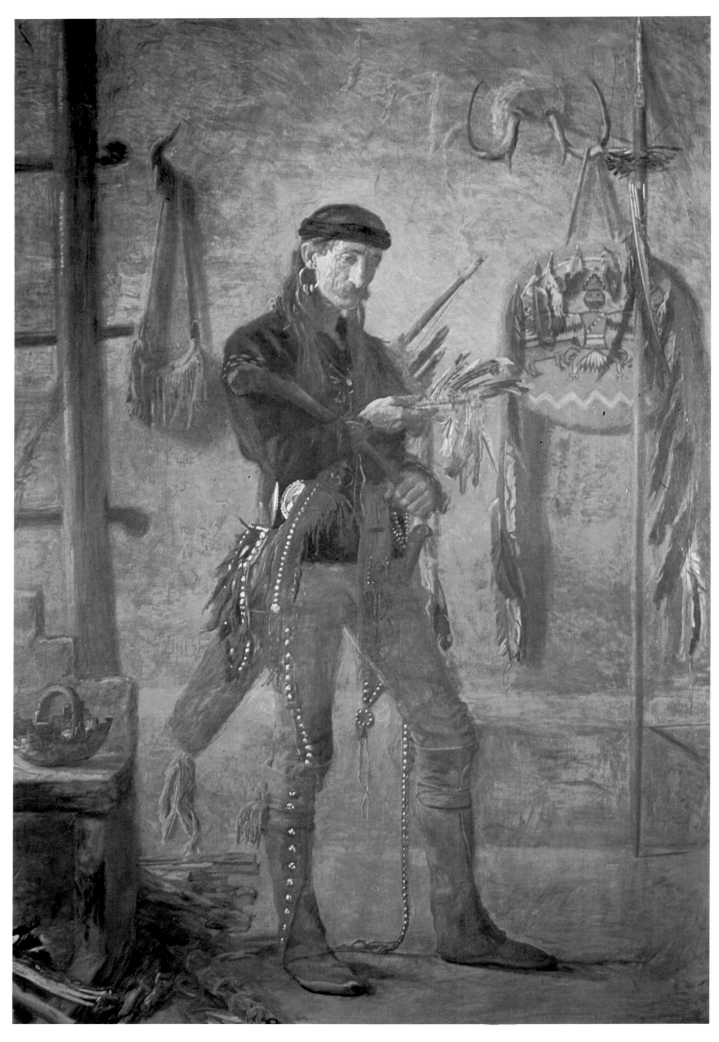

205. Thomas Eakins. *Frank Hamilton Cushing.* c. 1894. Oil on canvas, 90 x 60″. Thomas Gilcrease Institute of American History and Art, Tulsa, Okla.

The West meant many things to many artists. In the summer of 1887, when Philadelphia painter Thomas Eakins took up residence on a ranch in the Little Badlands of North Dakota, the West was a sanctuary—a place of spiritual refuge.

Eakins had just been dismissed as director of The Pennsylvania Academy of the Fine Arts, perhaps the most tumultous moment of his entire life. An escape from civilization and its restraints was mandatory.

Eakins revived in the Western milieu. He rode and sketched, and he learned something of the West as he tried to forget something of the East. When he returned to Philadelphia at summer's end, Eakins was rejuvenated. He had brought with him two ponies. Outfitted in full cowboy attire, he proudly rode home from the station, the perfect picture of a Western horseman.

The West never prevailed especially as a theme in Eakins's art, and he produced only a modest number of pieces directly related to his Dakota retreat. Of those, the several versions of a seated cowboy singer come closest to Eakins's normal *oeuvre. Home Ranch,* one of two oils of the subject, portrays Eakins's friend and fellow artist Franklin L. Schenck. He wears a buckskin suit from the wardrobe brought home by Eakins. This, allied with the disarray of a bunkhouse and the ranch hand in the background, helps create a feeling of Western life. Schenck was no Westerner but, properly accoutered, the part took on a convincing effect.

Eakins's most perceptive work of a Western subject dealt with the renowned ethnologist Frank Hamilton Cushing. Cushing had devoted his life to the West. He lived among the Zuni for five years, "being adopted into the tribe and initiated into the secret order of the 'Priesthood of the Bow.' "[1] He savored Zuni religion and myth, studying the people and their spirit with great empathy and reverence.

Eakins appropriately converted his studio into the interior of a Zuni house before setting to work on Cushing's portrait. The floors and walls are earth, a ladder allows entry to the scene, and an embellished shield highlights the wall behind. Cushing, gaunt and withdrawn in appearance, stares down at two Zuni fetishes. A dynamic scholar at twenty-three, he had written the definitive study on these emblems of Zuni spirituality;[2] now at thirty-four he seems interested only in the veil of memory.

Tragic possibility is written in Cushing's face, in an understanding that is beyond solace and in the emaciated figure of the man. He looks down, an anguish in his features, and a calm. It is a vision of the moral force of intellect inseparable from the tragic sense of life, and of an endurance that is both intellectual and physical, transcending both what is accidental to body and to individual experience. The man exists alone and in the broader experience of the age, expressing his reverence for a civilization being engulfed and destroyed in nineteenth-century America.[3]

[1] Lloyd Goodrich, *Thomas Eakins: His Life and Work* (New York, 1933), p. 185.

[2] See F.H. Cushing, *Zuni Fetishes* (Washington, D.C., 1883).

[3] Sylvan Schendler, *Eakins* (Boston, 1967), p. 138.

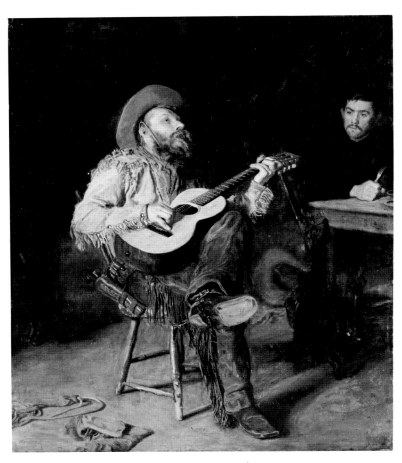

206. Thomas Eakins. *Home Ranch.* 1888. Oil on canvas, 24 x 20″. Philadelphia Museum of Art. Given by Mrs. Thomas Eakins and Miss Mary A. Williams

207. Thomas Eakins. *Cowboy at the B. T. Ranch, North Dakota.* 1887. Photograph. The Metropolitan Museum of Art, New York City. Gift of Charles Bregler, 1961

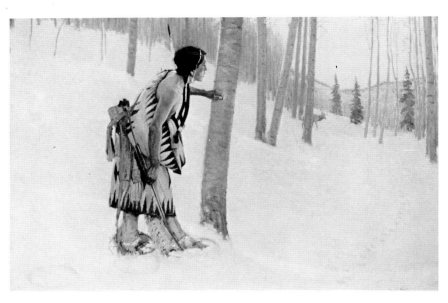

208. Bert Greer Phillips. *The Elk Hunter.* c. 1910. Oil on canvas, 28 x 40″. The Anschutz Collection, Denver

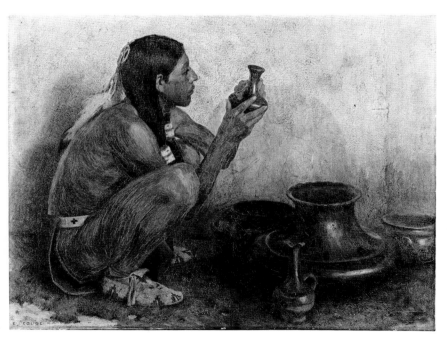

209. E. Irving Couse. *San Juan Pottery.* 1911. Oil on canvas, 36 x 45″. Detroit Institute of Arts. Gift of Mr. Charles Willis Ward

The Southwest—which so enthralled Frank Cushing—the pueblos, and the quiet, patterned life of the Indians there were not as new to art as they were to ethnology when he visited in the 1870s. For forty years New Mexico and Arizona, with their splendor and reserve, had played a role in American art. Nonetheless, it was not until a series of articles were written by Cushing for *Century Magazine* and illustrated by Henry Farny from John Hillers' photographs that Americans first opened their eyes on a popular level to the beauty of Southwest Indian life. Farny never went into the Southwest, but he helped spark an artistic flame which burned brightly for the next two generations.

The wave of artists who came to Taos and Santa Fe at the turn of the century were harbingers of a new sensibility toward the West. No longer was there concern for the fighting Indian, the reproach of the cavalry, or any of several glorified themes in the winning of the West. It was to the more aesthetic and cerebral elements of Western life that painters now turned, to the soul of things and to the picturesque.

Of this new group of painters, Joseph Sharp was something of a guiding light. He had made his first sketching trip to Santa Fe as early as 1883. And though he did not come to stay for another twenty-six years, he initiated the flow of artistic energy in that direction. He carried with him the bravura style of painting brought to American shores from Munich by Frank Duveneck. He was credited throughout his career for the ethnographic fidelity of his work; his friends even dubbed him "the anthropologist." Yet there was a true communion, a simple strength which gave his paintings a style and character of their own. Unlike other Taos painters, Sharp often depicted Plains Indian scenes, although his models were Pueblos. Such is the case with *Prayer to the Spirit of the Buffalo.*

Bert Phillips was the first artist to settle in Taos. He came to stay in 1898. For Phillips, the integral rhythm of Indian life with nature was foremost. In his painting *The Elk Hunter,* finished around 1910, Phillips establishes an emotional tableau for the countervailing forces of hunter and hunted. Designs in nature find repetition in the Indian's garment, attuned to their union of thought.

For E. Irving Couse such symbolism served to further the Indian image as a "fanciful and poetic ideal associated with the concept of man's goodness when existing in a state of primitive freedom."[1] A poetry of mood, a nostalgia without history, and a decorative formula into which Indian life was structured, controlled Couse's viewpoint. With paintings such as *San Juan Pottery,* Couse rose to tremendous popularity, though his style and expression changed little during the approximately thirty years he painted in Taos.

[1] Van Deren Coke, *Taos and Santa Fe* (Albuquerque, 1963), p. 14.

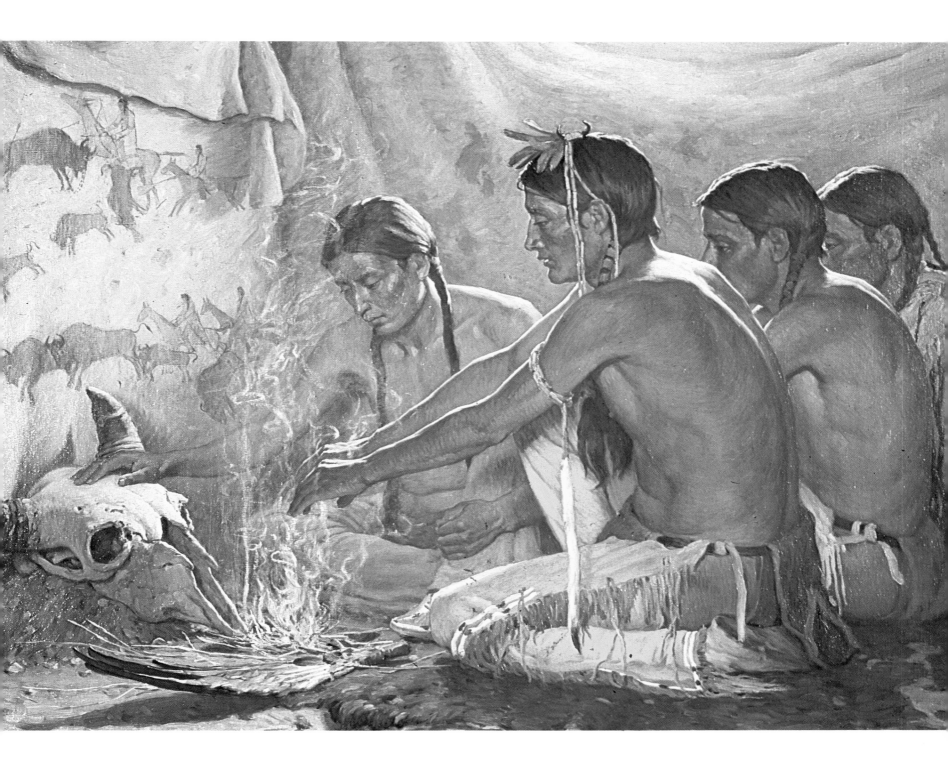

210. Joseph Sharp. *Prayer to the Spirit of the Buffalo.* c. 1920. Oil on canvas, 30 x 40″. Rockwell-Corning Museum, Corning, N.Y.

"The Taos painters, a group identifying themselves with the southwest country, have assiduously cultivated an Americanism having a . . . primitive picturesqueness," wrote Royal Cortissoz in the 1930s. "The field supplied by the Indian has been actively explored by E.L. Blumenschein, Walter Ufer, Victor Higgins and numerous companions. In substance the group has brought into American painting romantic motives studied against a notably vivid background."[1]

Remington, Russell, and others of their period had refused to sacrifice truth to grace. The Taos artists reversed the coin, extracting the pattern and chroma of Southwestern life for their painterly qualities. The change was not so much the result of an influx of new artists with new sensibilities, but rather came gradually with time and a newly awakened national focus on the beauty instead of the bellicosity of Indians. Ernest Blumenschein, who eventually became the creative leader of the Taos artists, first arrived in the region in 1898 as an illustrator for *McClure's Magazine*. A year later, one of these illustrations, entitled *The Advance of Civilization in New Mexico — the Merry-Go-Round Comes to Taos,* appeared in *Harper's Weekly.*[2]

Some have suggested that the artists' attraction to Taos and Santa Fe evolved because the Pueblos, unlike the Plains Indians, had been left relatively unchanged by the tumultuous events of the nineteenth century. The caption which accompanied Blumenschein's illustration of the merry-go-round would suggest a fallacy in this thought.

> Mr. Blumenschein's picture on the front page of this number of the WEEKLY represents the result of the first stage in the effort of a paternal government to make good Indians by other than the time-honored process of weighting them with lead. No descriptive text can convey the good that results from the government's Indian schools throughout the country so well as a glance at the contrast between the primitive native and the neat, tidy children returning to the ancestral palace. Original sin may be ineradicable, but education seems in a fair way to remove the aboriginal kind from our first instalment [*sic*] of the "white man's burden."[3]

The Indians in the Southwest were approachable and picturesque. Artists were equipped to deal with what they saw there, but were unwilling to confront the squalor and disillusionment of the Northern reservations. Joseph Sharp had tried living in both worlds for several years. In 1909 he gave up Montana and moved to Taos.

By the end of the first decade of the twentieth century, Taos was an established though young regional colony for artists. They sought, as Blumenschein did, "the richer values of creative form," transforming them into "fascinating realms animated by imaginative, complicated rhythms with design asymmetrical or subtly balanced, and color as rich as the earth of old Spanish and Indian civilizations."[4]

In Martin Hennings's *Passing By* is seen the transition of Taos expression from illustrative to painterly. The figures are still self-imposing on the landscape. The giant cottonwood backdrop, however, is stylized into sensuous pattern which skillfully weaves the Indian into his environment.

By the time Victor Higgins painted his *Pueblo of Taos,* around 1927, the Indian had become a purely decorative motif. In this painting Higgins demonstrates almost exclusive concern for figure-space relationships. "Moving beyond the Indian figures in the foreground, he tends to deemphasize personalities in favor of objects' relationships to one another. Rows of Indians are reduced to rapid strokes of color in the middle and background. They assume their positions in and around the Pueblo creating a tightly woven pattern of shapes that moves fluidly into the distant mountains."[5]

211. Ernest Blumenschein. *The Advance of Civilization in New Mexico—Merry-Go-Round Comes to Taos.* 1899. Duotone. General Research and Humanities Division, New York Public Library, New York City. Astor, Lenox, and Tilden Foundations

212. Victor Higgins. *Pueblo of Taos.* Before 1927. Oil on canvas, 43¾ x 53½". The Anschutz Collection, Denver

[1] Samuel Isham and Royal Cortissoz, *The History of American Painting* (New York, 1936), p. 575.
[2] *Harper's Weekly,* 43 (June 17, 1899).
[3] "The Wards of the Nation," *Harper's Weekly,* 43 (June 17, 1899), 609.
[4] Howard Cook, "Ernest L. Blumenschein, The Artist in His Environment," *New Mexico Quarterly Review* (spring, 1949), 18.
[5] Dean A. Porter, *Victor Higgins* (The Art Gallery of the University of Notre Dame and the Indianapolis Museum of Art, 1975), p. 12.

Martin Hennings

213. Martin Hennings. *Passing By.* c. 1924. Oil on canvas, 49 x 44″. The Museum of Fine Arts, Houston. Gift through the Ranger Fund, National Academy of Design

Frank Tenney Johnson

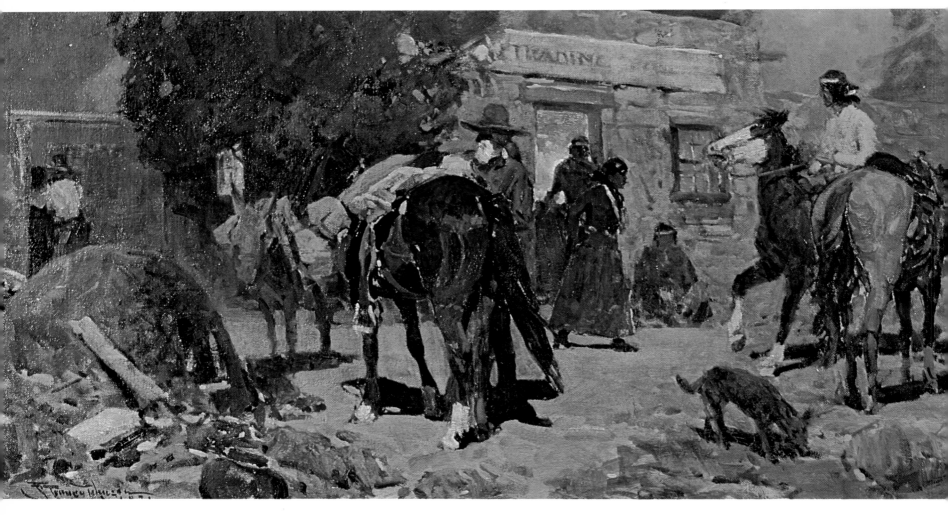

214. Frank Tenney Johnson. *Old Indian Trading Post.* c. 1921. Oil on canvas, 46 x 18″. Texas American Bank, Dallas

Just before nightfall, a pale glow is cast over objects, a glow that has beguiled and challenged many painters. Stars dot a rich, blue-green sky, while the light from fires takes on a warm, golden hue. The brightness of the day becomes muted, and once definite outlines merge gently into shadows.

There is a fine old picturesque trading post here, where the Navajos are constantly coming and going, particularly at night, They do a lot of their traveling in across the desert at night, to avoid the intense desert heat during the daytime. But seeing these people in the moonlight or even the magic light of just the stars has impressed me very deeply. What paintings I can make of some of the scenes around the trading post.[1]

Frank Tenney Johnson's words illuminate the depth of his feelings for the Southwest—the Indians, their life-styles, and their environment. The earth colors of the Navajos blended with his palette and their daily activities complemented his choice of theme. Johnson recorded the particular experience which inspired *Old Indian Trading Post.* "Indians and ponies and colts are all around this place. These Indians come from way back in the desert, and they are very friendly toward me. . . . In the evening I went to the trading post, just to watch the Navajos come and go."[2]

Old Indian Trading Post was executed almost fifteen years after Johnson's first sketching trip to the West. With encouragement from his bride, Vinnie Reeve Francis, Johnson traveled west with great anticipation and modest resources. The venture proved worthy of the sacrifice, for

215. Frank Tenney Johnson. *Madonna of the Desert.*
1933. Oil on canvas, 36 x 28″. Texas American
Bank, Dallas

Johnson became a portrayer of Western scenes and a frequent visitor to the area.

Two important figures in American art influenced Johnson. His early career included five months in New York City with John Henry Twachtman at the Art Students League. Twachtman was a member of the Ten American Painters, a group that rebelled against European dominance in Impressionism and exhibited together in 1898. "Twachtman was the most delicately sensitive of the group . . . always with a feeling for grace, for variations and contrasts of time."[3] Later Johnson returned to join Robert Henri's classes at the New York School of Art. Royal Cortissoz described Henri as "of the tribe of Manet, leaving imaginative picture making to other hands and contenting himself with the deft registration of the thing seen. . . .

Travelling much, he has portrayed any number of racial physiognomies. The ebullience of life is in them."[4]

Johnson's concentration on boldly silhouetted figures, which connotes a sympathy for the human element, and his painterliness are traits acquired from Henri. *Madonna of the Desert* contains a sensitivity and employs a palette similar to Twachtman's.

[1] Frank Tenney Johnson, quoted in Harold McCracken, *The Frank Tenney Johnson Book* (Garden City, N.Y., 1975), p. 94.
[2] Ibid., pp. 94–95.
[3] Samuel Isham and Royal Cortissoz, *The History of American Painting* (New York, 1936), p. 453.
[4] Ibid., p. 576.

Maynard Dixon

216. Maynard Dixon. *Earth Knower.* 1931. Oil on canvas, 40 x 50″. The Oakland Museum, Calif. Gift of Mr. Abilio Reis

In 1891, sixteen-year-old Maynard Dixon had written Remington for advice. He sent some sketchbooks for critique and posed the question of how best to proceed with an artist's career. Remington, impressed with the young man's forthrightness, responded at some length. "I do not 'teach,'" he concluded, "and am unused to giving advice—The only advice I could give you is to never take anyone's advice, which is my rule."[1]

Nonetheless, Dixon accepted much good counsel during his early years. He befriended and traveled with Edward Borein, established a close rapport with Western savant Charles Lummis, and absorbed a whole world of artistic influences working as an illustrator in New York City from 1907 to 1912. Dissatisfaction came with the arbitrary demands of editors who wanted Dixon to portray the West of infamy and violence which the artist had neither experienced nor desired to imagine. In 1912 he determined to come home to California. "I am being paid to lie about the West," he wrote Lummis. "I am going back home where I can do honest work."[2]

From this date Dixon bloomed as an artist. His evocative painting of 1915, *The Medicine Robe,* is a highly personal yet totally successful adaptation of Post-Impressionist tenets. In this picture are seen the spacing and formality of Puvis de Chavannes and the bravura brushwork of Pissarro. The Indian offered an ornamental motif and a vehicle for expressing inner meaning. Backlighted against a tawny sky, the wearer of the robe, the rock, the sage, and the grass are as one, cut from the same fabric and aglow with a uniform radiance.

After 1915 Dixon's style underwent a transformation. He began looking to the West for the breadth of its unfolding forms and the simplicity of the pictorial impulse it conjured up in an artist's mind. *Earth Knower* embodies these newly awakened perceptions.

My object has always been to get as close to the real thing as possible—the people, animals and country. The melodramatic Wild West idea is not for me the big possibility. The more lasting qualities are in the quiet and more broadly human aspects of Western life. I am to interpret from the most part the poetry and pathos of life of Western people seen amid the grandeur, sternness and loneliness of their country.[3]

Dixon was proof that trends similar to those germinated in Taos were found in equal force in other areas of the West.

[1] Letter from Frederic Remington to Maynard Dixon dated September 31, 1891, in the collection of Bob Rockwell, Corning, N.Y.
[2] Letter from Maynard Dixon to Charles Lummis dated January 6, 1912, in the collection of the Southwest Museum, Los Angeles.
[3] Wilbur Hall, "The Art of Maynard Dixon," *Sunset Magazine* (January, 1921), 44–45.

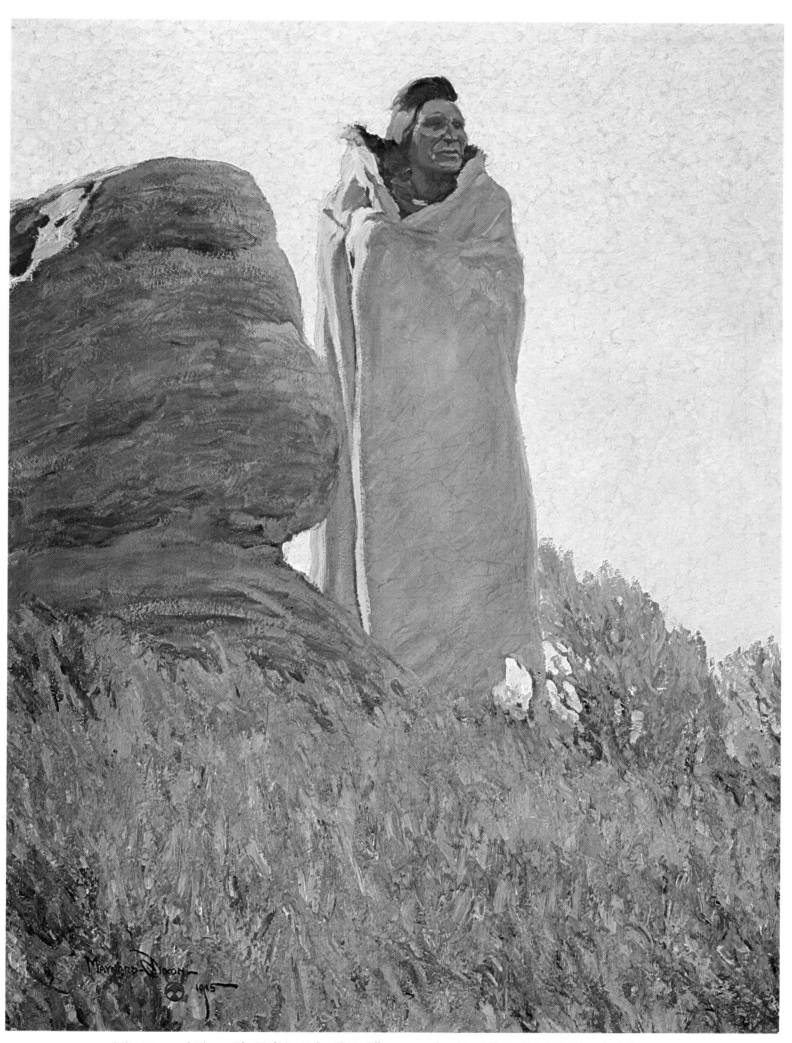

217. Maynard Dixon. *The Medicine Robe.* 1915. Oil on masonite, 40 x 30″. Buffalo Bill Historical Center, Cody, Wyo. Gift of Mr. and Mrs. Godwin Pelissero

218. Cyrus Dallin. *The Medicine Man.* 1899. Bronze, height 96″. Fairmount Park Commission and Fairmount Park Art Association, Philadelphia

Cyrus Dallin

There is no salutation implied, no greeting or welcome connoted in the formal gesture of Cyrus Dallin's *Medicine Man*. Instead, the simple and elegant figure, arm raised and hand extended, signals a warning against the vitiations of the white man, his sense of place, need, and time. There is little adornment and little action to detract from the purity of Dallin's statement, no embellishments to limit its power. His Crow visionary is statuesque and monumental, two characteristics which have solidified its expression in the minds of all who have cared to see beyond its patina.

Almost five years before Dallin dedicated *The Medicine Man,* Judge Lambert Tree presented to the city of Chicago another of Dallin's heroic Indian figures, *Signal of Peace.* It was, according to Judge Tree, too late to preserve the Indians themselves. The recognition of their greatness in works of art was atonement of sorts.

I fear the time is not far distant when our descendants will only know through the chisel and brush of the artist these simple, untutored children of nature who were, little more than a century ago, the sole human occupants and proprietors of the vast northwestern empire of which Chicago is now the proud metropolis. Pilfered by the advance-guards of the whites, oppressed and robbed by government agents, deprived of their land by the government itself, with only scant compensation, shot down by soldiery in wars fomented for the purpose of plundering and destroying their race, and finally drowned by the ever westward tide of population, it is evident there is no future for them except as they may exist as a memory in the sculptor's bronze or stone and the painter's canvas.[1]

For such national propitiation and, no doubt, the rewards other than redemption which naturally befell the sculptor, Dallin began modeling *The Medicine Man* in Paris during 1898. The French called it *l'Apothicaire* when it found a place among the entries of the Salon the next year.[2] The bronze was dedicated and permanently placed in Philadelphia's Fairmount Park in 1903 and has since been considered Dallin's finest work.

[1] William Howe Downes, "The Field of Art," *Scribner's Magazine,* 57 (June, 1915), 781.
[2] See Rell G. Francis, *Cyrus E. Dallin: Let Justice Be Done* (Springville, Utah, 1975), pp. 40–41.

219. James Earle Fraser. *End of the Trail.* c. 1918. Bronze, height 33¾″. Buffalo Bill Historical Center, Cody, Wyo.

James Earle Fraser

In the late 1800s, while science continued its debate with religion, an uneasy America hosted a rebirth of religious and governmental building projects and monumental art. In this milieu was an intellectual group of friends, centered around Henry Adams, a pessimistic philosopher, and including muralist John La Farge and sculptor Augustus Saint-Gaudens. Saint-Gaudens became the mentor of James Earle Fraser.

As a boy Fraser had modeled figures out of chalkstone from a nearby quarry, won art awards in public school, and studied with a sculptor. His father, a draftsman, wanted Fraser to pursue the same vocation, but yielded to his son's requests. While attending the Chicago Art Institute, Fraser visited the World's Columbian Exposition of 1893, where he saw a grand exhibit of sculpture. Of several artists who had used figures from the West as themes was Cyrus Dallin, whose *Signal of Peace* featured an Indian astride a horse.

Determined that Paris would best serve his potential, Fraser began his studies there in 1894. Four years later he entered a model of *End of the Trail* in an American Art Association competition and won an award.[1] One of the judges was Augustus Saint-Gaudens, with whom Fraser returned to the United States in 1900 and for whom he worked for four years.

A monumental plaster version of *End of the Trail* was exhibited in 1915 at the Panama-Pacific International Exposition in San Francisco. It received a gold medal, and subsequently the motif was reproduced on everything from ashtrays to bookends. Fraser appreciated the sculpture's fame, yet admitted his ignorance of the affair. "I have been told more than $250,000 worth of prints and photographs were sold of the statue. Who got the money, I don't know. I do know I didn't get any of it. As a matter of fact, everyone knew of the statue, but no one seemed to know its sculptor. I'm afraid I was too busy to take advantage of how much it was liked."[2] That people know the work but not its creator persists to this day.

While efforts to have the heroic sculpture cast in bronze proved vain until recently,[3] Fraser finally decided in 1918 to capitalize on the popularity of *End of the Trail* and rendered his own versions in sizes from miniature to three-quarter life. A mature and successful artist, Fraser had not forgotten his early days.

Moving from Minnesota to the Dakota Territory at the age of four, Fraser and his family found themselves in the midst of a transitional West. Indians dwelled in the area, along with white settlers, railroad crews, and soldiers.

> . . . I lived in the Indian country of Dakota, in the land that belonged to the Indians, and I saw them in their villages, crossing the prairies on their hunting expeditions. Often they stopped beside our ranch house; and camped and traded rabbits and other game for chickens. They seemed very happy until the order came to place them on reservations. One group after another was surrounded by soldiers and herded beyond the Missouri River. I realized that they were always being sent farther West, and I often heard my father say that the Indians would some day be pushed into the Pacific Ocean.[4]

The Dakota experience remained vivid in Fraser's memory and emerged in his sculptural eulogy to the American Indian, *End of the Trail*.

[1] *Kennedy Quarterly,* 5 (May, 1965), 223, and Dean Krakel, *End of the Trail* (Norman, Okla., 1973), p. 17.

[2] Fraser's memoirs, quoted in Krakel, op. cit., pp. 5–6.

[3] See Krakel, op cit., for the complete story of its restoration and installation at the National Cowboy Hall of Fame and Western Heritage Center, Oklahoma City.

[4] Quoted in Martin Bush, *James Earle Fraser, American Sculptor: A Retrospective Exhibition of Bronzes from Works of 1913 to 1953* (Kennedy Galleries, New York, 1969), p. 7.

A Painter's

World

Georgia O'Keeffe

220. Georgia O'Keeffe. *Light Coming on the Plains.* 1917. Watercolor, 11⅞ x 8⅞″. Courtesy of Georgia O'Keeffe. Amon Carter Museum, Fort Worth

The evolution of a free and completely individual style of art embodied in the expression of Georgia O'Keeffe provides one of the richest, most exhilarating chapters in the history of American art. Her vision was tantamount to nature, the symbol of beauty extracted in pure form and presented in highly personal terms. Reality and abstraction became one, lyrical yet precise melodic incantations of the corporeal.

In her mid-twenties, O'Keeffe spent four years as an art teacher in the Panhandle of Texas. Not many artists have found inspiration on that table of barren earth, but for O'Keeffe it was cathartic. "That was my country," she told a friend, "terrible winds and a wonderful emptiness."[1] She later recalled, "I couldn't believe Texas was real. When I arrived out there, there wasn't a blade of green grass or a leaf to be seen, but I was absolutely crazy about it. There wasn't a tree six inches in diameter at that time. For me Texas is the same big wonderful thing that the oceans and the highest mountains are."[2]

Few earlier artists had viewed the prairies as a thing of stirring beauty. Until O'Keeffe, perhaps T. Worthington Whittredge was alone in his observation. "I had never seen the plains or anything like them. They impressed me deeply. I cared more for them than for the mountains. . . . Whoever crossed the plains at that period, notwithstanding its herds of buffalo and flocks of antelope, its wild horses, deer and fleet rabbits, could hardly fail to be impressed with its vastness and silence and the appearance everywhere of an innocent, primitive existence."[3]

O'Keeffe's watercolors, *Evening Star No. III* and *Light Coming on the Plains,* were produced during her stay in the Panhandle. From these Texas sources came both an expression of personal mood and identification of the emblematic essence of place. Here was the genesis of modernism in the art of America's West, spawned in physical desolation from a fertile imagination.

[1] Quoted in Lloyd Goodrich and Doris Bry, *Georgia O'Keeffe* (New York, 1970), p. 9.
[2] Quoted in Pat Trenton, *Picturesque Images from Taos and Santa Fe* (Denver Art Museum, 1974), p. 162.
[3] Worthington Whittredge, *The Autobiography of Worthington Whittredge, 1820–1910* (New York, 1969), p. 45.

221. Georgia O'Keeffe. *Evening Star No. III*. 1917. Watercolor, 9 x 11⅞". Courtesy of Georgia O'Keeffe. The Museum of Modern Art, New York City. Mr. and Mrs. Donald B. Straus Fund

Georgia O'Keeffe

222. Marsden Hartley. *El Santo.* 1918–19. Oil on canvas, 36 x 32". Museum of New Mexico, Santa Fe

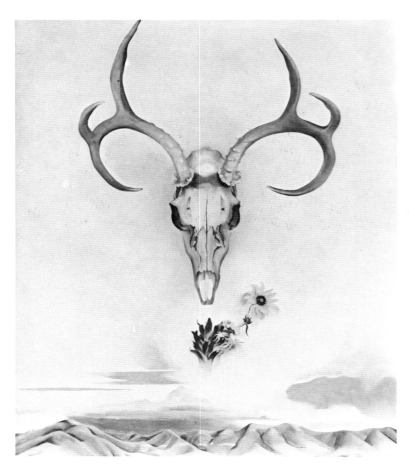

223. Georgia O'Keeffe. *Summer Days.* 1936. Oil on canvas, 36 x 30". Courtesy of Georgia O'Keeffe

Two of America's artistic avant-garde visited New Mexico in the years before 1920. Georgia O'Keeffe passed through for the first time in 1917 while on vacation with her sister, Claudia. Marsden Hartley arrived a year later with serious intentions; he came on assignment from a New York art dealer, Charles L. Daniel.

As early as 1915, while studying the dictates of German Expressionism in Europe, Hartley had found inspiration in Indian motifs and the West, neither of which he had yet witnessed firsthand. Now in New Mexico he succumbed to the impact of that unique land and light. None of the artists around him could capture the tenor of this land's emotion, the vital symbolism of its dwellers. It was simply because to him they were ill-equipped. "Of all the painters who 'commute' from the Atlantic and Pacific toward the valley of the Rio Grande," he wrote in 1918, "not one of them goes further than badly digested impressionism."[1] In a series of boldly conceived landscapes and symbolic, Cézannesque still lifes, Hartley pioneered the New Mexican scene as a studio for artists whose vision looked forward rather than backward. In a painting such as *El Santo,* Hartley "was influenced by the direct and yet mysteriously fragile quality of the *santos* he found in New Mexico, their meaning, as well as their flat design arrangements and raw color, had attraction for him."[2]

Georgia O'Keeffe returned to New Mexico in 1929 at the invitation of Mabel Dodge Luhan. She found a world in sympathy with the vigor of her generative expression. The earth-formed churches and somber crosses, the rolling hills and deep-cut arroyos provided her with a landscape so personally adaptable that it was as if no one else had seen it before her.

In 1931 she began to look beyond the land, to paint the animals of the desert floor, or, more precisely, their bones. She filled her canvases with their skulls, antlers, and skeletal fragments. In 1939, before moving permanently to New Mexico, she wrote,

> I have wanted to paint the desert and I haven't known how. I always think that I can not stay with it long enough. So I brought home the bleached bones as my symbols of the desert. To me they are as beautiful as anything I know. To me they are strangely more living than the animals walking around—hair, eyes and all with their tails switching. The bones seem to cut sharply to the center of something that is keenly alive on the desert even tho' it is vast and empty and untouchable—and knows no kindness with all its beauty.[3]

[1] Marsden Hartley, "America as Landscape," *El Palacio,* 5 (December, 1918), 340.

[2] Van Deren Coke, *Taos and Santa Fe* (Albuquerque, 1963), p. 51.

[3] Quoted in Lloyd Goodrich and Doris Bry, *Georgia O'Keeffe* (New York, 1970), p. 23.

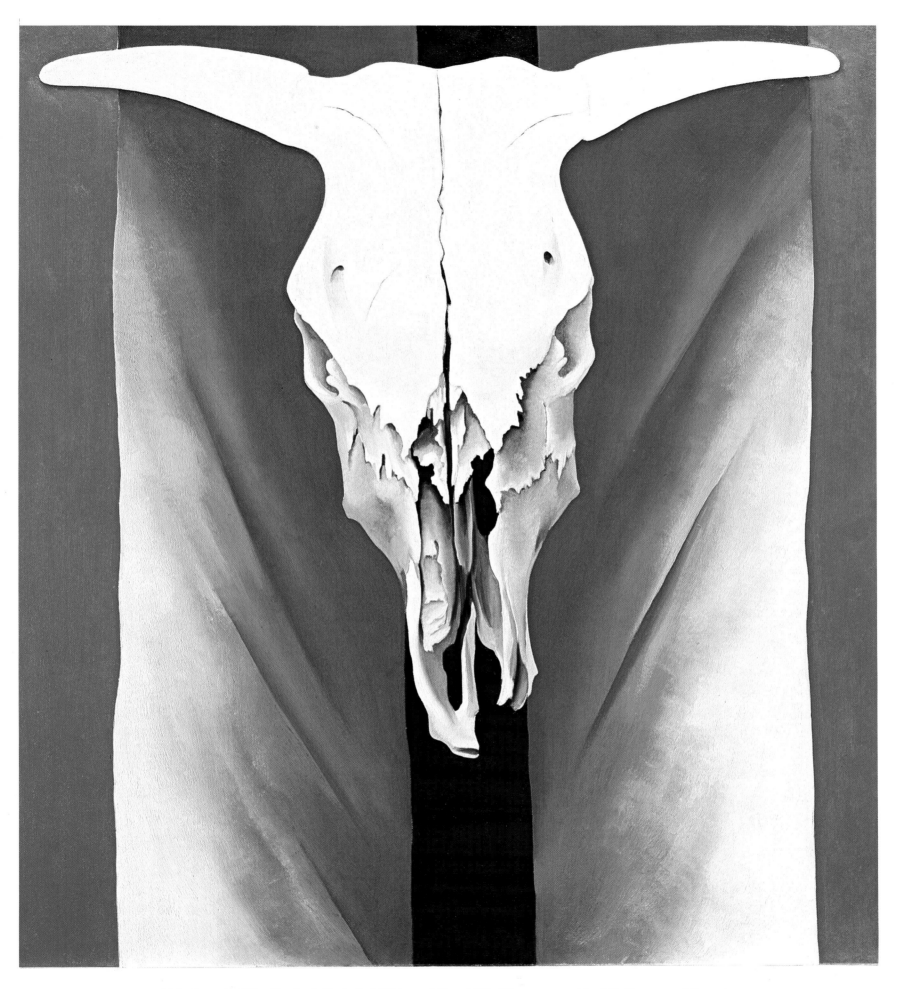

224. Georgia O'Keeffe. *Cow's Skull: Red, White, and Blue.* 1931. Oil on canvas, 40 x 36″. Courtesy of Georgia O'Keeffe. The Metropolitan Museum of Art, New York City. The Alfred Stieglitz Collection, 1949

John Marin

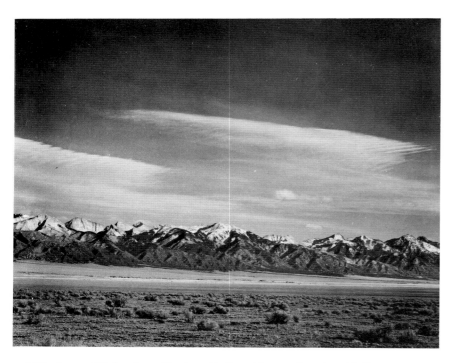

225. Laura Gilpin. *Great Northern Skyline of Sangre de Cristo.* 1945. Silverprint. Collection Laura Gilpin, Santa Fe

John Marin, at the age of sixty, came west to New Mexico for the first time with O'Keeffe in 1929. His staccato, flamboyant watercolor technique was already the trademark of a mature style, but New Mexico was new and exciting for him. In his ordered, architectonic view, the mountains, sky, and earth furnished contradiction and conflict on which his art thrived. The year before, he had written prophetically,

> Seems to me the true artist must perforce go from time to time to the elemental big forms—Sky, Sea, Mountain, Plain,—and those things pertaining thereto, to sort of re-true himself up, to recharge the battery. For these big forms have everything. But to express these, you have to love these, to be a part of these in sympathy. One doesn't get very far without this love, this love to enfold too the relatively little things that grow on the mountain's back. Which if you don't recognize, you don't recognize the mountain.[1]

For as divorced as Marin's work is thought to be from real things, he always relied on observation of nature. "He had no patience with any kind of art that had its origin within the mind without reference to the outside world. As a rule when he attempted to explain his work, he spoke of subject matter and his subjective reaction to it."[2] New Mexico was such a vitally real place that it even shocked Marin. "All my pictures this year will have labels tagged to them," he wrote his friend Paul Strand that summer. "This is so and so mountain I'd have you understand, and is, I'd have you understand, so and so feet high. Yes, all labeled with explanations like a *map*. That's the only way I know of, of getting by with this *dogoned* [sic] country."[3]

Not many artists agreed with Marin's style of interpretation. "Mr. Blumenschein offered me twenty-five dollars for one of my—dribbles," Marin wrote Alfred Stieglitz. "Truth demands that I amend the above by his saying that if he had the twenty-five in his pants at the time."[4] No one contested the splendor in what he painted. The grand outline of the Sangre de Cristos which appears in his watercolor *Near Taos, No. 6* inspired all who came into their shadow. Photographer Laura Gilpin knows well the contours of this magnificent land.

[1] John Marin, "John Marin, By Himself," *Creative Art* (October, 1928), quoted in Dorothy Norman, ed., *The Selected Writings of John Marin* (New York, 1949), p. 127.
[2] Larry Curry, *John Marin, 1870–1953* (Los Angeles, 1970), p. 17.
[3] Norman, op cit., p. 128.
[4] Ibid., p. 131.

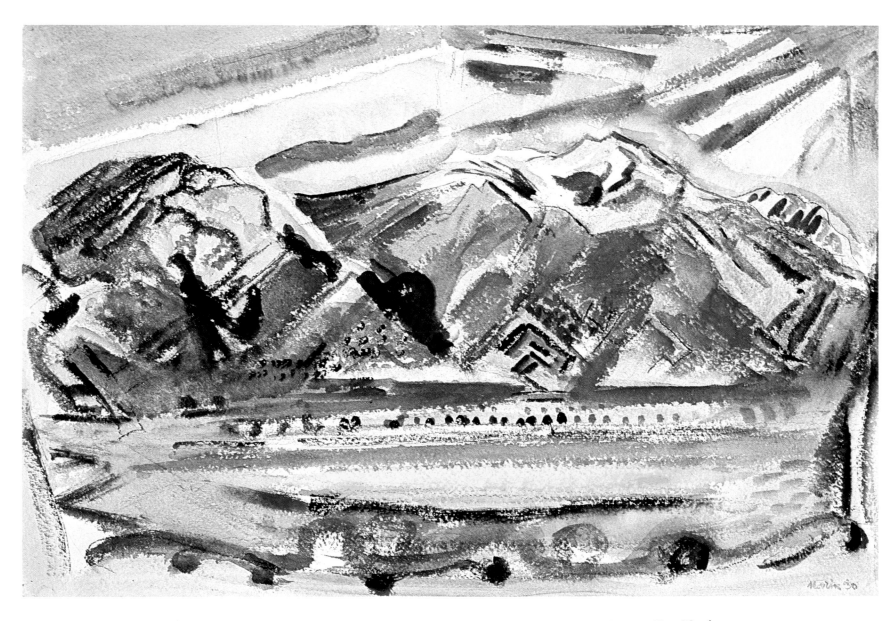

226. John Marin. *Near Taos, No. 6*. 1930. Watercolor, 15¼ x 22″. Amon Carter Museum, Fort Worth

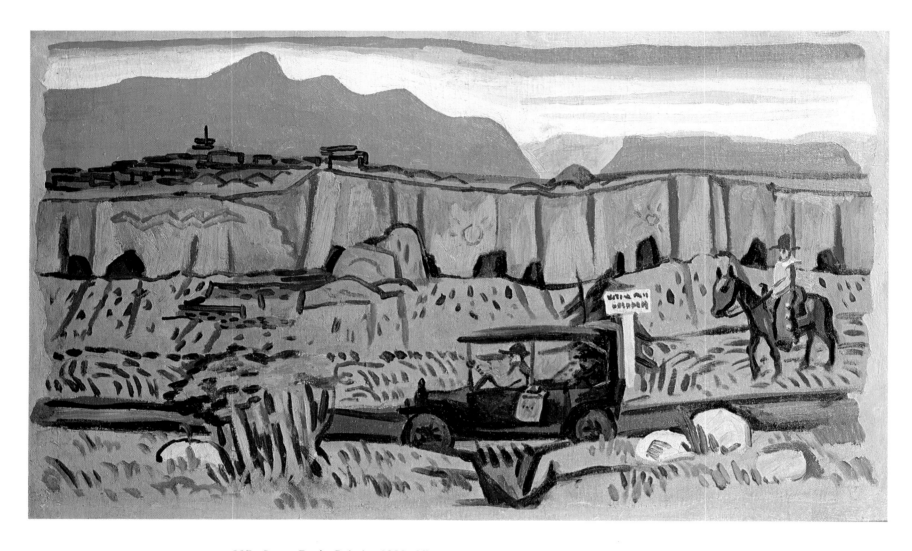

227. Stuart Davis. *Pajarito.* 1923. Oil on canvas, 22 x 36″. Collection Mrs. Stuart Davis

The Southwest as an artist's studio went through cycles of influence as one painter told another of its effulgence and charm. Robert Henri, who had visited Santa Fe in 1916, passed the word on to his students, John Sloan and Randall Davey.

It was a long trip for them even in Davey's Simplex racing car. "We hope to reach Santa Fe about July 15th," Sloan wrote his dealer Joseph Kraushaar back in New York. "I'll start to work with some joy, I believe. I've done so much manual labor, camp-ing and packing up and so much sitting still in the car, that I'll be glad to try the feel of a brush."[1] Davey made his home in Santa Fe, and Sloan returned summer after summer for the next thirty-odd years.

Sloan enjoyed all aspects of the New Mexican scene. Possessed of a sure wit, he waxed sarcastic in many of his Southwestern pictures, cutting into the irony of an art colony quickly turning tourist haven. Such is his view of Taos Pueblo during an Indian detour.

Sloan, despite these wry observances, had an abounding affection for the area; it touched the core of his person and his art.

> I like to paint the landscape in the Southwest because of the fine geometrical formations and the handsome color. Study of the desert forms, so severe and clear in that atmosphere, helped me to work out principles of plastic design, the low relief concept. I like the colors out there. The ground is not covered with green mold as it is elsewhere. The piñon trees dot the surface of hills and mesas with exciting textures. When you see a green tree it is like lettuce against the earth, a precious growing thing. Because the air is so clear you feel the reality of the things in the distance.[2]

For others, though, the milieu was uninspiring. Stuart Davis, encouraged to visit Santa Fe by Sloan, came west in 1923. Davis produced some marvelously formal, rather matter-of-fact and humorous, views of Southwestern landscape and life. But, unfortunately, Davis found little to incite fervor. He was surrounded by such ready-made pictures that he felt stymied. The need for his usual imaginative analytics was absent. Confronted with such spare diagnostic potential, Davis's resulting works are strangely childlike—simple and charming transcriptions of a summer's remembrance.

[1] Letter from John Sloan to Joseph Kraushaar written en route to Santa Fe, 1919, in the Archives of American Art, Smithsonian Institution, Washington, D.C.
[2] John Sloan, *Gist of Art* (New York, 1939), p. 147.

228. John Sloan. *Indian Detour.* 1927. Etching, 9¾ x 12⅝". Amon Carter Museum, Fort Worth

Thomas Hart Benton

During the first two decades of the twentieth century, many American artists fled to Europe, forming a sizable colony of expatriates. Their exodus coincided with active experimentation in artistic theories—Cubism, Expressionism, and abstraction. Eventually tiring of life abroad or losing their financial support, the expatriates dribbled home to find their country changed. The Depression had caused a re-evaluation of things American; subsequently many artists embraced this rediscovery. One of its earliest exponents was Thomas Hart Benton.

Possessed of the belligerent spirit of his great uncle, namesake, and proselytizer for Westward expansion, Benton became the chief spokesman for Regionalism, the 1930s glorification of rural American ways. Part of the reason for Benton's stridency was caused by a national feeling that the Midwest symbolized anything contemptible. Another factor was his self-contempt for ever having strayed from home. Of his continental experience, Benton later admitted that "I wallowed in every cockeyed ism that came along and it took me ten years to get all that modernist dirt out of my system."[1] Such was the depth of his emotion that Benton destroyed many of his canvases from this period.

The departure from European styles was not abrupt, however. Experience as an architectural draftsman in Norfolk during World War I had been catalytic. As a reborn advocate for things American, Benton developed a personal style, individual though not divorced from European influences. He selected some from the past, particularly classic figurative groupings and the sensual contouring of Michelangelo's sculpture, and some from the present—modernistic arrangements of colors and patterns. With this eclectic manner he interpreted scenes from American life.

While artists were continuing to journey across the ocean, Benton, in 1925, began an odyssey through the myriad small towns which dotted mid-America, absorbing every detail. Three years later he produced *Boomtown*. "I was in the Texas Panhandle when Borger was on the boom. It was a town then of rough shacks, oil rigs, pungent stinks from gas pockets, and broad-faced, big-boned Texas oil speculators, cowmen, wheatmen, etc. The single street of the town was about a mile long, its buildings thrown together in a haphazard sort of way. Every imaginable human trickery for skinning money out of people was there."[2] While fascinated by the various characters in Borger, Benton had to comment also on the town's ambiance.

Out on the open plain beyond the town a great thick column of black smoke rose as in a volcanic eruption from the earth to the middle of the sky. There was a carbon mill out there that burnt thousands of cubic feet of gas every minute, a great, wasteful, extravagant burning of resources for momentary profit. All the mighty anarchic carelessness of our country was revealed in Borger. But it was revealed with a breadth, with an expansive grandeur, that was as effective emotionally as are the tremendous spatial reaches of the plains country where the town was set.[3]

[1] Thomas Craven, *Thomas Hart Benton* (New York, 1939), p. 11, quoted in Barbara Rose, *American Art Since 1900* (New York and Washington, 1967), p. 119.
[2] Thomas Hart Benton, *An Artist in America* (New York, 1937), pp. 201–2.
[3] Ibid., p. 202.

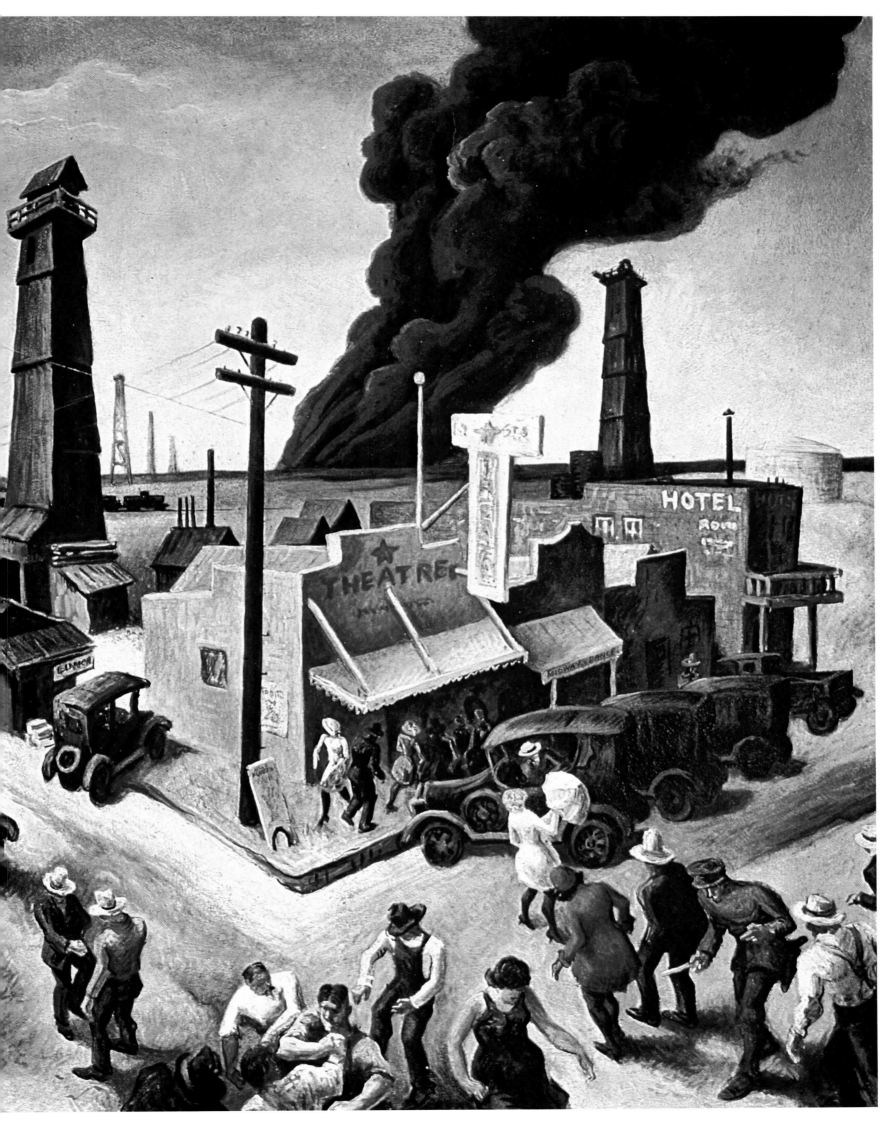

229. Thomas Hart Benton. *Boomtown*. 1928. Oil on canvas, 45 x 54". Memorial Art
Gallery of the University of Rochester, New York. Marion Stratton Gould Fund

"Having determined to be an artist, I bought a black shirt, a red tie, and a pair of peg-top corduroy pants. I wore this outfit with a derby hat which, when I let my hair grow, sat high on my head. I began to be regarded as a genius among my companions—my garb was proof of it."[1] Benton's glib words belied the struggle he waged with those who viewed artists as incomplete persons.

His career as an artist originated from an episode in which his character had been challenged. When his father served in Congress, the young man took some courses at the Corcoran Gallery of Art. Returning to Missouri after the legislator's unsuccessful bid for re-election, Benton traveled to Joplin in search of employment. One night at a bar, while scrutinizing a picture of a nude, Benton was ribbed by the clientele. Benton claimed to be an artist and, in further defense, went that night to the local newspaper's office, where a cartoonist was needed. The poorly qualified applicant was hired, stayed there for only a few months, then departed for the Art Institute of Chicago. "From the moment I first stuck my brush in a fat glob of color," Benton explained, "I gave up the idea of newspaper cartooning. I made up my mind that I was going to be a painter. The rich, sensual joy of smearing streaks of color, of seeing them come out in all sorts of unpremeditated ways, was too much for me and I abandoned my prospective fortunes in the big-time newspaper business without a qualm."[2]

One year later, 1908, Benton began his flirtation with the Parisian art world. However, once more his family had a strong influence on the artist, who eventually returned to his homeland. His father had taken him as a child to political gatherings in the rural corners of Missouri and entertained famous personages in their home. Stories of the old days filled his head, and as a child he saw them relived on visits to Oklahoma which, in Benton's day, still resembled frontier times.

Another force in Benton's life was Hippolyte Taine.[3] This French critic and historian espoused the tenet that an artist was a compilation of his heritage, familial and environmental. To comprehend his feelings, Taine said, "we must seek for them in the social and intellectual conditions of the community in the midst of which he lived."[4] Philosopher John Dewey, whom Benton read, also reinforced the importance of the environment. "The higher the form of life," Dewey proclaimed in 1920, "the more important is the active reconstruction of the medium."[5] Benton understood that the artist most likely to thrive was the one aware of his past.

Armed with intellectual reasoning, Benton approached the American scene for inspiration. *Cattle Loading, West Texas* caused the artist to recollect.

The pioneer West has gone beyond recall. The land is largely fenced. There are no more great cattle treks. Solemn Herefords have taken the place of the wild-eyed longhorns of the old days. There are no more six-shooter belted cowboys. The tough work of the cattle business is done by plain cow hands and fence tenders. On the trails to Wichita and Dodge City, where the hard-riding boys of the old days used to drive their long strings of cattle, the tractors and the combines are chugging.[6]

This painting and *New Mexico* have a comparative calmness about them. The gentle horizon predominates, though punctuated by the black smoke from the engine's stacks. These scenes of the rural plains seem a compromise between the relatively subjective and modernist view of the West which had developed by the 1930s and the objective vantage point of historicism.

[1] Thomas Hart Benton, *An Artist in America* (New York, 1937), p. 31.
[2] See Matthew Baigell, *Thomas Hart Benton* (New York, 1973), pp. 21–22.
[3] Benton, loc. cit.
[4] Quoted in Matthew Baigell, *The American Scene* (New York, 1974), p. 41.
[5] John Dewey, *Reconstruction in Philosophy* (Boston, 1962), p. 85.
[6] Benton, op. cit., p. 211.

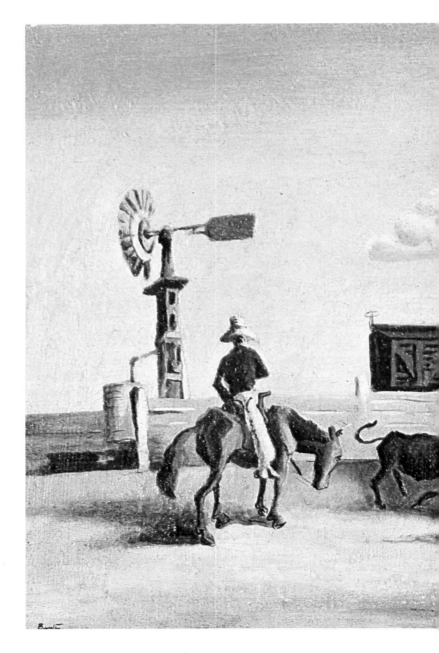

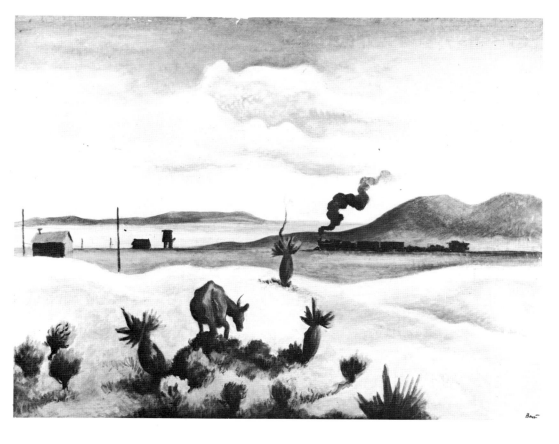

230. Thomas Hart Benton. *New Mexico.* 1926. Oil and tempera on wallboard, 20¼ x 26¼″. Denver Art Museum. Helen Dill Collection

231. Thomas Hart Benton. *Cattle Loading, West Texas.* 1930. Oil and tempera on canvas, 18 x 38″. Addison Gallery of American Art, Phillips Academy, Andover, Mass.

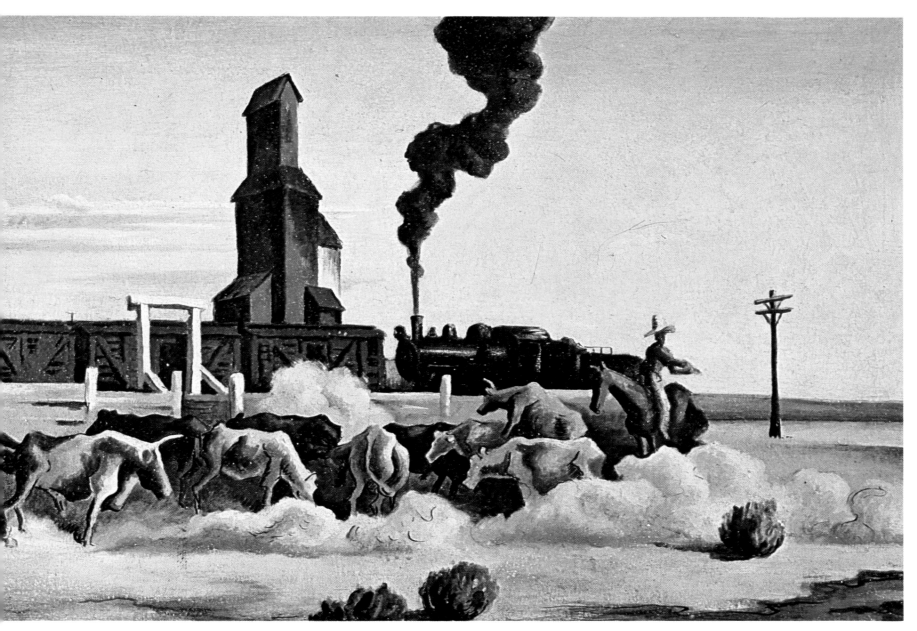

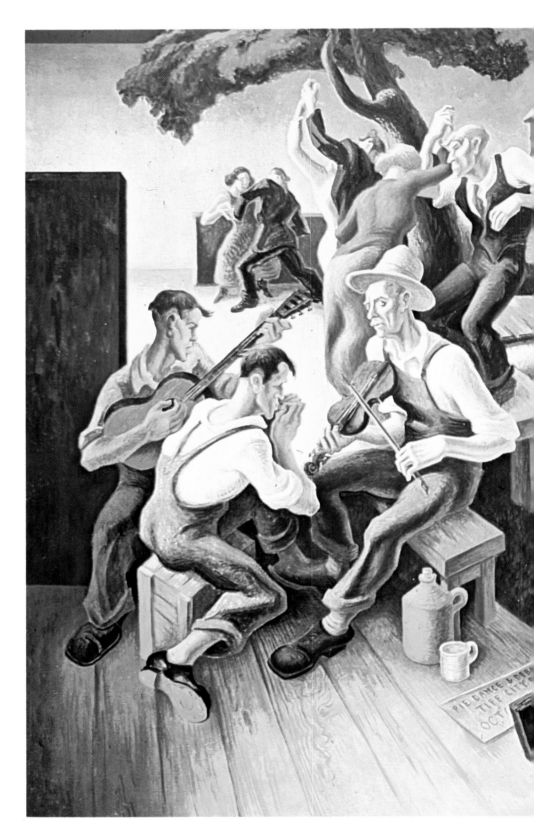

"**I** believe I have wanted, more than anything else, to make pictures, the imagery of which would carry unmistakably *American meanings* for Americans and for as many of them as possible."[1] This brief yet powerful statement epitomizes Thomas Hart Benton's purpose. He pictured his countrymen at work, at play, often bigger than life as they toiled to regain the nation's prosperity. An artist who painted for the people, Benton strove to share his dreams and ideas.

During the years of the Depression mural painting underwent a resurgence in America. Mexican artists in the 1920s had used murals to further their revolution by raising national awareness. Diego Rivera and José Clemente Orozco were even invited north to pursue their monumental work. Their medium was a natural for Benton's cogency and commitment.

Similar to the technique used by El Greco and Tintoretto, Benton created a small stage for his paintings. On it he placed clay models, which he then stretched out of proportion. This attenuation gave his canvases a dynamic tension and made his mannerism more forceful than life itself.

In 1932 Benton painted a series of panels entitled *The Arts of Life in America* for the Whitney Museum library. Of this and two other murals by Benton, art critic and historian Barbara Rose commented, "If Benton's compositions strike the viewer as false or contrived, it is because they are first plotted as abstractions, and then turned into figurative motifs, and not vice versa, as is the case with [Edward] Hopper and [John] Sloan. The figures are often unconvincing as figures, although Benton's ability to render the plasticity of three-dimensional form is such that they are charged with a seething vitality."[2]

Arts of the West, a panel of the Whitney library mural, purposely depicts those activities which do not require special instruction or guidance—wrangling, card playing, horseshoeing, dancing, and fiddling. Everyday people in leisure activities are recorded by Benton; they are the grassroots emanating from the environment. In defense of Western culture, Benton observed:

The claim is generally made that the hardships of pioneer life made the cultivation of aesthetic sensibilities impossible and that the pioneer psychology once established remained in the habits and ways of people, keeping them on a level of low sensibility. It is forgotten, however, that our aboriginal tribes, living under equal hardships, were able to cultivate aesthetic attitudes and practices to a very high degree. It is also forgotten that up to the time of the Civil War our pioneers themselves cultivated quite a number of arts and that they were particularly great singers, orators, and dancers. . . . The arts of our pioneers were simple arts perhaps, but they were genuine and they were assiduously cultivated.[3]

[1] Quoted in Matthew Baigell, *Thomas Hart Benton* (New York, 1973), p. 87.

[2] Barbara Rose, *American Art Since 1900* (New York and Washington, 1967), pp. 121–22.

[3] Thomas Hart Benton, *An Artist in America* (New York, 1937), p. 26.

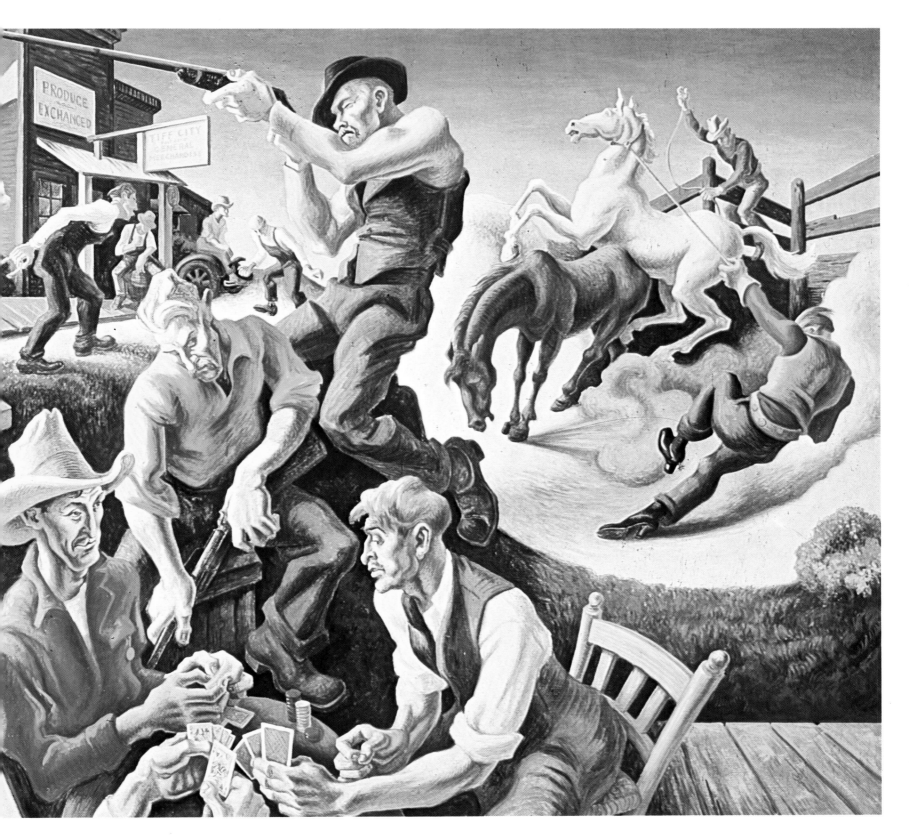

232. Thomas Hart Benton. *Arts of the West*. 1932. Tempera with oil glaze on linen, 8' x 13'. New Britain Museum of American Art, Conn. Harriet Russell Stanley Fund

Index

Photographic Credits

The author and publisher wish to thank the libraries, museums, and private collectors for permitting the reproduction of works in their collections. Photographs have been supplied by the owners or custodians of the works of art except for the following, whose courtesy is gratefully acknowledged:

Brandywine River Museum, Chadds Ford, Pa., 201; Jones, Bruce C., Centerport, N.Y., 91; Kennedy Galleries, Inc., New York, N.Y., 147, 148; Kimbell Art Museum, Fort Worth, Tex., 152; The Photo Works Inc., East Hampton, N.Y., 140; Roos, George, New York, N.Y., 49, 86, 182, 227; Strehorn, Bill J., Dallas, Tex., 214, 215; Todd Studios, St. Louis, Mo., 135.